D1596937

SHOOTING COWBOYS AND INDIANS

SHOOTING
COWBOYS
AND INDIANS

Silent Western Films, American Culture,
and the Birth of Hollywood

ANDREW BRODIE SMITH

UNIVERSITY PRESS OF COLORADO

Published by the University Press of Colorado
5589 Arapahoe Avenue, Suite 206C
Boulder, Colorado 80303

 The University Press of Colorado is a proud member of
the Association of American University Presses.

The University Press of Colorado is a cooperative publishing enterprise supported, in part, by
Adams State College, Colorado State University, Fort Lewis College, Mesa State College,
Metropolitan State College of Denver, University of Colorado, University of Northern Colorado,
and Western State College of Colorado.

The paper used in this publication meets the minimum requirements of the American National
Standard for Information Sciences—Permanence of Paper for Printed Library Materials. ANSI
Z39.48-1992

Library of Congress Cataloging-in-Publication Data

Smith, Andrew Brodie, 1967–
 Shooting cowboys and Indians: silent western films, American culture, and the birth of
Hollywood / Andrew Brodie Smith.
 p. cm.
Includes bibliographical references and index.
 ISBN 0-87081-746-9 (hardcover : alk. paper)
 1. Western films—United States—History and criticism. 2. Silent films—United States—
History and criticism. I. Title.
PN1995.9.W4 S63 2003
791.43'6278—dc21

 2003014272

Design by Daniel Pratt

13 12 11 10 09 08 07 06 05 04 10 9 8 7 6 5 4 3 2 1

CONTENTS

Acknowledgments | vii

Introduction | 1

"This Strange Land of Sunshine and Beauty": Selig Polyscope and the Invention of the Western-Film Genre | 9

"Plenty of Soldiers, Cowboys, Indians, Trappers, Et Cetera": The Chicago Studios and the 1909–1911 Western-Film Boom | 37

"A Genuine Indian and His Wife": James Young Deer, Lillian Red Wing, and the Bison-Brand Western | 71

"Cogs of the Big Ince Machine": New York Motion Picture Introduces "Bison-101" Western Features | 105

"The Making of Broncho Billy": Gilbert M. Anderson Creates the Western-Film Hero | 133

"The Aryan": William S. Hart and the Cowboy Hero in the Era of Features | 157

"No More Laces and Plumes": Neighborhood Theaters, Boy Culture, and the Shaping of "Shoot-'em-up" Stars | 187

Epilogue: Galloping out of the Silents | 217

Index | 223

ACKNOWLEDGMENTS

It is my pleasure to recognize the people and institutions that have provided support and encouragement during the course of researching and writing this book. I am especially indebted to my dissertation co-chairs in the UCLA Department of History, Norris Hundley, Jr., and Thomas S. Hines. This project is largely the outcome of their guidance and generosity.

I would like to acknowledge the help of many librarians and archivists, including the staff at the Margaret Herrick Motion Picture Academy Library, the British Film Institute, the Motion Picture Division of the Library of Congress, the Netherlands Film Museum, UCLA Arts Special Collections, Archives of the National Museum of American, the Museum of Modern Art History, New York Public Library of the Performing Arts, Wisconsin Center for Film and Television Research, Columbia University's Oral History Office, the Huntington Library, and the American Heritage Center.

For helping to fund this project, I am grateful to the Andrew Mellon Foundation, the Smithsonian, the UCLA History Department, the American Historical Association, the Illinois State Historical Society, the University of Wyoming's American Heritage Center, the University of Utrecht, and California State University, San Jose's Sourisseau Academy.

For reading and commenting on significant portions of this book, and for generally providing encouragement, I am grateful to Tad Blacketer, Angie Blake, Tamar Blaufarb, Nick Brown, Lorena Chambers, George Custen, John Mack Faragher, Elliot Freeman, Mathew Gilmore, Robin Isard, Kehaulani Kauanui, Timothy Maroni, Charlie McGovern, John McKieran-Gonzalez, Julia Mickenberg, Bridget Miller, Brian O'Neil, Maureen Selle, Tim Schafer, Joey Smith, Evelyn Stone, William Urrichio, and Nanna Verhoeff. I would also like to thank the staff at the University Press of Colorado and the anonymous readers of the manuscript.

I would like to acknowledge my family for their inspiration and encouragement—Martha Tobener, Jim and Patti Smith, James Russell Smith, Monica Ann Smith, Emily and Scott Bristow, Joey and Racha el Smith, and Molly and Mike Littlefield. Finally I'd like to thank my wife Nancy Kruse for her insights—intellectual and otherwise—and for making our life together a joyous adventure.

SHOOTING COWBOYS AND INDIANS

INTRODUCTION

The popularity of the "Westerns" has never waned. Today the cowboy pictures are fewer in number than they were ten years ago, and by that same token much fewer in proportion to the total output, but they continue to hold their place, if not at the top, at least quite close thereto. And why?

Simply because the one domain, which the camera has made distinctively its own, is that of the plains. Here the moving picture has created its own empire of romance. It is not a real country. It bears about the same relation to the actual West that a Sherlock Holmes story does to an ordinary detective's existence. The camera found the West a somewhat boisterous and formless region and showed it how to behave.[1]

—Journalist Randolph Bartlett, 1919

Westerns have been a perennial favorite of the U.S. movie industry and its audiences nearly since the development of narrative cinema. Through the years the popularity of such films has ebbed and flowed, but no other genre has maintained such a strong association with Hollywood and with American history and culture. Although among the most ubiquitous cultural forms of the twentieth century, the western has not captured its share of scholarly attention. Until the 1970s, academics generally dismissed

cowboy movies as specious and crassly commercial. Even Henry Nash Smith, the preeminent interpreter of nineteenth-century, frontier-themed dime novels, found twentieth-century westerns unworthy of analysis. They were, in his estimation, static, sensational, and gimmicky; driven by mere profit; and "devoid alike of ethical and social meaning."[2]

French auteur theory generated the first scholarly interest in westerns. Jim Kitses and other film critics celebrated great directors such as John Ford, Howard Hawks, Sam Peckinpah, Anthony Mann, and Budd Boetticher for working within the genre's structure to create a canon of classic films.[3] Auteur theory, however, was inadequate in explaining the enduring phenomenon of the genre in its many forms, and scholars began to look to sociological explanations to account for the western's popularity.

Sociologist Will Wright was among the first academics to identify changing patterns in the genre's basic plot structure and to account for these changes by looking to larger historical shifts within American society. In his useful study *Six Guns and Society: A Structural Study of the Western* (1975), he argued that the transition of the U.S. economy from an open to a managed market after World War II largely determined the evolution of sound-era cowboy pictures. Westerns made between 1930 and 1955 favored what he called the "classic plot" in which a lone gunfighter hero with an innate sense of justice and fair play saves a frontier town from gamblers or other villains. According to Wright, after 1955 the "professional plot" replaced the older classic story line. In the new kind of western, heroes travel in groups and are paid to battle evildoers. This development in the genre, Wright contended, reflected the fact that in a managed economy entrepreneurial individualism diminished in importance as workers were increasingly rewarded for identifying with the goals of a corporation and for functioning as part of a group.[4]

Although criticized for using a small sample of only the most commercially successful films, Wright's work stands as an important explanation of the genre's development. Scholars, however, have modified some of his findings. John H. Lenihan, for example, looked in greater detail at the relationship between American society and the western. In his *Showdown: Confronting Modern America in the Western Film* (1980), he demonstrated that it was not just the shift to a managed economy that determined the conventions of post–World War II westerns but also the period's pressing political and social concerns— including the Cold War, the movement for racial equality, and postwar alienation.[5] The genre, he concluded, was one of the mechanisms by which the United States as a society gave "form and meaning to its worries" about its destiny during an uncertain time.[6]

In the 1990s scholars asked new questions about the western. They were particularly concerned with the genre's ideological messages and its represen-

tation of gender norms. In *Gunfighter Nation* (1992), Richard Slotkin compli-
cated some of Wright's assertions about the political meanings the western
carried. He identified two dominant, and at times conflicting, ideologies oper-
ating in sound-era cowboy pictures: a "progressive" worldview—marked by a
faith in state-supported distribution of property, economic opportunity, and
political power—and a "populist" orientation, based in Jeffersonian agrarian-
ism and economic individualism.[7] Slotkin concluded that the genre's enduring
popularity is explained in part by filmmakers of differing political persuasions
effectively expressing their views through the form.

Most recently, academics have looked to the western for answers about
how dominant American notions of manhood developed. Analyzing sound-
era westerns from the perspective of the qualities of masculinity they pro-
moted, Lee Clark Mitchell, Jane Tompkins, and other scholars of American
literature have noted that such films proved remarkably consistent.[8] In this
regard Tompkins argued compellingly in her *West of Everything: The Inner Life
of Westerns* (1992) that the western's central figure—the stoic, isolated cow-
boy hero—developed at the end of the nineteenth century in response to the
threat men felt as women, espousing Victorian values, entered the public sphere.

Of the leading books on the western, none treated the silent era as truly
significant—a critical omission since it was a period of the genre's greatest
popularity and a time when filmmakers established many of its basic conven-
tions. These major studies also failed to examine the western in the context of
the growth and development of the U.S. film industry. Wright and Lenihan,
in fact, specifically dismissed the notion that the structure of studios, the star
system, and the intentions and political beliefs of prominent players in the
movie industry were important for understanding the western's social signifi-
cance.[9] The history of silent-era westerns, however, indicates how inextricably
linked the genre's evolution and the industry's development have been. Dur-
ing the sound era the system of production was undergoing less dramatic struc-
tural change than it did during an earlier period. Yet the social, cultural, and
political changes scholars have identified as shaping the western—transition
to a managed economy, changing gender roles, the currency of particular ideas
of political reform, the Cold War, and others—had the power to influence the
genre only insofar as they were filtered and interpreted through the studio
system. In other words, these studies show that films reflect greater societal
changes, but they tell us little about the process by which this happens.

This book addresses what I see as the two major gaps in the literature on
the western: the failure to examine closely silent-era films and the failure to
understand the genre's evolving conventions as a function of larger changes
within the industry.[10] Looking primarily at the three most important produc-
ers of westerns during the era when the studio system was developing—Selig

Polyscope, Essanay Film Manufacturing, and the New York Motion Picture Company—and the stars these studios created, my study traces the western from its hazy origins in the prenarrative cinema of the 1890s to the advent of motion-picture sound in the 1920s. I am especially interested in the role the genre played in the development of the American film industry and, in turn, how changes in the movie business shaped the western. My conclusions suggest that many of the most popular theses on the development of the western need modification. I show, for example, that what Wright identified as the western's classic plot was twenty years in the making prior to 1930. Moreover, its conventions were a response not only to contemporaneous social changes but also to the crystallization of a particular set of business conditions, including shifts in audience demographics and tastes, censorship and reform activities, and developments in film exhibition and distribution. Similarly, I show how the stoic, isolated cowboy hero, whom Tompkins traces back to the late nineteenth century, fully emerged in the cinema only during the 1920s after manufacturers relegated the genre to smaller and more modest neighborhood houses where male spectators predominated.

In addition to modifying conventional notions about the western, this book revises current thinking about the birth of Hollywood, particularly in regard to the establishment of Los Angeles as the center of American film-making and to the creation of the popular screen images of heroic white men that so dominated American popular culture for much of the twentieth century. Historians of the silent era have focused most of their attention on the commercially successful and technically and artistically innovative motion-picture firms from the first half of this period—Edison Manufacturing, the Biograph Company, and the Vitagraph Company.[11] These businesses, however, were neither leaders in the production of cowboy and Indian pictures that popularized the stereotypical western ethnic and gender images nor pioneers in moving film operations permanently to California. Using studio records, trade journals, the personal papers and reminiscences of industry professionals, and the films themselves, my study demonstrates that these distinctions belong to Selig, Essanay, and New York Motion Picture.

Although the biggest manufacturers initially avoided routine production of westerns, these other firms sent troupes to the Far West to shoot such pictures and in the process established Los Angeles as an important regional outpost for filmmaking. Several smaller and less influential manufacturers followed suit, and the relatively cheaply produced western came to dominate theater screens. The genre was especially popular with male spectators, particularly boys who looked to cinema cowboys as embodying the basic ideals of American manhood. As westerns carried a considerable symbolic association with the United States and its dominant values, such films generated a great

deal of attention and sometimes controversy. Exhibitors, critics, fans, and industry reformers argued about the genre's content. Selig, New York Motion Picture, and Essanay were in a special position to modify their product quickly in response to such heated discussions, as they manufactured westerns weekly.

During the silent period, these firms and the stars they created were instrumental in propelling the genre through three stages in which many of the western's sound-era conventions evolved. Initially, filmmakers produced cowboy pictures that combined the sensational depiction of violent crimes with scenic western landscapes. Native Americans, Mexicans, and white women were as likely to be central protagonists in such pictures as were white cowboys. Moreover, Indians who were involved in the production of early westerns created sympathetic nonwhite characters and wrote screenplays that dealt with racism and assimilation. In 1911, however, manufacturers began to shake the stigma attached to cowboys and Indians as the stuff of dime novels and "cheap" melodrama. They deemphasized the depiction of crime in westerns and pushed nonwhite characters into the background. The influence of Native Americans declined as the industry adopted modern modes of industrial production and filmmakers featured white men as the genre's central protagonists. Then in the period 1913–1919, to make westerns appealing to the middle-class and disproportionately female audiences of the new, well-appointed movie palaces, producers created western heroes who were deferential to traditional values of home, family, and church. In the 1920s, as the genre's popularity declined in first-run houses, manufacturers produced low-budget western "shoot-'em-ups" for neighborhood and second-run theaters. At this point filmmakers developed the stoic, isolated cowboy hero to appeal to the young male spectators who frequented these smaller, more modest houses.

In its broadest sense, my study contributes to knowledge of what historian Ann Fabian called the "commercialization of the western past."[12] As projects like this one and others suggest, industries of mass culture have long mined the history of the American West for profit. Many historical subjects have served a similar purpose, but the frontier—because of the preeminent place it has held in the public's imagination—has proven a particularly fecund source for those in commercial amusement. In the 1910s motion pictures replaced dime novels and Wild-West shows as the leading purveyors of popular images of the West. Therefore, knowledge of the medium is elemental to understanding how, in the context of market capitalism, Americans created dominant notions of regional history and identity. Moreover, it is fundamental for understanding how these characterizations and stereotypes impacted the larger society as people sought to adopt, modify, or resist them. My account of the history of silent cowboy and Indian pictures indicates the complex and contentious process by which business interests commercialized the western past.

It shows how early studios worked to make their representations of frontier history more compelling than competing versions offered by others to ensure the largest audience for their product.

Although my approach illuminates these larger issues, many important individual western films—produced by studios not under consideration here— fall beyond the realm of analysis. Only mentioned, for example, are the cowboy and Indian pictures of D. W. Griffith, Cecil B. DeMille's early features, and such mid-1920s epics as James Cruze's *The Covered Wagon* (Lasky, 1923) and John Ford's *The Iron Horse* (Fox, 1924). I discuss such exceptional productions insofar as they impact the routine manufacture of westerns. More detailed information on these and other well-known films can be found in Kevin Brownlow's *The War, the West and the Wilderness*, George Fenin and William Everson's *The Western From Silents to Cinerama*, and Jon Tuska's *The Filming of the West*. Although they do not treat the early history of the genre in a sustained or systematic fashion, these broad and largely anecdotal film histories contain interesting and valuable material on western films and cowboy stars of the silent period.[13]

A note to readers about a definition of "the western." During the silent era, producers, exhibitors, and moviegoers used a variety of terms to describe the genre—including *cowboy and Indian pictures, Wild-West films, frontier melodramas,* and *shoot-'em-ups.* Although these terms were seldom mutually exclusive, many in the industry recognized subtle distinctions in their meaning. Reviewers, for example, often used the term *Wild-West film* to refer to a particularly violent western. Similarly, in the 1920s the term *shoot-'em-up* came into vogue to designate a cheaply produced cowboy picture targeted for second-run and neighborhood theaters. During periods of the genre's extreme popularity, filmmakers, audiences, and critics also distinguished among a dozen or more subgenres, including *settler subjects, frontier military films, western comedies, all Indian stories,* and *ranch pictures.* I tend to avoid subgenre distinctions and generally, for the sake of variety, use the broader terms interchangeably. For the purposes of this study, a western is a film contemporaneously referred to as such by producers, exhibitors, or moviegoers. It typically features either cowboy or Indian characters or both and sometimes ethnic Mexicans. Moreover, it deals with one of a number of conditions associated with the frontier or with the consequences of U.S. territorial expansion—including, but not limited to, conflict between whites and nonwhites, migration, ranching, mining, and banditry. Violence, chase scenes, criminal activity, and simplistic morals are canonical hallmarks of the genre.

NOTES

1. Randolph Bartlett, "Where Do We Ride From Here?" *Photoplay* (February 1919): 36–37, 109.

2. Henry Nash Smith, *Virgin Land: The American West as Symbol and Myth* (Cambridge: Harvard University Press, 1970), 120.

3. Jim Kitses, *Horizons West: Anthony Mann, Budd Boetticher, Sam Peckinpah: Studies of Authorship Within the Western* (Bloomington: Indiana University Press, 1969).

4. Will Wright, *Six Guns and Society: A Structural Study of the Western* (Los Angeles: University of California Press, 1975).

5. John H. Lenihan, *Showdown: Confronting Modern America in the Western Film* (Urbana, Ill.: University of Chicago Press, 1980).

6. Ibid., 9.

7. Richard Slotkin, *Gunfighter Nation: The Myth of the Frontier in Twentieth-Century America* (New York: Atheneum, 1992).

8. Lee Clark Mitchell, *Westerns: Making of the Man in Fiction and Film* (Chicago: University of Chicago Press, 1996); Jane Tompkins, *West of Everything: The Inner Life of Westerns* (New York: Oxford University Press, 1992).

9. Wright, *Six Guns and Society,* 13; Lenihan, *Showdown,* 8.

10. Although no full-length academic studies address the silent western, there are half a dozen or so important articles and essays on the subject, including Richard Abel, "'Our Country'/Whose Country? The 'Americanisation' Project of Early Westerns," in *Back in the Saddle Again: New Essays on the Western,* Edward Buscombe and Roberta Pearson, eds. (London: BFI, 1998), 77–95; Richard Abel, "Perils of Pathe, or the Americanization of the American Cinema," in *Cinema and the Invention of Modern Life,* Leo Charney and Vanessa R. Schwartz, eds. (Berkeley: University of California Press, 1995), 183–223; Robert Anderson, "The Role of the Western in Industry Competition 1907–11," *Journal of the University Film Association* 31 (1979): 19–26; Geoffrey Bell, "The Adventures of Essanay and Broncho Billy," in his *The Golden Gate and the Silver Screen* (Cranbury, N.J.: Association of University Presses, 1984), 39–65; Diane Koszarski's essay on William S. Hart in her *The Complete Films of William S. Hart: A Pictorial Record* (New York: Dover, 1980); Peter Stanfield, "The Western 1909–14: A Cast of Villains," *Film History* 1 (1987): 97–112; Linda Kowall Woal, "Romaine Fielding: The West's Touring Auteur," *Film History* 7 (1995): 401–425.

11. Some outstanding recent monographs on the "big three" film manufacturers and their films include Charles Musser, *Before the Nickelodeon: Edwin S. Porter and the Edison Manufacturing Company* (Berkeley: University of California Press, 1991); William Uricchio and Roberta Pearson, *Reframing Culture: The Case of Vitagraph Quality Films* (Princeton: Princeton University Press, 1993); Tom Gunning, *D. W. Griffith and the Origins of American Narrative Film* (Chicago: University of Illinois Press, 1991).

12. Ann Fabian, "History for the Masses: Commercializing the Western Past," in *Under an Open Sky: Rethinking America's Western Past,* William Cronon, George Miles, and Jay Gitlin, eds. (New York: W. W. Norton, 1992), 223–238.

13. Monographs on the western that contain material on the silent period include Kevin Brownlow, *The War, the West and the Wilderness* (New York: Alfred A. Knopf, 1979); George Fenin and William Everson, *The Western From Silents to Cinerama* (New York: Orion, 1962); Jon Tuska, *The Filming of the West* (Garden City, N.Y.: Doubleday, 1976).

"THIS STRANGE LAND OF SUNSHINE AND BEAUTY"

Selig Polyscope and the Invention of the Western-Film Genre

We have had our special photographic corps in Colorado for several months. Our list of subjects from this grand state, with its gorgeous scenery and most wonderful attractions, is quite complete. . . . No other concern has ever made so many nor such good pictures in Colorado and we offer an entirely new line to all who want to take this golden opportunity of giving their audiences what they demand. . . . Every year from 75,000 to 150,000 tourists visit the state. . . . Hundreds of thousands more would go if they had the price. And all will cheerfully pay liberally to see pictures of this strange land of sunshine and beauty, of gold and precious stones.[1]

—Selig Company circular, 1902

Beginning in the late 1890s, a decade or more before anyone had conceived of such a thing as a western-film genre, filmmakers had been capturing the U.S. West's landscapes and human inhabitants in short, nonnarrative motion pictures then known as "actuality films." Railroads, chambers of commerce, hotels, newspapers, and other institutions involved in the economic development of the West saw such pictures as an effective means of marketing the area to potential migrants and visitors. Thus they offered

assistance in making them and sometimes even supplied the negatives free of charge to film manufacturers, who sold prints to vaudeville houses, black-tent exhibitors, lecturers, and other customers. These early films proved very popular with film audiences, in part because they fed into an ongoing popular-culture craze for things western as manifested in dime novels, still photography, plays, and Wild-West shows.

The rise of the British crime film in the summer of 1903 and the success of the Edison Company's *The Great Train Robbery* (Edison, 1903) ushered in dramatic changes in the cinematic representation of the American West.[2] In an attempt to profit from the popularity of these new sensational pictures, American filmmakers rushed similar stories into production. Chicago-based manufacturer William N. Selig believed he could create distinctive crime films by making them with authentic western backgrounds. With this idea in mind, he went to Denver to help journalist, commercial photographer, and Colorado booster Harry H. Buckwalter shoot such pictures. Buckwalter was committed to using the cinema to promote the Rocky Mountain area, and he insisted on integrating qualities of his scenic promotional subjects into the crime films. By combining key elements from these two older types of motion pictures— particularly spectacular natural landscapes, chase scenes, and sensational violence—by 1904 Selig and Buckwalter had gone a long way toward inventing the western. It would take several years, however, before audiences and exhibitors recognized the cowboy and Indian picture as a genre and before American manufacturers were in a position to produce it on a mass scale.

With his financial situation improving slightly after debilitating legal battles with Thomas Edison over patent infringement that nearly put him out of business, Selig hired leading crime-film producer Gilbert M. Anderson and sent him to Denver in 1906 to make pictures. Buckwalter, wanting to ensure that the Selig Company continued to respond to his clients' point of view, volunteered to help the manufacturer's new employee shoot films in Colorado. Even while Anderson focused his attention on the production of crime-themed melodramas, the photographer/journalist lobbied for films that depicted the area's natural wonders, scenic beauty, and economic potential. The western was born out of this creative tension, and in the winter of 1906–1907 Selig, Buckwalter, and Anderson produced what were likely the first motion pictures conceived and marketed as "westerns."[3]

Of the central figures behind the initial development of cowboy and Indian pictures, Selig was the first to enter the industry. His origins were humble. He was born in Chicago in 1864 to German-born parents. His father worked as a shoemaker, and the large, Roman Catholic Selig family lived on Krammer Street in a working-class, immigrant enclave. William was the fourth of seven children. He attended Chicago's public schools, and at age fourteen he was

apprenticed to an upholsterer. As his older brothers had entered clerical professions, he was the only child to follow his father into an artisanal occupation.[4] The training he received in the use of hand tools would serve him well when he began to tinker with motion-picture cameras and projectors.

As William was growing up, ethnic Germans were under attack from nativists in Chicago, and partly because of this they tended to live in nearly exclusive neighborhoods. They attended their own schools and churches and sponsored German dances, picnics, parades, lectures, and amateur theater performances.[5] William might have remained in this insular environment had it not been for his poor health, which led him to move to California when he was in his early twenties.

On the West Coast he developed an interest in showmanship and performed as a magician under the name Selig the Conjurer.[6] He eventually found his way into black-faced minstrelsy and had his own show called Martin and Selig's Mastodon Minstrels. It toured the West extensively by horse-drawn wagon. African American comedian Bert Williams, later an important vaudeville star, was part of Selig's original show. The troupe, Williams recalled, consisted of five whites, four blacks, and a "Mexican" who drove the horse team and played trombone.[7] The outfit was chronically underfunded, and Williams's five months with the show proved particularly difficult. He remembered only three weeks in which he was actually paid his salary of eight dollars plus food. He defected when the company was stranded in Bakersfield, California.[8] The rest of the troupe continued on.

While the minstrel show was in Dallas, Texas, in 1895, Selig visited a peepshow parlor and saw Edison's kinetoscope for the first time. According to film historian Terry Ramsaye, Selig quickly understood the commercial possibilities of combining Edison's apparatus with the magic lantern so moving images could be projected onto a screen.[9] The showman left minstrelsy and began to experiment with film projection. Meanwhile, he supported himself working as a commercial photographer. He specialized in making carbon prints, lantern slides, and photographic enlargements that railroads used in advertising campaigns to encourage travel and other commercial activity along their lines. He also acted as manager for a group of men who bought the rights to exhibit the vitascope, Edison's first commercial projector, in Minnesota and adjoining states.[10]

In 1897 Selig stumbled onto an opportunity to establish his own motion-picture business. After unsuccessfully attempting to build a projector, he discovered a Chicago machinist piecing together a pirated, French-designed Lumière cinématographe—a camera, projector, and printer in one. He convinced the man to assemble a duplicate projector that Selig then modified to use Edison-sprocketed film. The advantages of the French machine would have

been readily apparent to Selig, who had spent many years as a traveling enter-
tainer and experienced firsthand the problems with using the vitascope. The
cinématographe was a much simpler machine than Edison's. Hand-cranked
rather than electric, it was also more portable. Selig named his version of the
camera/projector the multiscope and later the polyscope. With a version of
this machine, he dominated much of vaudeville film exhibition in Chicago
and the Midwest from 1900 to 1902.[11]

The projector/camera provided the foundation for the Selig Polyscope
Company, a firm he established in 1897 and actively managed for most of its
twenty-two years of existence. Even as the operation expanded with many
producers working under him, Selig continued to monitor closely every de-
partment in his far-flung studios and manufacturing plants. He read all impor-
tant scenarios and reserved the right of final approval.[12] He was particularly
vigilant about monitoring scripts for controversial material that might incur
the wrath of censors or moral reformers.[13]

Like all early motion-picture manufacturers, Selig at first mostly produced
filmic records of newsworthy events, scenic landscapes, industrial wonders,
and interesting or exotic people. He usually made these so-called actuality
subjects at his own expense. Yet as with his still photography, he sometimes
managed to get locally based corporations, particularly railroads but also such
firms as the meatpacking giant Armour and Company, to finance the produc-
tion of films that directly or indirectly promoted their products. Selig sold
these pictures as he would any others, and exhibitors had no way of distin-
guishing the corporate advertising from anything else in his catalog.

Railroads were among the first businesses to recognize the promotional
value of moving pictures. As critic Lynne Kirby has pointed out, a natural
affinity existed between the railroad and cinema. Films made from moving
trains showed off the new medium's ability to record movement and register
speed.[14] As a result, such scenes were especially common before 1904. Rail-
roads sometimes hired manufacturers to shoot particular images, but instead
of paying cash for their services, they provided them with rail transportation.[15]
This arrangement had considerable value for early filmmakers who needed to
travel to capture fresh and unique scenes. The railroads became particularly
important corporate clients for Selig, and even as late as 1909, when his com-
pany was one of America's largest film producers, he continued to seek out
advertising contracts with them.[16]

While working for the railroads, Selig met commercial photographer Harry
H. Buckwalter, and the two became friends. Like Selig, Buckwalter was of Ger-
man ancestry, having left Reading, Pennsylvania, for the West at age sixteen.
Buckwalter ended his journey in Colorado Springs, Colorado, where he met
his future wife, Carrie Emmajean Fuller, whose father was a prominent figure

in the city's real-estate and home-building industries. Their marriage in 1889 linked Buckwalter to the state's development interests. The couple moved to Denver where they thought business opportunities would be better. Buckwalter developed an interest in photography and worked for the Denver Photo Supply Company and as a printer for the *Denver Republican*. In 1894 the *Rocky Mountain News* hired him as its first reporter/photographer. He eventually became assistant city editor.

While employed by local newspapers, Buckwalter maintained a large and well-equipped photographic studio in his Denver home. In 1896, as his business grew, he formed what would become the highly profitable Buckwalter Photographic Company, drawing clients from the state's most important commercial interests. He served as the official photographer for the Colorado Midland Railway as well as other firms and was an adviser to the advertising departments of many local businesses.

Buckwalter also engaged in a variety of social activities, many of which related to Denver's civic and commercial life. He was a member of the Chamber of Commerce and was one of the city's most active boosters. He belonged to several fraternal orders and designed items for their parades and initiation rituals. A tinkerer and an inventor, Buckwalter was interested in new technologies and the ways in which they could be used in campaigns to promote the city. In addition to motion pictures, he experimented with early X rays, lighting, and sound devices.[17] He developed and patented a high-speed camera shutter that he sold to Prosch Manufacturing.

Selig and others involved in Chicago's early film industry saw Buckwalter as an expert on things western and, like President Theodore Roosevelt, an advocate of the strenuous life. Motion-picture importer George Kleine praised Buckwalter as the consummate outdoorsman familiar with "every nook and cranny of the great Wild West."[18] This reputation was solidified when Buckwalter served as the official photographer and filmmaker for Roosevelt during his 1905 visit to the Rocky Mountains.

Buckwalter's experimentation with photography led naturally to a curiosity about motion pictures. In 1901 he arranged for Selig to supply him with a polyscope camera and one of his employees, Thomas S. Nash, to help operate it. Nash soon returned to Chicago and left the newly trained Buckwalter to his own devices. The Coloradan made tens of thousands of feet of scenic motion pictures for the Selig Company. Seeing the production of these films as a natural extension of his journalistic and photographic efforts to promote Colorado, he worked for the firm without remuneration. His advertising clients, particularly the railroads, supported his activities because he convinced them that the moving pictures would help advertise the state to potential tourists and migrants (see Figure 1.1).[19]

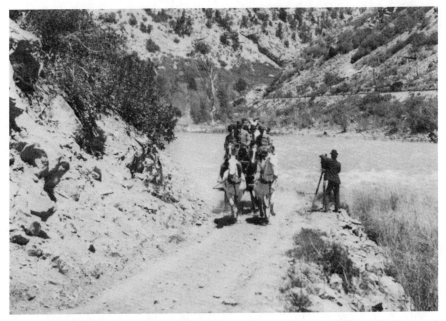

Fig. 1.1 Buckwalter filming Runaway Stage Coach *(1902). From William C. Jones and Elizabeth B. Jones,* Buckwalter: The Colorado Scenes of a Pioneer Photojournalist, 1890– 1920 *(Boulder: Pruett Publishing Co., 1989).*

Buckwalter and Nash shot many of their first scenic Colorado films from moving trains. In 1902 they spent three weeks capturing images along the lines of the Colorado Midland. The railroad provided them with a coal car and a locomotive engine to push it. The filmmakers attached a polyscope camera to the front of the train, and one man steadied the machine while the other turned the crank. These motion pictures constituted Buckwalter's first efforts to promote Colorado through the new medium. They also advertised the railroad, as in each film he prominently placed a sign that read "taken on the Colorado Midland." Buckwalter promised a local journalist that the scenes would be exhibited in theaters all over the country, as well as in Europe, Canada, and Mexico.[20]

In these pictures—as well as those he filmed on the Rio Grande Railroad, the Colorado and Southern Railway, the Pikes Peak cog line, and others—the Denver booster sought to display the state's natural beauty. Wanting to show off Colorado to best effect, he carefully studied the area's natural light and learned the conditions under which he could best make quality negatives. As an indication of his success, Buckwalter's railroad films received international

recognition when the London Photographic Society awarded his *Panorama of the Royal Gorge* (Selig, 1902) and *Panorama of Ute Pass* (Selig, 1902) first prize and second prize, respectively, in its 1903 film exhibition.[21]

Buckwalter's work reflected a tension between his wish to present Colorado and its environs as a unique place untouched by the worst aspects of industrialization and his desire to show the area as "modern"—integrated into the national economic system and therefore ripe for development. As a result, as much as Buckwalter meant for his railroad films to display natural beauty, they were also supposed to demonstrate the achievements of American railway engineers. Buckwalter presented the trains as manifestations of man's mastery over Colorado's difficult terrain, moving through the sublime Rocky Mountain landscape as the quintessential "machines in the garden." The descriptions of the films in Selig's catalog, likely penned by Buckwalter, are filled with celebratory accounts of the technological feats involved in construction of the tracks. Company publicity hailed a bridge depicted in the *Panorama of the Royal Gorge*, for example, "as the greatest single example of the skill of American constructing engineers in solving apparently impossible problems."[22]

The films Buckwalter made at railroad-sponsored Wild-West exhibitions evinced a similar tension. Western commercial interests organized these exhibitions—which featured rodeo activities, American Indian dances, and other romanticized and nostalgic displays of the Old West—to promote the region and demonstrate its economic potential. They were meant in part to disassociate the Rocky Mountain area from the social problems of urban centers in the East. Although the railroads offered special discount fares to draw crowds to such shows, Buckwalter and his corporate sponsors saw his filming of the expositions as a way to carry their message to an even larger public.[23]

The cowboy and the American Indian had long appeared in Buckwalter's corporate clients' trademarks, and the moving pictures he made of special events further promoted the figures as commercial icons.[24] The image of the virtuous and independent cowpuncher proved a particularly powerful symbol for boosters who sought to efface the reality of labor relations in Colorado, which at the time were contentious and violent. Buckwalter's rodeo films showed men engaged in such romantic pursuits as taming wild horses. In the oral presentations accompanying his moving pictures, the filmmaker explained how the forces of modernization were leading to the demise of such activities.[25] "Wire fence and . . . [the] steam car" have ended the cowboys' vocation, Buckwalter lamented in publicity material for his *Bucking Broncho Contest* (Selig, 1903), but "they are still . . . honest, generous, untamed, rough yet tender lords of the saddle" (see Figure 1.2).[26]

By combining images and narrative in such a fashion, Buckwalter sought to create the impression that, unlike eastern cities, the labor pool in the West

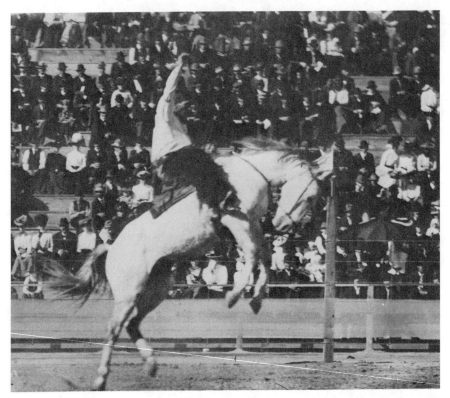

Fig. 1.2 Buckwalter photograph of cowboy. From Jones and Jones, Buckwalter.

was filled with virtuous and autonomous white men. Not surprisingly, workers engaged in activities associated with the moribund open-range cattle industry appeared much more often in Buckwalter's films than did people performing other kinds of industrial labor. In his twenty-four-film "Colorado Series," Buckwalter included only one film representing the state's important mining industry, *Hydraulic Giants at Work* (Selig, 1902). As the title indicates, this motion picture depicted work performed by machines rather than by human beings.

Although Buckwalter celebrated technological achievement and used a romanticized figure of the cowboy to detract from the harsher realities of industrialization in the region, he also incorporated images of Indians to suggest that Colorado was in many respects a premodern place and therefore filled with untapped resources. For the most part, his Indian films were of traditional dances. Buckwalter made some of these pictures at railroad-sponsored exhibitions. To produce others, he traveled to local reservations, including

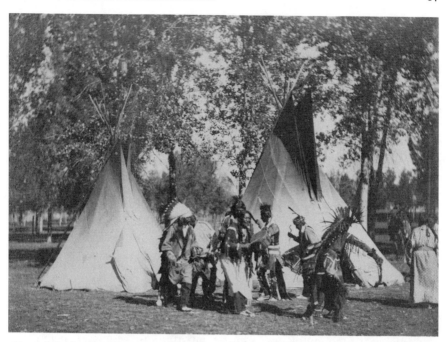

Fig. 1.3 Buckwalter photograph of Ute Snake Dance. From Jones and Jones, Buckwalter.

that of the Ute Indians in southwestern Colorado. The Smithsonian Institution sponsored the films in part, and Buckwalter swore to their ethnographic accuracy.[27] Yet he mostly sought to make American Indian cultural practices seem exotic, strange, and barbaric. In this way he tapped into a long European tradition of presenting the New World and its inhabitants as hideous and wild to encourage the will and energy needed for conquest.[28] In Colorado, these films promised potential emigrants, the ambitious might still reap the riches of colonization (see Figure 1.3).

In his promotional Indian pictures, Buckwalter exploited the general trend among Americans at the turn of the twentieth century to look away from Europe and toward the West to discover the uniqueness of their culture.[29] Audiences could see these "weird" and "horrible" dances and imagine the Rocky Mountain West as the cradle of the nation's primitive past. Such images suggested a place of abundance and riches, an exotic and prelapsarian world that stood outside the twentieth century. The Selig Company encouraged this kind of commercial fantasy, referring to Colorado in the advertising for Buckwalter's films as a "strange land of sunshine and beauty, of gold and precious stones."[30]

Although such Buckwalter films as *Indian Fire Dance* (Selig, 1902), *Shoshone Indians in Scalp Dance* (Selig, 1902), and *Ute Indian Snake Dance* (Selig, 1902) presented the Rocky Mountain area as a pastoral oasis where "primitive" peoples still danced to celebrate the harvest, he and the Selig Company also alternatively emphasized the federal government's success in "containing" Indians and limiting those cultural practices that might be potentially disruptive to industrial order. In the catalog descriptions for several of the dance films, Buckwalter explained that the government had either prohibited the activity in question or insisted that it be held in such a manner that federal agents could quell any resulting disturbances.[31] The Denver booster therefore used his Indian dance films to celebrate an exotic and uncolonized Colorado, while his accompanying oral explanations assured whites—with the Ghost Dance still of recent memory—that social disturbances caused by American Indians were a thing of the past. In Buckwalter's words, it was important for his films to explain to those "unaccustomed to travel that they can come to Colorado and . . . not be . . . stolen by Indians or cowboys."[32]

To ensure his Colorado films' effectiveness, Buckwalter himself exhibited the pictures both locally and throughout the United States. He felt that when it came to communicating commercial messages, his oral commentaries accompanying the motion pictures were as important as the images themselves. The films, he maintained, simply put his audiences' "brains" in a "receptive condition" so they might be convinced by his "quick [and] lucid presentation of facts."[33] In this regard, his faith in the advertising potential of the new medium was prescient. To his way of thinking, printed promotional materials rarely captured the attention of their intended audience. Moving pictures, on the other hand, were still novel. People were interested enough to pay admission to view them, even if, as in this case, they were advertising a product.

In 1903 the Colorado Midland Railway sent Buckwalter east to give forty-eight talks on the topic "Denver and Colorado." The purpose of these lectures was to get those already coming to Denver as part of a national gathering of Christian Endeavor Societies to spend time vacationing in other Colorado cities as well.[34] Several years later the Denver Convention League paid Buckwalter to address national gatherings of various groups around the country, particularly those of white-collar professionals. The filmmaker and his sponsoring institutions were especially interested in selling Colorado to the middle class. They were tired, Buckwalter said, "of boosting for the cheap crowds" who could only afford the cost of transportation to the state and had no money left for sightseeing.[35]

Drawing on his knowledge of the culture of fraternal organizations, Buckwalter was particularly effective in using motion pictures to promote Denver

as a convention site. In 1907 he and his two assistants made a presentation to the National Association of Stationary Engineers at Niagara Falls. Before screening the films they flew several large kites, each with a letter painted it so together the kites spelled DENVER. They then lit up the affair with colored searchlights. Buckwalter's presentation delighted the delegates who, although previously ambivalent about meeting in the city, overwhelmingly chose it for their next gathering.[36]

Once conventioneers made it to Denver or Colorado Springs, Buckwalter could target them with the outdoor motion-picture exhibitions he put on in those cities' parks. The showings, which he used to encourage intrastate tourism, occurred nearly daily in the summers between 1902 and 1906—sometimes attracting thousands of spectators at one time.[37] Buckwalter featured a varied program of films—including many of his local subjects, other Selig pictures, and motion pictures the company imported from Méliès, the renowned French manufacturer.[38]

Although Buckwalter's Colorado films were most effective as promotional tools when combined with his presentations, most people who saw the pictures did so without his commentary. The filmmaker gave prints of his motion pictures to the Selig Company, which in turn sold them to exhibitors throughout the United States and abroad. Since western themes and images now pervaded American popular culture, audiences were enthusiastic about the Colorado films. Selig called the demand for them "an amazing fad." According to Buckwalter's estimates, an average of 100,000 people a day saw the pictures. Many theater managers, he said, did not consider their programs complete unless they had at least one new Colorado scene every week.[39] By 1908 so many prints had been struck from his negatives that several originals had become unusable.[40]

Exhibitors played an important role in extending the commercial life of early nonnarrative subjects taken by Buckwalter and other filmmakers. George C. Hale, a former Kansas City fire chief, revived the moneymaking potential of railroad scenic films in May 1905 when he opened a motion-picture theater that looked like a railway passenger car and simulated the experience of train travel. He called the attraction Hale's Tours and Scenes of the World. The idea caught on, and such novelty theaters sprang up around the country. The most elaborate rumbled and swayed as scenic moving images flashed on a screen via rear-screen projection. Ticket sellers dressed like conductors, and signs advertised excursions to exotic locations. These new exhibitors demanded material like that Buckwalter had produced in Colorado, and his railroad scenes received their greatest public exposure as part of such attractions. According to the filmmaker, 50,000 people at a Hale's Tour in Chicago alone sat through screenings of his pictures.

The Denver producer was gleeful about the indirect promotion Colorado received from this fad. The phenomenon, he told a reporter, "started a wave of boosting for the state that is almost impossible to believe." Buckwalter was convinced that after seeing his motion pictures at such attractions, thousands of people would decide to spend their vacations in Colorado.[41] In truth, only a very small percentage of attendees could afford a trip there, which at the time was still something of a luxury. Such screenings, however, helped to keep the state in the public's imagination, as well as to whet moviegoers' appetites for "authentic" images of the West.

Even after the Hale's Tours phenomenon faded, Buckwalter's Colorado films continued to find an audience. One especially creative purveyor of amusements, J. D. Whaylen, used them as part of his Whaylen's Wild West on Canvas. Whaylen combined live western acts with an assortment of cowboy and Indian films.[42] He traveled by automobile and used the power from his cars' engines to run a projector and lights. Another exhibitor, M. W. Phillips, incorporated Buckwalter's *Indian Parade Picture* (Selig, 1902), *Indian Hideous Dance* (Selig, 1902), *Shoshone Indian Scalp Dance,* and *Ute Indian Snake Dance* into his illustrated historical lectures.[43] Phillips directed his presentations toward middle-class Protestant audiences, giving what he advertised as "instructive," "historically valuable," and "entertaining" talks at local YMCAs and churches.[44]

As exhibitors continued to screen these older actuality subjects to meet the public's demand for images of the West, Buckwalter and Selig went to work on the first story films shot in the region. They were inspired largely by the tremendous success of crime pictures, particularly the British-produced *A Daring Daylight Burglary* (Sheffield Photo, 1903), *Trailed by Bloodhounds* (Paul, 1903), and *A Desperate Poaching Affray* (Haggar, 1903). These films, according to historian Charles Musser, introduced violence and the chase scene to narrative cinema. They inspired the Edison Company's *The Great Train Robbery* (1903), the popularity of which also helped to precipitate a significant change in the dominant cinematic image of the American West.[45]

Edwin S. Porter made *The Great Train Robbery* with help from an aspiring stage actor named Gilbert M. Anderson. Based in part on Scott Marble's 1896 play by the same name, the film tells the story not only of a train robbery but also of a posse's pursuit of the bandits, ending in a final shoot-out. In the film Porter integrated common cinematic practices to construct a gripping narrative. The result was popular with a wide array of amusement seekers. Anderson recalled that spectators were wildly enthusiastic during the first public screening at a New York wax museum, the Eden Musee. They shouted and cheered during the presentation and insisted that the house run it again and again. The filmmaker also observed a more sedate but equally impressed audience at

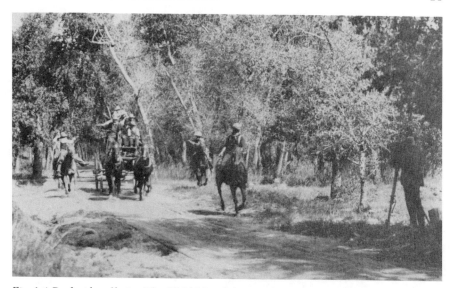

Fig. 1.4 Buckwalter filming The Hold-Up of the Leadville Stage *(1904). From Jones and Jones,* Buckwalter.

a screening of the film at Hammerstein's, one of New York's finest vaudeville theaters. Even as late as 1906 the film was, according to trade journalists, the leading favorite with American audiences.[46]

The success of Porter's film and the British imports that helped to inspire it caught the attention of American manufacturers, who sought to copy the films. The Lubin Company went as far as to stage *The Great Train Robbery* again and to release it as its own creation. Selig got into the act when the operator of his black-tent picture show, Thomas Persons, alerted him to the fact that Porter's crime picture was drawing impressive crowds wherever exhibitors screened it. Person suggested that the company undertake similar stories.[47] Selig concurred, and he traveled to Colorado where he joined with Buckwalter and produced two important films: *A Lynching at Cripple Creek* (Selig, 1904) and *The Hold-Up of the Leadville Stage* (Selig, 1904) (see Figure 1.4).

Although trade journalist James McQuade later referred to these pictures as the company's first "westerns," Buckwalter and Selig did not initially conceive them as such.[48] Prior to 1907, no such genre existed. Motion-picture manufacturers did not group films together according to whether they had frontier content, nor did the designation *western* appear in industry trade journals, film catalogs, or publicity materials. At the time *A Lynching at Cripple Creek* and *The Hold-Up of the Leadville Stage* were produced, a journalist for the

Cripple Creek Times called the films "border ruffian" subjects—an apt label that suggested they were crime films set in the West.[49] Over the course of their long exhibition, however, and as Vitagraph's *The Prospectors* (1906), Edison's *Life of an American Cowboy* (1906), and other films with frontier themes appeared, audiences and exhibitors began to identify these two Colorado films as westerns. Eventually, even William Selig, many years after their production, referred to *A Lynching at Cripple Creek* and *The Hold-Up of the Leadville Stage* as the first efforts to bring "the horse opera to the screen."[50]

Although the two films were to be about fictional crimes, Buckwalter was determined to make them in such a way that they promoted the Rocky Mountain West. He produced both pictures in famous Colorado localities and featured their place-names in the titles. The filmmaker also included scenic interludes in the pictures that looked and functioned much like his earlier, nonnarrative promotional films. As Musser has pointed out, Buckwalter interrupted the story of *The Hold-Up of the Leadville Stage* with long panoramic sequences of the Rocky Mountains.[51] At one point in the picture, to show off the Colorado scenery to best advantage, the filmmaker featured twelve different views of a stagecoach climbing a mountain trail.[52] In effect, these interludes were thinly disguised commercials for the state. As Buckwalter explained, he wanted to show "just enough of Ute Pass . . . Cheyenne Canon and Bear Creek to awaken a desire to see the scenery in reality." He dismissed the motion picture's "sensational" narrative as merely a "vehicle for getting attention paid to the scenic surroundings."[53] In an affirmation of Buckwalter's intention, Selig told a reporter during the making of the film that the "amount of good advertising" the state would get from the picture could "hardly be estimated."[54]

For all of Buckwalter's efforts to present an idyllic and scenic Colorado in these story films, a fundamental incompatibility existed between his goals and the commercial imperative to meet audience demand for sensational crime stories. Much to the chagrin of Buckwalter and the commercial interests he represented, the Selig Company marketed the pictures in ways that emphasized their violence and sensationalism rather than their scenic qualities. To publicize *The Hold-Up of the Leadville Stage*, Selig ran a bogus story in the Hearst papers that recounted how a party of tourists had come upon the motion-picture crew and mistaken the hold-up for a real crime. According to the account, the visitors drew pistols and began to shoot at the supposed bandits. Selig, the newspaper reported, was wounded in the fray; and the tourists, after realizing they had been deceived, excised their anger by setting fire to the stagecoach.[55]

The Selig Company did not need to invent sensational stories to promote its next Colorado crime film, *A Lynching at Cripple Creek*; the social conditions

of the industrialized West provided them. At the time Buckwalter made the film, Cripple Creek had been the site of a protracted and violent labor dispute between the Western Federation of Miners (WFM) and the Colorado Mine Owners' Association. In November 1903, several months prior to the shooting of the picture, men sympathetic to the WFM killed two mine bosses in a bombing. Colorado's governor declared martial law and brought in the state militia.

Buckwalter's film did not treat Cripple Creek's labor violence. Such negative publicity would have been anathema to him. He used the goldfields only as scenic backdrops against which he set a crime story with racial overtones. *A Lynching at Cripple Creek* is about an African American tramp who kills a white woman, is pursued by vigilantes, and is eventually caught and hanged.[56] Early accounts of the motion picture suggest that Buckwalter was again trying to include a promotional subtext. According to one journalist, his intention was to show the rest of the country that in Cripple Creek, justice did not depend on an inefficient court system but was swift and sure.[57] The film's unspoken implication was that jury trials were especially unnecessary in cases where blacks committed crimes against whites. It may have been that Buckwalter, who later exhibited some sympathy for the Ku Klux Klan (KKK), was attempting to send a message about racial relations in Colorado to both whites and blacks considering relocating there.[58]

Unfortunately for Buckwalter and Colorado's development interests, if not for the Selig Company, in June 1904—two months after the film's completion—more labor unrest occurred in Cripple Creek when a second bomb exploded, with results more sensational and bloody than the first. The explosion occurred on a train depot platform filled with scab miners coming off the night shift, and it killed thirteen men. Authorities used bloodhounds to track the perpetrators, but they never caught those responsible.[59] The bombing provided the state and local governments with an excuse to deport hundreds of WFM members who, after the incident, refused to renounce membership in the union.

This sensational event changed the meaning and importance of Buckwalter's film. The incidents in the mining camp, Selig correctly surmised, had made "people extremely anxious" to see images from the area. To capitalize on the notoriety of current happenings, the producer fabricated a connection between the film and the labor violence. "Prominent miners and citizens . . . involved in deportation troubles," the company claimed, could easily be identified in the picture.[60] It also made the most of the filmmaker's coincidental use of bloodhounds. According to a Selig circular, the dogs in the picture were the same ones that later tracked the perpetrators of the bombing. In part as a result of this kind of promotion, the film became a notable success. *Views and*

Films Index selected it as one of the twenty-five most popular films made between 1901 and 1906.[61]

Despite the film's commercial success, Buckwalter was no doubt unsettled by this publicity strategy. His messages about "swift" justice and the solidity of the color line in Colorado were lost in the attempt to associate the film with the current labor unrest. In an effort to make up for some of the publicity damage the picture caused, Buckwalter produced a second film about the town, *History of Cripple Creek* (1904)—one of which any Chamber of Commerce could be proud. As the title suggests, the second picture chronicled Cripple Creek's history and development and, according to one journalist, lacked "the shooting and blood-and-thunder element" of the first.[62]

Seeing that he could not readily shape violent crime films to propagate an effective commercial message about the Rocky Mountain West, Buckwalter became one of the first within the industry to argue against their production. In 1906 he began to speak out against the corrupting influence of "robbery pictures." His own scenic and ethnographic films, he claimed, had done much to counter the nefarious influence of the more morally questionable stories. His pictures of the Colorado mountains and valleys, he said, had contributed generally to "the purification of the picture business."[63] That same year he shut down his summer outdoor exhibitions early to protest the lack of wholesome films to screen.

As much as Buckwalter would have liked to turn back the clock on the cinematic representation of the West, he and Selig, by marrying filmic violence and scenic Colorado landscapes, had hit upon a formula that would lead to the western motion picture. As the genre developed, Buckwalter and Colorado's commercial interests increasingly lost control over the way filmmakers represented the region. The westerns of the forthcoming nickelodeon era would be heavily larded with depictions of crime and violence, despite the complaints of some who bemoaned scenes of "hold-ups, wild riding, excessive drinking, reckless gambling, and indiscriminate shooting" in films that were supposed to be representative of the region.[64] The genre, however, was destined primarily to serve the interests of the American film industry and not the institutions involved in the commercial development of the West.

Although Buckwalter and Selig had assembled the basic elements of the western, it was another two-and-a-half years until audiences, filmmakers, and exhibitors recognized the genre and before Selig Company and the industry as a whole were organized enough to exploit its commercial potential. Selig began to struggle financially in 1904, as he was slow to convert his vaudeville exhibition service to a new and more popular system of distribution whereby exhibitors rented films rather than buying them outright. The manufacturer was also overwhelmed by legal expenses incurred in trying to fight Edison,

who had sued Selig several times for infringing on his motion-picture patent. According to Ramsaye, by 1905 Selig had almost completely shut down his operations. Once again, however, the commercial relationships the film manu-facturer had fostered while making promotional films helped to sustain him. In this case it was meatpacking mogul Philip D. Armour who came to his rescue.

Armour was eager to counter the negative publicity caused by the 1906 publication of Upton Sinclair's *The Jungle*, a book that exposed the harsh and unfair labor practices within his industry. He recalled that Selig had made a series of motion pictures in the Armour plant back in 1901. Armour had made several trips to Selig's small Chicago studio to see the films after they had been developed. The scenes were intended for promotional purposes, so they cast the company and its operations in a positive light. When *The Jungle* was pub-lished, Armour asked Selig if he would make new prints of the slaughterhouse films. The producer told Armour he would be unable to do so because costly legal battles had put him out of business. Armour was undaunted, and he offered Selig legal support to fight Edison in exchange for copies of the motion pictures.[65]

Buoyed by Armour's aid, Selig resumed production of story films in the summer of 1906. As mentioned previously, that fall he hired filmmaker Gil-bert M. Anderson, one of the men involved in the production of *The Great Train Robbery*. Although Anderson would make only a few films for Selig, three would be among the first films conceived and marketed as "westerns."

Anderson was born Max Aronson in Little Rock, Arkansas, in 1880. His parents were both New York–born, second-generation American Jews. His father, Henry, was of Prussian descent, and his mother, Esther, was the daugh-ter of Russian immigrants. The Aronsons were a large and relatively prosper-ous family. Henry worked as a traveling cotton merchant, and Esther main-tained their spacious Queen Anne–style house and raised their seven young children with the help of a live-in servant. Max was the sixth child, and just prior to his birth the Aronsons moved from New York to Little Rock.[66] They eventually moved down the Arkansas River to the smaller town Pine Bluff.

At the time of the Aronsons' arrival, Little Rock's Jewish community consisted primarily of German immigrants eager to embrace the reform movement within Judaism and to Americanize their culture and religious practices.[67] In an 1890 guide to the southern city, a writer described the con-gregation of its B'nai Israel temple as "one of culture and refinement, holding liberal views."[68] This environment may have helped to foster a strong predi-lection for the stage among the Aronson children. In addition to Max, who was enthralled with show business from a tender age, his youngest sister, Leona, went on to a career in musical theater. His older brother Nathaniel also became

an actor and performed in dramatic stock companies in Chicago, New York, and elsewhere.

The family eventually moved to St. Louis, where Max became involved in his father's cotton business. He found himself increasingly drawn to the theater, however. During his off hours, he took acting lessons and performed as an extra in a few Shakespeare productions. Less interested in acting than in the production and financial aspects of the stage, he spent most of his professional life—even at the height of his film career—trying to establish himself as a theater mogul.

Realizing that opportunities in the Midwest were limited, Max and Leona moved to New York to pursue their stage careers. He changed his name to the less Semitic-sounding Anderson, worked as a theater manager for a time, and organized a western vaudeville act. Max was largely unsuccessful, however, and had to support himself in part by modeling for commercial artists.

Unable to find more respectable employment, he joined Edison film studios in 1902, where he worked with Edwin S. Porter on *The Great Train Robbery*. He assisted in the production and claimed to have been instrumental in writing the scenario. He also took on multiple acting roles in the film, including one as a bandit, another as a railroad passenger shot during a robbery, and still another as a tenderfoot in a western dance-hall scene. Audiences' enthusiastic response to *The Great Train Robbery* profoundly impressed Anderson and inspired him to turn his attention more seriously to the motion-picture business.[69] The film's action and sensationalism stuck in his mind, and he brought these elements into his own pictures.[70]

On the strength of his work in Porter's film, Anderson shopped himself around, looking for someone with whom he could form a motion-picture manufacturing company. For a time he worked at the Vitagraph studio but left when the company's partners refused to give him an interest in the firm. He then helped pioneering nickelodeon owner Harry Davis and his son-in-law John Harris build a small studio in Philadelphia. According to Anderson, this venture came to a rapid end when he discovered the entrepreneurs were interested only in making local pictures to run in their own establishments. Anderson's ambitions were much greater.[71]

In 1906 he traveled to Chicago and shortly assumed the management of a legitimate theater called the Whitney.[72] Once there, he met with motion-picture importer and distributor George Kleine to discuss forming a filmmaking partnership. Kleine was not interested, but he put Anderson in contact with Selig. Recently bailed out by Armour, the Chicago manufacturer was still short on cash, but he was impressed by Anderson's work on *The Great Train Robbery*—the film that had inspired his own company's Colorado crime films. Selig agreed to hire Anderson on a contract basis.[73]

Anderson made his initial motion pictures for the company, including a crime film called *The Female Highwayman* (Selig, 1906), on the south side of Chicago. He was eager to join Buckwalter in Denver, however, so, as he put it, he could make pictures with "rugged scenery and cowboys."[74] Selig complained about the transportation costs, and Anderson had to do some cajoling to convince his employer to send him West. The manufacturer eventually found the money to pay Anderson's way, and once in Denver the filmmaker rendezvoused with Buckwalter.

The Colorado booster was undoubtedly uneasy about the new arrival. He knew about Anderson's reputation as a producer of crime films and was dead set against such pictures. Prior to Anderson's visit to Denver, Buckwalter was making story films of a more innocuous variety, designed mainly to show off the state's wonderful scenery and surroundings and to convince people to spend their summer vacations in Colorado.[75] Nevertheless, he introduced Anderson to the Denver area and integrated him into his production activities. He brought him to Golden, Colorado, where they worked in December 1906 on *The Girl From Montana* (Selig, 1907), *The Bandit King* (Selig, 1907), and *Western Justice* (Selig, 1907).

Unlike previous arrangements, the Selig Company was now financing these Colorado pictures itself, so Buckwalter and the state's commercial interests had little editorial control over them. Yet the Denver booster still hoped to leverage his knowledge of the Rocky Mountain area's scenic landscapes and his expertise in filming in its natural light to help shape the productions. It may well have been because of his influence that Selig advertised Anderson's Colorado pictures as "western stories" rather than crime films.[76] By labeling them thus, the company directed the attention of audiences and exhibitors toward the productions' settings rather than their somewhat sensational narrative content. This had been Buckwalter's vision for the Colorado story films all along. Selig had his own incentive for downplaying the violence in these pictures, as he still sought the business of western corporations associated with tourism, and would-be motion-picture censors were already grumbling about the crime genre's negative social impact. The company even euphemistically advertised Anderson's thinly disguised Jesse James tale, *The Bandit King*, as a "fine western story of daring and courage."[77]

Buckwalter wanted to focus attention on the scenic settings of Anderson's films, but he had an even more specific promotional aim for the pictures. The Denver booster encouraged newspapers and trade journals to publicize the fact that the westerns had been made in Golden, Colorado, in the middle of December and January. In this way he hoped to promote Denver's sunny year-round weather and to spread the word about Colorado's attractions as a winter resort.[78] This effort appears largely to have failed, however. Anderson and

Selig had little interest in such a specific promotional agenda; their main objective was to make popular films with lots of action. As a result, company publicity material did not mention that Anderson had produced the westerns in the winter.

Anderson recognized the importance of showing western landscape, but he was ultimately more interested in staging a good sensational story with a well-articulated hero. Unlike Buckwalter, he had some background in stage melodrama; and although he knew nothing about the real West, he was familiar with staged representations of the region. Anderson was also more exacting in representing the western "type." He was unwilling to place just anyone in front of the camera and found it difficult to recruit authentic-looking cowboys in Golden. Buckwalter worked with actors from a local theater, The Brandon, but they did not suit Anderson. The eastern filmmaker hired several "rough-and-tumble looking girls" whom he dressed as men to round out his posse.[79]

Anderson not only used women as extras but featured them in leading roles in two of his three Selig westerns, *The Girl From Montana* and *Western Justice*. In this regard he was not alone. The Vitagraph Company likewise used a female hero in its early frontier-themed story film *The Prospectors*.[80] At a time when filmmakers were just beginning to develop the genre's conventions, these female characters constituted the first heroes of western movies. Placing women in heroic roles in part served a practical purpose. Filmmakers generally shot early narrative films with the actors quite a distance from the camera, making it difficult for audiences to distinguish a central cowboy figure from the supporting cast. A woman in a dress, however, stood out in a crowd of men.

Perhaps more important than this technical matter in determining the gender of the first western heroes was the immense popularity of the David Belasco play, and later the Giacomo Puccini opera, *Girl of the Golden West*. This 1905 drama featured a strong female character, "the girl," who operates her deceased father's saloon and gambling house and who, by force of arms, protects her bandit lover from the sheriff and his men. Anderson and other filmmakers copied Belasco's drama not only to tap into the general craze for western stories but also to cultivate a degree of "middle-brow" cultural legitimacy. This strategy would no doubt have appeased Buckwalter and Colorado's development interests.

The women in these first western films also had antecedents in less pretentious forms of amusement. Annie Oakley, Lucille Mulhall, and other female performers were popular figures in Wild-West shows at the time. Like the women featured in such outdoor attractions, the heroines of Anderson's early westerns handled horses and guns with skill and confidence. In essence, Anderson took Belasco's "girl of the golden West" and integrated the character into a story line that called for Wild-West show–type horse stunts. This

combination showed off the medium to its best advantage, as such feats of horsemanship could not practically be performed in a theater. The Selig Company made its actresses' prowess at such activities a central element in its promotional campaign. It advertised the girl's ride to save her lover in *The Girl From Montana* as "one of the most thrilling and exciting scenes which has ever been produced in a moving picture."[81]

In addition to the inspiration they drew from other forms of entertainment, Anderson and other filmmakers were responding to the changing social conditions in America. At that time young, single women from all classes and backgrounds were leaving their family homes, moving into cities, and taking their places in the public world of work.[82] Like their real-life counterparts, the early western-film heroines challenged Victorian notions of decorum. These characters were not the home-bound upholders of traditional moral values that would appear in later westerns but were women who did the things men did and who took action in the public realm.

For the title role of *The Girl From Montana* Anderson cast a local Denver "society girl," Pansy Perry, who had notable equestrian abilities. The film opens with an emblematic close-up of the actress and her horse, a shot that identifies her as the picture's central character (see Figure 1.5). A humble cowboy and a wealthy easterner vie for her affections. After she rejects the easterner, he decides to frame his rival. He pays a "Mexican" to steal a horse and plant it on the cowboy's ranch. An enraged mob, thinking he is a horse thief, captures the cowboy; just as they are about to hang him for his supposed crime, the girl rides to his rescue. She saves him at the last minute by shooting the rope, and she holds back the mob with her pistol while he escapes.[83]

Similar to *The Girl From Montana*, Anderson's *Western Justice* featured a woman in the lead role. Her pluck and courage result in the capture of her father's murderer. She organizes and leads the posse, remaining in the foreground during the chase scenes. According to the Selig catalog, the actress gave "an exhibition of horsemanship which words cannot fairly portray."[84]

By drawing on a complex set of antecedents that primarily included Colorado's scenic subject, the crime film, stage melodrama, Wild-West shows, and the legitimate stage, the Selig Company was instrumental in inventing the western—the most uniquely American film genre. The people who first saw these deceptively simple one-reel films, however, had little way of understanding their importance. In fact, the films do not seem to have captured the imaginations of exhibitors or film audiences. In an indication of the unimpressive reception, neither Anderson nor the Selig Company revisited the genre for another year. Whereas Selig promoted these "westerns" as "the film success of the season," Anderson more honestly recalled that they were "slipshod" productions and that exchange managers complained of their poor quality.[85]

Fig. 1.5 Pansy Perry in The Girl From Montana *(1907). From Charles Musser,* The Emergence of Cinema: The American Screen to 1907 *(Berkeley: University of California Press, 1990).*

Because of the weak response to *The Girl From Montana,* Selig declined when Anderson asked if he could make more films for the company. The manufacturer severed ties with the filmmaker even before all the pictures he had made in Colorado were released. Anderson and Selig seemed to have had problems seeing eye to eye. The filmmaker thought Selig was "dull" and lifeless and felt he lacked real vision of the future of motion pictures. In a move that probably angered the manufacturer, Anderson, after their association had ended, tried to convince key Selig Polyscope employees Thomas Nash and Thomas Persons to join him in a new production venture, but they too declined.[86]

In May 1907 Anderson formed a new film-manufacturing company, Essanay, with Selig's local rival, Chicago-based film distributor George K. Spoor. He did not initially produce westerns with his new firm but concentrated on comedy subjects. Later that same year, both Essanay and Selig became Edison licensees. With the formation of the patent trust, the business climate for motion-picture production was no longer clouded by the uncertainty of patent-infringement lawsuits. Selig and Essanay could more confidently put their profits back into

plant and equipment. By winter of 1908 both companies had resumed the production of westerns and for a time would stand alone as world leaders in the genre.

As the fortunes of Selig and Anderson rose, Buckwalter faded from production activities. The future of filmmaking in the West belonged to others. He remained active, however, in motion-picture distribution and exhibition. In 1908 he opened the Denver Film Exchange, which he ran for many years with the help of his son John. He also worked as a consultant for those in the motion-picture business in Wyoming and Colorado, and he traveled throughout the two states to install projection equipment and make special presentations of current films.[87]

Buckwalter's original vision of the western story film as a vehicle for showing off the region's landscape would remain a central element of the genre. In particular, his legacy reverberated at the Selig and Essanay Companies as those manufacturers sent mobile production crews throughout the West to find unique and unphotographed scenic areas against which to stage their films. Although Hollywood westerns later became known for their stark arid and semiarid landscapes, in the first decade of the twentieth century Americans were still discovering the aesthetic qualities of the fantastic land forms of the Southwest; and Essanay and Selig crews tended to film in lush, green mountain valleys filled with lakes and rivers. This choice of scenery was in part a legacy of Buckwalter, who wanted to present an abundant and fertile West—one that seemed full of commercial possibility.

Before filmmakers developed the generic mythic space they simply called "the West," which often referred to no specific place in the region, the Selig Company continued to advertise most of its westerns according to where they had been filmed. Even as late as 1911 the manufacturer billed *Western Hearts* (Selig, 1911) as "a dramatic epic of the Colorado Foot Hills" and *Why the Sheriff's a Bachelor* (Selig, 1911) as "a western drama played in Colorado's Rocky Mountains."[88] In other words, the company continued to operate under the assumption that producers should market films made in the region in a way that directed moviegoers' attention toward a specific and identifiable landscape. In this way, Selig endowed its westerns with an air of authenticity and at the same time distinguished them from similar films made on the East Coast and in Europe. Such a marketing strategy might also have helped to get wealthier moviegoers out of stuffy and cramped nickelodeon theaters, as Buckwalter hoped, and onto trains to see the West for themselves.

NOTES

1. "The Supplement of Colorado Films," Selig Polyscope Company, 1902, Selig Collection, Margaret Herrick Library, Los Angeles, California.

2. Charles Musser, *The Emergence of the Cinema: The American Screen to 1907* (Berkeley: University of California Press, 1990), 365.

3. For the most succinct discussion of the absence of the western genre from early cinema, see Charles Musser, *Before the Nickelodeon: Edwin S. Porter and the Edison Manufacturing Company* (Berkeley: University of California Press, 1991).

4. 1880 U.S. Census material from William Selig clipping file, Margaret Herrick Library, Los Angeles, California.

5. Eric Hirsch, *Urban Revolt: Ethnic Politics in the Nineteenth-Century Chicago Labor Movement* (Berkeley: University of California Press, 1990).

6. Terry Ramsaye, "Col. Selig's 50 Years," *Motion Picture Herald*, March 11, 1944, 35.

7. Quoted in Eric Ledell Smith, *Bert Williams: A Biography of the Pioneer Black Comedian* (Jefferson, N.C.: McFarland, 1992), 11.

8. Ibid.

9. Ramsaye, "Col. Selig's 50 Years," 35.

10. *Los Angeles Evening Herald and Express*, October 8, 1938, in William Selig clipping file, Margaret Herrick Library, Los Angeles, California.

11. Musser, *The Emergence of Cinema*, 290.

12. *Motion Picture World (MPW)*, January 30, 1915.

13. For example, see Letter from Bosworth to Selig, November 8, 1910, Clarke Scrapbooks, Margaret Herrick Library, Los Angeles, California; Frank Finnegan to Selig, April 7, 1909, Selig Collection, Margaret Herrick Library, Los Angeles, California.

14. Lynne Kirby, *Parallel Tracks: The Railroad and Silent Cinema* (Devon: University of Exeter Press, 1997), 20.

15. For example, the Chicago, Rock Island and Pacific Railway Company asked Selig to "supply one film of the Rock Island train in the vicinity of Colorado Springs . . . in exchange for transportation . . . of people who are exclusively in your service, having no other business." Chicago, Rock Island and Pacific Railway Co. to Selig, December 22, 1903, Selig Collection, Margaret Herrick Library, Los Angeles, California.

16. Francis Boggs, Selig's producer in California, wrote to his employer in August 1909 that he was trying to land "a big contract" with several railroad officials. Boggs to Selig, August 16, 1909, Clarke Scrapbooks, Margaret Herrick Library, Los Angeles, California.

17. Buckwalter's life and career are detailed in William Jones and Elizabeth Jones, *Buckwalter, the Colorado Scenes of a Pioneer Photojournalist, 1890–1920* (Boulder: Pruett, 1989); William Jones, "Harry Buckwalter: Pioneer Colorado Filmmaker," *Film History* 4 (1990): 89–100.

18. George Kleine to H. H. Buckwalter, June 3, 1924, box 5, George Kleine Collection, Manuscripts Division, Library of Congress, Washington, D.C.

19. On Buckwalter's early work for Selig, see H. H. Buckwalter to George Kleine, August 24, 1916, box 19, George Kleine Collection, Manuscripts Division, Library of Congress, Washington, D.C.

20. "To Exhibit Scenery in Eight Languages," *Colorado Springs Gazette*, May 22, 1902, 3.

21. "Colorado Springs Picture Won First Prize in London," *Colorado Springs Telegraph*, December 14, 1903, mss. 1411, Colorado Historical Society, Denver.

22. "The Supplement of Colorado Films."

23. Earl Pomeroy, *In Search of the Golden West: The Tourist in Western America* (Lincoln: University of Nebraska Press, 1990), 122–123.

24. For example, one of Buckwalter's most important clients, the Colorado Midland Railway, used an Indian in its logo until 1905. "Midland Drops Its 'Big Indian,'" *Rocky Mountain News* [Denver], January 26, 1905, 3.

25. Although the texts of Buckwalter's presentations do not survive, the films' descriptions in the Selig catalog indicate at least the way the company wished them to be interpreted.

26. "February Supplement, Sheridan, Wyoming Series," Selig Polyscope Company, 1903, Selig Collection, Margaret Herrick Library, Los Angeles, California.

27. *Evening Telegraph*, September 25, 1902, 3, mss. 1411, Colorado Historical Society, Denver.

28. Leo Marx makes this point in *The Machine in the Garden: Technology and the Pastoral Ideal in America* (London: Oxford University Press, 1964), 43.

29. Anne Farrar Hyde, *An American Vision: Far Western Landscape and National Culture, 1820–1920* (New York: New York University Press, 1990).

30. "The Supplement of Colorado Films."

31. "February Supplement, Sheridan, Wyoming Series."

32. "Working to Boom Colorado," *Colorado Springs Gazette*, January 9, 1905, 5.

33. *MPW*, June 29, 1907, 265.

34. "Buckwalter to Lecture About Colorado," *Denver Republican*, April 13, 1903; "Special Inducements That Will Bring Christian Endeavorers to This City," *Colorado Springs Gazette*, April 10, 1903, 1, 3.

35. *MPW*, June 29, 1907, 265.

36. Jones, *Buckwalter*, 8; "Boomed Denver at All Times and All Places," *Denver Republican*, September 28, 1907, mss. 1411, Colorado Historical Society, Denver.

37. "Thirty Thousand People Cheer Moving Pictures," *Denver Times*, July 21, 1902, mss. 1411, Colorado Historical Society, Denver.

38. "New and Pleasing Gold Camp Picture," *Colorado Springs Gazette*, July 18, 1904, 3.

39. "Impressive Advertising," *Durango Democrat*, September 27, 1906, 1.

40. *Views and Films Index*, January 18, 1908, 3.

41. *Denver Republican*, March 7, 1906, mss. 1411, Colorado Historical Society, Denver.

42. Whaylen's Wild West on Canvas to Selig, October 26, 1904, and August 23, 1907, Selig Collection, Margaret Herrick Library, Los Angeles, California.

43. Ibid.

44. M. W. Phillips to Selig, 1909, Selig Collection, Margaret Herrick Library, Los Angeles, California.

45. Musser, *The Emergence of Cinema*, 365.

46. *Views and Films Index*, April 5, 1906, 6.

47. Terry Ramsaye, "The Romantic History of the Motion Picture," *Photoplay Magazine* (1923): 98. Clipping from the George Kleine Collection, Manuscript Division, Library of Congress, Washington, D.C.

48. *MPW*, May 12, 1917, 948.

49. "H. H. Buckwalter Snaps Sensational Moving Picture," *Cripple Creek Times,* April 10, 1904, 6.

50. *Los Angeles Evening Herald and Express,* October 8, 1938, William Selig clipping file, Margaret Herrick Library, Los Angeles, California.

51. Musser, *The Emergence of Cinema,* 399.

52. *Hold-Up of the Leadville Stage,* Selig circular, 1904, in *Thomas A. Edison Papers: Motion Picture Catalogs by American Producers and Distributors 1894–1908, a Microfilm Edition,* Charles Musser, ed., reel 2, Arts Library, UCLA, Los Angeles.

53. "Working to Boom Colorado," 5.

54. "Stage Coach Held-up Within Mile of the City," *Colorado Springs Gazette,* October 3, 1904, 3; quoted in Musser, *The Emergence of Cinema,* 399.

55. Musser exposes this promotional hoax in *The Emergence of Cinema,* 399.

56. In the Selig Company circular for the film *A Lynching at Cripple Creek,* no mention is made of the tramp being a black man. In at least one early description of the film, however, a journalist identified the character as such. *Tracked by Bloodhounds,* Selig Polyscope circular, 1904, Selig Polyscope Collection, Margaret Herrick Library, Los Angeles, California; "New and Pleasing Gold Camp Picture," 3.

57. "H. H. Buckwalter Snaps Sensational Moving Picture," 6.

58. No evidence directly links Buckwalter to the Klan. He referred to an anti-Klan meeting held in Denver in September 1924, however, as a meeting of "koons, kykes and katholics." A riot nearly broke out at the event as members of the KKK shouted down the anti-Klan speakers. Buckwalter wrote that he had "a bully time watching the fun." H. H. Buckwalter to George Kleine, September 9, 1924, box 5, George Kleine Collection, Manuscripts Division, Library of Congress, Washington, D.C.

59. Marshall Sprague, *Money Mountain: The Story of Cripple Creek Gold* (Boston: Little, Brown, 1953), 255.

60. *Tracked by Bloodhounds,* Selig Polyscope circular, 1904, Selig Collection, Margaret Herrick Library, Los Angeles, California.

61. *Views and Films Index,* May 12, 1906, 8.

62. "New and Pleasing Gold Camp Picture," 3.

63. "Buckwalter Closes Picture Season at Stratton Park," *Colorado Springs Gazette,* August 27, 1904, 3. For more on Buckwalter's opinion of crime films, see "Moving Pictures of Denver Sought," *Denver Republican,* December 16, 1907, 8; *MPW,* January 4, 1908, 6.

64. "A Misrepresented West," *Motion Picture News (MPN),* September 24, 1910, 11.

65. Terry Ramsaye, *A Million and One Nights: A History of the Motion Picture Through 1925* (New York: Simon and Schuster, 1926), 386–387.

66. U.S. Census 1880, Arkansas vol. 11, e.d. 143, sheet 12, line 19, National Archives, Washington, D.C.

67. Carolyn Gray LeMaster, *A Corner of the Tapestry: A History of the Jewish Experience in Arkansas 1820s–1990s* (Fayetteville: University of Arkansas Press, 1994), 51.

68. Quoted in ibid., 61.

69. On the production of *The Great Train Robbery* (1903), see Musser, *The Emergence of Cinema,* 352–355, 357; "Turning Point. Interview With Broncho Billy Anderson" (sound recording), Archive of Recorded Poetry and Literature, Library of Congress, Washington, D.C., 1958.

70. Transcript of William K. Everson interview with G. M. Anderson circa 1958, 6, author's collection.

71. Ibid., 9.

72. Anderson and Sam P. Gerson last managed the Whitney during the 1907–1908 season. An article in *Show World* noted the two had been associated with the Whitney "for sometime," indicating they may have managed it the previous season. "Max Anderson Has Changed His Mind," *Show World,* June 5, 1909, 8.

73. On G. M. Anderson's career prior to Essanay, see *Show World,* July 6, 1907, 17; James S. McQuade, "Essanay's Western Producer G. M. Anderson," *Film Index,* July 23, 1910, 11; "The 'Acting' Member of Essanay," *MPW,* January 6, 1912, 27; "The Big 'A' of the Essanay Company," *Nashville Tennessean,* March 15, 1914; H. H. Buckwalter to George Kleine, August 24, 1916; Ramsaye, *A Million and One Nights,* 417–418, 421, 443; Ezra Goodman, "The Movies First Chaps and Spurs Hero," *New York Times,* October 10, 1948; "Turning Point. Interview With Broncho Billy Anderson" (sound recording); "G. M. Anderson," Oral History Transcript, Columbia University, New York City, 1958, 1–17; Lane Roth and Tom W. Hoffer, "G. M. 'Broncho Billy' Anderson: The Screen Cowboy Hero Who Meant Business," *Journal of the University Film Association* (Winter 1978): 5–13.

74. "G. M. Anderson," Oral History Transcript, 13–17.

75. "Advertises State by His Pictures," *Denver Republican,* January 2, 1907, mss. 1411, Colorado Historical Society, Denver.

76. *Variety,* March 9, 1907, 15; "Selig Polyscope Catalog," 1907, *Thomas A. Edison Papers,* reel 2.

77. Essanay advertisement in the *New York Clipper,* 1907.

78. "Actors and Actresses Pursue Dude and Are Photographed," *Denver Republican,* February 9, 1907, mss. 1411, Colorado Historical Society, Denver.

79. "G. M. Anderson," Oral History Transcript, 13–17.

80. Vitagraph's *The Prospectors* (1906) is about a widow who operates a western saloon to support her family. She uses her gun to rule over the rough miners and cowboys who frequent her place. *Views and Films Index,* June 16, 1906, 8.

81. Selig Polyscope, "Complete Catalog," 1907, 44; *Western Justice,* Selig Polyscope Supplement 57, June 1907, Selig Polyscope Collection, Margaret Herrick Library, Los Angeles, California.

82. Joanne J. Meyerowitz, *Women Adrift: Independent Wage Earners in Chicago, 1880–1930* (Chicago: University of Chicago Press, 1991), 5.

83. UCLA Film and Television Library has an incomplete viewing copy of *The Girl From Montana.*

84. *MPW,* June 29, 1907, 268.

85. Ibid., 257; "G. M. Anderson," Oral History.

86. Ramsaye, "Romantic History of the Motion Picture," 98. Clipping from the George Kleine Collections, Manuscript Division, Library of Congress, Washington, D.C.

87. Jones, "Buckwalter," 95.

88. Selig Polyscope circulars for 1911, Selig Collection, Margaret Herrick Library, Los Angeles, California.

"PLENTY OF SOLDIERS, COWBOYS, INDIANS, TRAPPERS, ET CETERA"

The Chicago Studios and the 1909–1911 Western-Film Boom

Western subjects . . . have won immense popularity with the people and there has been a great and unsatisfied demand for more pictures of such a variety. We read with interest a novel depicting life and adventures on the Western plains and mountain trails, and sit in breathless suspense in our seats at the theater, to the clank and jingle of spurs, the banging of firearms and the rat-a-tat-tat of galloping ponies. Western films have been not less popular, and the manufacturer who has ever issued a series has always been eager to issue more.[1]

—Moving Picture World, 1909

We have some good stories to put on out there. . . . We will stop in Colorado to make a subject dealing with mining, will get a good ranch story in Montana or Wyoming. We are going into Oregon for some more "Wonders of Nature" subjects, will visit the beauty spots along the Columbia River and possibly take a picture of the salmon industry. We are going to get some sea stories along the Pacific Coast, and will visit Yosemite Valley for another scenic subject. Then we will visit old Mexico and possibly spend two or three months there. We are taking everything for production purposes with us. We intend to and will break all records in the line of Western pictures.[2]

—Gilbert M. Anderson, 1909

The western remained an infrequently produced genre until fall 1909 when American manufacturers turned it into the nation's leading film type. Several factors led to its sudden dominance. Initially, filmmakers were attracted to westerns because they could produce them relatively easily and inexpensively. This was important, as the rapid proliferation of nickelodeon theaters caused a dramatic increase in demand for motion pictures. Also, the western proved an advantage to U.S. producers who were competing

against European manufacturers for shares of the domestic and foreign markets. Those involved in the U.S. film industry promoted the genre as a uniquely American product, one other national cinemas could not duplicate. Finally, manufacturers began to produce the genre in great volume because its action, sensationalism, and scenic splendor had wide appeal with cinema audiences.

Although many manufacturers had begun to produce westerns, the Chicago-based Essanay and Selig Companies were consistently among the leaders in the field in terms of quality and quantity. In part, they achieved this position by being the first to exploit routinely the landscape of the American West as background for their films. They could easily do so because their studios, headquartered in the Midwest rather than on the East Coast, had ready access to the West. From their bases of operations in Chicago, they sent mobile production units into the Plains states, the Rocky Mountain West, the Southwest, and California. These units never stayed long in any one location but were regularly on the move to find the best light and most spectacular surroundings. Such nomadic activities were instrumental in their "discovery" of Los Angeles and establishing it as a center for the production of westerns.

On their trips throughout the region, Essanay and Selig filmmakers integrated natural landscape, Wild-West action, and melodramatic staging and plotting in ways that increasingly standardized the genre. Although their production methods were similar at first, each company developed its unique kind of western, and these films impacted the genre in profound and distinctive ways. Essanay's main producer, Gilbert M. Anderson—trading on his growing popularity as an actor—made simple, melodramatic, and comedic westerns that focused on the psychology of his main characters. His films were instrumental in introducing and developing the motion-picture cowboy hero. Selig and his producers, motivated by a desire to elevate the cinema's cultural status, teamed with Wild-West shows to stage elaborate and more expensive westerns that featured spectacular battle scenes between whites and Indians. Selig's films prefigured the epic western and established the notion that the genre should convey a sense of history and celebrate American nationalism.

More than any other factor, the nickelodeon boom and the subsequently increased demand for films spurred Selig, Essanay, and other companies to begin regular manufacture of westerns. In 1906 entrepreneurs began hastily converting storefronts into the first theaters dedicated primarily to showing moving pictures. These venues tended to be small, seating no more than 200 people. Lights and flashy posters around their entrances attracted customers. Admission was initially only five cents, hence the name *nickelodeon*. They featured a mixed program of short films, each no longer than one reel. Shows lasted at least a half hour and played continually. As the recession of 1907 hit, nickelodeons spread throughout the country. Particularly popular with immi-

Fig. 2.1 Nickelodeon playing Wild-West films. From Q. David Bowers, Nickelodeon Theaters and Their Music *(New York: Vestal Press, 1986).*

grant populations and the working class, the storefront theater soon rivaled vaudeville as the most important venue for film exhibition (see Figures 2.1 and 2.2).[3]

The proprietors of these new nickel theaters needed fresh films—twenty to thirty a week—to operate effectively. Growing competition among them led to lengthier programs and further increased the demand for motion pictures. The boom left film distributors desperate for new titles to supply to their expanding list of exhibitors. No one felt the problem more acutely than Chicago distributor George K. Spoor, who had founded the National Film Renting Company in 1904 to sell motion pictures to such nonvaudeville exhibitors as traveling showmen and black-tent operators. With the advent of nickelodeons, the demand for films overwhelmed this branch of Spoor's business. He was therefore particularly receptive when Anderson, recently released from his association with the Selig Company, proposed that they form a production company.[4] Spoor eagerly put up $2,500 to finance the equipping of a studio. Combining the first letters of their surnames, they came up with the company's name, Essanay.

Like William Selig, Spoor was among the industry's earliest visionaries. Born in 1871 into a family of railroad employees from Waukegan, Illinois, he went to work at age sixteen cleaning locomotive engines for the Northwestern Railway Company. He was eventually promoted to the position of "train caller" at the Chicago depot and acquired a newsstand concession at the same station.

Fig. 2.2 Nickelodeon with cowboy out front to draw a crowd. From Bowers, Nickelodeon
Theaters.

He became convinced of the future of motion pictures when he noticed that
his best-selling titles were those most heavily illustrated, including *Harper's
Monthly, Leslie's Illustrated Weekly Newspaper,* and *Munsey's Magazine.* The pub-
lic, he reasoned, might also pay to see moving images projected onto a screen.

In addition to his small business at the train depot, Spoor managed the
Waukegan Opera House. There he met Edward Hill Amet, a mechanical engi-
neer employed by the local scale company who had been tinkering with a
design for a motion-picture projector. Amet needed money to complete the
project, and Spoor was willing to provide it. The result was the magniscope, a
portable projector to be used by itinerant showmen. The venture proved a
modest success. Spoor recalled that he made $1,500 in three weeks of exhibi-
tions in Waukegan and the neighboring lake towns of Kenosha and Racine,
Wisconsin. He and Amet built and sold several hundred of the new projectors
and also produced short scenic and industrial films. In 1899 Spoor invested his
profits from the magniscope in acquiring exclusive rights to a new projector
built by E. J. Bell. With this machine, he established a motion-picture service
for vaudeville theaters that he called the kinodrome.[5]

Spoor competed fiercely with Selig's polyscope for vaudeville contracts
throughout the Midwest.[6] Emblematic of the contentious rivalry, he hung in

his office a piece of tattered film, sprocket holes torn out, and a sign that read "Done by the Selig Polyscope Company."[7] Spoor's kinodrome was a popular projector. He also distinguished his service by providing an operator with each of his machines long after other firms had ceased the practice.[8] Vaudeville circuits in the Midwest and the Mississippi Valley, including Kohl and Castle theaters and Orpheum houses, signed long-term contracts for Spoor's kinodrome.

In the wake of the nickelodeon boom, Spoor and Anderson began producing their own story films under the Essanay name and emblazoned with their Indian-head trademark. By summer 1907 they had converted a storage room behind Spoor's office into an open-air studio.[9] The building abutted the Chicago jail, and the prisoners had a clear view of the production activities—undoubtedly a pleasurable diversion from their otherwise dreary routines. During action scenes they yelled to the actors, "Shoot him! Kill him!" The jail's warden found the company's filming disruptive and demanded that the operation be enclosed or moved. Spoor and Anderson built a new studio above the Richardson Roller Skate Company on North Well Street.[10]

Soon after the company's founding, the partners agreed that Essanay would become an Edison licensee, joining four other American companies—Vitagraph, Kalem, Lubin, and Selig—and two French companies, Pathé and Méliès.[11] Essanay was particularly fortunate in being invited to become a member of the Motion Picture Patents Company (MPPC) because it was a fledgling manufacturer and not yet a significant contender in the industry. Edison offered the firm inclusion in the trust to strengthen it against the threat posed by the powerful Biograph Company, which was still holding out against the trust.[12] Essanay and the other licensees agreed to pay Edison royalties on the films they sold in the United States. In return, they could operate in a stable business climate, free from the uncertainties of copyright infringement litigation.

As a member of the trust, Essanay was poised for commercial success. To supply the new nickelodeon exhibitors, the undercapitalized film company and others like it looked to motion pictures that could be made outdoors. In this way, they increased output without having to invest immediately in enlarging their studios. Relying a great deal on natural lighting, Anderson produced comedies around the Chicago area. When the weather turned overcast in the fall, he left for California. He traveled with his cameraman, Jesse Robbins, and Ben Turpin, a vaudeville comic renowned for performing cross-eyed. After being run off by the police when attempting to film in various parts of southern California, the troupe eventually received permission to shoot exteriors in Boyle Heights, at the time a predominately Jewish neighborhood in East Los Angeles. Anderson soon set up a small, temporary studio there and

made films with Turpin and local vaudevillians as well as bellboys from the hotel where he was headquartered.[13]

While Anderson was busy churning out comedies in Los Angeles, the western—another kind of outdoor film—began to grow in popularity. Exhibitors, eager to acquire enough films for their daily programs, embraced the new genre for its novelty. It quickly became a mainstay of the nickelodeon program. Many exhibitors soon considered their offerings incomplete if they did not have at least one cowboy and Indian picture on every bill. As one theater manager explained, he needed a "dramatic picture for the lover of drama," a "western picture for the western mad crowd," and a "comedy picture for the lover of mirth and laughter."[14]

Lawrence Lee, a former producer of popularly priced stage melodrama, came to work for Essanay in Chicago and made the company's first westerns. With Spoor's backing he hired twenty-five professional cowboys from Wild-West shows and shot *The James Boys in Missouri* (Essanay, 1908) in Chicago's Riverside Park and the Michigan Hills.[15] After its completion he went to Berrien Springs, Michigan, to make another western about a family of outlaws, *The Younger Brothers* (Essanay, 1908).[16]

These films were in the tradition of crime westerns that Anderson had produced the year before for the Selig Company. The choice of subject was obvious for Essanay. Jesse James in particular was a popular figure in turn-of-the-century commercial culture. He was second only to Buffalo Bill as a featured historical character in dime fiction.[17] From 1901 to 1903, western dime-novel publisher Frank Tousey ran a series called *The James Boys Weekly*. At the same time, Frank James toured the country with Cole Younger in the Cole Younger and Frank James Wild West Show. Several popular melodramatic plays were based on the James family, one of which probably provided the basis for *The James Boys in Missouri*.[18] Yet if James was well liked among enthusiasts of "cheap amusements," many middle-class reformers saw him as immoral and ungenteel. Censorship boards in Chicago and other cities banned Lee's celebratory picture.

At about the same time Essanay made *The James Boys in Missouri*, the Selig Company resumed production of westerns after more than a year's absence. To create these films William Selig hired Francis Boggs, a former leading man and stage director for dramatic stock companies.[19] When he first signed with Selig, Boggs stayed in Chicago long enough to learn the basics of filmmaking from the staff there. Later he retraced Anderson's path to Colorado, where he worked with Harry Buckwalter and Selig cameraman Thomas A. Persons.[20] Boggs continued to travel throughout the Southwest, making such westerns as *An Indian's Gratitude* (Selig, 1908), *The Cowboy's Baby* (Selig, 1908), *The Cattle Rustlers* (Selig, 1908), *The Ranchman's Love* (Selig, 1908), and *A Montana School Marm* (Selig, 1908). Selig clearly assumed that exhibitors were familiar with the genre,

as the company prominently used such phrases as "real western drama" and "greatest western picture ever turned out" in advertising the film series.[21]

Under Buckwalter's tutelage, Boggs became highly proficient at filming natural landscape. Company circulars promised "scenery that the world's artists gaze at in amazement without hope of duplicating . . . [and] that tourists from the old world come thousands of miles to see."[22] This was not, exhibitors and trade journalists confirmed, mere company propaganda. A manager of a nickelodeon in Austin, Texas, observed that Boggs's *An Indian's Gratitude* was bringing in customers from around the city who were enchanted by the depiction of Colorado's natural wonders and beauty.[23] Impressed by this series of westerns, trade journalists hailed Selig as the leading American firm in terms of "large and striking scenic effect."[24]

Boggs was particularly effective at arranging the kind of naturalistic composition of scenery and actors that would become a hallmark of the genre. His *The Cattle Rustlers*, for example, contains scenes of men stealing and rebranding steers that have the look of documentary filmmaking. At one point cattle crowd the foreground of the frame while the Colorado foothills fill the background, dwarfing the rustlers sandwiched between the two scenic elements. Boggs fell back on more traditional staging conventions of melodrama when the story turned to the posse's pursuit and capture of the criminals. In some scenes the filmmaker lines his actors up in a single plane as if they were on a proscenium.[25] As Boggs and other makers of western films attempted to integrate melodrama, sensational action, and natural background, the effect was sometimes jarring. "Selig has just two results in the scenic line," a reviewer observed, "natural and delightful and 'phoney' to the rankest degree"[26] (see Figures 2.3 and 2.4). Boggs and others, however, eventually succeeded in seamlessly integrating melodramatic storytelling with the West's natural landscape.

With the success of his initial efforts, Boggs continued to search for sunny weather so he could produce more outdoor motion pictures. In his travels he and his troupe visited Los Angeles and stayed there during the winter of 1908.[27] In the spring they were back in Chicago gearing up for another production tour. This time Boggs traveled with an expanded troupe, including leading man Tom Santchi, actress Jean Ward, manager and actor James L. McGee, actor Harry Todd, and cameraman James Crosby. As Boggs had shown considerable aptitude in filmmaking, Selig gave him free rein to travel wherever he pleased. New Orleans was to be the destination of this second tour, but the troupe eventually ended up in Los Angeles again. Boggs set up shop in back of a downtown Chinese laundry on Olive Street, in part because he could hang scenery from the clotheslines. Later he wrote to Selig recommending that his production unit be allowed to stay in southern California. His employer agreed,

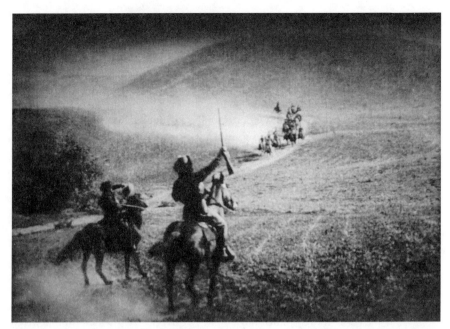

Fig. 2.3 Naturalistic scene from Bogg's film The Outbreak *(Selig, 1911). From the collections of the British Film Institute.*

Fig. 2.4 A scene from The Outbreak *using typical melodramatic staging conventions. From the collections of the British Film Institute.*

Fig. 2.5 Selig's Edendale studio. From Kalton C. Lahue, Motion Picture Pioneer: The Selig Polyscope Company *(New York: A. S. Barnes and Co., 1973).*

and by August 1909 Boggs had nearly finished converting a small suburban house into a studio. It would be the first permanent motion-picture factory established in Los Angeles (see Figure 2.5).

For the location of his studio Boggs chose Edendale, an area just north of downtown later known as Silverlake. Other firms followed him there because the suburb had a great deal of open space ideal for filming outdoors and offered a wide variety of scenery—including woods, lakes, rivers, and crumbling adobe buildings from California's Spanish and Mexican periods. It was also readily accessible from downtown, so vaudeville and legitimate actors could come to work via the streetcar. For such reasons Edendale became a center for the production of westerns and the first hub of Los Angeles's film industry. New York Motion Picture and the Pathé Company opened studios in the neighborhood shortly after Selig did.

If Boggs showed foresight in choosing Los Angeles for his base of operations, he also—earlier than most—took the artistic possibilities of cinema seriously. Soon he was devoting most of his energies to making films and leaving the business details of running the Edendale studio to his assistant manager, James McGee. Boggs shared Selig's ambition to produce the industry's best films. He mounted simple western melodramas that traded on the depiction of beautiful natural landscape made possible by location shooting. In Boggs's estimation, his films were the best of any being made in terms of production and scenic effect, but he was jealous of the Biograph Company because of the

quality of its acting. Trade journalists echoed this sentiment, including one who called the Biograph Company the "head of the class" when it came to acting and Selig Polyscope the leader in making films with "action."[28]

To bolster his troupe's histrionic talent, Boggs hired Hobart Bosworth, a successful stage actor who had played for ten years in Shakespearean comedies with the renowned Augustin Daly stock company (see Figure 2.6). Bosworth had been running his own acting school in Los Angeles since the turn of the twentieth century. His stage career had ended abruptly when he came down with tuberculosis and no longer had the stamina to act. He moved west to recover and lived in tents for months in the desert. To pass the time he took up landscape painting, thus developing an interest in the region's natural and social history. Later he became an active member of a support group for the Southwest Museum.

When Boggs first approached Bosworth about appearing before the camera, the classically trained actor was offended. He agreed to accept the work, however, because his school was failing and he needed the money. Bosworth discovered that motion-picture acting was less physically demanding than the stage, and because he performed mostly outside in the fresh air, he could work without damaging his health. The actor was impressed by Boggs's seriousness, and he developed tremendous admiration for the filmmaker, describing him as "the broadest minded and nimblest witted producer" he had ever met. Inspired by Boggs's enthusiasm for the medium, Bosworth was soon writing and producing his own films for Selig.[29]

Although another classically trained actor, William S. Hart, later achieved greater fame in cowboy roles, Bosworth was the first to move from the Shakespearean stage into westerns. He infused his cowboy and Indian characters with the more laconic acting style of the legitimate stage and helped move the western away from its association with cheap melodrama. Selig used Bosworth's cultural legitimacy to the industry's best advantage by sending him to elite women's clubs to make presentations. Bosworth, dressed in a frock coat, screened Selig westerns and action films as well as European motion pictures and lectured on the cinema's scientific, artistic, commercial, and educational possibilities.[30]

In terms of scenic beauty, originality of stories, and quality of acting, the westerns Boggs and Bosworth made were among the most influential examples of the genre. By 1910 two separate production units worked out of the Selig studio in Edendale. Bosworth took one on location around California, and Boggs typically worked with another in and around the studio.[31] The company took advantage of the state's scenery and historical landmarks. Soon after arriving in Los Angeles, Selig obtained exclusive rights to use the mission buildings of southern California in motion pictures.[32] This gave Boggs a decided

In the Days of Gold

A Penetrating Analysis of Characters brought out in a Western Story of Thrilling Situations

Written and Produced by HOBART BOSWORTH and F. E. MONTGOMERY

CAST

JUANITA LOPEZ	Betty Harte	JUAN LOPEZ	Frank Richardson
ENRIQUE LOPEZ	Roy Watson	DICK HARDING, "A black sheep"	Hobart Bosworth
	MOTHER LOPEZ	Anna Dodge	

THE LOPEZ family is attacked by Indians and are all killed, excepting Juanita and her mother. Juanita hears the shooting, sees the Indians attack her home, and carry off her mother. She decides she would be safer dressed as a boy, so she don's her brother's clothes, and cuts her hair off. Then tries to reach shelter. Dick Harding, a Western cowboy, comes suddenly upon Juanita. She tries to explain to him, but he does not understand Spanish, so she finally makes herself understood by gesticulations. He places her behind him on his horse, and gallops off just as the Indians dash up. After a hard ride, they out-distance the red men and reach camp. The Sheriff, Dick and cowboys pursue the Indians, and come upon them as they are in the act of burning Mother Lopez at the stake. A short fight and the Indians are defeated, but too late, as the mother is already dead. Harding then takes Juanita to his cabin, thinking she is a boy. They become very much attached to each other. Dick turns miner, and one day makes a lucky strike. Later on he learns that Juanita is a girl and realizing that he loves her induces her to marry him.

Miss Betty Harte

SELIG

Fig. 2.6 Handbill for Selig film starring Bosworth. From Lahue, Motion Picture Pioneer.

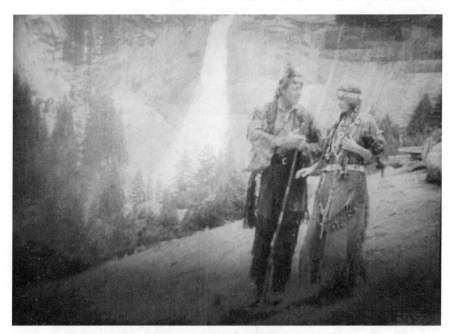

Fig. 2.7 Bosworth filming on location, Indian Vestal *(Selig, 1911). From the collections of the British Film Institute.*

advantage in producing films about early California. The company also uti-lized such scenic spots in the northern part of the state as Yosemite Valley and Mount Shasta (see Figure 2.7). The scenarios were often fresh and original. Boggs sometimes borrowed from classical plays. His *Range Pals* (Selig, 1911), for example, employed the plot of a Roman costume drama, *Damion and Pythias,* and turned the main characters into cowboys named Steve and Dave. Bosworth borrowed from current newspaper accounts of a southern California manhunt for a renegade Indian named "Willie Boy" to make *Curse of the Redman* (Selig, 1911). Critics praised the Boggs and Bosworth films for their "poetic charm," integration of plot and scenic elements, and overall imaginative qualities.[33]

As westerns increased in popularity, many other manufacturers rushed to join the Selig Company in southern California. By 1911 six major studios were operating at least one unit year-round in the area: Selig, New York Motion Picture, Kalem, Nestor, American, and Pathé West Coast. All of them special-ized in cowboy and Indian subjects.

Not everyone producing westerns joined the mad dash to southern Cali-fornia. Some companies, like Biograph and Essanay, sent units to southern

California but only for extended visits and not to remain permanently. Gilbert M. Anderson, for one, had always been vaguely dissatisfied with the landscape in Los Angeles, and he resisted setting up a permanent studio there. Instead he maintained mobile production facilities that allowed him to shoot on location throughout the West.

In winter 1909 Anderson had turned his energies from comedy to cowboy films after noting the success of his company's western crime films. By all accounts, the Jesse James and Cole Younger pictures were big hits, and men and boys wrote the company asking for more of the same.[34] Anderson traveled around northern and southern California in search of scenic locations to make westerns. The filmmaker looked in vain for someone to play the leading roles. He recalled offering the job to Dustin Farnum, the actor who had gained fame in a long run of Owen Wister's stage play *The Virginian*. Farnum declined, and Anderson, who had never thought of himself as much of an actor, reluctantly assumed the duties himself.[35] Exhibitors and audiences received these westerns enthusiastically, and the filmmaker resolved to turn his attention exclusively to the genre.[36] In fall 1909 Essanay announced that it would double its production to release a western every Saturday.[37]

Anderson and his stock company worked at a frantic pace to meet the ambitious production schedule. They could churn out a one-reel western, typically made up of fewer than forty shots, in a few days.[38] Anderson conceived the scenarios himself, often borrowing plots from magazines, western story papers, or popular stage plays. To save time, he never used a shooting script and rarely communicated his ideas to his troupe before shooting.[39] Many actors found these methods frustrating. "The average day was spent nervously," one remembered, "because you never knew what was going to happen, or what you'd be doing."[40]

The filmmaker traveled with a stock company of eight people, about the same size as Boggs's original troupe. It included his cameraman, Jesse Robbins; Jack O'Brien, an actor specializing in villains; character actor Arthur Smith; and W. K. Russell, a property man and "assistant hero" and villain. Anderson played most of the leading male parts, and he hired leading ladies and ingenues from the vaudeville houses and stock companies in the various western cities where the company worked.[41] He kept his troupe constantly on the road, traveling by train from town to town in search of new scenic locations. The company never stayed in an area for more than three months. Once Anderson or his cameraman discovered a desirable spot in which to film, they rented several rooms in a local hotel, one of which served as a temporary office. Then the group rode by horseback into the surrounding countryside to shoot its films.[42] This nomadic existence mirrored life on the road in a trouping stage company. Anderson kept up this lifestyle longer than most because it suited his simple

melodramatic tales and provided him with a taste of the theatrical world of which he had always yearned to be a part.

Anderson, like Boggs and Selig, believed that by producing motion pictures in the West he could distinguish his westerns from those made by his competition on the East Coast and in Europe. On location, he argued, he and the other actors absorbed the regional atmosphere that made their characterizations more authentic. "No western type produced in the East," Anderson once told a journalist, "can possibly compare with the Essanay western; as no matter how gifted the actor, he cannot get the true spirit, the life color, and the touches that make for vivid character delineation unless dwelling for some time among the types, immediately before he attempts to impersonate them."[43]

Whereas Boggs and others built studios in Edendale and elsewhere in southern California, Anderson remained committed to nomadic location shooting. His journeys typically began in Chicago and took him to Colorado, where he and his production unit worked through the fall. As the weather changed they headed south for El Paso, Texas, and from there to southern California, filming in such places as Santa Barbara, San Diego, and Catalina Island. By early spring the company was usually back in Colorado, the state Anderson deemed "the finest place in the country" for making "Wild West stuff."[44]

In Colorado Essanay filmed in and around Golden, a town less than fifteen miles from Denver and connected to it by interurban rail. Denver had a number of active vaudeville houses and stock theaters that could easily supply Anderson with the talent he needed to make westerns. The filmmaker located an especially scenic canyon outside Golden in a town called Morrison, and he headquartered his company there at the Hotel Morris. Spoor visited the area and later described it to a trade journalist:

> [T]he scene of operations chosen by Mr. Anderson is one that could not be surpassed for the production of Western drama and comedy. . . . The scenic surroundings are simply superb. There are rushing water cascades, caves, inspiring mountain views, deep canyons and glimpses of sky that are simply a delight to the producer and camera man. A corral for the horses and a building for properties and paint frames provide all the artificial accessories required.[45]

During its travels, Anderson's troupe swelled to twenty actors in addition to twelve ranch hands Essanay billed as "real cowpunchers."[46] Actresses such as Clara Williams joined the company permanently. Williams had appeared in stock theater in Los Angeles and San Francisco as well as in vaudeville before connecting with Essanay in southern California. The motion-picture company called her a "picturesque girl of the Rockies" and declared that she had spent several years on a cattle ranch where she became intimately familiar with cowboy life.[47] She served for several years as Anderson's leading lady and

then played alongside Hart. She eventually starred in her own features for the Triangle Film Company.

Despite the presence of women in the company, a rough masculine environment usually prevailed on the road. Cameraman Roland Totheroh remembered that after a day of filming, the crew often ate together around a big table in the hotel where they roomed. The cowboys would then go drinking in the local saloons, becoming rambunctious and sometimes violent.[48] A female resident of Niles, California, where the company eventually became permanently headquartered, recalled that the cowboys used to intimidate some of the local townspeople. "It was a wild town then," she noted, and the "cowboys . . . on their way home from the bars or the dance on Saturday night, would stumble into our house shooting off their guns. My mother was afraid with all those crazy guys in town."[49]

After nine months of constant traveling and filming in the West, Anderson and his company returned to Chicago for the summer. During the 1909–1910 season they shot 65,000 feet of film and completed fifty-two one-reel story subjects, as well as many additional scenic and industrial motion pictures.[50] Critics generally praised Anderson's efforts. They felt his films' scenery and acting were authentic and that the stories were novel and plausible.[51] One fan offered the opinion that Anderson's western characters were "more true to life" than anything the Bison, Pathé, Selig, and Kalem motion-picture companies created.[52] The filmmaker would, he promised exhibitors, keep his western company intact and continue to make films as long as the demand was strong.[53]

The genre's popularity did not soon wane. At one point in 1910, when Essanay replaced its weekly western with a general dramatic subject, the firm was inundated with letters from nickelodeon managers demanding the return of cowboy and Indian films.[54] In the summer of that same year, *Film Index* reported that exchanges were purchasing all the western films available, but exhibitors continued to complain that they were not getting enough.[55]

Operators around the country attested to the genre's immense popularity with audiences. The owner of the Senate Theater in Chicago claimed *The Cowboy Millionaire* (Selig, 1909) had brought him his "biggest day's business in two years."[56] W. C. Quimby, an exhibitor from Zanesville, Ohio, who traveled thousands of miles on the rivers of the South and the Midwest in a showboat converted into a floating nickelodeon, claimed to be in as good a position as anyone to judge the average patron's preferences. During summer 1910 he played a different town or city every evening to audiences he characterized as consisting of all age groups and "every nationality." The first question he was asked when he landed in a new city, he observed, was invariably the same: "Have you got any Wild West pictures this time?"[57] A Chicago exhibitor

painted a similar picture. His audiences were unresponsive to scenic, indus-trial, and educational films. They wanted sensational pictures like "those show-ing battles between Indians and cowboys, Indians and early settlers, Indians and soldiers, and Northern and Southern soldiers." The exhibitor concluded that if they gave audiences "plenty of soldiers, cowboys, Indians, trappers, etc., along with good comedies," exhibitors could keep the preponderance of mov-iegoers happy.[58]

To explain the genre's unparalleled popularity, trade journalists pointed to the abundance of western-themed material that had appeared in books and on the stage during the years preceding the nickelodeon boom.[59] The first decade of the twentieth century saw the steady production of Wild-West dime novels and weekly western story papers. Even more important, western melodra-mas and comedies had been especially popular in "ten-twenty-thirty" theaters just prior to their appearance on the screen.[60] Also, many successful western-themed stage productions—such as *Girl of the Golden West* (1905), *The Virginian* (1904), and *The Squawman* (1905)—toured the better-appointed theaters cater-ing to the middle classes.

The genre was capturing the imagination of audiences not just in the United States but all over the world. On the strength of their cowboy and Indian subjects, Essanay and Selig established healthy export businesses. In 1910 George Spoor sent his brother, Harry A. Spoor, to open an office in London. According to one observer, it was the most elaborate and impressive of any of the firms dealing in American imports there. By its first month in business in London, the company was selling at least twenty prints a week to distributors in Europe.[61] Many of these films were likely westerns, as the genre was proving tremendously popular, particularly with British audiences.[62] At the same time, Selig established agencies to handle its product in Berlin, St. Petersburg, Hong Kong, Sidney, Melbourne, Johannesburg, and Rio de Janeiro. A journalist for *Motography* described the western's international popularity:

> It does not seem as if too many of these Indian and cowboy films could be fed to the moving picture goers of the rest of the world. From Liverpool to Moscow and from Stockholm to Melbourne the patrons eagerly watch the unfolding of every one of the highly colored dramas of the prairies and the mountains. It does not matter if the story is only slightly different from what they have seen before. This is the America that they have long imagined and heard about.[63]

Western films provided aspiring immigrants and others with some of the most striking and dramatic images of the United States they had ever seen. They also profoundly affected cultural and intellectual life in the countries where they were popular. According to film historian Deniz Gokturk, Ameri-can Wild-West pictures informed the work of German artists George Grosz,

Rudolf Schlichter, and Otto Dix.[64] Critic Siegfried Kracauer commented on these early films' popularity in Germany:

> The success of the American Westerns was particularly sweeping. Broncho Billy and Tom Mix conquered the hearts of the young German generation, which had devoured, volume after volume, the novels of Karl May. . . . By their simple manner and untroubled outlook, their ceaseless activity and heroic exploits, the American screen cowboys also attracted many German intellectuals suffering from lack of purpose. Because they were mentally tossed about, the intelligentsia welcomed the simplifications of the Westerns, the life in which the hero has but one course to follow.[65]

If largely because of the efforts of Selig, Essanay, and other manufacturers the western had become the international face of American motion pictures, it also helped the U.S. industry compete against foreign manufacturers at home.[66] At the time of the western's initial popularity, American filmmakers were facing a domestic market virtually dominated by the French. Before the formation of Edison's Motion Picture Patent Company, the uncertainty and instability caused by copyright infringement litigation kept capital out of the industry and allowed foreign manufacturers to capture the American market. The western's overwhelming popularity, however, gave U.S. manufacturers an advantage. Unlike other domestically produced subjects, the genre was an unmistakably "American" contribution to cinema because its themes and characters grew out of the well-known frontier experience.[67] European companies could not effectively emulate the cowboy and Indian film. One particularly prescient motion-picture importer in America lamented that his business would suffer as a result of Essanay's decision to put out a weekly western.[68]

The genre, trade journalists wrote, represented the roots of a nationalist cinema. American manufacturers had been too quick to copy foreign themes, they argued, but with the western, filmmakers were now exploring the unique American "character" through motion pictures. They asserted that the popularity of the genre with audiences and manufacturers alike signaled a new strength within the domestic industry. Journalists predicted the western would become the "foundation of an American moving picture drama."[69]

Much of this sentiment was thinly disguised propaganda for the U.S. film industry. After all, American filmmakers had borrowed many of the initial conventions of the western from the British crime film. Nonetheless, trade journalists, exhibitors, and others in the industry were hostile to European manufacturers who endeavored to produce westerns. They declared them fundamentally handicapped, "like the novelist who goes to the guide books for his descriptions of foreign scenes."[70] They treated factual errors in foreign-made cowboy and Indian films as affronts to national pride, confirming that westerns

should be made exclusively in America and by Americans. One exhibitor, complaining about the French Pathé Company's *The Western Hero* (1909), wrote that European filmmakers should be told that Indians do not wear "checked gingham shirts . . . live in huts or tents made of cornstalks, or camp in apple orchards." Journalists derided the film's producer for using bobtail horses and English saddles.[71]

In reality, it became increasingly difficult for any company, European or American, to produce cowboy and Indian films outside the U.S. West. Critics routinely dismissed as "false" the westerns made by Kalem, Lubin, and other American manufacturers that shot such films in the East. Among trade journalists, the phrase *Jersey scenery* became a frequently used term of criticism.[72] The accused studios initially defended the state as a more appropriate place to make cowboy and Indian pictures than "the barren old flat lands of the West."[73] Such critiques, however, eventually forced European and East Coast–based firms to send their own production crews to the region to manufacture westerns. At the beginning of 1910 the French Méliès Company had a production unit in San Antonio, Texas, and shortly afterward Pathé established a permanent studio in Los Angeles. The largest East Coast patent companies, the so-called big three (Vitagraph, Biograph, and Edison), also sent units westward to make films. They conceded routine production of the genre, however, to their more conveniently located associates in Chicago. Whereas the western never represented more than 4 percent of the total combined output of the big three manufacturers, by 1910 every fourth film made by the Chicago patent companies was a cowboy and Indian picture.

Not surprisingly, Selig, as the manufacturer largely responsible for introducing the genre, initially led in its production. The company manufactured six such films in 1908, nineteen the next year, and twenty-seven the year after that. At its peak, the western represented 20 percent of the company's total output. In 1910, when Anderson began to produce weekly cowboy films, Essanay surpassed Selig to become the patent companies' leading producer of the genre. During that year Essanay churned out forty-six such films. With the increased production, the western came to constitute a third of the company's total output. Essanay held fairly steadily to that rate into the teens, releasing one or two westerns a week. By 1912 the company was producing seventy-four such films a year, almost twice as many as Selig and more than three times the number produced by the big three manufacturers combined.[74]

As these figures indicate, the western's popularity translated into significant profits for Selig and Essanay. Having started their operations without outside investment, they were able to put a large percentage of their initial returns into plant and equipment.[75] In 1909 Spoor broke ground on a new 60,000-square-foot motion-picture plant on Argyle Street in Chicago. A journalist for

Fig. 2.8 Selig's new Chicago studio, 1911. From Lahue, Motion Picture Pioneer.

Show World called it "one of the largest and best equipped studios of its kind in the country."[76] A few months later Selig also completed an expansion project. The company's trade was so vigorous that it needed to double its print-making capacity, and it spent $75,000 to erect a new three-story building in Chicago.[77] The first two floors housed film-processing facilities, a carpenter shop, and dressing and property rooms; the top floor was a state-of-the-art, glass-enclosed studio (see Figure 2.8). By 1910 Essanay and Selig had turned Chicago into a global center of motion-picture production—responsible, according to *Variety,* for a fifth of the films manufactured in the world. Each company now employed 200 people in its factories.[78]

At the same time Selig was expanding his Chicago plant, he spent another $20,000 on improvements at the Edendale studio.[79] He had a large new Spanish-colonial–style building erected on the property. The edifice signaled the film industry's permanent arrival in southern California and was also an architectural advertisement for the company's popular mission-period films. Selig's workforce at the Edendale plant rose to over a hundred (see Figure 2.5).

While Selig and Spoor invested in permanent facilities in Chicago and Los Angeles, Anderson acquired new technologies for nomadic location shooting. During his first season of traveling in California, he lacked the capacity to film indoors and either had to make pictures that took place exclusively outside or had to return to Chicago to film interiors. In 1909, while touring the West, Essanay staff members designed a large portable studio with a canvas roof that they could easily compress when it came time to relocate in search of better weather conditions or to find more dramatic scenery.[80] In addition, Anderson purchased a portable lighting system to supplement natural sources inside the new studio.[81]

While Anderson was on location and Boggs worked out of the Edendale satellite studio, other production units could utilize the more costly space inside the Chicago factories. If this arrangement gave the western-film producers considerable flexibility in capturing outdoor scenery, they sacrificed some creative control. Initially, when on location neither Boggs nor Anderson had the capacity to develop film, and therefore they were unable to edit their own pictures. The tanks of developing solution and drying drums required to produce a negative were too bulky to transport. Westerns, as outdoor films taken over several days under different lighting conditions, were particularly difficult to develop. They needed to be processed in sections, depending on how much the film had been exposed on a particular day. Whereas traveling companies were still small, developers could make quality negatives more efficiently at the main factory than they could on tour with a production unit.[82]

As Boggs and Anderson gained access to developing equipment, it facilitated the standardization of their product and allowed for more elaborate westerns. Boggs and Selig built a developing plant as part of their permanent studio in Edendale.[83] Anderson lacked the capacity to do the initial processing of his films until the end of 1910 when the filmmaker added to his collection of portable production equipment a railway car containing the requisite tanks and drums. He could now develop his films on the road, screen and edit them, and reshoot badly photographed scenes before sending them to the Chicago factory for duplication.

As the addition of the developing car suggests, Anderson remained resistant to establishing a permanent studio in the West. Until 1912, he continued to make his circular production tours of the region or moved back and forth between cities in northern and southern California.[84] Anderson's simple, moralistic, and lighthearted western comedies and melodramas were particularly suited to nomadic production because they rarely required numerous extras, costumes, livestock, or props.

Rather than rely on the depiction of warfare and other spectacular scenes, Anderson built his stories around the psychology of his central cowboy fig-

ures. From early on his films were largely character-driven, and audiences responded enthusiastically to his western impersonations. Fame came to the filmmaker in an era before motion-picture manufacturers had created the publicity apparatus that supported and encouraged stardom. As film historian Eileen Bowser has pointed out, Anderson was among a small number of actors who appeared regularly in front of the movie camera prior to 1910. As a result, he became one of the first players with whom audiences could readily identify.[85] Even though he did not create his famous "Broncho Billy" character for several years, Anderson was gradually developing his distinctive western hero.

In many of his first films, Anderson played a cowboy rube character that was likely inspired by the western-themed comedies featured in cheap melodrama houses in 1906 and 1907.[86] In *Ranchman's Rival* (Essanay, 1909), he takes on the role of a naive, trustworthy, love-struck cowboy who loses his "gal" to a crafty easterner; he plays the part in a comical manner. In one interlude Anderson's character brings his sweetheart a box of chocolates. At her gate, before handing over the candies, he opens the box and pops one into his mouth. He looks around cautiously and then smiles broadly, pleased with his playfully deceptive act.[87] Similarly, in *Western Chivalry* (Essanay, 1910), Anderson appears as one of a group of cowboy buffoons. He acts clownish, making exaggerated facial expressions, and he wears an oversized hat pulled down low over his ears.[88]

Anderson had a good instinct for comedy. He produced musical comedies for the legitimate stage both while making motion pictures and later after he left the industry. The filmmaker was also among the first to recognize Charlie Chaplin's genius. In 1914 he signed the comic to Essanay at the unprecedented salary of $1,250 a week and allowed him complete creative control over the filmmaking process.[89] Critics praised Anderson's own comedic performances and responded favorably to the humorous elements in Essanay westerns.[90] "When the conventional cowboys are shown in farce or comedy, especially by the Essanay players," a reviewer commented, "they are . . . pleasing and amusing."[91]

As his western rube figures suggest, Anderson at first did not depict the cowboy as a serious dramatic hero. That development came later, as he established a fixed location for Essanay's West Coast studio and began his Broncho Billy series. In fact, during his first two seasons with Essanay, he only occasionally featured a central white cowboy figure in his films. This conformed to an industry-wide trend between 1908 and 1911 in which filmmakers used Mexican and Indian characters prominently in the genre. Such figures were often villains, but they also appeared as heroes. In fact, some American firms—New York Motion Picture and Kalem among them—specialized in the production of pictures that featured only American Indian characters. Filmmaker James

Young Deer, a Winnebago Indian, produced and acted in such movies for both companies and later for Pathé West Coast, and he routinely placed Indians in heroic and sympathetic roles.[92]

Anderson also initially relied on nonwhite characters and sometimes showed them performing heroic acts, albeit usually in the service of whites. In his *A Mexican's Gratitude* (Essanay, 1909), a sheriff prevents the hanging of a Mexican whom a group of white cowboys has mistakenly accused of horse stealing. In the following scenes, the Mexican returns the favor by rescuing the sheriff from the clutches of a western villain and his accomplices. Similarly, in *The Cowboy and the Squaw* (Essanay, 1910), a white cowboy defends an Indian woman from the insults of a bad man. Later the Indian woman twice saves her newfound protector from death at the hands of the same villain.[93]

Before the advent of his Broncho Billy series, Anderson regularly cast himself in nonwhite parts. In *The Dumb Half Breed's Defense* (Essanay, 1910), for example, he played a mixed-blood mute who comes to the aid of his sister who is being abused by her white husband.[94] Similarly, in *An Indian's Sacrifice* (Essanay, 1910), Anderson portrayed an "educated" Indian whose white friend offers him his daughter in marriage.[95] In what is likely the only surviving motion picture in which the filmmaker took on a nonwhite part, *The Mexican's Faith* (Essanay, 1910), Anderson's titular character makes unwanted advances to a white woman. In a subsequent scene, she saves him from the cowboys who are about to tie him up and lash him for his transgression. Anderson's character repays the white heroine's kindness by thwarting an evil easterner's plan to kidnap her. Anderson, in heavy grease paint and looking as though he were in a minstrel show, grins broadly and rolls his eyes to indicate his sexual desire for the heroine (see Figure 2.9).[96]

By 1912, as trade journalists and exhibitors began to complain about the sensationalism and sexual suggestion in western stories featuring Indians and Mexicans, Anderson discontinued using them as central protagonists.[97] Moviegoers associated the actor/filmmaker with white cowboy roles and rejected his racial impersonations as stagy and unrealistic. One journalist sarcastically compared Anderson's performance in the film *An Indian Girl's Sacrifice* (Essanay, 1910) to that of popular minstrel players of the period: "Anderson as the Indian. Help! . . . You looked like [Dave] Montgomery and [Fred] Stone in the 'Ham Tree.' Who in the wild and wooly ever told you that you could play injun? . . . We like you in the dashing cowboy and outlaw characters."[98]

In response, in part, to these negative reactions, when he began regularly producing his Broncho Billy films, Anderson abandoned race as a theme almost completely and instead foregrounded his white hero's moral and psychological conflicts.[99] The series rarely reflected the kinds of activities associated with empire building and the violent conquest of territory and people. Such

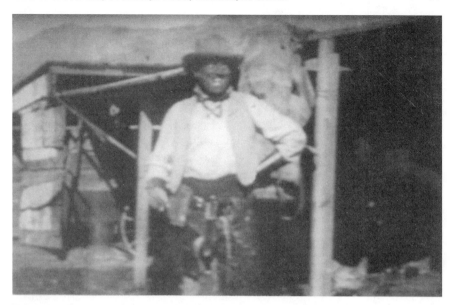

Fig. 2.9 Anderson in The Mexican's Faith *(1910). From the collections of the British Film Institute.*

cliché western topics as railroad building, Indian fighting, and settlers migrating to the West were conspicuously absent. Whereas in 1909 almost half of Essanay westerns had racial conflict as a theme, by 1913 less than 10 percent did.[100] Anderson had largely moved Mexican and Indian characters into the background of his films, and his mythical West had become overwhelmingly white.[101]

While Anderson played with melodramatic conventions in developing his western hero and Boggs shot films on location in the West, Selig producers in Chicago undertook more elaborate and spectacular westerns that portrayed warfare between Indians and whites. Initially, they made such films in and around the main studio where the staff and equipment were available to produce them. To handle the complexities of these pictures, Selig hired directors who had experience producing large-scale plays and operas on the legitimate stage. The most notable was Otis Turner, who in 1908 came to work for Selig after twenty-five years as a director for such leading theatrical producers as Charles Frohman and Henry Savage.[102] Turner's stage experience made him especially valuable in mounting frontier military spectacles for the cinema. A writer for *Motography* called him "a veritable Napoleon in handling difficult scenes and large groups of actors."[103]

In winter of 1908–1909, Turner and Selig brought to the Chicago studio a group of Sioux Indians who were likely off-season Wild-West show performers. They set up an encampment near the Selig plant at the corner of Irving Park Boulevard and Western Avenue.[104] When the weather was sunny, Turner used the troupe to stage battle scenes. If it was overcast, the Indians remained idle while moviemaking continued inside the studio. With these actors Turner produced some of the first story films to feature Wild-West show–type spectacles. Films like *On the Warpath* (Selig, 1909), *Boots and Saddles* (Selig, 1909), and *In the Bad Lands* (Selig, 1909)—variously advertised as "early settler" and "Indian military" westerns—depicted the Sioux troupe committing depredations against white settlers. The films ended, like so many Wild-West show acts, with the arrival of the U.S. Cavalry.[105]

As their scale suggests, Selig was willing to spend extra money on these productions because he believed more expensive motion pictures would help his own business and the industry as a whole. He instilled in his producers his desire to be the leading company in terms of quality, and he allowed them to make ambitious films.[106] As the manufacturer put it, he wanted to put on "the very best films" to "educate the people up to the highest class picture entertainment."[107]

Selig took it as his mission to elevate motion pictures from the realm of "cheap amusements" in the United States and abroad. He was an active proponent of larger, better-appointed theaters and of increasing admission prices from five to ten and twenty-five cents. He also lamented what he considered the degraded conditions of cinema in some European countries. The Italian industry in particular, he observed, was "on the downward path" because of sensational and violent pictures that upset "the better class of people." He felt the American product, once it gained a strong foothold, could bring about better conditions for the new medium worldwide.[108]

By 1909, in light of these views, Selig began to deem western crime stories—a genre he was instrumental in popularizing—as inappropriate for the American motion-picture industry. He rejected scripts such as *Cowboy Justice* for featuring lynchings of desperado characters.[109] Selig producers increasingly replaced stories of murderous frontier outlaws with films that depicted western violence as a fundamental part of nation building and as a reflection of whites' pioneering spirit. If the cowboy pictures of Anderson and others were predicated on the melodramatic struggle between individual characters, Selig producers began to focus on the historical conflicts among groups. A critic lauded the company's new "settler subjects" for depicting the "valid" kind of western violence that resulted from fighting "nature" and "Indians."[110]

In presenting warfare between whites and Indians, Selig producers naturally looked to Wild-West shows whose producers could still lay claim to being the amusement industry's preeminent interpreters of western history. The

relationship between the Wild-West show and motion pictures went back to the origins of cinema. In 1894 William K. Dickson made films of characters from the Buffalo Bill show at Edison's Black Maria studio in West Orange, New Jersey. Such star performers as Annie Oakley, Pedro Esquivel, Vicente Oropeza, and Buffalo Bill himself appeared before the motion-picture camera.[111] After the development of the western genre, filmmakers relied even more heavily on the personnel, props, and other equipment from these shows.

At the time of the western film's initial popularity, scores of Wild-West troupes toured the United States and Europe. They tended to be inactive in the winter, and during the off-season, motion-picture producers could engage their services relatively cost-effectively. Without Wild-West shows it may have been prohibitively difficult for early filmmakers to organize the staff and equipment to make westerns with large battle scenes. In summer 1909, with most of the best Indian performers on tour, Selig and Turner had tried to work directly with Indian agent E. C. Swigert to secure Native American extras. They found themselves having to compete with Swigert's other commitments, however, including a contract he had made for the Indians to work baling hay.[112]

Selig producers and others looked to Wild-West shows not only for actors and equipment; they also incorporated the outdoor amusements' stunts and staging as basic elements in their films' narratives. In the process they created new ways of visually depicting the West and its history. In fall 1909 Selig sent a troupe to Oklahoma to make films with the Miller Brothers 101 Ranch Wild West Show.[113] These westerns featured actual Wild-West performers and successfully integrated "fancy" riding, rope tricks, and other stunt work into simple melodramatic narratives.[114] One critic writing of Selig's *Pet of the Big Horn Ranch* (1909) praised the company's producers for allowing "natural action" rather than "stagey posing" to tell the story. He determined that in this regard the manufacturer was taking the western film in the positive direction other manufacturers had taken the society drama.[115]

On the heels of the success with the 101 Ranch, Selig signed a contract with Will A. Dickey's Circle D Ranch and Wild West Show and Indian Congress to provide cowboys, Indians, and props for western films. Turner took the troupe into Missouri and Oklahoma, traveling in a special train filled with Indian and cowboy performers as well as horses, cattle, costumes, and props. The entourage also had a mobile commissary and a hospital.[116] The irony of having to ship all the elements of the western from Chicago to Oklahoma was not lost on eastern filmmakers whom journalists had criticized for finding their cowboys and Indians in the Bowery.[117]

As Selig and other companies enlisted Wild-West show personnel, westerns began to look more like the historical reenactments performed as part of those outdoor amusements. Prior to this alliance the main method of convey-

ing action in the genre was the chase scene, involving intercutting between a pursuer and a pursued. Manufacturers had borrowed this dramatic element from both the melodramatic stage and early crime films. Although the chase scene did not disappear, it increasingly gave way to action scenes based on Wild-West show staging. Organizers of these events held their performances in arenas and thus tended to present historical reenactments using concentric circles. The most obvious example was the ubiquitous staging of besieged white settlers surrounded by a hostile band of Indians.

Turner was among the first to adopt similar scenes for western films. He did so as early as 1909 in the first military westerns he made with the Sioux troupe in Chicago. The filmmaker set up such scenes in a way that encouraged viewers to identify with the white settlers. In *Across the Plains* (Selig, 1910), he placed the camera directly outside the wagon train, looking in on the migrants. When the Indians attack, Turner holds the settlers in a medium shot as they load and fire their guns. The "savages" make many circles around the encampment and behind the camera and out of view. By filming from this position, Turner ensured that spectators would feel as though they themselves were surrounded by the enemy. The Indians are essentially faceless, and moviegoers see them only intermittently between the wagons. The camera position remains the same as the cavalry comes and routs the Indians.[118] Such scenes quickly became one of the most clichéd elements of the genre. Just a year after their first appearance, critics were already complaining of their overuse.[119]

If producers at the Selig Company borrowed staging conventions from Wild-West shows, they also adopted the amusement's rhetoric in support of American expansionism. As critic Richard Slotkin and others have pointed out, Buffalo Bill and his emulators used their performances to justify white violence on the frontier and to defend U.S. imperialism.[120] Whereas the film industry had previously utilized the language of Manifest Destiny in promoting its product, after the engagement of Wild-West shows that rhetoric became more explicit. The Selig Company advertised westerns made with the 101 Ranch, such as *The Ranch King's Daughter* (1910), by promising that the films showed "the toil, peril and hardships of the class who redeemed from actual barbarism that unutilized territory which now forms a portion of the Great American commonwealth—the once Wild West."[121] Similarly, the firm characterized the cowboys in *Ranch Life in the Great Southwest* (1910), a film produced with the Circle D Ranch and Wild West Show, as those "brave and hardy men who helped make . . . [history] and in many instances sealed it with their blood in desperate battles and fierce personal encounters with the most formidable . . . of all savage foes."[122]

Such language also pervaded the falsified show business biographies of the Wild-West show performers who moved into filmmaking. One of the first and

most important cowboy actors to come out of this milieu, Tom Mix, began working for Selig in 1910 when Will A. Dickey hired him to meet Turner and the Circle D Ranch and Wild West Show in Missouri. The Selig Company readily propagated the fictionalized persona Mix had created while working in the Wild-West outdoor amusement industry. In advertising Turner's *Ranch Life in the Great Southwest,* in which Mix starred, the manufacturer emphasized the actor's cowboy past, his association with empire building, and his physical prowess. He was, publicity materials noted, a champion "bulldogger," had served as the chief of scouts in Cuba and as a Maccabean scout in the Philippines during the Spanish-American War, was involved in the Battle of Tien-Tsin in China, had been a Texas Ranger, and had a father who was wounded in the Battle of Wounded Knee.[123] Although Mix did not gain prominence until after going to work for the Fox Corporation in 1917, the brand of Wild-West show-manship he and Turner developed at the Selig studio greatly affected the characteristics of the western-film hero in the 1920s.

For all of Selig's success in integrating authentic western landscapes and melodramatic stories with historical reenactments, trick riding, stunt work, and the ideology of the Wild-West show, the company's preeminence in the genre declined in 1912. The most spectacular epic westerns were now being produced by independent motion-picture companies more willing to invest in longer and more expensive films. The Selig Company also lost its two most important directors of westerns. Otis Turner left for Universal, one of the independents that now rivaled Selig for large-scale cowboy and Indian pictures, and Francis Boggs died. In a case of life imitating art, a Japanese American laborer, gardener, property man, and sometimes film actor at Selig Polyscope's Edendale studio, Frank Minnematsu, shot and killed Boggs and wounded Selig in the arm. According to press accounts, Minnematsu had been drinking heavily and become delusional. He believed the acts of violence performed in front of the camera were rehearsals for actual evil deeds to be committed outside the studio. A jury found him guilty of first-degree murder and sentenced him to life imprisonment at San Quentin. The industry consensus was that he had taken the life of one of cinema's most talented and promising artists.[124]

Although Selig's westerns declined in importance, Anderson continued to make popular cowboy pictures. The filmmaker developed his western hero in such a way that the hero had a wide demographic appeal. He was able to continue with his breezy one-reel westerns even as other companies mounted more ambitious productions. Anderson's Broncho Billy remained the genre's leading hero until William S. Hart emerged in 1916.

In the initial period of the western-film boom, Selig and Essanay did a great deal to shape the direction of the genre and of the industry as a whole.

They demonstrated that the international demand for cowboy and Indian films was virtually inexhaustible. Moreover, in meeting this demand, they helped to establish Chicago and then Los Angeles as centers of motion-picture production. The companies set the standard in terms of location shooting in the West and forced other manufacturers to follow their lead. Most important, the firms anticipated the future of the western. Selig producers integrated scenic and melodramatic stories with Wild-West show staging and ideology, and Essanay and Anderson established the white cowboy as the genre's central figure.

NOTES

1. "Essanay Will Release Two Reels," *Motion Picture World (MPW)*, November 11, 1909, 638.

2. *Views and Films Index*, October 2, 1909, 9.

3. The extent to which the middle class became patrons of nickelodeon theaters is a matter of debate among scholars. The first film historians characterized the nickelodeon as an exclusively working-class institution; see Terry Ramsaye, *A Million and One Nights: A History of the Motion Picture Through 1925* (New York: Simon and Schuster, 1926); Lewis Jacobs, *The Rise of the American Film* (New York: Harcourt, Brace, 1939). This long-accepted view of the nickelodeon was challenged in the 1970s by a generation of scholars who argued that from very early in the development of the nickelodeon, the middle class began to patronize the movies; see particularly Russell Merritt, "Nickelodeon Theaters, 1905–1914: Building an Audience for the Movies," in *The American Film Industry*, Tino Balio, ed. (Madison: University of Wisconsin Press, 1976), 59–82; Robert C. Allen, "Motion Picture Exhibition in Manhattan, 1906–1912: Beyond the Nickelodeon," *Cinema Journal* 18, no. 2 (Spring 1979): 2–15. Film historian Ben Singer has reopened the debate once again with new evidence that suggests that, at least as far as New York City is concerned, the older view of the nickelodeon as a working-class venue may be more correct than the one offered by the revisionists; see Ben Singer, "Manhattan Nickelodeons: New Data on Audiences and Exhibitors," *Cinema Journal* 34, no. 3 (1995): 5–35.

4. For the history of Spoor's business enterprises prior to the establishment of Essanay, see envelope #2131, the Locke Scrapbooks, Billy Rose Theater Collection, New York Public Library, Lincoln Center, New York City; "Kinodrome Making Is an Art," *Show World*, August 10, 1907, 14; Terry Ramsaye, "Romantic History of the Motion Picture," *Photoplay Magazine* (1923): 98; Gladys Priddy, "Essanay Lot Gone, Not Its Guiding Hand," *Chicago Sunday Tribune*, December 21, 1947, part 3, 4; "G. M. Anderson," Oral History Transcript, Columbia University, New York City, 1958, 17; Charles Musser, *The Emergence of Cinema: The American Screen to 1907* (Berkeley: University of California Press, 1990), 162–163, 288–289.

5. "Kinodrome Making Is an Art," 14.

6. On the history of motion pictures in vaudeville, see Robert C. Allen, *Vaudeville and Film, 1895–1915: A Study in Media Interaction* (New York: Arno Press Dissertation Series, 1980).

7. "G. M. Anderson," Oral History Transcript, 17.

8. Charles Musser explains that during 1903 and 1904, as the exhibitor's role became simpler and projectors easier and safer to operate, exhibition services shifted projection responsibilities to the theater's electrician. Musser, *The Emergence of Cinema*, 366–367. In 1907 Spoor claimed his kinodrome service was unique in that it furnished an operator with its projectors. "Kinodrome Making Is an Art," 14.

9. *MPW*, July 27, 1907, 327.

10. "G. M. Anderson," Oral History Transcript, 18; Louis M. Starr, "How Chicago Spawned an Industry—and a Lot of Great Names," *Chicago Tribune*, January 26, 1947, Essanay clipping file, Chicago Historical Society, Chicago, Illinois.

11. On the formation of the MPPC, see Eileen Bowser, *The Transformation of Cinema 1907–1915* (Berkeley: University of California Press, 1990), 21–26.

12. Charles Musser, *Before the Nickelodeon: Edwin S. Porter and the Edison Manufacturing Company* (Berkeley: University of California Press, 1991), 516–518.

13. "G. M. Anderson," Oral History Transcript, 19–20.

14. *Motion Picture News (MPN)*, December 13, 1910, 9.

15. "Essanay Staff," *Views and Films Index*, June 6, 1908, 6.

16. Ivan Gaddis, "The Origin of 'Broncho Billy' Motion Pictures," March 1916, Anderson clipping file, New York Public Library, Lincoln Center, New York City.

17. Don Russell, *The Lives and Legends of Buffalo Bill* (Norman: University of Oklahoma Press, 1960), 413.

18. Charles Bragin, *Bibliography of Dime Novels, 1860–1928* (Brooklyn: Charles Bragin, 1938), 21. On the stage play *The James Boys in Missouri*, see William A. Settle, *Jesse James Was His Name: or, Fact and Fiction Concerning the Careers of the Notorious James Brothers of Missouri* (Columbia: University of Missouri Press, 1966), 175.

19. As he died suddenly at a young age, precious little material is available on the life and work of Francis Boggs. Much of what exists is people's reminiscences of him. On the filmmaker's life and career, see Letter from Francis Boggs to William Selig, August 16, 1909, Clarke Scrapbooks, Margaret Herrick Library, Los Angeles, California; "The Wonders of a Picture Factory," *Motography* 6, no. 1 (July 1911): 3, 7–19, reprinted in Lahue, *Motion Picture Pioneer*, 74–83; *MPW*, November 11, 1911; Hobart Bosworth, "The Picture Forty-Niners," *Photoplay* 9, no. 1 (December 1915): 75–81; "Camera Kick," *Los Angeles Times Sunday Magazine*, May 5, 1940, Bosworth clipping file, Margaret Herrick Library, Los Angeles, California; William N. Selig, "Cutting Back: Reminiscences of the Early Days," *Photoplay* 17, no. 3 (February 1920): 43–46, 130.

20. "Weird Sights in Store for Denver People," *Denver Republican*, June 9, 1908, mss. 1411, Colorado Historical Society, Denver.

21. See "The Cowboy's Baby," Supplement 113, August 1908, and "The Ranchman's Love," Supplement 123, October 8, 1908, in *Thomas A. Edison Papers: Motion Picture Catalogs by American Producers and Distributors 1894–1908, a Microfilm Edition*, Charles Musser, ed. (Frederick, Md.: University Publications of America, 1984), reel 2.

22. See "An Indian's Gratitude," Supplement 109, July 1908, in *Thomas A. Edison Papers: Motion Picture Catalogs*, reel 2.

23. *Views and Films Index*, August 15, 1908, 12.

24. *New York Dramatic Mirror (NYDM)*, November 14, 1908, 10.

25. The British Film Institute houses a copy of *The Cattle Rustlers* (1908).

26. *Variety*, February 26, 1910, in *Variety Film Reviews, 1907–1980*, vol. 1 (New York: Garland, 1983–1986), 18V.

27. Kalton C. Lahue, *Motion Picture Pioneer: The Selig Polyscope Company* (New York: A. S. Barnes, 1973), 13.

28. *NYDM*, October 2, 1909, 32.

29. On the life and career of Hobart Bosworth, see Hobart Bosworth clipping file, Margaret Herrick Library, Los Angeles, California; Hobart Bosworth Microjacket, British Film Institute, London; Bosworth clipping file, Blum Collection, Wisconsin Center for Film and Television Research Archive, Madison; J. Stewart Woodhouse, "Ship Ahoy Bosworth," *Picture Show*, October 18, 1919, 7; Bosworth, "Picture Forty-Niners," 75–81; "Hobart Bosworth, Dean of Film Industry, Dies," *Los Angeles Times*, December 31, 1943, part I, 1, 8.

30. Bosworth to Selig, November 8, 1910, Clarke Scrapbook, Margaret Herrick Library, Los Angeles, California.

31. Eugene Dengler, "Wonders of the Diamond-S Plant," *Motography* 6, no. 1 (July 1911): 7–19, reprinted in Lahue, *Motion Picture Pioneer*, 81.

32. *NYDM*, August 5, 1914, 24.

33. *NYDM*, October 18, 1911, 30.

34. Jack McPhaul, "Movies' First Cowboy Star Recalls His Work in Chicago," *Chicago Sun-Times*, April 29, 1951, Anderson clipping file, New York Public Library, Lincoln Center, New York City.

35. "G. M. Anderson," Oral History Transcript, 23; "How Many Each Day See 'Broncho Billy'?" *Nashville Tennessean*, March 1, 1914, Anderson clipping file, New York Public Library, Lincoln Center, New York City.

36. On the popularity of Essanay's first westerns, see *NYDM*, March 27, 1909, 13; *MPW*, March 27, 1909, 366; April 4, 1909, 442; *NYDM*, April 17, 1909, 13; *Variety*, April 24, 1909, in *Variety Film Reviews, 1907–1980*, vol. 1, 18V; *Views and Films Index*, October 2, 1909, 9; *MPW*, November 20, 1909, 334.

37. *MPW*, November 6, 1909, 638.

38. "G. M. Anderson," Oral History Transcript, 25.

39. Mabel Condon, "Sans Grease Paint and Wig," *Motography* 9, no. 7 (April 5, 1913): 229.

40. Quoted in Donald J. Newman, "The Town on the Range Where Westerns Grew Up," *Los Angeles Times*, Calendar Section, February 1, 1981, 24.

41. *NYDM*, October 2, 1909, 31; *MPW*, December 4, 1909, 801.

42. "In the Far West: How the Essanay Company Are Meeting the Demand of the Public for 'Western' Subjects," *Bioscope*, February 9, 1911, 11–12.

43. James S. McQuade, "Essanay's Western Producer G. M. Anderson," *Film Index*, July 23, 1910, 11.

44. "The Essanay Company Out West," *MPW*, December 4, 1909, 801.

45. "Essanay's Western Company," *Film Index*, May 21, 1910, 7.

46. *Nickelodeon*, July 15, 1910, 43.

47. "Clara Williams: A Western Actress Popular in the Essanay Western Pictures," *NYDM*, September 14, 1910, 31.

48. "Roland H. Totheroh Interviewed," Timothy J. Lyons, ed., *Film Culture* (Spring 1975): 233–234.

49. Quoted in Michael Covino, "The Town That Would Be Hollywood," *Express: The East Bay's Free Weekly*, August 11, 1989, 1.

50. McQuade, "Essanay's Western Producer G. M. Anderson," 11.

51. *Show World*, December 4, 1909, 13; December 11, 1909, 10; *NYDM*, March 5, 1910, 16; November 2, 1911.

52. *NYDM*, May 24, 1911, 35.

53. *NYDM*, July 9, 1910, 22.

54. "Interview With George K. Spoor," *Bioscope*, May 26, 1910, 8.

55. *Film Index*, July 2, 1910, 27.

56. Manager of the Senate Theatre, Chicago, to Selig, October 20, 1909, Selig Collection, Margaret Herrick Library, Los Angeles, California.

57. *MPW*, February 11, 1911, 314.

58. *MPW*, May 14, 1910, 793.

59. *Film Index*, July 2, 1910, 27.

60. On the popularity of western melodrama, see "The Popular-Price Theatre," *NYDM*, May 16, 1908, 8; Frank Winch, "Blood and Thunder Plays Repudiated by the Public," *Show World*, July 27, 1907, 10.

61. J. W. Tippet to Powers, September 24, 1913, "Correspondence Sept. 1913–Jan. 1914," box 10, Aitken Papers, Wisconsin Historical Society, Madison; H. J. Streyckmans, "Motographic History Stirs up a Rumpus," *Show World*, January 1, 1910, 4.

62. "The Popularity of Western Films," *Bioscope*, August 18, 1910, 4.

63. "Exporting the American Film," *Motography* (August 1911).

64. Deniz Gokturk, "How Modern Is It? Moving Images of America in Early German Cinema," in *Hollywood in Europe*, David W. Ellwood and Rob Kroes, eds. (Amsterdam: VU University Press, 1994), 44–67.

65. Siegfried Kracauer, *From Caligari to Hitler: A Psychological History of the German Film* (Princeton: Princeton University Press, 1974), 20.

66. Film historian Richard Abel has detailed the complexity of the American film industry's response to the supremacy of France's Pathé in the U.S. market. In his excellent "Perils of Pathé, or the Americanization of the American Cinema," in *Cinema and the Invention of Modern Life*, Leo Charney and Vanessa R. Schwartz, eds. (Berkeley: University of California Press, 1995), 183–223, Abel makes clear that at least part of the U.S. strategy to compete against Pathé was to support the western as a uniquely American form of cinema.

67. "What Is an American Subject?" *MPW*, January 22, 1910, 82.

68. George Kleine to Sussfeld and Co., August 13, 1909, box 24, Kleine Collection, Manuscripts Division, Library of Congress, Washington, D.C.

69. *MPW*, November 20, 1909, 712.

70. "The Producer's Art," *MPW*, July 31, 1909, 131.

71. Ibid. The story of *The Western Hero* had become such a part of industry folklore that film producer and importer George Kleine mentioned the film many years after its release, in a letter to a European manufacturer, as an example of the difficulty some European companies had capturing the "spirit" of American subjects. George Kleine to

Leon Gaumont, undated, box 24, George Kleine Collection, Manuscripts Division, Library of Congress, Washington, D.C.

72. *NYDM*, June 25, 1910, 17; July 16, 1910, 18; October 26, 1910, 29.

73. *NYDM*, February 8, 1911, 30.

74. I arrived at these figures by counting the titles that appeared in *Moving Picture World*. They are imprecise because not every film produced necessarily appears in the trade journal. I offer them here mostly for comparison.

75. George Kleine to Leon Gaumont, August 13, 1909, box 24, George Kleine Collection, Manuscripts Division, Library of Congress, Washington, D.C.

76. *Show World*, October 24, 1908, 13; *Variety*, June 5, 1909, 13, in *Variety Film Reviews, 1907–1980*, vol. 1, 18V.

77. *NYDM*, April 23, 1910, 21.

78. *Variety*, December 10, 1910, 52, in *Variety Film Reviews, 1907–1980*, vol. 1, 18V.

79. Lahue, *Motion Picture Pioneer*, 13.

80. "Essanay's Western Stock Company," *Nickelodeon*, July 15, 1910, 43.

81. *NYDM*, December 4, 1909, 18.

82. For a description of how film negatives were developed at the time, see John B. Rathbun, *Motion Picture Making and Exhibiting* (Chicago: Charles C. Thompson, 1914), 41–43.

83. *Variety*, April 9, 1910, in *Variety Film Reviews, 1907–1980*, vol. 1, 18V.

84. On the activities of the Essanay Company in California in 1911, see Geoffrey Bell, *The Golden Gate and the Silver Screen* (Cranbury, N.J.: Association of University Presses, 1984), 41; the reminiscences of Essanay cameraman Roland Totheroh in "Roland H. Totheroh Interviewed," 231.

85. Bowser, *Transformation of Cinema*, 106.

86. On the popularity of western comedies in melodramatic theater, see Winch, "Blood and Thunder Plays," 10.

87. *Ranchman's Rival*, Motion Picture Division, Library of Congress, Washington, D.C.

88. The British Film Institute has a print of *Western Chivalry* under the incorrect title "City Cousin and the Cowboy."

89. David Robinson, *Chaplin: His Life and Art* (New York: McGraw-Hill, 1985), 134–135.

90. *NYDM*, July 19, 1910, 20.

91. *NYDM*, December 7, 1910, 30.

92. For more information on James Young Deer, see Chapter 3.

93. For a description of *A Mexican's Gratitude*, see *MPW*, May 15, 1909, 636; *NYDM*, May 15, 1909, 15. For a description of *The Cowboy and the Squaw*, see *NYDM*, March 5, 1910, 16.

94. For a description of *The Dumb Half Breed's Defense*, see *MPW*, September 16, 1911, 820.

95. For a description of *An Indian's Sacrifice*, see *Film Index*, August 20, 1910, 25.

96. The British Film Institute has a copy of *The Mexican's Faith*.

97. I discuss racial representation in nickelodeon westerns and censorship in detail in Chapter 3 when I deal with the career and films of James Young Deer.

98. *MPN*, October 22, 1910, 11.

99. "Anderson in Role of Indian," *MPW,* April 13, 1912, 122. Anderson's last non-white roles were in *Under Mexican Skies* (Essanay, 1912) and *The Indian and the Child* (Essanay, 1912).

100. I determined these percentages by reading the available trade journal descriptions of Essanay westerns. For 1909 I found descriptions for thirteen westerns, six of which dealt with racial conflict. For 1913 I found seventy-nine descriptions, seven of which had racial conflict as a major theme.

101. For more on Anderson's development of the western-film hero, see Chapter 5.

102. M. B. Leavitt, *Fifty Years in Theatrical Management 1859–1909* (New York: Broadway Publishing, 1912), 283, 293.

103. Eugene Dengler, "Wonders of the Diamond-S Plant," *Motography* 6, no. 1 (July 1911): 8, reprinted in Lahue, *Motion Picture Pioneer,* 74–83.

104. F. W. Shorey, "Making a Selig Film," *Film Index,* January 30, 1909, 4–5.

105. *Film Index,* May 15, 1909.

106. Boggs to Selig, August 16, 1909, Clarke Scrapbooks, Margaret Herrick Library, Los Angeles, California.

107. "Selig Talks," *Film Index,* September 18, 1909, 12, reprinted in Lahue, *Motion Picture Pioneer,* 54–56.

108. Selig's report on Europe, November 4, 1909, box 26, George Kleine Collection, Manuscripts Division, Library of Congress, Washington, D.C.

109. Frank Finnegan to Selig, April 4, 1909, Selig Collection, Margaret Herrick Library, Los Angeles, California.

110. *Nickelodeon,* January 7, 1911, 21.

111. Charles Musser, *Edison Motion Pictures, 1890–1900: An Annotated Filmography* (Washington, D.C.: Smithsonian Institution Press, 1998), 125–129, 135–137, 140–141, 144–145.

112. E. C. Swigert (Indian Agent) to Selig, July 31, 1909, Selig Collection, Margaret Herrick Library, Los Angeles, California.

113. *Variety,* January 29, 1910, in *Variety Film Reviews, 1907–1980,* vol. 1, 18V.

114. *Variety,* September 11, 1909, in *Variety Film Reviews, 1907–1980,* vol. 1, 18V.

115. *NYDM,* October 23, 1909, 15.

116. *NYDM,* April 23, 1910, 21.

117. *NYDM,* April 30, 1910, 18.

118. The Motion Picture Division of the Library of Congress houses a copy of *Across the Plains* under the title "Unidentified Selig."

119. *Nickelodeon,* March 15, 1910, 159.

120. Richard Slotkin, *Gunfighter Nation: The Myth of the Frontier in Twentieth-Century America* (New York: Atheneum, 1992), 63–87.

121. *Film Index,* January 29, 1911, 16.

122. *MPW,* June 18, 1910, 1088.

123. James McQuade, "Famous Cowboys in Motion Pictures," *Film Index,* June 25, 1910, 9.

124. On the murder of Boggs, see "Life Price of Fancied Wrong," *Los Angeles Times,* October 28, 1911, part II, 2; "Jap Shoots Selig; Slays Manager," *Chicago Daily Tribune,* October 28, 1911, 4; *NYDM,* November 1, 1911, 27; *MPN,* November 4, 1911, 6; Bosworth, "Picture Forty-Niners," 78.

"A GENUINE INDIAN AND HIS WIFE"

James Young Deer, Lillian Red Wing, and the Bison-Brand Western

If the directors of the moving picture companies knew how foolish their women and girls look in the Indian pictures, with from one to three turkey feathers stuck in the top of their heads, they would be more careful. . . . We always laugh and think it a great joke when we see the leading girls in the pictures made up as Indians, with the chicken feather in the hair. It is funny, but they would all look much better without them. The braves wear the eagle feather, one or two, after they are braves, but they have to earn them. The chief and council-chief have the war bonnet. Have also seen pictures with all the made-up Indian men with big war bonnets on their heads. Another big laugh, but don't think the managers know this; if they did, they would do different. Then again, they should get the real Indian people.[1]

—John Standing Horse, Carlisle Indian School, 1911

Selig and Essanay were the dominant manufacturers of westerns among the patent companies, but many competitors operated without licenses from Edison. Like the Chicago studios, these so-called independent firms were attracted to cowboy and Indian films because such pictures were in high demand and could be produced at a low cost. Many fledgling independent manufacturers established themselves in the industry by dedicating half or more of their total output to the genre.

Among these firms, New York Motion Picture Company was initially the most influential in terms of development of the western, and film scholars and critics have correctly recognized the company's contribution. They have focused, however, on its post-1911 productions, especially those involving producer Thomas H. Ince and cowboy star William S. Hart.[2] Yet from its inception in 1909, New York Motion Picture was an important producer of westerns. The company's American Indian director/actor James Young Deer, along with his actress wife, Lillian Red Wing, made the most distinctive contributions to the genre—depicting Native Americans more sympathetically and in more complex ways than any other silent-era filmmakers.

Historian Brian W. Dippie has written that the Indian first appeared in cinema "as a poetic savage . . . in a pristine forest . . . whiling away the golden hours before the white man arrived to destroy his idyll."[3] This description is accurate for some early films but not for all. Before filmmakers had firmly established the conventional cinematic image of Native Americans as a "vanishing" people, Young Deer created strong, willful, and individualized Indian characters. Sometimes the director's heroes defended themselves and their tribes from the abuses of whites. Other times they wanted to assimilate into the dominant society but as equals and on their own terms.

Audiences' and critics' calls for realism in westerns helped to facilitate Young Deer's rise to prominence in the motion-picture industry. At the height of his career, many in the business were worried that reformers' complaints about the negative depiction of Indians might lead to state-controlled censorship—a possibility that further emboldened Young Deer to attempt controversial films that dealt with racism, assimilation, and other contemporary Indian social issues. Underlying most of his pictures was the message that the fears and prejudices of whites rather than the savagery of Indians created the hostility between the two peoples. As his responsibilities became greater and his films more complex and costly, however, Young Deer had to relinquish some creative control, and his films' message became less distinctive. At the same time, censors, "high-class" exhibitors, and the trade press were increasingly vigilant about policing controversial, race-oriented themes. By the teens, Young Deer's Indian westerns had become indistinguishable from other filmmakers' similar product.

Although they worked for many studios, Young Deer and Red Wing began to have a significant presence in the film industry when they joined the independent manufacturer New York Motion Picture. Motion-picture exchange owners Adam Kessel and Charles Baumann and filmmaker Fred Balshofer had founded the company in 1909 at the height of the nickelodeon boom. Kessel and Baumann provided the capital for equipment and personnel, and Balshofer brought his knowledge of motion-picture production to the partnership.

Originally trained as a photographer, Balshofer apprenticed for a New York City stereograph firm and later worked for the prominent Underwood and Underwood Company and then for Shields Lantern Slide. Like so many others who would later make western films, the course of his life changed after he saw Edwin Porter's *The Great Train Robbery*. Struck by the dramatic and suspenseful way in which Porter had produced the story, he recalled how much it seemed like a stage play. Balshofer became convinced that his future lay in motion pictures.

A few years later, Balshofer discovered the Philadelphia optical shop of film manufacturer Siegmund Lubin. The photographer boldly went inside and expressed his interest in cinema. He recounted to Lubin his decade-long experience producing lantern slides and stereographs, and the manufacturer offered him a job on the spot. His first task was to make black-market duplicates of imported French films of the Méliès and Pathé Companies. Later he had the opportunity to work with a motion-picture camera. He shot replacement title cards for Lubin's dupes and then made films outdoors under the guidance of the company's general manager and director, Jack Frawley.

Balshofer left Lubin in 1907. He moved back to New York where he began to shoot films for the Mosher and Harrington motion-picture exchange. By this time most of the biggest film companies had agreed to become Edison licensees, and under the terms of the arrangement they could not sell motion pictures to independent exchanges. Their supply cut off, these distributors found themselves in desperate need of films. Balshofer saw the market developing; looking for a partner, he found Herman Kolle with whom in 1908 Balshofer formed his own motion-picture manufacturing company, Crescent Film. They set up shop in a corner of a summer beer garden and dance hall Kolle's father owned in south Brooklyn.

When Balshofer had finished making his first reels, he went to peddle them on Fourteenth Street, the center for film exchanges in New York. Choosing an office at random, he walked into Adam Kessel and Charles Baumann's ambitiously named Empire Film Exchange. The partners liked what they saw and negotiated an exclusive contract with Balshofer.

Kessel and Baumann were Brooklyn natives. Balshofer later described them as men who had "been around" and who were not the type to shy away from a fight. Kessel had been a bookmaker for horse-racing tracks throughout Brooklyn and Long Island. He acquired the film exchange when the original owner borrowed $2,500 from him and failed to repay the loan. Kessel expanded the operation and, along with several other exchanges, formed a combination in which they divided New York City into territories and set the price of film at ten cents a foot. When Kessel needed a small space to set up a subexchange, he asked his friend Charles Baumann if he could use part of his Sixth Street

office. Baumann, a former streetcar conductor who boasted of pocketing a nickel for every four fares he rang up, agreed to help his friend. He paid no attention to the reels being traded out of his office until he saw his portion of the profits, which within a few months reached several hundred dollars a week.[4]

When Crescent Film went out of business, Kessel and Baumann agreed to go into partnership with Balshofer. They bought out Kolle's share of the company for $500 and put up another $1,500 to equip and launch a new firm they called New York Motion Picture (NYMP). The partners decided on the bison for their trademark. Balshofer was fortunate in allying with Kessel and Baumann. The exchange men's capital and moxie would be crucial if the new firm was to compete with the patent companies. Balshofer, for the first time adequately financed, outfitted a new film-processing laboratory. He bought printers, drums, developing tanks, and other equipment needed for dye-toning and tinting film. Edison had arranged with the Eastman Company to keep film stock out of the hands of independents, so Balshofer had to go through New York–based film importer Jules Brulatour to obtain raw stock produced in Europe by the French Lumière Company.[5]

Balshofer had known for a few months that westerns were in demand by film exchanges, but he had been unable to finance their production because of the costs of renting props, costumes, and horses and of hiring actors and extras. Now, backed by Kessel and Baumann's money, such films were within the realm of possibility. He took a crew to Fort Lee, New Jersey, where he produced Bison's first western, *Davy Crockett in Hearts United* (NYMP, 1909). Balshofer hired two experienced actors—Charles K. French, who had done some film acting at the Biograph studio but mostly had made his living as a banjo player and a minstrel show performer, and Evelyn Graham, an actress from the legitimate stage.[6]

In addition to the talent in front of the camera, Balshofer made certain the technical quality of Bison's pictures was good. His years of photographic experience helped to ensure a reasonably well-made product, which contributed to the company's initial success. *Motion Picture World* described an early Bison effort as "extremely well stage managed throughout," nicely photographed, and carefully printed.[7] The quality of these first westerns led to impressive financial results. Kessel recalled that *Davy Crockett* cost just over $200 to make and realized a gross profit of $2,300.[8]

The film's commercial success confirmed the partners' belief that westerns were moneymakers. Balshofer's second and third efforts for Bison were *The Squaw's Revenge* (NYMP, 1909) and *The True Heart of an Indian* (NYMP, 1909). For the latter the filmmaker recruited Charles Inslee, another Biograph actor, to play the lead. He dressed the well-built Inslee in a loincloth and caused something of a sensation. Balshofer recalled that "the ladies simply

went gaga over him . . . whenever he appeared on the screen in one of his naked Indian hero roles." Women sent admiring letters to the New York Motion Picture Company addressed simply to "The Indian" and "The Lone Indian."[9]

As such responses indicate, a sizable and enthusiastic audience existed in 1909 for films featuring Indians. Balshofer was eager to cater to this fan base.[10] Crucial to his effort was recruiting for the Bison Company two Winnebago Indian performers, James Young Deer and Lillian Red Wing. Balshofer felt the couple would add, as he put it, "realism and color" to his productions.[11] He recognized their publicity value and boasted to an industry trade journal that he had secured "a genuine Indian and his wife" to work in his stock company.[12]

Young Deer was born in Dakota City, Nebraska, just north of the Omaha Winnebago reservation (see Figure 3.1). His Winnebago ancestors were originally from Wisconsin, but the federal government divided the tribe when it aided the British during the Revolutionary War and the War of 1812. The actor was descended from a branch of the Winnebagos the U.S. government removed to Iowa in 1840 and later to reservations in Minnesota. The tribe relocated again to Crow Creek, South Dakota, and from there migrated to the Omaha reservation in eastern Nebraska in 1864 and 1865 to escape starvation.[13] Although the filmmaker was too young to have personally experienced these forced removals and migrations, both his and Red Wing's parents lived through many of them.

Lillian Red Wing, who starred in and helped produce many of her husband's films, was born in Nebraska in 1883 (see Figure 3.2). Her real name was Lillian St. Cyr, and she grew up on the Omaha Winnebago reservation in the home of her older brother, David St. Cyr, living with his wife and their seven children. Red Wing graduated from the Carlisle Indian School in Pennsylvania, an institution at the time committed to complete assimilation of Indians. After retiring from acting in the 1920s, she moved to New York where she was active in Indian affairs until her death in 1974.[14]

Young Deer began his entertainment career in the 1890s with the Barnum and Bailey Circus. Like so many others who later became involved in the production of western films, he worked for a time with the Miller Brothers' 101 Ranch Wild West Show. Young Deer and Red Wing got their start in motion pictures working for many of the companies that filmed in and around Fort Lee and Coytesville, New Jersey—the most convenient place on the East Coast to make westerns. It was only a combined ferry trip and short trolley ride from New York. The small rural towns were filled with dirt roads, trails, ponds, streams, wooded areas, and other scenic locations ideal for filmmaking.[15]

Young Deer and Red Wing entered the business at an opportune time. The nickelodeon boom helped to sustain a brisk demand for one-reel westerns,

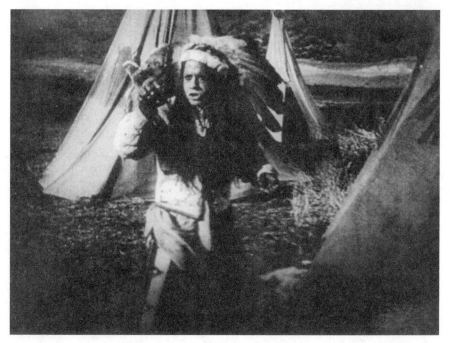

Fig. 3.1 James Young Deer in the Bison film The Flight of Red Wing *(1910). From the collections of the British Film Institute.*

and American film companies produced dozens a week. The increasing call for realism from filmgoers and critics made producers eager to give their motion pictures a flavor of the "actual" West. Under these conditions, the couple's American Indian heritage became a marketable commodity, and they quickly rose to an influential position in the young industry.

The New York–based Kalem Company gave Young Deer his first motion-picture experience, hiring him to act in its popular Indian films. Later, the Lubin Company of Philadelphia acquired him to perform in front of the camera, as well as to write scenarios and direct films. Biograph enlisted the actor for a role in D. W. Griffith's Indian tale *The Mended Lute* (1909), and Vitagraph featured him and Red Wing in *Red Wing's Gratitude* (1909). The company promised "an unusually real and interesting picture of actual Indian life" because "the star parts are assumed by two real Indians who have aided the producer in creating the actual atmosphere of an Indian camp . . . [and] have loaned real Indian accouterments and clothing" (see Figure 3.3).[16]

With Young Deer and Red Wing signed on to his crew, Balshofer and the Bison troupe left Fort Lee because of the heavy Patent Company presence

Fig. 3.2 Lillian Red Wing in Celebrations on the Ranch *(Pathé, ca. 1913). From the collections of the Netherlands Film Museum.*

there and traveled to Neversink, a small town in the Catskill Mountains. The company lived in a dilapidated boardinghouse and converted a nearby barn into a studio. It hired locals to perform as extras. In Neversink, Balshofer discovered the rewards of going far afield to make westerns. He recalled that "the imposing Catskill mountain scenery . . . combined with the clear mountain air, made it possible to get sharp, brilliant photography."[17] The effect led to an increased sale of Bison films. When the weather turned wintry, the company returned to New York City.

That first trip to the mountains was a prelude to a longer and more costly journey Bison undertook to the other side of the country in November 1909. The company followed Selig's Francis Boggs to Los Angeles to find good weather and to satisfy critics' and spectators' demands for realistic western scenery. Those who made the trip included Balshofer, French, Graham, Young Deer, Red Wing, and Inslee, as well as vaudeville actor J. Barney Sherry, property man Bill Edwards, and assistant cameraman Maxwell Smith.[18] They intended to stay in Los Angeles only for the season, but—like the Selig Company—they ended up relocating there permanently.

Bison set up shop in an abandoned grocery and feed store on Alessandro Street in Edendale just down the street from the Selig Company. Until Ince

Fig. 3.3 Young Deer and Red Wing (the two figures on the right) on location in Coytesville, New Jersey, 1909. From Fred J. Balshofer and Arthur C. Miller, One Reel a Week *(Berkeley: University of California Press, 1967).*

arrived at the end of 1911, the studio consisted of just two rooms. The office and stage were in one room; the scenery, props, wardrobe, and art department in another.[19] Balshofer chose Edendale for the same reasons Boggs had: its proximity to a variety of scenic locations and to downtown Los Angeles. Once in southern California, the filmmaker hired several other actors and entertainers, including the leading man from an Illinois-based stock company, Jack Conway, and Wild-West show cowboy Art Acord. Within a year the stock company had twenty-four actors. Its operating expenses rose to $1,500 a week.[20]

Once Balshofer realized Bison would be in Los Angeles permanently, the company began installing the equipment to develop film there in 1910—around the same time Selig and Boggs did so at their West Coast studio. Postproduction responsibilities were divided between Edendale and New York. Workers in the Los Angeles plant developed the exposed negatives and gave them to Balshofer to edit. He then sent them east where employees in New York filmed title cards and did the toning and tinting on the final positive prints.

Unlike Selig, the company operated for two or three years without an indoor studio. Balshofer was in no hurry to build one because he made his films almost exclusively outside. Initially, he filmed many westerns around several old adobe buildings on a ranch near the corner of LaBrea Avenue and Hollywood Boulevard. Bison also used Griffith Park as a filming location and set up an Indian village stage set there. The park's hills, canyons, and streams made it ideal for westerns.[21]

Although Bison was one of the first motion-picture manufacturers to come to Los Angeles, within a few years the company was sharing Griffith Park with five other production companies, and the park was becoming overcrowded. Citizens criticized filmmakers for leaving litter, frightening wild animals by firing blank cartridges, and harassing park visitors who happened to walk into the range of the camera. There were even allegations that one of the companies had set fire to a ranger's cabin to capture the event on film. The Los Angeles Board of Park Commissioners threatened to revoke the filmmakers' permits.[22]

In search of less traveled scenic locales, the Bison Company went to Big Bear Valley, a remote summer resort twenty-five miles outside San Bernardino, California.[23] The roads to the site could not be traveled by automobile, and Balshofer sent the company's equipment to the location by horse-drawn wagon. The actors took a shorter route on horseback. The crew lived in rustic cabins and a lodge that catered to hunters. Balshofer later described the location:

> Big Bear lake is a large body of water surrounded by giant fir trees, picturesque meadows edged with huge boulders, and in nearly every direction were vistas of snowcapped mountains that afforded beautiful backgrounds. Our Indians paddling along the lake shore from one village to another provided atmosphere and color such as had never been seen before in western pictures.[24]

Bison's efforts to seek out unique locales paid off, as reviewers generally praised the company's use of scenery. Balshofer had honed an instinct for capturing landscapes since his days as a stereograph photographer, and his company was the most adventurous among the independents in seeking out such backdrops. The canoe scenes he shot on lakes and rivers were particularly well received, and critics coined the word *Bisonesque* to describe them.[25] The firm, however, did not always use landscapes as effectively as its two main Patent Trust competitors, Selig and Essanay. Critics sometimes complained about the lack of long shots in Bison films and about company players' tendency to line up in front of the camera, blocking the scenery.[26]

The firm's scenarios also tended to be inferior to those of Selig and Essanay. Bison's stories, those of Young Deer aside, were fairly unoriginal. They generally fell within three basic types: the "squaw-man" plot in which an Indian

woman and a white man fall in love, the tale of the "good Indian" who comes to the rescue of white settlers, and the all-Indian story structured around intertribal romance and warfare. One critic sardonically enumerated the elements of a typical Bison western: "a love story, considerable gun play . . . the capture of one party, the escape and capture of another, with different individuals tied to different trees . . . and some demonstrative love making between an Indian girl and her white admirer."[27]

If Bison westerns could not always compete with Patent Company writing and production quality, they still attracted attention because they were often more sensational. Censorship boards and the trade press carefully monitored the depiction of criminal acts perpetrated by white characters, but it was permissible—even expected—that Indians would behave savagely. Bison and many other companies took advantage of this stereotype to depict acts of violence in their films. Indeed, such scenes were part of what made Indian westerns popular. As a result, even when filmmakers presented heroic Indian characters, their unfeeling brutality often dehumanized them. In Bison's *The Redskin's Bravery* (NYMP, 1911), for example, a white settler's daughter feeds a hungry Indian, and he befriends her. When two "bad men" later attack the girl, the Indian jumps into action, throwing off his blanket and revealing his muscular torso and arms. He pursues the bad men and drowns them with his bare hands. After the murders, he raises his arms and smiles in celebration of his victory.[28]

For all their mixed virtues, New York Motion Picture's Indian westerns were highly successful, and like Essanay and Selig, the company realized considerable financial gains from the genre. By 1911 the firm was selling so many copies of its Bison films that it had to build a new, larger factory in New York to handle the increased production of prints.[29] The pictures' success enabled the company to become, along with Carl Laemmle's Independent Moving Picture Company (Imp), the most prosperous of the independent firms. As the dominant forces outside the Patent Trust, Laemmle, Kessel, and Baumann joined to form the Motion Picture Distributing and Sales Company—the first entity designed to coordinate the production and distribution of independent films. The new firm contracted with nonpatent manufacturers for their product, created a varied and balanced program of films, and sold them as a block to exchanges.[30]

As Young Deer and Red Wing were central to Bison's early success, they can be counted among those who first enabled the independent movement to prosper. In a period before the full emergence of the "movie star" phenomenon, the actors became iconographic figures by which the moviegoing public identified Bison films. In 1910 *Motion Picture World* determined that Young Deer was a familiar presence in Indian pictures, and *Motion Picture News* described Red Wing as "a favorite with the people."[31] Bison encouraged the couple's visibility, featuring their names in the titles of the films in which

Fig. 3.4 Bison troupe, 1911. Red Wing is standing on the left, Young Deer is standing on the right, Fred Blashofer is seated in the front row left, and Charles Bauman is seated on the right. From Balshofer and Miller, One Reel a Week.

they appeared, such as *Young Deer's Bravery* (NYMP, 1909), *Red Wing's Recovery* (NYMP, 1909), *For the Love of Red Wing* (NYMP, 1910), *Young Deer's Return* (NYMP, 1910), and *The Flight of Red Wing* (NYMP, 1910).

A 1910 publicity photo of the Bison troupe suggests the couple's importance to the stock company. The photographer placed Red Wing and Young Deer in the foreground. They stand one on each side of the troupe, affording a complete view of their traditional Winnebago dress.[32] Not only are they the most visible people in the photo, but their costumes are more elaborate and detailed than those of the other actors (see Figure 3.4).

Whereas Balshofer was ultimately responsible for the production of Bison westerns, Young Deer and Red Wing played creative roles that extended beyond their acting. The division of labor within the stock company was still fairly informal compared with commercial filmmaking of a later period.[33] It was common practice for actors to double as writers, set designers, handymen, and laborers. Balshofer paid members of his troupe ten dollars for each scenario they created. Likewise, he asked Red Wing to design and construct Indian

camp sets for the company. Young Deer's production experience with Lubin and Vitagraph made him especially valuable, and he was involved in writing and staging the pictures in which he and Red Wing starred.[34]

In a further indication of the Indian couple's importance to Bison, when the Pathé Company lured Young Deer and Red Wing away from the firm at the end of 1910, Balshofer hired Josephine Workman—a white vaudevillian from the Boyle Heights neighborhood of Los Angeles—and billed her as Princess Mona Darkfeather, the only authentic "Indian actress" working in motion pictures. He ran a bogus story in Motion Picture News about how he had discovered her in an Indian village near Needles, California.[35] Darkfeather went on to star in Indian roles in hundreds of films for New York Motion Picture and then for Universal.

Meanwhile, Pathé sent Red Wing and Young Deer east to work in its recently built New Jersey plant. Young Deer rose to prominence with an independent firm, but he gained his greatest power and autonomy with Pathé, a French-owned firm and Edison licensee. Pathé, whose westerns were under attack in the trade press for their inauthenticity, hired Young Deer and Red Wing to add legitimacy to its efforts.[36] Young Deer directed several films in the company's East Coast plant, including The Cheyenne Brave (1911) and The Red Girl and the Child (1911).[37] After the filmmaker proved himself competent, J. A. Berst, head of American operations for Pathé, sent him back to Los Angeles to run the company's West Coast studio. The plant was located in Edendale in the heart of southern California's small but burgeoning movie industry. It was within a block of Selig Polyscope and across the street from Young Deer's former employer, New York Motion Picture. The studio was very small when Young Deer arrived, but Pathé purchased an area the equivalent of a city block for him to expand the operation.[38]

Although Young Deer was the studio head in Los Angeles, he did not have complete autonomy. Berst sent detailed instructions from New York explaining how he was to proceed. As the filmmaker built a new studio on the property, the Pathé executive sent this advice:

> 1. Have the scenery large enough. For instance 12 ft. high by 18 ft. wide. 2. The scenery must be painted nearly black. Don't use any light colored scenery. . . . 4. When the inside and outside of a house is shown, the furniture must be in keeping with the style of the house and the sort who live in it. 5. Flowers and palms always give a nice effect to the interior of a house. . . . 7. All doors must have real locks and no imitation locks.[39]

Berst also sent comments about Young Deer's casting choices and his actors' relative merits.

As Berst advised from New York City, Young Deer produced over a hundred one-reel westerns at the Alessandro Street studio before the company

abandoned the location as too small for the increasing scale of motion-picture making. In 1912 the filmmaker oversaw construction of a new Pathé studio on a thirty-five-acre site on Donegan's Hill overlooking Edendale. *Motion Picture World* called it virtually a small town dedicated to the production of westerns.[40] The new studio allowed Young Deer to use more extras and to create expansive Indian sets. Also, with the added space, more than one production unit could work on the grounds at the same time.[41]

The new location offered room to choreograph the kind of stunts that were becoming an increasingly important part of westerns. Young Deer contracted with a Wild-West show—as Otis Turner of the Selig Company had done earlier—to provide him with props, horses, and cowboy and Indian actors. He worked with future cowboy film star Jack Hoxie and his troupe, which was wintering in Los Angeles.[42] In an indication of the increasing complexity of stunts, as well as the cruelty with which show animals were sometimes treated, three of Young Deer's employees were arrested and fined for severely injuring a sick horse when they pushed it over a cliff to capture its fall on film.[43]

While Young Deer directed motion pictures and ran the studio, Red Wing continued to act in her husband's films and other companies' western features. She starred in a Tom Mix picture, *In the Days of the Thundering Herd* (Selig, 1914), and became perhaps best known for her portrayal of the Indian maiden Nat-u-rich in Cecil B. DeMille's 1914 version of *The Squaw Man* (Lasky). She continued to act into the early 1920s—appearing, for example, in William S. Hart's *White Oak* (Paramount, 1921).

Young Deer and Red Wing's rise to the center of the motion-picture industry was in part a testament to their vision and talent. Larger forces working within the film business, however, helped to facilitate their success, particularly the industry's desire to live up to its own promotional claim that the medium was uniquely realistic. As with still photography before it, the promise that motion pictures could show the "actual," the "real," was an early selling point and provided a way to distinguish the entertainment form from the stage and other competing forms of amusement. Just as critics derided as second-rate those westerns made against a backdrop of "Jersey scenery," they applied a similar standard of authenticity to the representation of American Indians. The stage technique of covering white actors with Bole Armenia, a red paint, was unconvincing to many film viewers, and trade literature was replete with complaints about white actors' inability to take on Indian roles. One journalist gave such players this sardonic advice: "To be a stage Indian, swell out your chest, put a bulldog curve on your lips, grunt occasionally, and assume the gestures of a ham-actor in the role of Virginius. The only difference between a stage Roman and a stage Indian consists in makeup."[44] Similarly,

critic Stephen Bush sniffed, "[W]e have Indians a la Francais, 'red' men re-cruited from the Bowery and upper West End Avenue. We have Licensed Indians and Independent Indians—the only kind we lack are the real Indians."[45]

Conventional wisdom inherited from the stage had it that Native Ameri-cans were incapable of histrionic performance. As "naturalistic" acting be-came increasingly fashionable within the industry, however, this older idea seemed absurd.[46] How could costumed and painted white actors play Indian characters more realistically than actual Indians? Native Americans would be more believable if they merely stood in front of the camera and behaved like themselves. The "Spectator," a film critic for the *New York Dramatic Mirror*, explained the change in thinking:

> It was not so many months ago that a certain film manufacturer told the Spectator of the difficulty he had . . . in trying to use genuine Indians as actors in Indian films. "Why," said he, "we could not use them at all. We tried our best to make them act, but they wouldn't do it. We had to make all the negatives over again with white actors made up for Indians, and the result was then satisfactory." But that was before the days of great improvement in motion picture acting methods. The manufacturer and his director expected their people to "act." The idea of merely being natural in a film scene had not yet been recognized as the proper thing. The Indians, in particular . . . found it impossible to move about and behave in the manner of stage Indians and their work was pronounced impossible. . . . To-day this same manufacturer and director do not hesitate to employ real Indians when occasion offers.[47]

If filmmakers initially inherited the stage's bias against Indian players, within a few years they had begun to view such actors as embodying the very essence of naturalism required to perform before the camera. As a result, lim-ited opportunities opened up for Native Americans within the film industry. Although Young Deer was probably the most consistent employer of these performers, *Motion Picture World* reported in 1912 that Vitagraph, Thanhouser, Bison, Selig, and other companies had "full-blood" and "half-blood" Indians on their payrolls.[48] Still, some thought the industry should hire more. Moving-picture fan John Standing Horse complained that there were about a hundred Indian actors in New York, yet they remained unemployed most of the time.[49]

Although Indians were gaining a modest presence in motion pictures be-cause of calls for realism and changing notions about "naturalistic" acting, a debate within and outside the industry about how filmmakers should charac-terize Native Americans helped to determine the kind of roles these actors would play. Many Indians who attended films, as well as reform-oriented whites, complained that manufacturers—in an effort to make a quick buck—were propagating harmful and dangerous images of tribal peoples. Humanitarians, who earlier had criticized Wild-West shows for similar reasons, were particu-

larly concerned that by depicting Indians as savages, the motion-picture industry was hurting assimilationist programs.[50] Worried about the specter of state censorship, industry trade journalists took these complaints seriously, and some joined the chorus against the negative depiction of Indians.

The debate over the cinematic image of Native Americans came to a head in early 1911 when Selig Polyscope released a film entitled *Curse of the Redman*. Hobart Bosworth, leading man and assistant director for Selig's Edendale studio, wrote and directed the film and played the lead. He based the picture on press accounts of murders allegedly committed in 1909 in southern California by a Chemehuevis Indian named Willie Boy. In a series of dramatic events later known as "the last great western manhunt," Willie Boy killed fellow tribe member Mike Boniface when the latter refused to let Willie Boy marry his daughter, Carlota. Willie Boy then fled to the desert with the young woman. A sheriff's posse pursued the couple, and during the chase Carlota died. The press blamed Willie Boy for her death, but historians James Sandos and Larry Burgess have since concluded that the posse was probably responsible. When down to his last bullet, the renegade committed suicide to avoid being captured (see Figures 3.5 and 3.6).[51]

Although the incident grew out of what was essentially a personal dispute between Willie Boy and Boniface, Bosworth turned the story into a parable about boarding schools' failure to assimilate Indians and about the dangers of alcohol consumption among tribal peoples. Bosworth's film begins with a scene shot on location at the Sherman Indian School in southern California. The Willie Boy character, Zerapai, is graduating from the institution. Later he returns to his tribe in a western-style suit, and the other Indians shun him because of his "modern ways." Alienated, Zerapai takes to drinking, commits murder under the influence of alcohol, abandons his sweetheart in the desert, and, after an extended chase, kills himself to avoid being captured.[52] Reviewer James McQuade accurately characterized Bosworth's message when he wrote that the film showed that "the veneer of civilization, gained during a few years['] residence in an Indian school," was unequal to "the calls and claims of heredity and tribal influence."[53]

Bosworth made *Curse of the Redman* at a time when sentiment against off-reservation education for Indians was pervasive. According to Theodore Roosevelt's commissioner of the Indian Office, Francis Leupp, and other critics of such programs, Indians instructed in this manner became a people without a home, isolated from both the tribal and dominant societies; as a result they tended to "regress" to traditional ways. Increasingly, the federal government was closing boarding schools in favor of daytime vocational training.[54]

Employees of the Selig Company knew *Curse of the Redman* would be politically charged, and they worried about possible negative reaction even before

Fig. 3.5 After adopting western ways and dress, Bosworth's Willie Boy–like character, Zerapai, is rejected by his tribe in Curse of the Redman *(1911). From the collections of the British Film Institute.*

its release. William Selig made Bosworth reshoot several scenes, including one in which the Willie Boy character beats Carlota. Bosworth stood by the film's message, and he was concerned that without its most violent scenes it would not have the same impact. He wrote to Selig:

> I do hope the Board of Censorship will permit the use of the original scenes which were carefully planned to show the terrible result of allowing liquor among the Indians. I am very much afraid that these new scenes will spoil the entire effect of the picture by bringing sympathy to the besotted Indian . . . and may smash my moral lesson.[55]

Despite the company's efforts to tone down the film, *Curse of the Redman* was still controversial. It especially piqued the anger of Indians. While in Washington, D.C., to meet with President William Howard Taft over other matters, a group of Cheyenne and Arapaho Indians saw Bosworth's film. They were adamant about their dislike of it. Big Bear—one of the delegation's leaders—told the press: "I don't like it. It is bad to be lied about to so many people. We have to go home. If we did not I would go to President Taft and ask him to stop it [from being shown further]."[56]

Fig. 3.6 Zerapai becomes a drunk, Curse of the Redman *(1911). From the collections of the British Film Institute.*

The Indians complained to Commissioner of the Office of Indian Affairs Robert Valentine about *Curse of the Redman.* Valentine was sympathetic, and he promised that he would personally see what could be done to improve the situation.[57] The commissioner wrote a letter to Selig that, although not mentioning *Curse of the Redman* specifically, detailed the kind of Indian film the Office of Indian Affairs would like to see made. He encouraged the filmmaker to depict Indians engaged in "industrial work" rather than "in their old dress and engaged in their old time customs." The commissioner suggested that American filmmakers had misled Indians into thinking it was their traditional practices rather than their integration into the U.S. economy as workers that most interested the public and the U.S. government (see Figure 3.7).[58]

In part because of the controversy over *Curse of the Redman,* the general din in opposition to current Indian films continued for several years. Those working to bring Native Americans into the labor market feared movies were undermining their efforts. A superintendent of a southern California Indian reservation observed that when Indians went into the city to attend moving-picture shows, as they often did, they received mixed messages about their role

Fig. 3.7 "Indian pictures as the Indians want them"; trade journal cartoon, Nickelodeon, *March 4, 1911.*

in society. At a time when he and others were teaching them to abandon traditional culture and become farmers, filmmakers depicted them engaged in warfare. According to the official, movies should show Indians using rakes and hoes rather than guns and arrows.[59] The superintendent of the Carlisle Indian School, Moses Friedman, took a similar position, and *Motion Picture News* reported that he was directly lobbying the federal government to censor Indian westerns.[60]

Trade journalists and others in the motion-picture business took the complaints of the Indians and their advocates seriously because they were concerned about the possibility of state intervention in their industry. Moreover, the controversy arose at a time when many in motion pictures were campaigning against sensational Wild-West subjects anyway, as they felt such films alienated potential middle-class customers. The Indians' critiques were yet another indictment against the less savory aspects of the genre. Trade journalists ran a number of articles and editorials on the situation, mostly taking the

side of Native Americans. *Motion Picture News* praised the protest the Indians lodged, explaining that although the Indians were neither "preachers," "up-lifters," nor "protectors of the legitimate drama," they had a valid complaint against the motion-picture industry nonetheless.[61] *Motion Picture World* featured an article that called the Indians' protest "an uprising." It suggested that the unrest was spreading to other reservations throughout the West and warned that the problem might lead to congressional action. The journal's editors concurred with the delegation that film manufacturers had used white men costumed as Indians to create "thrilling pictures of wild western life" that were libelous in their depiction of Indians.[62]

To help make their case, trade journalists filled their publications with letters penned by Indians critical of Wild-West films. In an especially eloquent plea, a motion-picture fan named Red Eagle argued for stricter censorship of westerns. He complained that thanks to the American film industry, the average child and adult had an image of the Indian as "a yelling[,] paint-dedaubed [sic] creature, reeking of barbarism and possessing little or no intelligence." Red Eagle asked that the National Board of Censorship do more to prevent the screening of films that depicted Indians negatively. He held that if filmmakers were going to depict Native Americans, they should only show tribal rites and ceremonies and that these should be performed exclusively by those "capable of going through the ceremony without holding it up to ridicule and derision."[63]

In the middle of this trade press campaign for fairer portrayals of American Indians, Young Deer became head of West Coast productions for Pathé. The industry debate no doubt emboldened him, and it also kept censors and trade journalists from objecting to his films more than they might have otherwise. Young Deer used the opportunity to make westerns that spoke to issues of miscegenation, assimilation, and racism.

Almost all of Young Deer's one-reelers grew out of a set of conventions producers of Indian westerns had established as early as 1909. Dime novels, the early crime film, and the western melodramas of "cheap theater" houses inspired the genre's three basic dramatic elements: Indian characters, chase scenes, and violent altercations. Successful legitimate western stage plays also provided the cinema with popular Indian-themed material, although filmmakers often corrupted such dramas beyond recognition in an effort to inject their motion pictures with the kind of sensationalism audiences had come to expect.

One play stood above all other sources in terms of the number of one-reel imitations it inspired: Edwin Milton Royle's *The Squaw Man* (1905). The drama was a huge domestic and international success and had a remarkably long run. It opened at New York's Wallack's Theater on October 23, 1905; became a

national road show the following season; and came back to Broadway in 1907–
1908. Meanwhile, the play made a splash in London under the title "The
White Man," and it was performed around the world under that title or its
original for years. Producers revived it again for Broadway for the 1921–1922
theatrical season.[64] The drama launched the career of William S. Hart, who
played the villainous cowboy Cash Hawkins in both the Wallack premier and
the first road show. He later became the leading dramatic impersonator of
western characters on the stage and the most prominent western-film star of
the period 1916–1920.

The first scene of *The Squaw Man* is set in England at the ancestral estate
of the earl of Kerhill. Colonel Henry Wynnegate, the earl, has just collected
20,000 pounds for his regiment's orphanage. The dean of Trenthan congratu-
lates the Wynnegates, reminding them that "the noblest deeds of history have
sprung from pride of birth, pride of name, the pride of family, pride of race!"
The earl's cousin, Captain James Wynnegate, has also helped with the charity
drive, but his efforts have gone overlooked. Diana, the countess of Kerhill,
who is secretly in love with James, chides him for being too idealistic and
sentimental. She gives him this prophetic warning: "[C]onfronted with the
alternative of suffering or causing suffering you would suffer. You are marked
for the sacrifice." It is later revealed that the earl has invested the charitable
contributions in a speculative venture and lost all the money. James decides
he will take the blame for his cousin to protect Diana from the knowledge of
her husband's misdeed. James, hereafter Jim Carson, emigrates to America to
escape punishment and settles in Maverick, a frontier cow town.

A few years pass. Act two begins in the Long Horn Saloon. The villain,
Cash Hawkins, and his men are trying to ply a Ute Indian chief, Tabby-wana,
with alcohol to swindle him out of his land. Jim prevents the transaction, and
in retaliation Cash attempts to kill him. Tabby-wana's daughter, Nat-u-rich,
shoots Cash, saving Jim's life. As a result, Jim and Nat-u-rich become roman-
tically involved, and they have a child. Meanwhile, back in England, when her
husband dies Diana discovers that Jim is innocent of the embezzlement charges,
and she comes to Maverick to enjoin him to move back to England. Jim de-
cides that he will send his son to Europe to be educated but that he must do
the honorable thing and live out his days on the frontier with his Indian wife.
The story ends with Nat-u-rich shooting herself so Jim can be reunited with
Diana and so her mixed-blood son can sever all connection with the tribal
world and enjoy the fruits of European civilization.[65]

The Squaw Man reflects the then-dominant beliefs about Indian and white
miscegenation that at the time of its writing were nearly a hundred years old.
In the eighteenth century, Anglo-Americans looked upon intermarriage as a
legitimate means of acquiring tribal peoples' land. By the nineteenth century,

however, the federal government could move American Indians away from white settlements and onto new land made available by the Louisiana Purchase. Relocation rather than intermarriage became the most expedient way for the burgeoning European American population to gain access to tribal lands.[66] At this point the taboo against Indian and white miscegenation began to develop.

The question of assimilation again weighed on the minds of Americans in the 1880s as Indians suffered complete military defeat and for the first time were surrounded on all sides by whites. Many supported the integration of Indians into the dominant society. As historian Frederick Hoxie has pointed out, however, this ideal eroded during the first decade of the twentieth century. A general rise in racism sparked by increased immigration, the ascendancy of westerners to national political prominence, nostalgia about Indians brought on by the closing frontier, and new ideas about the fixity of racial and cultural differences led white intellectuals, social reformers, and policy makers to question seriously whether Indians could ever rise to the so-called civilized state. Increasingly, European Americans believed Indians saw the world in fundamentally different ways from themselves and that the Natives had neither the will nor the capability to change. If Native Americans were to integrate into the dominant society, it could only be as menial or semiskilled laborers.[67]

The Squaw Man in part registers Edwin Milton Royle's reception and understanding of these new notions about the limits of Indian assimilation. In the last act of the play, Diana suggests to Jim that Nat-u-rich go to school for a few years to prepare for a life back in England. Jim replies that it is "too late"; the gifts of civilization would be lost on her. If the fictional Nat-u-rich is fated to a circumscribed social position because of her cultural and racial differences, so by analogy are all Indians. As a member of an unassimilable people, her suicide is the final and inevitable solution to the problem of Indian-white relations. Her death represents the death of all tribal peoples in the United States. When she is gone, when they are gone, so are the intractable problems surrounding assimilation.

It would be hard to overemphasize the importance of the "squaw-man" story to early America cinema. Filmmakers retold the story hundreds of times, and it was the dominant plot of the Indian western genre. The story was so popular that a reviewer for the Nickelodeon facetiously recommended in 1911 that "a record . . . be kept of the number of Indians who sacrifice themselves (in photoplays) to save the lives or promote the happiness of white benefactors."[68]

Although manufacturers remade the play in dozens of ways during the nickelodeon period, none of the versions was as distinctive and inventive as Young Deer's. He recognized that the story as traditionally told depicted Indians

as a "vanishing people" and that the propagation of this stereotype, tinged as
it was with fatalism, helped to deny Indians a stake in America's future. Young
Deer responded by making films that exposed the racist notions behind the
basic premise of the play.

The filmmaker challenged the assumptions of The Squaw Man most boldly
early in his career, often by inverting the genders of those involved in the
mixed relationship. In the first film over which he had a degree of artistic
control, The Falling Arrow (Lubin, 1909), Young Deer romantically linked a
non-Indian woman and a Native American man. The film is based on a love
affair between an Indian named Young Deer (played by Young Deer) and the
daughter of a "Mexican planter" named Felice (played by Red Wing). It begins
with Young Deer meeting Felice at the river where she has come to fetch
water. Jim, the white outlaw, sneaks up on them and follows Felice home. The
bad man forces himself on her, and she attempts to repel his advances by
hitting him with her water pail. Young Deer is witness to Jim's nefarious deeds,
and he rescues Felice, bringing her to her parents' ranch house. In the next scene
the woman visits Young Deer in his Indian village, and after an intertitle that
reads "sweethearts," there is a medium close-up of the couple in tender em-
brace, exchanging gifts. The filmmaker then cuts to the interior of the ranch
house where Young Deer is asking Felice's father for his daughter's hand. He
reacts by grabbing the Indian's arm and pushing him angrily out of the house.
Later, outlaw Jim enters the home, kidnaps the girl, and takes her to his hide-
out. The imprisoned Felice notifies Young Deer of her whereabouts by attach-
ing a note to an arrow and shooting it into the Indian camp. After reading the
message, the Indian comes to the rescue, wresting the gun from the bad man
and making him surrender the woman. Young Deer brings Felice back to her
father, who offers the Indian money for his bravery. He refuses, explaining
that he only wants to marry Felice, and her father finally consents.[69]

Young Deer recycled the basic plot of The Falling Arrow throughout the
first three years of his career. At the end of 1909, he remade the film with the
New York Motion Picture Company under the title An Indian's Bride. The
scenario was almost identical to the Lubin film, right down to a desperate
message sent by arrow. In this film, however, an Indian and a white "western
girl" fall in love. Her father objects to the marriage but changes his mind when
the Indian rescues the girl from the clutches of a villainous "Mexican." The
film ends with Young Deer adopting "civilian clothes" to please the white
girl's father.[70]

In 1910 the filmmaker took up the same story again but this time with a
different ending. In Young Deer's Return (NYMP, 1910), Young Deer saves a
prospector from a band of hostile Indians, and the white man gives him a
watch as a token of his appreciation. The Indian later attends the Carlisle

School and becomes assimilated into the dominant society. He falls in love with a white woman who returns his affections. The woman brings Young Deer home to meet her father, and he is enraged at the thought of her marrying an Indian. Young Deer recognizes the man as the prospector whose life he saved many years ago on the frontier. He produces the watch to prove his identity. The white man recognizes his prejudice and offers Young Deer his daughter. The Indian, however, is indignant. He walks back to his tribe, discards his "civilized garments," and marries a woman of his own race.[71]

With these films Young Deer was responding to the racist assumptions behind the treatment of Indian assimilation in *The Squaw Man*, as well as to the way the playwright and others characterized Native American men as either murderous savages or drunkards and dupes. Given the prejudice against sexual relations between white women and nonwhites at the time, it seems Young Deer was trying to provoke even those most committed to assimilation. Yet these motion pictures are not primarily about interracial sex. As was sometimes characteristic of those who used melodramatic forms, Young Deer presented personal situations in his films to comment on larger social issues. Young Deer's Indian heroes perform heroic acts for whites with the expectation that the reward will be an opportunity to integrate into the dominant society. In having his Indian characters seek to marry white women, Young Deer insisted that these protagonists be seen not merely as noble savages but as manly heroes who through their bravery have earned the right of full and equal citizenship.

Many filmmakers offered heroic Indian characters. Yet they typically did so by resorting to the noble savage stereotype—depicting "good Indians" as loyal, brave, strong, simple, and dedicated to family and children.[72] Young Deer, however, made westerns in which his Indian protagonists acted to protect their own communities and families rather than to uphold European civilization. Interracial coupling was not always at issue. For example, in his *For the Sake of the Tribe* (Pathé, 1911), American soldiers in charge of a government storehouse deny Indians their rations, mistakenly believing they have stolen some supplies. The soldiers demand that the tribe turn over the thieves. Three Indian men agree to be executed for a crime they have not committed rather than let the tribe's women and children starve. As the Indians dig their own graves, the real culprits are captured, and the men are allowed to go free.[73] Similarly, in *Red Eagle, the Lawyer* (Pathé, 1912), one of a series of films Young Deer made on the Yuma reservation in 1912, an Indian lawyer prevents a band of unscrupulous speculators from acquiring tribal land.[74]

Whereas some reviewers criticized Young Deer's motion pictures for their unbelievable plots and inferior acting, they initially made no comment about his depiction of interracial love.[75] The filmmaker even inspired imitators, and

motion-picture companies like Champion, Essanay, and Selig made films that depicted white women in romantic situations with Indian men.[76] Censors and trade journalists allowed Young Deer and others considerable license in this regard for three primary reasons. First, the filmmaker initially worked within an industry that was only beginning to formalize its methods and standards of censorship. The manufacturer-sponsored National Board of Censorship, founded in 1908, was still in its infancy, and many state and local censorship boards operated simultaneously with their own criteria. Second, audiences and critics were not generally offended by squaw-man–type plots because such stories had long provided an acceptable framework to treat forbidden or illicit love between whites and Indians.[77] Finally, it was in the industry's interest to produce and distribute films with positive images of Indians to quiet public complaints about the cinematic representation of tribal peoples.

If Young Deer at first operated with considerable artistic freedom, he later did not escape criticism for his more controversial subjects—particularly as trade journalists, exhibitors, and manufacturers became more conscious of catering to the tastes of middle-class adults. Although many in the industry sought fair and realistic portrayals of Indians, by 1911 that intent did not extend to the depiction of interracial sexual situations between Indians and white women. When Young Deer again depicted such a romantic relationship in the Pathé film *Red Deer's Devotion* (1911), the trade press objected. An editor for *Motion Picture World* felt the film would "not please a good many." Although conceding that a love affair between a white girl and an Indian was possible, he concluded that its depiction caused feelings of "disgust" that could not be "overcome."[78] The reviewer for the *Nickelodeon* concurred, writing that "the marriage between the Indian and the white heroine is not calculated to make the film popular," as "it hits one of Americans' most adamantine prejudices."[79] In another context, the trade journal stated unequivocally that it would not countenance such material in the future: "When the object of . . . [a white woman's] misguided passion is an Indian, a member of an alien and inferior race, our feelings simply revolt at the idea. . . . [T]here is really a moral law, a sentiment, a prejudice . . . against [such] a union."[80]

In 1914 the Chicago police censorship board demanded that scenes depicting a Mexican or an Indian character touching a white woman, even in an effort to take her against her will, be cut from films before their exhibition in the city.[81] After several years the trade press and censors increased their vigilance over the kind of films Young Deer made. Although he would continue to deal with issues of assimilation and racism, *Red Deer's Devotion* was the last film in which he explicitly treated romantic love between an Indian and a white woman.

As if to confirm the truism that systems of censorship sometimes make artists work more creatively, Young Deer responded to industry-controlled

monitoring by producing some of his most complex and socially trenchant films. In particular, he used the squaw-man plot in ever more sophisticated and subtle ways to manifest his beliefs about assimilation, especially his notion that whites and Indians could best integrate on tribal rather than Anglo-American terms. Three notable films—*For the Squaw* (Pathé, 1911), *For the Papoose* (Pathé, 1912), and *The Prospector and the Indian* (Pathé, 1912)—serve as examples of how Young Deer successfully communicated his controversial social views within the confines of what audiences, censors, and critics considered acceptable Indian melodrama.[82]

In *For the Papoose,* Young Deer created a squaw-man character who is nothing short of despicable. In the opening scenes he is drinking liquor and kissing his mixed-blood child. When he puts the flask up to the baby's lips, his Indian wife rises to prevent the misdeed, and he pushes her away violently. The woman's brother steps between his sister and the white man to prevent further violence. Later the squaw man runs away with his child and with a white settler woman whom the tribe has taken prisoner. His brother-in-law chases them and eventually catches up. The Indian sneaks up from behind and grabs the white man around the neck. The miscreant resists but to no avail. As the Indian is pulling his knife from its sheath, the camera cuts to the white woman, whose face registers the horror of the events. When the killing is done, the Indian walks toward her and wipes the blood from the knife onto his palm. He points offscreen and bids her to leave.[83]

This film is faithful to Royle's *The Squaw Man* in terms of the race and gender of its main protagonists, and like the original play it ultimately suggests that whites and Indians cannot integrate. Young Deer, however, changed the story to present autonomous and powerful Indians who dictate the terms of interracial relations. Instead of placing the mixed-race family within a white settlement, as in the original play, Young Deer showed it existing as part of an Indian tribe. The result is that the film's central issue becomes whether a white man can live by Indian mores rather than, as in Royle's version, whether Indians can enter into white society. Young Deer also resolved the question of to which society the mixed-blood child belongs in a different way. If Nat-u-rich commits suicide so her son can return to European civilization, the death of the child's white father in *For the Papoose* reaffirms that the boy is an Indian and will live as part of the tribe.

In a similarly themed film, *The Prospector and the Indian,* Young Deer told the story of Jim Harrison, a white man who falls in love with an Indian woman named White Star. White Star's father sees that Harrison's intentions are honorable and makes no objection to their marriage. The prospector takes the woman to his settlement, where the whites look upon the union with displeasure. They pin a sign to the couple's door indicating that whites and Indians

should not marry and that the woman must leave the settlement. So as not to bring disgrace upon Harrison, White Star runs away and attempts suicide. Outraged, Harrison goes to his wife's tribe and encourages the Indians to attack the whites. They set the settlement on fire, destroying it. White Star recovers, and Harrison joins the tribe.[84]

In this version of the squaw-man tale, the whites rather than the Indians are the tragic figures. Their paranoia about miscegenation brings about the ruination of their settlement.[85] The Indians are not threatened by the couple, and in fact they clearly attach importance to the biracial family and act to preserve it. In this regard Young Deer depicted the tribe as more accommodating and flexible than European American society. As in *For the Papoose,* the filmmaker imagined a world in which Indians maintain their autonomy and determine the context of white-Indian interaction.

Finally, in *For the Squaw,* Young Deer followed the plot of Royle's original quite faithfully until the white man is about to leave his Native bride and their mixed-blood child for a white lover. The Indian wife explains to her tribe that something must be done to prevent her husband from abandoning her. As the white woman arrives on the frontier by train, the tribe goes en masse to the station to explain to her that the man she has come to marry already has a wife and family. With the Indians' encouragement, she returns to the East. In the end, because of the tribe's successful intervention, the white man stays with his Indian bride.[86]

For the Squaw was among Young Deer's more hopeful films. It does not end disastrously for either whites or Indians. Right-minded and virtuous people from both races prevail. The Indians appeal to the white woman's higher sense of duty and obligation, and although the squaw man is clearly a villainous character, the tribe welcomes him back and gives him a chance to redeem himself.[87] Here Young Deer's message is that assimilation works only if based on mutual respect and tolerance and only when conceived as the union of equal cultures.

As these films suggest, Young Deer and Red Wing were ambivalent about assimilation. Sometimes they depicted Indians existing as equal citizens in a white world; other times they showed them living in separate but powerful and autonomous societies. As much as their stories were products of their imaginations, one cannot help but read them as reflections of their personal experiences as acculturated Indians. Their initial brush with the issues surrounding assimilation may have occurred in Indian boarding school. Although it is unclear where and how Young Deer received his formal education, through Red Wing he was at least aware of the promises and costs of the total assimilation policy introduced at the Carlisle Indian School by the school's director, Richard H. Pratt. Pratt believed in the equality of all people regardless of race,

and he deplored the way reservation Indians were barred from the larger society. At the same time, however, he callously required the students at Carlisle to abandon completely their tribal language and culture.[88]

As adults, Young Deer and Red Wing seemed to have struck a balance between the ideas of assimilation and Indian cultural autonomy. In 1913 journalist Margaret Price provided a rare glimpse into the couple's personal lives when she visited their home. She characterized the dwelling—located a short distance from the Pathé studio—as "a delightful mixture of Americanism and Indianism," with all the "regular American" amenities but filled with Indian artifacts—including portieres made of exotic beads, colorful rugs and mats, and other Indian "ornaments."[89] The couple's interior decorating reflected the attitude they manifested in their films: a belief in the promise of assimilation and a pride and interest in American Indian culture.

Although Young Deer rarely moved beyond the most clichéd conventions of melodrama, he was able to manipulate the western to create many dignified Indian characters and occasionally to offer a critique of racism and of the dominant thinking about assimilation. As Pathé West Coast expanded and his responsibilities grew, however, the filmmaker had to relinquish control over many of the motion pictures the studio produced. For efficient mass production, variation in films needed to be minimized; and to appeal to audiences' expectations, Young Deer was forced to rely more and more on standard conventions and narrow Indian stereotypes. The industry no longer considered interracial sexual situations or the question of American Indian assimilation acceptable subjects. Young Deer's artistic license was also increasingly limited as censors, "high-class" exhibitors, and the trade press became more vigilant in policing "objectionable" race-oriented material. Although he continued to make Indian westerns into the mid-teens, only a few of his later films dealt with social issues, and they did so in much less overt ways than his earlier works. Young Deer's product became increasingly indistinguishable from that of other companies.

By 1913 the Indian filmmaker's most innovative and challenging work was behind him. After five years of heavy production, the market for the genre began to wane. The western's popularity in the United States was in temporary but serious decline. Moreover, star-driven features, usually of three or more reels, became the industry norm in the teens. Although he made at least one four-reel production, Young Deer's career did not survive the transition into the period of feature filmmaking.[90]

As Young Deer's fortune waned, Red Wing's star momentarily rose. Cecil B. DeMille cast her in his first film, a faithful adaptation of Edwin Milton Royle's *The Squaw Man* (Lasky, 1914) (see Figure 3.8). Ironically, if there were a place for the actress in feature westerns, it was in the narrowly conceived

Fig. 3.8 Red Wing and Dustin Farnum in the death scene from Cecil B. DeMille's The Squaw Man *(1914). From* Moving Picture World, *February 24, 1914.*

role of the self-sacrificing Indian maiden she and Young Deer had done so much to challenge. The possibilities of the pre-studio era were a thing of the past. DeMille and the picture's male lead, Dustin Farnum, spoke of Red Wing as though she were a naive "pure blooded Indian girl," even though she had more moviemaking experience than both men combined.[91] The trade press widely praised her performance while ignoring or dismissing her previous career. Louis Reeves Harrison of *Motion Picture World*, for example, wrote that heretofore Red Wing's work had been "dull" and that the "highest merit" of the DeMille film was the opportunity it gave to such an "accomplished actress."[92]

On New Year's Day 1913, Young Deer entered a float in the Tournament of Roses Parade for the Pathé Company. The entry reflected his support for Indian assimilation at the highest social levels, as well as his admiration for traditional cultures. The float was called "Indian Life—Past and Present," and on one end stood an Indian dressed as a college graduate and on the other an old Indian woman and a traditionally dressed warrior in front of a tepee.[93] The message was quintessential Young Deer. Tribal culture should be a point of pride, and it should not prevent the assimilation of Indians into the highest ranks of the dominant society. Unfortunately, Young Deer paraded the image

of the college-educated Indian at the very time policy makers were giving up on education as a pathway to Native American social equality.

If the Pasadena elites were willing to allow Young Deer to participate in their venerable parade, the coming leaders of the American film industry would have no place for his strong Indian characters or his ideas about assimilation. The notion of the vanishing Indian was increasingly popular among American intellectuals, the U.S. government, and the public. It would become the predominant Indian stereotype used by the film industry in the period 1913–1919.

NOTES

1. *Motion Picture World* (*MPW*), November 11, 1911, 398.

2. See, for example, George N. Fenin and William K. Everson, *The Western From Silents to Cinerama* (New York: Orion, 1962), 67–107.

3. Brian W. Dippie, *The Vanishing American: White Attitudes and U.S. Indian Policy* (Middletown, Conn.: Wesleyan University Press, 1982), 211.

4. Adam Kessel, "When the Field Was Fresh," *MPW*, March 10, 1917, 1523.

5. The memoirs of Fred Balshofer and one of his early assistants, Arthur C. Miller, have been published in a valuable book. Fred J. Balshofer and Arthur C. Miller, *One Reel a Week* (Berkeley: University of California Press, 1967). Unless otherwise noted, the material detailing Balshofer's early career and the founding of the New York Motion Picture Company comes from these memoirs.

6. *Variety*, August 6, 1952, 55.

7. *MPW*, June 26, 1909, 781.

8. Kessel, "When the Field Was Fresh," 1523.

9. Balshofer and Miller, *One Reel a Week*, 41.

10. *MPW*, June 26, 1909, 781.

11. Balshofer and Miller, *One Reel a Week*, 28.

12. *MPW*, July 31, 1909, 267.

13. On the history and culture of the Nebraska Winnebagos, see David Lee Smith, *Folklore of the Winnebago Tribe* (Norman: University of Oklahoma Press, 1997).

14. On Lillian St. Cyr, see U.S. Census 1900, Nebraska, Thurston County, Winnebago Precinct, e.d. 187, sheet 4, line 1; "Red Wing, Star of the Movies," *Grand Rapids Press*, April 25, 1913; *New York Times*, March 14, 1974, 40: 3; "Red Wing," *Variety*, March 20, 1974.

15. On James Young Deer, see "James Young Deer," *MPW*, May 6, 1911, 999; Kevin Brownlow, *The War, the West and the Wilderness* (New York: Alfred A. Knopf, 1979); Balshofer and Miller, *One Reel a Week*, 28.

16. *Views and Films Index*, October 16, 1909, 8.

17. Balshofer and Miller, *One Reel a Week*, 41.

18. Balshofer maintained that Smith was an informant for the Patent Trust.

19. Thomas Ince, "Early Days at Kay Bee," *Photoplay* (March 1919): 42–46.

20. G. P. von Harleman, "Motion Picture Studios of California," *MPW*, March 10, 1917, 1600.

21. Balshofer and Miller, *One Reel a Week*, 56–57.

22. *MPW*, January 21, 1911, 137; February 11, 1911, 302.

23. Balshofer recalled that the company went to Big Bear to hide from Patent Company detectives. This makes little sense, however, because Bison sent press releases to trade journals announcing its move to the area.

24. Balshofer and Miller, *One Reel a Week*, 64–65.

25. *New York Dramatic Mirror (NYDM)*, September 27, 1911, 32.

26. *NYDM*, January 4, 1911, 31.

27. *MPW*, January 22, 1910, 92.

28. A copy of *The Redskin's Bravery* is found in the Motion Picture Division of the Library of Congress, Washington, D.C.

29. *NYDM*, November 15, 1911; Balshofer and Miller, *One Reel a Week*, 66–67.

30. *NYDM*, April 9, 1910, 17; Eileen Bowser, *The Transformation of Cinema, 1907–1915* (Berkeley: University of California Press, 1990), 80.

31. *MPW*, February 26, 1910, 300; *Motion Picture News (MPN)*, February 19, 1910, 7; September 24, 1910.

32. To compare the costumes of Young Deer and Red Wing with those of other Winnebago performers, see "Winnebago Performers, Indians and Steamer Near the Standing Rock Amphitheater," September 26, 1929, lot. 12942, Prints and Photographs, Library of Congress, Washington, D.C.

33. On the division of labor under what Janet Staiger calls "the director system," see David Bordwell, Janet Staiger, and Kristin Thompson, *The Classical Hollywood Cinema: Film Style and Mode of Production to 1960* (New York: Columbia University Press, 1985), 113–120.

34. No record exists of Young Deer having written scenarios for Bison. There are, however, strong similarities between Red Wing and Young Deer's Bison films and those he is known to have authored for Lubin and Pathé. This suggests that he was writing for the Bison Company.

35. *MPN*, December 10, 1910, 3; Billy H. Doyle, "Princess Mona Darkfeather," *Classic Images*, September 1993, 54–55.

36. Richard Abel has written extensively about the history of the Pathé Company. See in particular his *The Ciné Goes to Town: French Cinema, 1896–1914* (Berkeley: University of California Press, 1994). He writes specifically about Pathé hiring Young Deer and Red Wing in Richard Abel, " 'Our Country'/Whose Country? The 'Americanisation' Project of Early Westerns," in *Back in the Saddle Again: New Essays on the Western*, Edward Buscombe and Roberta Pearson, eds. (London: BFI, 1998), 77–95.

37. "James Young Deer," *MPW*, May 6, 1911, 999.

38. *MPW*, January 1, 1911, 13; January 28, 1911, 199.

39. J. A. Berst to Young Deer, December 15, 1910, Thomas K. Peter Collection, Seaver Center, Los Angeles County Natural History Museum, Los Angeles, California.

40. *MPW*, September 14, 1912, 1067.

41. The increasing elaborateness of Young Deer's Indian sets can be seen in films like his *Love of an Indian* (Pathé, 1913), Netherlands Film Institute, Amsterdam.

42. Jack Hoxie interview quoted in Edgar M. Wyatt, *The Hoxie Boys: The Lives and Films of Jack and Al Hoxie* (Raleigh, N.C.: Wyatt Classics, 1992), 19.

43. *MPW,* April 26, 1913, 367.

44. *Nickelodeon,* March 25, 1911, 336.

45. "Moving Picture Absurdities," *MPW,* September 16, 1911, 773.

46. On the shift from histrionic to "natural" acting styles in early cinema, see Roberta Pearson, *Eloquent Gestures: The Transformation of Performance Style in the Griffith Biograph Films* (Berkeley: University of California Press, 1992).

47. *NYDM,* December 14, 1910, 28.

48. *MPW,* January 13, 1912, 119.

49. *MPW,* November 4, 1911, 39.

50. L. G. Moses, *Wild West Shows and the Images of American Indians, 1883–1933* (Albuquerque: University of New Mexico Press, 1996), 67.

51. Sandos and Burgess describe the dispute between Boniface and Willie Boy as a clash of belief systems. Willie Boy was a Ghost Dance participant, and Boniface adhered to the traditional Chemehuevis beliefs. James A. Sandos and Larry E. Burgess, *The Hunt for Willie Boy: Indian-Hating and Popular Culture* (Norman: University of Oklahoma Press, 1994).

52. The British Film Institute has a print of *Curse of the Redman.*

53. *Film Index,* February 4, 1911, 11.

54. On the history of Indian education at the time, see Frederick E. Hoxie, *A Final Promise: The Campaign to Assimilate the Indians, 1880–1920* (Lincoln: University of Nebraska Press, 1984), 189–210.

55. Hobart Bosworth to William Selig, November 8, 1910, Clarke Scrapbook, Margaret Herrick Library, Los Angeles, California.

56. "Indians Say They're Lied About," *Nickelodeon,* February 25, 1911, 216.

57. Ibid.

58. Department of the Interior, Office of Indian Affairs, to Selig, May 13, 1911, Margaret Herrick Library, Los Angeles, California.

59. *MPN,* October 7, 1911, 24.

60. *MPN,* March 16, 1912, 23.

61. *MPN,* March 4, 1911, 10.

62. "Indians War on Films," *MPW,* March 18, 1911, 581.

63. *MPN,* December 16, 1911, 32.

64. For more information on Edwin Milton Royle's *The Squaw Man,* see *The Best Plays and the Year Book of the Drama in America 1899/09* (New York: Dodd, Mead, 1909–1947), 207–209; William S. Hart, *My Life East and West* (Boston: Houghton Mifflin, 1929), 166–169, 184–187.

65. Royle, *The Squaw Man,* in *The Best Plays and the Year Book of the Drama in America 1899/09,* 210–244.

66. Robert S. Tilton traces the changing thinking about Indian-white miscegenation by examining how depictions of Pocahontas have changed over time; see his *Pocahontas: The Evolution of an American Narrative* (New York: Cambridge University Press, 1994), 26. Tilton argues that from the eighteenth to nineteenth centuries the dominant representation of Pocahontas shifted from "wife of John Rolfe" to "savior of John Smith." In the former persona Pocahontas was a positive role model for racial mixing. In the latter she was the "mythic protector" of Europeans in the New World.

67. Hoxie, *A Final Promise*, 112–113.

68. *Nickelodeon*, February 4, 1911, 138.

69. An incomplete print of *The Falling Arrow* is available in the Motion Picture Division of the Library of Congress, Washington, D.C. The last scene in which Felice's father consents to the marriage is missing. An exhibitor likely eliminated the ending from the print, thinking his audience might find it objectionable.

70. *MPW*, November 20, 1909, 737.

71. *MPN*, October 1, 1910, 14.

72. Historian Robert F. Berkhofer Jr. describes the characteristics of the noble savage in his *The White Man's Indian: Images of the American Indian From Columbus to the Present* (New York: Alfred A. Knopf, 1978), 72–85.

73. *MPW*, August 26, 1911, 556.

74. *MPW*, November 16, 1912, 696.

75. See, for example, *NYDM*, May 15, 1909, 15.

76. See, for example, the reviews of Champion's *The Indian Land Grab* (1910), *Nickelodeon*, December 15, 1910, 335; Selig's *When the Heart Calls* (1912), *NYDM*, June 12, 1912, 31; Essanay's *An Indian's Sacrifice* (1910), *Film Index*, August 20, 1910, 25.

77. Such films, in the words of one reviewer, could suggest "the dark and seamy side of sex relationships." *Nickelodeon*, February 18, 1911, 196.

78. *MPN*, March 25, 1911, 656; *MPW*, March 25, 1911, 656.

79. *Nickelodeon*, March 25, 1911, 336.

80. *Nickelodeon*, December 15, 1910, 335.

81. *Motography*, August 1, 1914, 151.

82. *MPW*, January 13, 1912, 146; *Film Index*, June 17, 1911, 17.

83. The Motion Picture Division of the Library of Congress houses a copy of *For the Papoose*.

84. For a description of *The Prospector and the Indian*, see *Bioscope*, January 30, 1913, iii.

85. Young Deer made this point even clearer in another version of the story called *The Squaw Man's Revenge* (Pathé, 1912). The plot is the same as that of *The Prospector and the Indian* except that the white man's wife is not of Indian blood but a white woman who has been raised as an Indian. In this film no miscegenation takes place, but paranoia over it ends up destroying the white settlement. For a description of *The Squaw Man's Revenge*, see *MPW*, January 13, 1912, 146.

86. For reviews and descriptions of *For the Squaw*, see *Motography*, July 1911, 91; *MPW*, June 17, 1911, 1365; *NYDM*, June 28, 1911, 30.

87. Reviews in industry journals that characterized Young Deer's depiction of a white man as "despicable" suggest that he wanted the audience to sympathize with the Indian woman. *Motography*, July 1911, 41; *NYDM*, June 28, 1911, 30.

88. For the history of the Carlisle Indian School, see Linda F. Witmer, *The Indian Industrial School: Carlisle, Pennsylvania, 1879–1918* (Carlisle, Pa.: Cumberland County Historical Society, 1993); Dippie, *The Vanishing American*, 111–121.

89. Margaret Price, "Red Wing, Star of the Movies," *Grand Rapids Press*, April 25, 1913, Locke Scrapbook, New York Public Library, Lincoln Center, New York City.

90. See *MPW*, October 9, 1915, 275, for a notice about James Young Deer directing a four-reel film with George Gebhart, one of the Bison Company's original actors.

91. Cecil B. DeMille, *The Autobiography of Cecil B. DeMille* (Englewood Cliffs, N.J.: Prentice-Hall, 1959), 89; *MPW,* February 28, 1914, 1243.

92. *MPW,* February 28, 1914, 1068.

93. *MPW,* January 18, 1913, 251.

"COGS OF THE BIG INCE MACHINE"

New York Motion Picture Introduces "Bison-101" Western Features

There is now a very large class of people who desire something better than stories of the Wild West and the exploits of the typical cowboy with knife in belt, lariat and revolver flourishing at every opportunity. This may suit the younger or less intelligent people, and, in moderation, the older or better informed, but they are not the type which will ensure the future popularity of the industry, nor do they show the higher possibilities of the moving pictures.[1]

—Journalist A. L. Barrnett, 1911

Certainly the Indian is picturesque in dress and behavior, the Indian blanket a noble and colorful drapery, not outclassed by the Roman toga, and his dances are a distinct addition to our plastic repertory. But I shall no doubt raise question, if not downright opposition, by declaring that his chief dramatic value is by way of providing an attractive background for psychological drama. The difficulty is that the social organization of Indian life fails to provide those contrasts and opposi-tions which compose the drama of action.[2]

—Critic Mary Austin, 1911

Although popular with audiences in the United States and abroad, by 1911 the western was proving to be a source of contention within the motion-picture industry. Trade journalists and exhibi-tors, particularly those who wanted to elevate the status of the movies to attract more affluent spectators, attacked westerns as boring and offensive. They associated such films with "lowbrow" taste and "cheap amusements" and worried that the genre's "blood and thunder" aspects attracted "rough," masculine audiences to

nickelodeons and deterred female patronage. This was a concern because women had the moral authority to establish moviegoing as a genteel and therefore appropriate bourgeois activity. Despite the complaints, manufacturers were unwilling to eliminate the western because it continued to be popular with important segments of the moviegoing public, including young boys, working-class men, inner-city patrons, and audiences abroad.[3]

Because the films were too profitable to abandon, opponents waged a campaign to modify cowboy and Indian pictures stylistically, demanding that manufacturers downplay criminal activity and lurid violence to make such films less offensive to middle-class adults. Producers, critics believed, could improve westerns if they demanded more "naturalism" from their actors and paid closer attention to accuracy in costuming and scenery. Meanwhile, other opponents of the genre suggested that manufacturers make cowboy pictures more romantic by eliminating signs of industrialization or modernization and by introducing heroic figures who could teach moral lessons and instill a sense of patriotism. In a word, critics wanted western films to be more like Wild-West shows. Purveyors of this older form of entertainment had long presented a spectacular, fact-based version of the history of the West but at the same time had used their performers to buttress higher national ideals and goals in ways that made the shows more than merely another cheap amusement.

Although other manufacturers modified their product in response to such complaints and advice, the New York Motion Picture Company acted first and achieved more success. To expand the audience for its westerns, the company invested a great deal of money in them, increasing production costs to unprecedented levels. The firm secured 18,000 acres in the Santa Monica mountains of Los Angeles and hired a significant portion of the cast of the Miller Brothers' 101 Ranch Wild West Show. To manage these expensive new resources, it hired producer and filmmaker Thomas H. Ince, an innovator in bringing modern industrial practices to filmmaking. Further systematizing production at the company's outdoor studio, he was able to employ hundreds of extras full-time and to regularly stage westerns that were twice as long as and more spectacular than any being released.

Ince and the New York Motion Picture Company spent money on cowboy and Indian films to elevate their sensationalism but also to give them credence as conveyors of history. In this way they hoped to shake the genre's association with cheap amusements. With the larger budgets, the company brought the western film closer to the Wild-West show both aesthetically and ideologically. Like the purveyors of this older form of entertainment, Ince publicized his cowboy and Indian pictures as "truthful" records of the past, and he used them to promote the United States as the world's new imperial power. At this point motion pictures began to usurp the Wild-West show's cultural

and political role because the medium could offer a global audience epic productions of western warfare on a more regular basis and at a lower cost.

Prior to the release of New York Motion Picture's new westerns, the so-called Bison-101 features, many exhibitors and critics worried about the long-term effects overproduction of the genre might have on the industry. Whereas journalists initially heralded cowboy and Indian pictures as the basis for a uniquely American cinema, such films were increasingly dividing those in the moviemaking business as well as cinema audiences. Many found their violence offensive. One frustrated observer complained that a person could not enter a nickelodeon without being subject to "a screen full of the smother of Western desperadoes' guns, dynamite explosions, or torrents of gore."[4]

Part of the controversy surrounding the western stemmed from the genre's association with dime novels and stage melodrama, which many in the industry viewed as degraded, working-class forms of entertainment.[5] As narrative cinema developed, film manufacturers initially adopted many of the plots and themes from these older sensational media in hopes of attracting the traditional customers of cheap amusements.[6] Critics and some exhibitors, especially those who wanted to increase their businesses' profits and respectability by attracting middle-class adults, grew suspect of this practice. They believed cinema's association with such déclassé cultural forms kept the "better" sorts of customers away, repulsed by gratuitous violence and lurid emotion.[7]

Exhibitors were especially sensitive to charges that their product was part of the lowbrow tradition of the dime novel. They did not want to inherit the social stigma that had surrounded that medium and thus denied the connection.[8] Yet throughout the nickelodeon era, moviegoers and critics routinely made the association between cheap fiction and the cinema. In 1910 one newspaper editor articulated a sentiment common among reform-minded individuals:

> What, indeed, is the moving picture show but dime-novel literature flashed
> on a screen by means of magic lanterns and purveyed to youthful minds
> pictorially for half the old price? It is in the dime novel that its enormous
> popular vogue has its source and it is by dime-novel standards that its moral
> influence must be measured.[9]

Film westerns were particularly subject to comparisons with dime fiction because the two forms shared similar characters, settings, and narratives based on crime and violence on the frontier. Observers complained that Wild-West movie posters looked like "flaring, glaring" dime-novel covers.[10] Such promotional materials depicted the West in ever more lurid terms and sometimes transgressed dominant middle-class notions of good taste. Film reviewers also began routinely to describe western motion pictures as "dime-novel-like." Typically, this phrase was meant pejoratively. According to a critic for a Duluth,

Minnesota, newspaper, many cowboy and Indian films were "nothing more than picturized versions of 'Nick Carter' and 'Diamond Dick' stories."[11]

Not everyone in the industry was concerned about the relationship between westerns and dime fiction. Some film manufacturers who stood to profit from the association even encouraged it. In 1912 David Horsely, owner of Nestor Motion Picture Company, established a business alliance with Frank V. Tousey, a thirty-year veteran of dime-fiction publishing whom Anthony Comstock had arrested in March 1884 under new laws regulating the distribution of "immoral" fiction. As a political progressive, Horsely was exceptional among early manufacturers. He envisioned a cinema that would be supportive of working-class causes, later joining with the Brotherhood of Railway Trainmen to create the Motive Motion Picture Company—a studio dedicated to the production of pro-labor films.[12] Horsely's willingness to connect his studio with the dime-novel industry was consistent with his political views and his vision of a working-class cinema.[13]

Horsely and Tousey made arrangements to produce stories that would be featured simultaneously on nickelodeon screens and in the publisher's leading national dime-fiction western newspaper, the *Wild West Weekly*. Tousey furnished the filmmaker with proofs of a given story several weeks before it went to press. Horsely produced a motion picture based on the narrative and released it concurrently with the edition of the *Wild West Weekly* featuring the original story. The paper contained a notice on its cover advertising the current Nestor film, and the motion picture's introductory title made clear that the movie was adapted from a story running in the weekly.[14] The men made the papers available to theater managers wholesale so exhibitors could sell them directly from their box offices.

Unfortunately for the Nestor Company and the *Wild West Weekly*, the series was unsuccessful. Horsely and Tousey had badly miscalculated the extent to which exhibitors would respond to a scheme linking the movies and dime fiction so overtly. A theater manager from Norwich, Connecticut, became infuriated when he received a circular that detailed the marketing plan. He wrote a searing letter to a trade journal:

> It is bad enough for the films to be compared at times with the yellow "dime novel," but to be actually adapted from them is about my idea of the limit. . . . If I am ever unlucky enough to receive one of these "uplifting" subjects from my exchange I shall most certainly cut off the leader that states the "books" are on sale at the box-office. I shall also inform the exchange that they will be minus a customer if they insist on sending me such "rot."[15]

Even the editors at *Motion Picture News*, who were biased toward independent manufacturers such as Nestor, complained about Horsely's new strategy

for marketing his western films. One determined that it was "ill advised" to connect "blood and thunder stories with cinematography."[16]

Nestor's partnership with Tousey lasted only a month. During that time the company released six "Young Wild West" films to mediocre reviews. One critic characterized the series as "rather low class."[17] Horsely had begun the project just as Nestor was uniting with a dozen other independents to form the Universal Film Manufacturing Company. Universal abandoned the series because of exhibitors' protests from around the country. The editors of *Motion Picture World* celebrated the termination of the Nestor westerns as an example of the power united and outspoken exhibitors could have over manufacturers.[18]

In many respects, nickelodeon operators' hostility toward Horsely's plan reflected their desire to cater to more affluent audiences. By 1911 exhibitors were well aware that middle-class reformers were attacking westerns not only for their depiction of Indians but also for their putative effects on children. Newspapers ran stories decrying the negative social impact of "Wild-West" moving pictures. The Waterloo, Iowa, *Reporter* featured an article about a holdup attempted by three boys whose minds had been "inflamed with scenes of robbers and the Wild West depicted by moving pictures."[19] George B. Wright, New Jersey state commissioner of charities and corrections, advocated the abolishment of the western and other sensational motion pictures because they were responsible for many youthful misdeeds. Boys who went to the movies, he claimed, got "'Wild West' notions" that moved them to act rashly and with negative consequences.[20] In New York the rhetoric against the genre reached such a pitch that some nickelodeon operators had the impression that the city was going to ban such films outright.[21] The authorities in Akron, Ohio, did forbid the exhibition of cowboy films for a time after a young girl, in emulation of a western she had seen, attempted a "Jesse-James–style" holdup of a Cuyahoga Falls bank.[22] In the face of such criticism, industry support for the genre began to wane.

High-class exhibitors, who wished to attract patrons of an elevated social standing, were among the first to abandon the western. They felt the "better" sorts of customers were put off by the genre and that such films only appealed to children and the working class. Will C. Bettis of Toledo, Ohio, built a large, well-appointed theater in an effort to attract "the best people of the city." Yet his exchange, he complained, was supplying him with inappropriate films to woo such customers. "You can imagine my disappointment and chagrin," he wrote to a trade journal, "when I found a few days ago three out of the four reels that I [was to] run at each performance were Indian and Cowboy pictures."[23] Another exhibitor, from Fremont, Ohio, told a similar story, noting that when patrons came to his theater and saw "a poster depicting some Western or Indian picture," they often showed their displeasure by going to another nickelodeon. "I

can see many of my best customers come up, take a look, and go away," he lamented, "and methinks I can hear that nickel jingle, but not in my pocket."[24]

In support of such sentiments, Stephen Bush, a prominent industry critic, denounced those exhibitors who were not conscientious about considering the effect westerns had on the environments in nickelodeons. According to Bush, those who showed an inordinate number of westerns fostered a "spirit of roughness" in their theaters. They gave their businesses over to "crowds of rowdies" and allowed "scorbutic-looking youths with atrophied brain cells" to gather in front of their theaters and frighten "desirable people" away. The sight of such patrons, he concluded, was "a distinct threat to a normal man's appetite and digestion" and caused women to avoid such theaters "as if they were infested with the plague."[25]

By the end of 1911, a peak year for production of the genre, a consensus was building among trade journalists and "high-class" exhibitors: westerns were making conditions in "bad" nickelodeons worse and preventing the "better" theaters from becoming prosperous. At the time, all the major editorials published in industry journals about cowboy and Indian films were seriously disparaging. The western, editors claimed, had served its purpose but was no longer an appropriate type for a cinema aspiring to greatness. One critic designated the genre as the industry's "one weak spot."[26] Another described Indians and cowboys as "nasty," "dirty," "uncomfortable," and "unpleasant"; and he speculated that "educated adults" were being repelled by "stupid Indian and Cowboy themes."[27] *Motion Picture News* also inveighed against the western, claiming letters sent to the journal complaining about the genre could easily fill three issues.[28] "A very large class of people," one writer announced, desired "something better than stories of the Wild West and the exploits of the typical cowboy with knife in belt, lariat and revolver flourishing at every opportunity."[29] Such movies did not reflect the "higher possibilities" of cinema or hold any "real utility to the people of Nickelodia."[30]

Not every critic questioned the western's moral value. Some believed moviegoers had simply tired of the genre. According to *Motion Picture World,* filmmakers cranked out westerns in complete ignorance of the tastes of the general moviegoing public, who now viewed "Indian and Cowboy subjects" at best with "amusement and toleration." The editors at *Nickelodeon* explained:

> It is just simply the case of a gold mine that has been worked to the limit and can give no more desirable ore. Apparently all the old Western expedients are frayed to a frazzle and audiences have become familiar with them to the point of contempt. Given the first one hundred feet of a reel and any photoplayer of average sophistication can predict the rest. Western melodramas have lost their ability to create suspense, and minus this quality they have small excuse for being. All that remains is the scenery, and even that has lost its novelty.[31]

Fig. 4.1 Children crowd into a nickelodeon to see a western. From Bowers, Nickelodeon Theaters.

Despite the increasingly heated rhetoric against westerns, a substantial portion of the nickelodeon-going public—including those outside the United States—still enjoyed them. The type was especially popular with boys and young men. Even exhibitors who spoke against the genre acknowledged that "noisy hordes" of "unwashed boys in the front seats" continued to demand westerns on every nickelodeon bill.[32] A 1911 survey of eight-year-olds conducted by New York's Child Welfare Committee confirmed that the genre was the favorite motion-picture subject of three out of four boys. Girls also preferred westerns but in less overwhelming numbers (see Figure 4.1).[33]

Critics and exhibitors also grudgingly acknowledged the continuing popularity of westerns with "foreigners and the American working element" located in "large, congested cities."[34] Such films, they complained, appealed to the lowest common denominator among moviegoers, what one journalist called the "seething mass of human cattle" who filled nickelodeons in such places as New York's Lower East Side.[35] Bush argued that the industry needed to adopt different grades of exhibition service to ensure delivery of Wild-West films to theaters in poorer neighborhoods and of films based on classic literature to small-town and suburban movie houses.[36]

Finally, the demand from abroad—especially from Europeans—kept the production of westerns higher than it might have been otherwise. Selig, Essanay, New York Motion Picture, and other studios found lucrative export markets

for the genre. Foreign customers, many critics believed, became the decisive factor behind the cowboy and Indian film phenomenon; and they charged manufacturers with disregarding the tastes of domestic moviegoers for the sake of profits to be made overseas. According to a scenario writer, the overall quality of motion pictures was improving except for "a sad backsliding to cowboys and 'guns' for the sake of the European trade."[37] Bush warned manufacturers not to overproduce westerns. "As long as the people of this country . . . pay for seeing . . . pictures," he asserted, "their taste and their demands deserve the first, indeed the only consideration, quite regardless of the wishes and preferences of the European public."[38]

The genre's continuing popularity among some of the industry's most reliable customers created a problem for manufacturers: How could they deliver the Wild-West sensationalism important segments of their audience demanded while at the same time appeasing those in the industry who wanted to attract more affluent moviegoers? A possible solution was to make stylistic changes to downplay "blood and thunder" melodrama. If the western could not be effectively eliminated, then it might be reformed from the inside. After all, few considered the frontier drama an exclusively degraded form. Americans had long recognized variations in quality within the genre. James Fenimore Cooper's *The Last of the Mohicans*, for example, was in every way superior to the most sensational "Deadwood Dick" dime novels. As one journalist concluded, "[I]f western pictures must be given, let them be of an elevating educative trend, something that will teach a good lesson and not leave a bad taste in the mouth with its many holdups, murders, and shootings."[39]

Looking to preempt reformers' attacks on the cinema and to expand the medium's potential audience, filmmakers could tame sensational cowboy and Indian films by making them more realistic and at the same time more romantic.[40] The impulse toward mixing these two seemingly contradictory styles had an earlier parallel in the western fiction of Frank Norris, who lamented the prevalence of "road agents and desperadoes" in dime novels. Writers, he argued, would only create great national epics about the West if they synthesized romance—man's internal emotion and higher consciousness—with realism, surface details, and commonplace facts. He called this hybrid style *naturalism*, and by 1911 critics were arguing for its application to western films without actually using the term.[41]

Trade journalists and exhibitors often chided manufacturers of cowboy and Indian pictures for their lack of commitment to realism. An editor from *Nickelodeon* upbraided filmmakers for going west to find "a stomping ground for melodrama" rather than to portray "real Western conditions."[42] A proprietor of a theater in South Dakota recommended that manufacturers only send "Cowboy-Indian–slaughter bar-room pictures" to eastern exhibitors where

people did not know what the West was really like.[43] Industry critics had allies in moviegoers from the West, who were also discomfited by the screen images of the region and its peoples. One such spectator wrote *Motion Picture World* to complain about the genre's "everlasting holdups, wild riding, excessive drinking, reckless gambling and indiscriminate shooting"—all not true to life and insulting to audiences in the West.[44]

Other critics not only demanded that filmmakers more accurately represent the region but—seemingly contradictorily—also argued for introducing more romance into the genre and creating idealized western characters. There is "a constant temptation to [create] 'realism' of a most undesirable variety," they complained, and they asked producers to depict "old, romantic pioneer days" and the "richer color and free life of earlier times."[45] Reviewers routinely criticized the appearance of paved or well-graded roads and urged filmmakers not to treat such topics as labor disputes or large-scale commercial agriculture. Motion-picture producers needed to "drop the haze of romance gently over" cowboy and Indian films, a critic suggested, "to blur the rough action of rough characters, and soften the sharp outline of stories."[46] In this way, filmmakers could legitimize the genre—especially in the eyes of middle-class patrons who associated its melodrama and histrionics with emotion, misrule, and irrationality.[47]

Whereas most manufacturers of westerns found themselves having to respond in some manner to the strictures of journalists and exhibitors, New York Motion Picture made the most dramatic changes to its product. At the beginning of 1912, the company announced that its Bison troupe would embark on a new series of films that were longer—two reels instead of one—and more spectacular than any westerns ever made. The president of New York Motion Picture, Charles Baumann, conceded that Bison's earlier pictures had been of the "Diamond-Dick–novel" variety and had propagated many untruths about the region. Now, however, the films would depict "the actual life and experiences of the early settlers in the Far West, the Indian tribes, the gold prospectors, the cattle herdsmen, etc." The company would spare no expense or time in securing the proper settings and correct costumes, as well as in maintaining historical accuracy.[48] New York Motion Picture used the brand name "Bison-101" for its new western features to advertise that it had made them in conjunction with the 101 Ranch Wild West Show and to prevent exhibitors and moviegoers from confusing them with the company's original brand of cowboy and Indian films.

At the very moment the genre was coming under fire from high-class exhibitors and trade journalists, the owners of New York Motion Picture risked the expense of producing and marketing these elaborate films. Having made westerns for several years, they were certain of their export value and equally

convinced of a loyal fan base in the United States. By increasing the films' length, spending more money on production, and substituting historical spectacle for stagy melodrama, manufacturers could, they believed, further expand the audience for cowboy and Indian films. Unlike Horsely of the Nestor Company, who wanted to connect the western more explicitly to the culture of the dime novel, those who ran New York Motion Picture calculated that by associating the genre with the "middlebrow" Wild-West show, they could win over those in the industry who objected to such films.

To make the new westerns, New York Motion Picture hired Thomas H. Ince, the director who had been working for Carl Laemmle's Imp Company in Cuba. Born in 1882, Ince had been involved in theater from a young age. His father was John E. Ince, an English-born actor and comedian, and his mother— also British—was Emma Brenna, a star of comic opera. Thomas became involved in dramatics almost as soon as he could talk. He had some success in juvenile roles with various theatrical companies and also occasionally worked behind the scenes in stage management. In 1908 he traveled extensively over vaudeville circuits with a comedy sketch he created entitled "Wide Mike."[49]

Although he had worked in a short-lived variety show in which motion pictures played a part, Ince, like almost everyone involved in legitimate theater at the time, considered working in cinema to be beneath him. In his estimation, movies were "not in harmony with the best traditions of the stage." Yet finding himself unemployed and lured by the prospect of a steady income, he looked for work at Imp's New York studio. The company hired him as an actor. From the first day, Ince found himself absorbed by the filmmaking process. He was eager to try his own hand at directing, and within a few months the studio gave him the opportunity to do so. Imp placed him in charge of a stock company, sending him to Cuba to make films. In fall 1911 the owners of New York Motion Picture, who were looking for someone to make westerns in California, hired Ince away from Imp, offering him a salary of $150 a week.[50] Ince traveled to Los Angeles with his wife, actress Elinor Kershaw; cameraman Ray Smallwood; and leading lady Ethel Grandon.

Ince's personal vision was essential to the creation of the Bison-101 western. Although he directed only the first few films in the series and then relinquished the responsibility to others, his employees adopted his approach. Ince had found the original Bison films produced under the Bison Company's founding manager, Fred Balshofer, monotonous and unoriginal. As he put it, they were indistinguishable, with the cowboys and Indians sometimes riding uphill and other times riding downhill.[51] Filmmakers, he believed, could improve westerns and other films if they built them around simple themes with universal appeal. In his opinion, "cheap melodrama" was "proving a menace to the permanency" of cinema, but pictures that propagated higher ideals could alleviate

the threat.[52] This did not mean abandoning moviegoers who enjoyed the thrills the medium offered but rather meant making a film "based upon a fundamental principle of life" that would hold the interest of anyone: "the laborer or the capitalist, the shop girl or the queen."[53]

As Ince made his way to California, Balshofer and Baumann were in Los Angeles preparing for his arrival and gathering the materials the new producer would need to make large-scale westerns. Balshofer's original troupe had sometimes shot films on a picturesque property north of Santa Monica called Santa Ynez Canyon. Balshofer liked the area not only for its scenic value but also because it was isolated and easily securable. It could be readily entered only by traveling along the beach road from Santa Monica to the canyon's mouth, located at what would later be the intersection of the Pacific Coast Highway and Sunset Boulevard. The land had been part of a Mexican rancho called Boca de Santa Monica and later became the Whitworth Ranch. To obtain the property, New York Motion Picture had to negotiate with three different companies. The Pacific Electric Railway owned the mouth of the canyon and leased it to the studio for $75 a month. Santa Monica Mountain Park Company held title to most of the ranch and rented the property to the manufacturer for an additional $2,400 a year. Balshofer recalled that the studio leased another section of the canyon from Santa Monica Water and Power Company. After coming to terms with all parties, Ince and his directors had 18,000 acres of some of the most scenic landscape in southern California for their exclusive use.[54]

Once committed to the location, Bison made many improvements to the canyon so it could film there year-round. During the summer months, water scarcity was a problem for all commercial filmmakers working in Los Angeles. Mobile production units could move to better-watered locales. The now firmly located Bison Company, however, had to install pumps and dams so crews could make the creeks flow on command even during the summer. The company also constructed a sprinkling system that helped keep dust down when it was dry.[55] Eventually, Ince turned Santa Ynez Canyon into an elaborate outdoor studio. By 1914 he had added an electrical power plant and telephone system and was growing vegetables and raising cattle to feed his growing workforce.[56] The canyon soon became known as "Inceville" (see Figure 4.2).

Having secured a large outdoor studio, New York Motion Picture increased its staff to produce the new feature westerns. Baumann and Balshofer leased a large portion of the nearby Miller Brothers' 101 Ranch Wild West Show that had been entertaining summer beach crowds in Venice, California. The troupe was among the most successful Wild-West shows of its day and cost New York Motion Picture $2,000 a week. With it came seventy-five cowboys, twenty-five cowgirls, and thirty-five Indians, as well as oxen, bison, horses, prairie

Fig. 4.2 Inceville. From Anthony Slide, Early American Cinema *(Metuchen, New Jersey: Scarecrow Press, 1994).*

schooners, and stagecoaches.[57] Adam Kessel now advertised the Bison troupe as "the largest stock company in the whole world" (see Figure 4.3).[58]

The Indian performers obtained from the 101 Ranch turned out to be the most important acquisition. They were a Ponca band originally from Oklahoma. As the company's needs increased, Native Americans were hired from throughout the Plains states and the Southwest and included Oglalas, Sincangus, Cheyennes, Poncas, Kiowas, Pawnees, Osages, Sac and Foxes, and Comanches.[59] In its promotional material, the New York Motion Picture Company presented these performers as though they were from a single tribe. To keep them readily accessible, the company moved the Indians into a tepee village at the crest of the southern ridge of Santa Ynez Canyon. When Ince and other filmmakers wanted to use the performers, they dealt with W. A. Brooks, a former Miller Brothers' employee whom New York Motion Picture hired to supervise the Indians' daily activities. If Brooks or the filmmakers had trouble communicating with the Natives, they used the services of several graduates of off-reservation boarding schools who were hired as interpreters.

IMPORTANT ANNOUNCEMENT

Realizing that the day of the ordinary cowboy and Indian picture has passed from public favor, a radical change has been made in the Bison company, and in the future nothing but

SENSATIONAL—SPECTACULAR— WESTERN—HISTORICAL— MILITARY SUBJECTS

will be released. To this end the entire stock company has been reorganized and new directors employed, the regular company now numbering sixty people. In addition, we have leased from the Miller Brothers their

Famous 101 Ranch Wild West Show

including the entire company of 350 people (riders, actors and Indians), together with their horses, equipment and paraphernalia. The Bison company now is unquestionably

THE LARGEST STOCK COMPANY IN THE WORLD

Scenarios have been especially written featuring incidents requiring.

Dare-Devil and Sensational Feats of Horsemanship

The massive productions now being made will create a furore wherever shown. We will begin releasing them in a few weeks.

Watch for Release Dates!

NEW YORK MOTION PICTURE CO., 1 Union Sq., New York City

Fig. 4.3 *New York Motion Picture advertisement for Bison-101 features. From* New York Dramatic Mirror, *December 6, 1911.*

The Indian performers were valuable assets to the film company. Native Americans possessing the requisite Plains costumes were still something of a rarity in Los Angeles. Before they arrived, Bison often had to hire ethnic Mexicans to play Indian roles.[60] The Miller brothers' group represented the first actual Native Americans the studio had employed full-time since James Young Deer and Lillian Red Wing left the company. The procurement of the troupe gave New York Motion Picture a distinct advantage in producing westerns, and it no doubt inspired Ince to focus exclusively on Indian-themed films.

When the 101 Ranch went on tour in the spring, Balshofer made arrangements with the Miller brothers for all the Indians to remain except for the show's star performers. When the tour ended in the fall, most of the Indian troupe returned to Santa Ynez Canyon, swelling the studio's ranks.[61] None of the Native Americans, however, remained at the site permanently. They worked only long enough to fill their trunks with goods purchased in Santa Monica and Venice and then returned to their reservations. Ince sent them back while making arrangements for new Indian actors to take their places.[62]

Eventually, New York Motion Picture Company circumvented the Wild-West show middlemen and employed Indians directly at salaries ranging from seven to twelve dollars a week.[63] At this point Ince had to sign an agreement with the Office of Indian Affairs—much like those required of Wild-West show operators—in which he assumed full responsibility for the Native performers' well-being. This arrangement helped fuel a paternalistic attitude on the part of Ince and his filmmakers toward the Indians.

Among other things, the producer was obliged to see that they had a minimum number of hours of education each day. By 1916 Ince had a two-story schoolhouse built next to the canyon's Indian village, and the boarding school graduates in the troupe served as teachers. Reflecting the current thinking of many white reformers, Ince felt the Indians could benefit most from remedial instruction. He explained to the trade press:

> There is no reason in the world why these Indians should not be given an education. . . . We don't expect to teach the Indians philosophy and economics, but we do intend to instill into their minds the rudiments of the elementary subjects. Their minds are susceptible to development along these lines and we are going to do our best to bring about the development.[64]

Over time, the Indians became just one of many groups of nonwhite performers housed at Santa Ynez Canyon. As Ince explained, the quest for realism necessitated that the "modern Motion Picture camp" maintain a "parliament of men." By around 1915, many different races, ethnicities, and nationalities were represented at the studio. Ince described his workforce in a way that revealed the studio's racial hierarchy:

Self-preservation demands that each distinct race be segregated from the other. The Indian scorns every race but the white race, for which he has a filial respect. The Hindu keeps by himself, where the shadow of others than his own caste can't cross his food. The Jap eats his bean curd and drinks his green tea peacefully, contemplating his next door neighbor, the Chinaman, whose territory he would like to annex. The Chinaman holds aloof . . . and casts furtive glances at the pepper-heated Mexican, whom he distrusts.[65]

The producer saw his own role as that of benevolent "white chief" who relied on kindness, tact, and diplomacy to get the culturally and racially diverse extras to perform before the camera.[66] He behaved like an amateur anthropologist, carefully observing and studying the interactions and customs of his heterogeneous workforce so he would know how best to motivate them.

With the exception of the great Japanese actor Sussue Hayakawa, Ince hired nonwhites mostly as extras. This was especially true for Indians, whom the producer placed in his westerns to enhance the realism of their settings and spectacles. Older Indian men like William Eagleshirt sometimes played small parts as tribal chiefs, but white actors in red face generally appeared in all important Indian roles (see Figure 4.4). Although earlier New York Motion Picture's James Young Deer had played unique and distinctive characters, in Ince's films Indian performers were relegated to large group scenes. Moreover, the firm released almost no promotional material on specific Bison Indians, and in part as a consequence of this policy, critics treated the Native actors as though they were little more than scenic elements.[67] They commented on the Natives' "magnificent physiques"; "dusky, glittering bodies"; and "brilliant robes" but singled out few individual performers.[68]

Ince employed many nonwhite actors within his centralized system of production, but they had almost no creative input. They became little more than cogs in what was now a motion-picture factory requiring the year-round labor of 500 people. To put out standardized, lengthy, and elaborate features on a routine basis, Ince introduced production methods that limited his employees' autonomy. He divided the labor of filmmaking into discreet and routinized tasks, and he controlled his underling directors by monitoring the continuity scripts from which they shot their films.[69] To many in the industry, Ince seemed a great "efficiency expert." One journalist noted that his whole "studio-ranch crackles with system."[70] On a visit to Santa Ynez Canyon, another observer described what he called the "every-minute efficiency" of Inceville:

Each of the numerous directors on the job at Santa Ynez canyon is given his working script three weeks ahead of time. When the time arrives for putting on a picture, the costumes are on the hooks of the tailor shop, locations are

Fig. 4.4 New York Motion Picture's "Film Fancies." From the collections of the American Heritage Center.

ready, props are on hand and the producer has had much time in which to familiarize himself with the script. Filled with the theme and action, he goes out and, with the cogs of the big Ince machine oiled to the smallest gear and the entire plant running as smoothly as an automobile in the hands of a salesman, the picture travels from beginning to end without delays.[71]

Ince did not integrate the 101 Ranch Indians into his Taylorized working environment without some resistance from them. At times they became in-

transigent, especially when acting in battle scenes. Ince found them "stolid, non-communicative," and altogether too peaceful. He later wrote that "arousing their anger sufficiently to attack the enemy with any semblance of reality" was among his most difficult tasks.[72] To Ince's further consternation, the Indians occasionally interrupted filmmaking by taking small props and refusing to return them.

The Indians also carved out a measure of autonomy with their recreational activities. They often went to Santa Monica to drink in the saloons. Such excursions created a problem for Ince because the Office of Indian Affairs held him accountable for the Natives' off-studio activities. Wild-West show operators had long struggled with similar problems, especially when Native American performers intentionally violated the "morals clause" of their government contracts to gain advantage over their employers.[73] Like the purveyors of this older amusement, Ince was concerned that any word that the Indians were drinking alcohol might give the Office of Indian Affairs cause to take them away. He eventually threatened the tavern owners with a lawsuit to prevent them from serving his actors.

As his Indian performers were sometimes reluctant participants, Ince found it most expedient when staging frontier spectacles for the camera to follow the contours of original 101 Ranch acts. By not having to reinstruct the troupe to perform in an unfamiliar manner, he saved time and money. Essentially, the warfare scenes in most Bison features were little more than variations on the two major historical reenactments in 101 Wild-West shows: Oklahoma's 1876 Pat Henry Massacre and the 1844 Mountain Meadows Massacre. Battle spectacles like these wagon train attacks provided the dramatic center of such Bison features as *War on the Plains* (NYMP, 1912), *The Deserter* (NYMP, 1912), *Blazing the Trail* (NYMP, 1912), and *A Soldier's Honor* (NYMP, 1912). Other films like *Memories of a Pioneer* (NYMP, 1912), *Indian Massacre* (NYMP, 1912), *The Post Telegrapher* (NYMP, 1912), and *A Little Daughter of the West* (NYMP, 1912) featured Indians attacking whites in other circumstances.

By 1912 wagon train attacks were hackneyed conventions of Wild-West shows, but Ince and his directors reinvigorated such spectacles. In this regard, Santa Ynez Canyon played a major role. Bison filmmakers used the natural contours of the vast outdoor studio to frame Wild-West spectacles in unique and dramatic ways. Typically, they moved the wagon train along the canyon floor and placed cameras at various heights along the ridge. Ince and his crews favored long shots to best show off the landscape and the large troupe of performers. At times they positioned cameras at great distances from the action, filling a given shot with natural scenery and leaving the action to a remote corner of the frame. By filming Bison-101 features in this manner, New York Motion Picture made the most of its investment in Santa Ynez

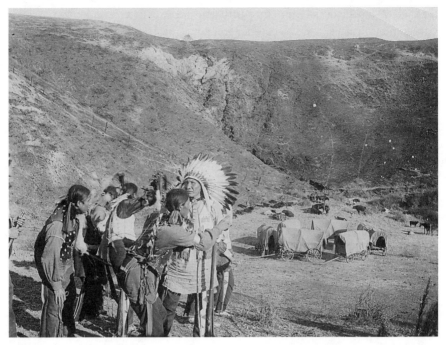

Fig. 4.5 Scene from Blazing the Trail *(1912). From the collections of the American Heritage Center.*

Canyon and offered audiences the kind of scenic splendor Wild-West shows could only suggest. Reviewers responded favorably to this cinematic technique.[74] A European critic noted that the company's westerns contained "a sense of space and of vastness seldom conveyed by a camera." He wrote that watching a Bison-101 film was like "standing upon the edge of a high cliff, gazing over leagues of virgin forest lands, and witnessing sometimes from afar off . . . a savage drama" (see Figures 4.5 and 4.6).[75]

Ince placed the camera at various points on the canyon ridge not only for aesthetic effect but also to capture scenes of warfare more effectively. At a time when filmmakers were still experimenting with ways to depict events occurring simultaneously in multiple spaces, the producer used the geography of his outdoor studio to best advantage. For example, in *War on the Plains* a group of cowboys comes to the rescue of settlers hostile Indians have sur-rounded. To distract the attackers, the cowboys set fire to the Indians' village, which is in a nearby canyon and away from the scene of the fighting. During this sequence Ince placed a camera high on the ridge that separated the be-

Fig. 4.6 Scene from Blazing the Trail *(1912). From the collections of the American Heritage Center.*

sieged settlers and the tepee village. From this location a camera pan back and forth alerts the viewer to the spatial relationships between the two events.[76] Critics appreciated Ince's solutions to such problems, heralding his "capacity for conceiving and executing large and impressive movements" of people in an intelligent manner.[77]

In addition to the warfare scenes, Bison filmmakers adapted other, less sensational aspects of the 101 Ranch Show—including its exhibition of everyday Indian life and customs. The Miller brothers, like many proprietors of Wild-West shows, opened their Indian village to audiences before and after performances so spectators could see up close how Natives actually lived. Bison producers echoed this aspect of the Wild-West show experience by featuring several brief scenes of tribal life in most of their westerns. The Bison-101 Indian village, similar from film to film, was usually made up of a tight cluster of a dozen or more tepees with fifty or so Indian men, women, and children standing or sitting outside and engaged in activities such as weaving, skinning animals, dancing, and cooking. These scenes satisfied Americans' and Europeans' curiosity about Indian life while also giving Bison-101 westerns further

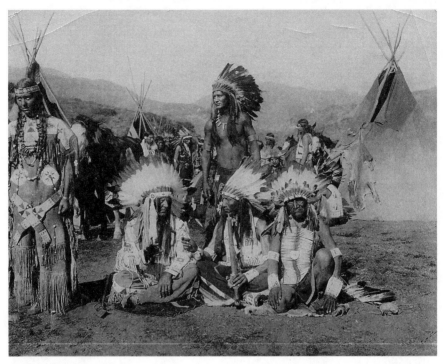

Fig. 4.7 Scene from Battle of the Redman *(1911). From the collections of the American Heritage Center.*

authenticity. Moreover, the views helped provide a contrast between the "dying" tribal way of life and the modern industrial European-American society that would supersede it. Bison filmmakers made this point even stronger by ending most of their westerns with the destruction of the Indian village (see Figure 4.7).[78]

Although there was little substance to Ince's frequent boast that he was the first to "put on a real Wild-West show" in motion pictures, he did—in the tradition of Selig's Otis Turner—integrate the amusement into the very marrow of the western film.[79] Plots were secondary elements of Bison-101 films. They unfolded in the shadows of complexly orchestrated Wild-West spectacles. As Richard V. Spencer, lead editor at the Bison Company, explained, scenarios for the company's feature westerns were based on simple themes "capable of spectacular development." He instructed would-be screenwriters to compose their stories in ways that allowed for maximum utilization of the large 101 staff and that did not tie filmmakers to the particulars of a narra-

tive.[80] The plots of Bison features, reviewers noted, tended to be thin, but they praised the films for the magnificence of their "savage pageantry."[81] One critic concluded that the company's westerns managed to thrill despite everyone knowing ahead of time that "the Indians are going to have a war dance and attack the settlers, that some hero or heroine will go through all sorts of perils to reach the military post, and that the troops will arrive in the nick of time."[82]

Subordinating plot to spectacle was nothing new in Ince's motion pictures, for cinema had traded on sensationalism from its inception. Like the purveyors of Wild-West shows, however, Ince and the Bison Company put frontier spectacle to a specific ideological purpose—"educating" the American public and international audiences about past conquests to promote the new standing of the United States as a global power. In using their westerns to serve American nationalism, Ince and his directors lent credibility to their spectacles, and as a consequence they distanced the genre from dime novels and other cheap amusements and expanded its appeal to middle-class pleasure seekers. In a world where the old colonial order was beginning to unravel, Bison-101 features, which time and again featured the heroics of the U.S. Cavalry, reminded audiences at home and abroad of the seasoned military might the nation might unleash against indigenous insurgents. Critic Louis Reeves Harrison congratulated the Bison Company for doing the country a great service by investing in grand martial spectacles that were accurate in their historical details. He decried the typical film that supposedly presented episodes of national development but dealt only in "stale and insipid love affairs" and ignored "the sufferings and struggles of American pioneers." To his way of thinking, Bison was setting an example by producing truly historical pictures that could proudly "tell our story abroad" and "be educational at home."[83]

The Bison Company's move away from melodrama and toward historical frontier spectacles designed to buttress American nationalism culminated in the film *Custer's Last Fight* (NYMP, 1912). In this picture Ince and his directors retold the incidents surrounding the Battle of Little Big Horn, beginning with the incursion of white settlers into Sioux territory and ending with the demise of Custer and his men. The film has a documentary-like quality that is enhanced by the naturalistic acting, especially by the Indian performers. The Bison producers paid special attention to the specifics of the military maneuvers and used intertitles to impart explanatory information. They presented the battle as a conflict over scarce resources and did not directly demonize the Indians. To heighten the realism, the filmmakers resisted adding overtly fictional elements. The company promised absolute accuracy and advertised that "a thousand soldiers" and "a thousand Indians" took part in this "re-enactment of the most tragic and heroic incident in the nation's history."[84]

Unlike most Bison-101 westerns, this feature ends with the defeat of whites. The filmmakers, however, attached an epilogue to the picture that helps place the battle in the context of America's imperial progress, or what Harrison called the larger "narrative beyond the tragedy."[85] The film ends with a dedication of a Custer monument on the battlefield site. As a group of soldiers stands at attention, a young white girl lays a ceremonial wreath at the foot of the marker. She represents the ultimate triumph of the civilization for which Custer and his men sacrificed their lives. This conclusion establishes the fallen soldiers as the heroes of the story and as martyrs to the cause of progress more effectively and convincingly than would have been the case if the filmmakers had resorted to turning the Indians into melodramatic villains.[86]

In a testament to its relative sophistication and to its subject's enduring popularity, Custer's Last Fight had a longer exhibition life than any other Bison-101 western. In 1925 theater operators were screening re-released prints of the film, and traveling showmen used it well into the sound era. In 1932 Robert R. Maskill purchased a print of the film, and for three years he exhibited it as part of a road show. He screened it throughout the Far West and the Midwest, including on many Indian reservations, and he continued to bill the film as "the greatest Indian frontier spectacle ever shown."[87]

Custer's Last Fight was Bison-101's most enduring film, but the series as a whole had a lasting impact on the western and on industry practices in general. These features captured the attention not only of the public but also of those in the motion-picture business. Even before their release, the trade press commented favorably on the films. According to a critic for Motion Picture World, the westerns were proof that independent manufacturers had joined the ranks of the world's most accomplished motion-picture producers. He urged distributors and exhibitors to reward New York Motion Picture's efforts by ordering its product liberally.[88] The firm's owners reinforced this reception by announcing that the studio's new "sensational-spectacular-western-historical-military subjects" represented a radical departure from "the ordinary cowboy and Indian picture."[89] They personally previewed them for exchange men and exhibitors around the world. Baumann escorted the initial Bison-101 westerns to major cities in Europe. H. J. Streychmans and Kessel conducted similar promotional campaigns in the United States.[90]

Bison-101 features were such a departure from the films preceding them, in terms of both length and production value, that the standard system of distribution and exchange was inadequate to handle them. Originally, New York Motion Picture released the films in the United States and Canada through the Sales Company, the firm that handled distribution for many independent manufacturers. The studio, however, soon realized that its expensive Bison features would be unprofitable at the traditional ten cents a foot the Sales

Company charged exchanges. At the outset, New York Motion Picture received only fourteen orders for its western features in the United States and Canada, a gross of only about $2,800 per film. To treat the Bison-101 productions in a more equitable manner, the Sales Company established a special features department that sold the exclusive territorial rights to films at the higher price of fifteen cents a foot. Handled in this way, the Bison-101 features were more attractive to exchanges because with no competition in their service areas, they charged exhibitors more for the films—and exhibitors in turn likely raised prices at their box offices.[91] The Sales Company quickly found buyers for all fifty American and Canadian territories it had created. This translated into a gross of about $15,000 per film.

As New York Motion Picture's features were forcing changes in the way independents distributed their films, they were also winning over western-weary critics. The *New York Dramatic Mirror* called one of the first films in the series "an exceptional and noteworthy achievement."[92] The journal's main film critic, "the Spectator," wrote of Bison-101 westerns:

> They are so far in advance of the general run of cowboy and Indian pictures that they mark a distinct and independent step in motion picture development. In quality of story, technique of construction and management, elaborate and comprehensive treatment and artistic effect [they are superior]. . . . The chief charm[s] of the 101 Bison series are . . . their apparent truthfulness and their manifest bigness without appearing to be overcrowded.[93]

Moviegoers were also pleased. Bison-101 films, the Pastime Theater in South Bethlehem, Pennsylvania, reported, had broken all box office records.[94]

Although these feature westerns took the industry by storm, their success was ultimately short-lived. New York Motion Picture lost the Bison-101 brand name when it joined the Universal Film Manufacturing Company and then, because of leadership disputes, defected. Carl Laemmle, who ascended to the presidency of Universal after Kessel's and Baumann's departure, as well as others in the organization felt all New York Motion Picture's assets and properties belonged to his company. He ordered that the firm's New York laboratory on 19th Street be broken into and then took over the operation. To prevent the same thing from happening at Santa Ynez Canyon, W. A. Brooks ordered the Bison Indians to dress in full costume and parade along a ridge in full view of anyone trying to enter the property. Meanwhile, Universal hired a minor Bison director, Frank Montgomery, who began to produce inferior western features under the Bison-101 imprimatur. Following a highly publicized court battle, Universal won the right to use the brand name, but New York Motion Picture kept the Santa Ynez Canyon studio as well as its equipment and staff.[95] Subsequently, Ince and his employees put out cowboy and Indian films under

the brand names Kay Bee and Domino. Not until actor William S. Hart became a major star in 1916, however, did the company's westerns achieve the level of success the original Bison-101 features had enjoyed.[96]

In the meantime, Ince and New York Motion Picture had demonstrated that westerns could still be a point of pride for the American film industry and that such pictures could appeal to a wide audience. With the release of the new Bison films, trade journalists' perennial attacks on the genre virtually ceased. By 1912 the editors at *Motion Picture News* noted that westerns were more frequently of a "refined and moral nature" as companies were "gradually drawing away from the artificial cowboy and the impossible sheriff and . . . turning to gigantic spectacles of true Western frontier life."[97] Although the genre's popularity would ebb and flow, the Bison features proved that as the aspirations of the industry changed, filmmakers could adapt the western to audiences' tastes.

NOTES

1. A. L. Barrnett, "Will Moving Pictures Always Be Popular?" *Motion Picture News (MPN)*, August 12, 1911, 12.

2. Mary Austin, "The Dramatic Values of Indian Life," *New York Dramatic Mirror (NYDM)*, March 29, 1911, 5.

3. Historian Lawrence Levine discusses the development of a cultural hierarchy in America during the late nineteenth century and the subsequent coinage of the terms *highbrow* and *lowbrow*. The former referred to cultural products that were "highly intellectual" or "aesthetically refined," and the latter designated material that supposedly lacked those qualities. The terms were derived from the phrenological terms *highbrowed* and *lowbrowed*. Lawrence W. Levine, *Highbrow/Lowbrow: The Emergence of Cultural Hierarchy in America* (Cambridge, Mass.: Harvard University Press, 1988), 221–222. A great deal had been written on the history of "cheap amusements" and the relationship of the working class to commercial culture at the turn of the twentieth century; see, for example, Roy Rosenzweig, *Eight Hours for What We Will: Workers and Leisure in an Industrial City, 1870–1920* (Cambridge: Cambridge University Press, 1983); David Nassaw, *Going Out: The Rise and Fall of Public Amusements* (New York: Basic Books, 1993); John Kasson, *Amusing the Million: Coney Island at the Turn of the Century* (New York: Hill and Wang, 1978); Kathy Peiss, *Cheap Amusements: Working Women and Leisure in Turn of the Century New York* (Philadelphia: Temple University Press, 1986); Elliott J. Gorn, *The Manly Art: Bare-Knuckle Prize Fighting in America* (Ithaca: Cornell University Press, 1986), 129–144; Alan Havig, "The Commercial Amusement Audience in Early 20th-Century Cities," *Journal of American Culture* 5 (Spring 1982): 1–19.

4. "The Forgotten South," *MPN*, October 15, 1910, 6.

5. The consumers of dime novels and melodrama did not always divide along class lines. For example, Michael Denning has pointed out in his study of dime-novel fiction that as the nineteenth century came to a close, the cheap-fiction industry marketed less to working-class adults and increasingly focused on young readers of all social backgrounds. He argues that by 1900 the story papers' historical association with the

working class had diminished; see Michael Denning, *Mechanic Accents: Dime Novels and Working-Class Culture in America* (London: Verso, 1987), 27–46. Although this may be true, the perception of those in the motion-picture industry who sought a more affluent audience was that dime fiction was a working-class amusement. The audience for "ten-twenty-thirty" melodrama was also mixed but tended to be weighted toward lower-middle-class consumers; see Nassaw, *Going Out*, 40–43; Harry James Smith, "The Melodrama," *Atlantic Monthly* (March 1907): 322.

6. The industry trade press speculated that the nickelodeon was inheriting its audience from the dime-novel industry; see "The Press and the Moving Picture," *Motion Picture World* (*MPW*), March 20, 1909, 325.

7. The gentrification of cinema in the United States during the nickelodeon period has been a much discussed and debated topic in film history. For insightful analysis, see Robert C. Allen, "Motion Picture Exhibition in Manhattan, 1906–1912: Beyond the Nickelodeon," *Cinema Journal* (Spring 1979): 2–15; Russell Merritt, "Nickelodeon Theaters, 1905–1914: Building an Audience for the Movies," in *The American Film Industry*, Tino Balio, ed. (Madison: University of Wisconsin Press, 1976), 59–82; Lary May, *Screening Out the Past: The Birth of Mass Culture and the Motion Picture Industry* (New York: Oxford University Press, 1980); Tom Gunning, *D. W. Griffith and the Origins of American Narrative Film: The Early Years at Biograph* (Chicago: University of Illinois Press, 1991); Miriam Hansen, *Babel and Babylon: Spectatorship in American Silent Film* (Cambridge, Mass.: Harvard University Press, 1991), 60–89; Roberta E. Pearson, *Eloquent Gestures: The Transformation of Performance Style in the Griffith Biography Films* (Berkeley: University of California Press, 1992), 120–139; William Uricchio and Roberta E. Pearson, *Reframing Culture: The Case of the Vitagraph Quality Films* (Princeton: Princeton University Press, 1993); Sumiko Higashi, *Cecil B. DeMille and American Culture: The Silent Era* (Berkeley: University of California Press, 1994), 7–29; Ben Singer, "Manhattan Nickelodeons: New Data on Audiences and Exhibitors," *Cinema Journal* (Spring 1995): 5–35; Robert Allen, "Manhattan Myopia; or, Oh! Iowa!" *Cinema Journal* (Spring 1996): 75–103; Steven J. Ross, *Working-Class Hollywood: Silent Film and the Shaping of Class in America* (Princeton: Princeton University Press, 1998).

8. The dime-novel industry was a frequent target of middle-class reformers during the second half of the nineteenth century; see John Springhall, "The Dime Novel as Scapegoat for Juvenile Crime: Anthony Comstock's Campaign to Suppress the 'Half-Dime' Western of the 1880s," *Dime Novel Round-Up* (August 1994): 63–72.

9. *MPW*, August 27, 1910, 452.

10. "Dime Novel Effect," *Motography*, January 18, 1913, 31–32.

11. *MPW*, December 3, 1910, 1301.

12. For a discussion of David Horsely and the Motive Motion Picture Company, see Ross, *Working-Class Hollywood*, 149–151.

13. Springhall, "The Dime Novel as Scapegoat for Juvenile Crime," 63–72.

14. "To Picture Tousey's 'Wild West' Stories," *MPW*, June 1, 1912, 810.

15. *MPW*, July 20, 1912, 261.

16. *MPN*, July 20, 1912, 17.

17. *MPW*, August 3, 1912, 547.

18. *MPW*, August 31, 1912, 870.

19. "Emulate Wild West Men and Robbers Seen in Moving Pictures," *MPW*, April 25, 1908, 396.

20. *MPN*, September 30, 1911, 25.

21. *MPN*, October 22, 1910, 12.

22. "Cowboy Films Forbidden," *NYDM*, July 26, 1911, 20; *MPW*, August 5, 1911, 302.

23. *MPW*, February 17, 1912, 558.

24. "An Exhibitor's Complaint," *MPN*, November 18, 1911, 22.

25. *MPW*, February 17, 1912, 558.

26. Stephen Bush, "The Overproduction of Western Pictures," *MPW*, October 21, 1911, 189.

27. "The Indian and the Cowboy," *MPW*, December 17, 1910, 1399.

28. "Wild West Pictures," *MPN*, November 18, 1911, 6.

29. *MPN*, August 12, 1911, 12.

30. "Wild West Pictures," 6.

31. "The Passing of the Western Subject," *Nickelodeon*, February 18, 1911, 181.

32. Bush, "Overproduction of Western Pictures," 189.

33. "Pictures That Children Like," *Film Index*, January 21, 1911, 3.

34. *MPW*, August 5, 1911, 280.

35. *MPW*, September 24, 1910, 698.

36. "Gradations in Service," *MPW*, May 2, 1914, 645.

37. *MPW*, July 22, 1911, 109.

38. Bush, "Overproduction of Western Pictures," 189.

39. *MPN*, November 25, 1911, 5.

40. Roberta Pearson in *Eloquent Gestures* finds a similar process occurring in the development of the "realistic" acting style in Biograph films during this period. Verisimilar acting was viewed as a way to legitimate film as an entertainment form for the middle classes.

41. On Frank Norris's ideas of naturalism, see Richard W. Etulain, *Re-imagining the Modern American West: A Century of Fiction, History, and Art* (Tucson: University of Arizona Press, 1996), 21–23.

42. "Passing of the Western Subject," 181.

43. "Tired of Western Pictures," *MPW*, February 17, 1912, 590.

44. "A Misrepresented West," *MPN*, September 24, 1910, 11.

45. *MPW*, October 21, 1911, 189; October 19, 1912.

46. William H. Kitchell, "The Films of the Future," *MPW*, December 9, 1911, 811.

47. For further explication of the idea that the melodrama was an unsettling form of entertainment for many in the middle class, see Stanley Corkin, *Realism and the Birth of the Modern United States: Cinema, Literature, and Culture* (Athens: University of Georgia Press, 1996), 24.

48. "Bison 101 Feature Pictures," *MPW*, January 27, 1912, 298.

49. Kenneth O'Hara, "The Life of Thomas H. Ince, Part I," and "The Life of Thomas Ince, Part V," *Picture Play Magazine* 6, no. 3, 20–26 and 64–74, Ince Biography File, Motion Picture Division, Library of Congress, Washington, D.C.

50. Thomas H. Ince, "History and Development of the Motion Picture Industry," 1921, unpublished manuscript, Arts Library, UCLA, Los Angeles.

51. Quoted in Anthony Slide, *Early American Cinema* (Metuchen, N.J.: Scarecrow, 1994), 84.

52. Thomas H. Ince, "Is the Motion Picture a Fad?" *Motography*, January 9, 1915, 51.

53. Ince, "History and Development of the Motion Picture Industry," 47–48.

54. On New York Motion Picture's acquisition of Santa Ynez Canyon, see lease between Ince and Pacific Electric Railway, "Correspondence 1917, July 20–Aug.," box 15, Aitken Papers, Wisconsin Historical Society, Madison; lease between Ince and Santa Monica Mountain Park Company, "Correspondence 1917, Oct.," box 15, Aitken Papers, Wisconsin Historical Society, Madison; Fred J. Balshofer and Arthur C. Miller, *One Reel a Week* (Berkeley: University of California Press, 1967), 75; ibid., 16, 19.

55. "Western Operations of the New York Motion Picture Company," *MPW*, August 24, 1912, 777.

56. J. Boothe, "Thomas H. Ince, Director Extraordinary," *Motography*, May 16, 1914, 335.

57. Balshofer and Miller, *One Reel a Week*, 76.

58. "Bison Company Gets 101 Ranch Wild West," *MPN*, December 2, 1911, 14.

59. On the Indians of the 101 Ranch Wild West Show, see Ellsworth Collings, *The 101 Ranch* (Norman: University of Oklahoma Press, 1937), 168–170; L. G. Moses, *Wild West Shows and the Images of American Indians 1883–1933* (Albuquerque: University of New Mexico Press, 1996), 176–188.

60. Thomas H. Ince, "The Early Days at Kay Bee," *Photoplay* (March 1919): 44.

61. *Motography*, October 12, 1912, 299; *MPW*, October 26, 1912, 313.

62. Oral history of Ann Little in "The Westerns in the 1920s," conducted by Robert Birchard, American Film Institute, Los Angeles, California.

63. "Indian Actors," *Photoplay* (February 1913): 111.

64. Quotation in "Ince to Start School," *MPW*, February 19, 1916, 1111–1112; "Ince Opens Indian School," *Motography*, March 4, 1916, 524.

65. Thomas H. Ince, "Troubles of a Motion Picture Producer," *Motion Picture Magazine*, undated, Ince clipping file, Blum Collection, Wisconsin Center for Film and Television Research, Madison.

66. Ince, "History and Development of the Motion Picture Industry," 19.

67. Louis Reeves Harrison, "The 'Bison-101' Headliners," *MPW*, April 27, 1912, 321.

68. *Bioscope*, April 4, 1912, 65. The Indians were not alone in having to toil anonymously at Santa Ynez Canyon. Ince kept the vast majority of his actors interchangeable so he could easily replace them. Indeed, one critic suggested that Bison achieved realism in its westerns in part by not allowing any of its players "an undue prominence." *Bioscope*, April 25, 1912, 291.

69. Ince did not have complete control over production. Bison director Irvin Willat remembered that he rewrote all the scripts handed down from the scenario department so he could direct films in the way he thought fit. Ince was not involved in this final rewriting, nor did he even see the last version before shooting began. Oral history of Irvin Willat in "The Westerns in the 1920s," 17–18, conducted by Robert Birchard, American Film Institute, Los Angeles, California.

70. Harry C. Carr, "Ince: Rodin of Shadows," *Photoplay* (July 1915), Locke Scrapbooks, New York Public Library, Lincoln Center, New York City.

71. "Tom Ince of Inceville," *NYDM*, December 24, 1913, 34.

72. Ince, "History and Development of the Motion Picture Industry," 17.

73. Moses reports at least one incident where Sioux Indians associated with the 101 Ranch Wild West Show tried to gain the upper hand over their employer by consuming alcohol to intentionally threaten the show's contract with the Office of Indian Affairs. See Moses, *Wild West Shows*, 185.

74. *NYDM*, April 24, 1912, 27.

75. *Bioscope*, April 4, 1912, 63–65.

76. A copy of *War on the Plains* is housed in the Motion Picture Division, Library of Congress, Washington, D.C., under the title "Men of the Plains."

77. *NYDM*, May 22, 1912, 34.

78. Typical Bison-101 Indian villages can be seen in such extant films as *War on the Plains* (1912), *Indian Massacre* (1912), *The Battle of the Red Men* (1912), and *The Deserter* (1912), all housed in the Motion Picture Division of the Library of Congress, Washington, D.C., and in *The Lieutenant's Last Fight* (1912) and *The Post Telegrapher* (1912) from the Netherlands Film Museum, Amsterdam.

79. See, for example, "Thomas H. Ince's Rapid Rise to Fame," *NYDM*, May 27, 1916, Locke Scrapbooks, New York Public Library, Lincoln Center, New York City.

80. *MPW*, March 30, 1912, 1163.

81. *Bioscope*, April 4, 1912, 63.

82. Harrison, "The 'Bison-101' Headliners," 321.

83. Ibid.

84. Quotation in *NYDM*, June 19, 1912, 33; May 29, 1912, 32.

85. Louis Reeves Harrison, "Custer's Last Fight," *MPW*, June 15, 1912, 1116.

86. *Custer's Last Fight*, Motion Picture Division, Library of Congress, Washington, D.C.

87. R. R. Maskill, "Yesterday's Memories Today," Classic Film Collector, undated, 47, in Box 4, "Newspaper Clippings," Tex Jordan Collection, American Heritage Center, Laramie, Wyoming.

88. *MPW*, February 24, 1912, 659.

89. *NYDM*, December 6, 1911, 35.

90. "Boosting New Bison Films," *NYDM*, January 31, 1912, 60.

91. "Big Independent Developments," *NYDM*, April 3, 1912, 27; "'101' Bison Problem Solved," *NYDM*, April 10, 1912, 25; "Bison Features for Special Release," *MPW*, April 27, 1912, 322.

92. *NYDM*, February 28, 1912, 37.

93. *NYDM*, April 17, 1912, 25.

94. *MPW*, April 20, 1912, 252.

95. On the dispute between Universal and New York Motion Picture, see Balshofer and Miller, *One Reel a Week*, 83–91; *NYDM*, July 3, 1912, 26; July 10, 1912, 27; *MPW*, July 20, 1912, 235; July 27, 1912, 335; August 3, 1912, 533; *NYDM*, August 7, 1912, 27; August 14, 1912, 25; *Motography*, August 17, 1912, 146–147; *NYDM*, September 4, 1912, 26; September 11, 1912, 26; October 2, 1912, 31; *MPW*, October 5, 1912, 51; *NYDM*, October 16, 1912, 27; October 23, 1912, 26; *MPW*, October 26, 1912, 313.

96. Balshofer and Miller, *One Reel a Week*, 91.

97. *MPN*, May 3, 1913, 14; December 21, 1912, 14.

"THE MAKING OF BRONCHO BILLY"

Gilbert M. Anderson Creates the Western-Film Hero

"Broncho Billy" has been grinding out the better sort of Wild West Indian pictures. Every one of 'em has a healthy moral. . . . They do a boy no more harm than shooting the chutes or drinking a glass of ginger beer. Movie experts have continued to wonder how in the dickens Billy does it . . . concoct those blood-and-thunders, without the almost inevitable back-fire. They have shootin' and stage-coach hold-ups and brawls in mining camps, and long, hard pony rides and Indian massacres . . . every grim ingredient of Beadle at his best, but somehow the "stinger" is removed in a mysterious manner. It's all been a jolly, Peter-Pannish lark, sweetened by a moral at the end and with Billy's bright eyes and hypnotic smile shining at you through the rifle smoke.[1]

<div align="right">—Journalist W. Livingson Larned, undated</div>

The picture theatre public has now had an opportunity of beholding that immortal personage, Broncho Billy, in almost every sort of situation, under almost every sort of circumstance, and yet in spite of everybody's familiarity with every aspect of his many-sided character, his popularity increases daily. The truth is that, thanks to his sterling manly qualities, his pluck, and his iron strength of will . . . we have all learned to regard him with a genuine affection. We have ceased to think of him as an imaginary figure in a series of imaginary romances. He has become for us a personal friend and comrade, to whom we can turn by the agency of the cinematograph.[2]

<div align="right">—Bioscope, 1914</div>

Although cowboy characters had figured in cinema since the medium's inception, Gilbert M. Anderson's "Broncho Billy" was among the first film audiences could readily identify. Anderson played his western hero dressed in a simple costume consisting of baggy denim pants, a dark collared shirt, leather gauntlets, boots, and a wide studded belt. Broncho Billy—an unpropertied cowboy loner—was part social bandit, part country rube, part crime fighter and detective. Typically, he lived as an outlaw and an outcast

until undergoing a reformation that instilled in him a newfound sense of re-
sponsibility to women and children. Anderson's cowboy hero rarely took part
in Indian fighting, westward migration, or other activities associated with empire
building on the frontier. The dramatic conflicts in his films were psychologi-
cal rather than social or economic.

Anderson created Broncho Billy for the same reasons New York Motion
Picture developed the Bison-101 feature: to reinvigorate demand for west-
erns. When the filmmaker and his stock company first toured the West, they
had little competition in the market for "authentic" cowboy and Indian mo-
tion pictures. By 1911, however, many manufacturers had production units
working in the region, and according to some exhibitors, domestic demand
for such films was waning. In the face of a shrinking market, Anderson be-
came less concerned with the cinematic representation of the "actual" West
and concentrated more on the development of a heroic figure who could
capture moviegoers' attention. Such a character, the filmmaker hoped, would
bring audiences back to theaters weekly.

Anderson shaped his cowboy hero particularly in response to those moral
crusaders—both within and outside the industry—who were disturbed by de-
pictions of crime, violence, and interracial sex in cowboy and Indian pictures
and who equated the genre with "cheap amusements" and "lowbrow" tastes.
Nearly fifty years later historian Henry Nash Smith argued that the western
story's social and ethical relevance had diminished in the eyes of twentieth-
century Americans because the concept of "virgin wilderness" no longer held
sway in an industrial and increasingly urban nation; but beginning in 1911
Anderson and Essanay Film Manufacturing attempted to resacralize the fron-
tier drama by imbuing it with traditional, middle-class ideals of morality, man-
hood, and character.[3] The company began to market its westerns as "uplifting"
entertainment for the entire family, and it presented Broncho Billy as an ethi-
cal role model who could teach moral lessons to children, helping them achieve
personal success.

As the first cowboy star, Broncho Billy challenges the notion, advanced
by scholar Jane Tompkins, that the western was a reaction against women's
entrance into the public sphere during the late nineteenth century and against
the Victorian moralities they espoused.[4] Tompkins has argued that creators of
cowboy and Indian films rejected Protestantism and domesticity and celebrated
manliness, physical power, and endurance. Although this is an accurate de-
scription of westerns of the mid-1920s and of the sound era, the genre's first
heroes did not turn their backs on home life, the church, or the moral author-
ity of women. In westerns of the period 1911–1919, Broncho Billy and other
cowboy figures routinely affirmed the durability of Victorian values, and in the
process they helped make movie houses comfortable for middle-class families.

During the first three years that Anderson and his production unit traveled the West, they did not develop a single dominant hero figure. Instead they featured a variety of characters, including Mexicans, Indians, rubes, and villains. Their main concern was to create sensational films that took advantage of unique and authentic scenery. Yet as Anderson's fame grew and audiences began to associate him with white cowboy roles, it became increasingly clear that his characterizations, not real western landscapes, were what most distinguished Essanay's offerings. Moreover, by 1911 Anderson noted that the demand for his company's westerns was fading. The industry had overproduced such films, and although they were still popular abroad, the domestic market appeared flooded. Exhibitors who had built larger and better-appointed theaters questioned the genre's ability to attract middle-class customers.[5] In response, Anderson decided to introduce into his westerns what he called a "central figure for the audience to get interested in."[6]

Anderson believed that by creating such a character he could effectively distinguish his product and profit from his increasing renown with motion-picture audiences. Inspired by the number of fan letters he received addressed to "Broncho Billy," a role he had played in the motion picture *Broncho Billy's Redemption* (Essanay, 1910), Anderson began incorporating the character into virtually all his films.[7] He standardized his cowboy costume and constructed his scenarios to foreground the new figure's personality and psychology.[8] At the same time, Essanay increased the publicity surrounding Anderson himself. Just a few months before the release of the new series, the company billed him as "the most photographed man in the world." Essanay maintained that 300,000 moviegoers around the globe saw him daily and that his face was almost as familiar to Americans as that of President William Howard Taft.[9]

As Anderson placed more emphasis on his cowboy heroes, nomadic production made less sense.[10] Therefore, in 1912 he built a studio in the northern California town of Niles. Essanay purchased land 200 yards from the town's railroad station. Anderson erected six bungalow cottages to house company employees and their families. According to Charlie Chaplin, who for a time lived and worked with Anderson at Niles, these accommodations were rustic, to say the least:

> It was dark when we entered his bungalow, and when we switched on the light I was shocked. The place was empty and drab. In his room was an old iron bed with a light bulb hanging over the head of it. A rickety old table and one chair were the other furnishings. Near the bed was a wooden box upon which was a brass ashtray filled with cigarette butts. . . . Nothing worked. The bathroom was unspeakable. One had to take a jug and fill it from the bath tap and empty it down the flush to make the toilet work.[11]

Anderson also had an indoor studio constructed as well as developing rooms, a carpenter shop, an office, horse stables, and garages. Later he added tennis courts and renovated a baseball diamond where the company's team, the Essanay Indians, practiced and held its games.[12] By the end of 1912, nineteen actors and twenty-one other personnel worked at the studio, staffing three separate production crews.[13] Anderson and his unit alone could produce nearly a western a day at a cost of $700 to $800 each.[14] During one particularly sunny period in March 1914, they set a studio record by completing six films in a week.[15]

At a time when most major film companies were settling in southern California, Anderson chose Niles Canyon based in part on the quality of its landscape. He told an interviewer, "I wanted good rough Western scenery. . . . I looked at Los Angeles and didn't like it."[16] He was also impressed by the citizens of Niles, who welcomed the company and were refreshingly cooperative.[17]

Yet perhaps as important as anything to Anderson's choice was Niles's proximity to San Francisco's vibrant theatrical community. At the time, Los Angeles was something of a backwater in terms of the dramatic arts. Filmmakers who settled there could hire talent from the city's downtown vaudeville houses, but Anderson's needs were much greater.[18] For him, the movies were mostly a way to finance his ventures in the production of live musical comedy, and for several years he had been using a significant percentage of his share of Essanay profits to buy his way into the field. During 1908 and 1909 he and a partner took over the management of Chicago's Bush Temple Theater. Nathaniel Anderson, Gilbert's older brother, performed as a member of the stock company there and likely looked after the filmmaker's interests while the latter was away in the West. Later Anderson, a second partner, and Nathaniel embarked on a more ambitious theatrical undertaking: converting an old roller skating rink into a legitimate house called the San Souci.

With a seating capacity of 1,200, the San Souci was among the biggest venues in Chicago. Anderson hoped to fill it by offering quality, "high-class" entertainment at low admissions.[19] By selling more tickets, he believed, the theater could make up the cost of the more expensive dramatic and musical offerings. Anderson had miscalculated. Although the featured acts received strong reviews, the theater was not profitable, and he had to close the house before its first season ended. The same fate befell his stock company at the Bush Temple Theater.[20]

The success of Essanay westerns afforded Anderson the opportunity to pursue in even more extravagant fashion his dream of becoming a theater mogul. Once settled in Niles, he built the 1,600-seat Gaiety Theater in San Francisco to present high-quality musical comedy at reduced admissions. Anderson spent much of his time living in San Francisco's Saint Francis Hotel,

looking after his theatrical ventures and traveling back and forth to Niles to make films. He became increasingly isolated and uninterested in moviemaking. Chaplin recalled of Anderson at this time:

> His indulgences were flamboyantly colored cars, promoting prize fighters, owning a theatre and producing musical shows. When he was not working in Niles, he spent most of his time in San Francisco, where he stayed in . . . hotels. He was an odd fellow, vague, erratic and restless, who sought a solitary life of pleasure; and although he had a charming wife and daughter in Chicago, he rarely saw them. They lived their lives separately and apart.[21]

Anderson's ventures in producing live entertainment in San Francisco were no more successful than they had been in Chicago. His managing director at the Gaiety, S. F. Rosenthal, quit a year and a half into the venture, and Anderson had to close down the theater in 1915, reporting losses of $200,000. A second financial setback befell the filmmaker the same year when he lost another $100,000 in New York trying to start a musical comedy company called the "Anderson Players."[22]

Although his business instincts seemed to fail him at every turn when it came to legitimate theater, Anderson continued to have extraordinary success in motion pictures. The medium seems to have suited him. Perhaps this was because, unlike the stage, he had nearly complete creative control over production and could respond quickly to audiences' changing demands. Not only was Anderson one of the most popular motion-picture stars of his era, he was a director in charge of his own production unit, a producer who headed his own studio, and half owner of one of the country's largest film-manufacturing firms. As he was involved in almost every aspect of the production process, his position was unique among early film moguls.

With his significant power and influence, Anderson had a great deal of flexibility in developing and modifying his western hero. He and the Essanay Film Company responded successfully to fans' tastes, the dictates of censorship boards, and social reformers who demanded wholesome films. These forces increasingly led the filmmaker to modify the outlaw figure as it appeared in the first crime westerns and to create a central protagonist who exhibited paternal qualities and deferred to traditional middle-class religious and cultural values.

In pictures like *The Hold-Up of the Leadville Stage* (Selig, 1904), *The Bandit King* (Selig, 1907), *The James Boys in Missouri* (Essanay, 1908), *The Younger Brothers* (Essanay, 1908), and *The Road Agents* (Essanay, 1909), Essanay, Selig, and other domestic manufacturers featured western bad-men characters to exploit such figures' popularity with working-class audiences. In this regard, American filmmakers were participating in a popular cultural tradition that

was several decades old. According to historian William A. Settle Jr., lingering sectionalism, economic rivalry between Chicago and smaller cities in the Midwest, labor unrest, and Granger and Populist sentiment against railroads and banks gave rise in the 1880s to the folk hero status of Jesse James and others.[23] Anonymous balladeers depicted such figures as champions of the rural working class who "robbed the rich of every stitch" and redistributed the money to the needy.[24] Those involved in cheap commercial amusements, particularly dime-novel writers and producers of stage melodrama, picked up this tradition and widely celebrated western bandits into the twentieth century.

Edward Wheeler was among the first dime-fiction writers to create a western hero who defied the law and disrupted social order by robbing stagecoaches and banks.[25] According to historian Michael Denning, it was no coincidence that Wheeler's Deadwood Dick series, enormously popular from 1877 to 1903, began the same year as the national railroad strike. Dime novelists, he argued, appealed to working-class readers by modernizing the traditional social bandit tale and placing it in a capitalist context. Wheeler and others took the original targets of such outlaws—feudal lords and aristocrats—and transformed them into railroads, banks, and other corporate villains. Cheap-fiction writers celebrated western bank robberies and train holdups as heroic actions that upheld a moral economy in the face of market forces that seemed particularly unfair and destructive. In this way, the dime-novel industry exploited an anticapitalist—particularly antirailroad—sentiment pervasive at the time among working-class people.[26]

The real Jesse James and Cole Younger and the fictional Deadwood Dick were the central inspirations behind the so-called good/bad-man figure Anderson and others adapted for early western films. As those in the motion-picture business would soon discover, however, middle-class social reformers sometimes looked the other way when it came to the depiction of social banditry in dime novels or stage melodrama, but they were more vigilant about policing the cinema for such material. In 1908 the Chicago censorship board prohibited Essanay's *The James Boys in Missouri* from being exhibited in the city. Nickelodeon owner Jake Block ignored the commission's dictate and showed the film anyway, along with another banned picture, *Night Riders*. The police fined Block, and he contested the action in the Illinois Supreme Court. He argued that because James was a significant figure in American history and the city did not similarly restrict stage productions with identical content, the film had been unfairly censored. Justice C. J. Cartwright held against Block, holding that nickelodeons should be under the strictest censorship because of the large number of children and working poor who attended them. Although he agreed that the film about Jesse James was historical, it did not follow that it was not also immoral.[27] In 1911 other cities followed Chicago's lead and banned

films about the James brothers, including Minneapolis, Minnesota; Detroit, Michigan; Bowling Green, Kentucky; and Parsons, Kansas (see Figure 5.1).[28]

Although Block tried to challenge the Chicago censorship board, other exhibitors—particularly those in the West and Midwest who wanted to attract a middle-class family trade—practiced self-censorship and refused to screen films glorifying criminal activity. In 1907 Charles Stebbins, a Kansas City, Missouri, optician turned film exhibitor, warned the Selig Company not to send him "anything of the highway robbery or hold-up nature," as he would not exhibit such material. Similarly, in March 1909 exhibitors in some western towns refused to screen Essanay westerns, complaining that their depiction of banditry showed the region and its people in a poor light.[29] Over the next few years these protests became even more pronounced.

Trade journalists who wanted to elevate the movies' cultural position also objected to crime westerns, particularly Jesse James films. In 1911, when an unidentified manufacturer released *The James Boys in Missouri*—likely a re-release of the 1908 Essanay film—there was an outcry among trade journalists. They were particularly concerned that the picture depicted the outlaws' mother supporting her sons' criminal activity. Critics felt this would surely offend reform-oriented women. Everyone who ran film exchanges, a writer for *Motion Picture News* suggested, should raise their voices in protest over being sent such a film that clearly desecrated the home and family. A woman writing for the trade journal denounced *The James Boys* as "a menace to order and an incentive to lawlessness." Another critic encouraged politically organized women—including suffragists, members of the Women's League of Clubs, and those involved in the Woman's Christian Temperance Union—to "rise up" against such blatant "polluting" of children's minds.[30]

As a result of earlier problems and protestations like these, as well as events such as the Christmas Day closing of all New York nickelodeons by Mayor George B. McCellan Jr., the Edison Trust manufacturers established the National Board of Censorship in 1909. The patent companies financed the board, and it operated in conjunction with the People's Institute settlement house. Its executive committee was staffed largely by wealthy Protestants who monitored industry product for adherence to traditional, family-based, middle-class values. As historian Lary May has pointed out, the introduction of industry-wide censorship signaled motion-picture producers' growing realization that the suggestion of immorality in their films was bad for business. Producers hoped the board would appease middle-class Americans who saw motion pictures, particularly crime films and pictures with sexually suggestive content, as a threat to social order.[31]

Essanay adjusted its product to meet these new standards. Anderson never again produced anything celebrating western banditry as openly as did the

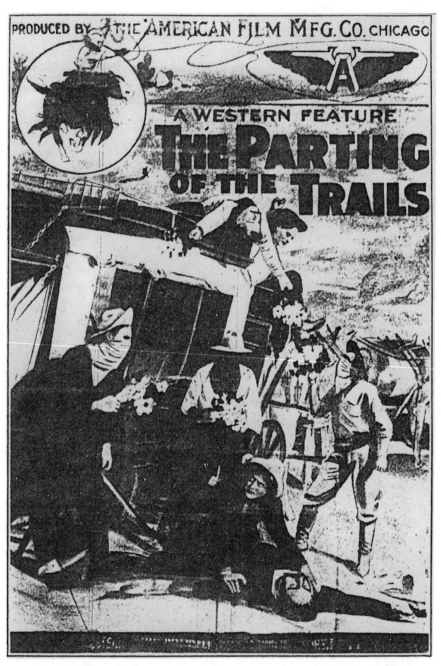

Fig. 5.1 Censored western-film poster; flower bouquets painted over guns. From Moving
Picture World, September 30, 1911.

films he or his employee Lawrence Lee had made prior to the establishment of the board. Pictures about Jesse James, Cole Younger, or any other historical western bandits were now clearly beyond the pale of acceptability. Moreover, by 1910 Anderson had eliminated most actual scenes of holdups from his films and now merely suggested their occurrence.

Even at the height of protests against crime films, however, Anderson less abandoned than domesticated the western outlaw. Such characters were still popular with moviegoers, especially those who questioned the Victorian values censorship boards promoted. At this time many groups in the United States—including immigrants, African Americans, intellectuals, writers, farmers, businessmen, and efficiency experts—challenged some element of what historian Henry F. May has called the "standard American credo" of the nineteenth century: a commitment to Protestant morality, faith in progress, and belief in the supremacy of Anglo-American culture.[32] Partly for this reason, the film outlaw not only survived the early attacks but went on to flourish. By 1914, in the estimation of Motion Picture World's Louis Reeves Harrison, the character had replaced the cowboy as the most popular type of motion-picture hero. For Harrison, the shift was symptomatic of Americans seeking to unshackle themselves from Victorian tradition:

> The individual who commits a crime of heroism or tells a noble lie is . . . to our taste. Our inherent sense of justice . . . has made us considerate of human weakness in many of its forms and inclined to throw off the icy hands of precedence and legal procedure. I do not know of any audience more generally representative of national opinion than that of the moving picture show, and its sympathy for the big-hearted outlaw has a decided significance.[33]

If the film bandit became one of the most popular heroes of the cinema, it was largely because of the ability of Anderson and others to appease critics by creating an outlaw character who suggested irritation with nineteenth-century mores but did not wage Jesse James–style attacks on the engines of progress. According to scholar Eric J. Hobsbawm, actual social bandits fought incorporation to protect traditional ways of life, practicing what he termed "revolutionary traditionalism."[34] Anderson's heroes engaged in less threatening activity. Instead of fighting corporate capitalism, they rebelled against the rigid dictates of Victorianism—and they did so in a way that did not even fundamentally challenge traditional ideals. To put it another way, if the filmmaker's western outlaws threw off the "icy hands of precedence" with one hand, with the other they were likely reaching for a Bible.

At their most radical, Anderson's western bandits were antiheroes who raised new doubts and questions about old nineteenth-century verities. But like many real people at the time, his characters less repudiated traditional

ethics than called into question the indiscriminate application of rigid moral codes. Such codes were inefficient and cumbersome, especially in the West where, as legend had it, social propriety had always been less stringent than elsewhere. Anderson's bandits committed illegal acts, but they often carried them out with the unselfish intention that they would improve the circumstances of a neighbor or a friend in need. For them, robbery was often simply a question of expedience, a way to take matters into their own hands. If they occasionally established their own rules, if they sometimes put the ends before the means or behaved in ways that were ill-mannered or indecorous, at least they got things done and got them done quickly.

Anderson asked motion-picture audiences to look at the context of Broncho Billy's actions before judging them as either good or bad. This was in sharp contrast to melodramatic theater where characters typically appeared as either wholly villainous or untaintedly virtuous. In this regard, Anderson was creating one of the first truly modern characters of commercial cinema. He never went too far with this moral relativism, however, for fear of offending traditionally oriented patrons. Anderson's films almost always ended with Broncho Billy rediscovering Victorian institutions and beliefs. The western hero never made a priori assumptions about the value of the bourgeois family or the integrity of Protestant values; but while making his way in the world, he nonetheless found these elements of traditional middle-class culture compelling.

In addition to the changes Anderson made to the western outlaw character, he altered the traditional relationship between that figure and his family and community. As Hobsbawm has noted, threads of kinship connected the social bandit to a village whose population supported him as he carried out a program of robbery and sabotage.[35] Such was the case, for example, with Jesse James, who rode with his brother and whose mother—Confederate sympathizer Zerelda Samuels—figured as the primary inspiration in his rebellion.[36] Initially, Essanay films reflected social bandits' connection with family and community. Lawrence Lee's banned film *The James Boys in Missouri* (1908), for example, opens with Zerelda encouraging her boys to violence and revenge after Jay-hawkers had tortured the boys' stepfather, Dr. Samuels. Another scene shows James giving a poor widow money he has stolen in a train holdup so she can pay her mortgage.[37]

After 1909, the outlaws in Essanay's films no longer had the support of their fellow town folk (see Figure 5.2). Anderson often upheld as moral exemplars the people who surrounded his bandits, particularly women. The sweethearts and mothers of his heroes, as well as other members of white frontier communities, reminded the outlaws of such basic middle-class Victorian notions as respect for authority and for the property rights of others, deference to women and children, temperance, self-improvement, Christian charity, and

Fig. 5.2 Scene from Broncho Billy's Narrow Escape *(1912). From the collections of the British Film Institute.*

moral redemption through self-sacrifice. Although they were willing to for-give the bandits' transgressions, the community members never condoned their criminal actions. In the denouement of many of his films, Anderson con-nected the bandits to some kind of family environment where it would be nearly impossible for the characters to continue their criminal ways and still uphold their newfound personal obligations.[38] The bandits' outlaw code of ethics dissolved in the face of a surrogate Christian family and a moral and just rural western community.

Anderson touched on these themes as early as 1909 with films like *The Reformation* (Essanay, 1909), which featured a Jesse James–type bandit who reforms when he discovers his mother riding on a stagecoach he planned to rob.[39] The filmmaker then began to articulate the formula fully with the Broncho Billy series. Not uncoincidentally, Anderson's western hero came to the screen regularly after a year of steady complaints about the content of westerns and a decline in demand for such films. Prior to the appearance of Anderson's cowboy hero, many "high-class" exhibitors and trade journalists associated the genre with less "desirable" customers—namely, working-class men, children, and immigrants. Opponents of the genre denounced the minority of loud and bois-terous fans who, of "inferior intelligence," expressed preference for sensational

westerns over educational subjects.[40] They complained that production companies were churning out cowboy and Indian films in complete ignorance of the tastes of their "better class" of patron.[41] Recognizing that these motion pictures were dividing their audiences, Anderson and Essanay shaped their western-film hero to appeal to more affluent moviegoers while attempting to bridge the social and cultural differences among motion-picture audiences.

As Anderson refined his cowboy hero for the middle class, the filmmaker looked to a writer of western and adventure stories named Peter B. Kyne who, according to Anderson, was the actual creator of Broncho Billy.[42] Kyne's western hero was an outlaw whose career as a bandit is cut short when he takes over the responsibilities for a fatherless family and is instilled with a new appreciation of virtue and the possibility of moral improvement. After robbing a stagecoach, he comes upon a woman in a wagon attempting to get her dying baby to the doctor. Broncho Billy takes over the vehicle's reins and drives the woman and her child to town. In the process, the sheriff captures the bandit and throws him in jail. Out of gratitude, the woman comes to visit Broncho Billy every day while he is serving his sentence. The story ends with the couple marrying while the bad man is still behind bars.[43]

Although Broncho Billy's alliterative name evoked such familiar heroes of the "yellow backs" as Buffalo Bill, Jesse James, Deadwood Dick, and Fred Fearnot, Kyne actually tailored the outlaw-cowboy character for the middle-class–oriented magazines that published most of his fiction. The *Saturday Evening Post*, where Anderson recalled first seeing the Broncho Billy story, was particularly representative of bourgeois culture in America. Historian Theodore P. Greene determined that not since the days of the early republic "had a general magazine in America so clearly reflected . . . the life and interests of a single class."[44] The *Post's* customers represented the kind of people Anderson and other filmmakers wanted to attract to the movies. Thus it made sense to adopt the Broncho Billy character for the screen. Although Essanay never paid the author for the rights, the company used the figure in hundreds of films.

Readers of the *Saturday Evening Post*, even if they had not come across Kyne's story, would have found Broncho Billy's qualities familiar. According to Greene, the *Post's* typical hero was a man who worked outside the ranks of existing political, social, and economic groups but who was ultimately willing to sacrifice his freedom, his very position as an outsider, for the well-being of others and for the good of society.[45] Broncho Billy fits neatly into this profile. He began a typical film as a stoic and isolated man and ended it as a virtuous, self-sacrificing citizen. He and the other manly idols who inhabited the pages of such publications as the *Saturday Evening Post* symbolized middle-class America's attempts to temper Gilded-Age individualism with a social conscience.

Modeling Broncho Billy after magazine heroes was only one element in Essanay and Anderson's strategy to allay some moviegoers' anxieties about westerns. They used Christianity to a similar end. Pagan American Indian and Roman Catholic Mexican characters dominated the genre prior to 1912, which reinforced the opinion held by "high-class" exhibitors and others that westerns were barbaric and overly passionate. To counter this impression, Anderson evoked some of the ideals of evangelical Protestantism, which, as historian Paul E. Johnson and others have shown, helped to form the middle class in the nineteenth century and continued to define bourgeois culture in the twentieth century.[46] The filmmaker incorporated into his films such Christian themes as moral uplift, self-sacrifice, and redemption. Anderson, who was Jewish, utilized these themes to enhance his product's respectability.

According to Jane Tompkins, the typical western-film hero rejected Christianity as too much aligned with the moral sphere of women in favor of an individualistic code of ethics.[47] Although this characterization is accurate for later westerns, in Anderson's original incarnation of the motion-picture cowboy, religion played a prominent role in the character's inner life. Although the filmmaker avoided injecting specific Christian doctrine into his pictures, he often introduced a general evangelical sentiment by relying on a Bible as a prop. Essanay reinforced the connection between Broncho Billy westerns and Christian morality in its publicity. The company, for example, circulated a letter to Anderson written by a Santa Monica, California, minister. The man praised the filmmaker for "awakening the good, the beautiful and the true in the roughest and most depraved of mortals" and for preaching "sermons more effectively than many of the narrow visioned gentlemen of the cloth."[48] Such publicity was also likely meant to counter anti-Semitic objections to Anderson's films.

By 1911, just before the Broncho Billy series went into regular production, Essanay was using Christian themes in its westerns. One of the first films of this type was *The Bad Man's First Prayer* (Essanay, 1911). In the picture a bandit (Anderson) falls in love with another outlaw's daughter. The woman, who is virtuous, catches the bad man holding up a stagecoach and makes him promise to reform. When the woman's father robs the same coach, Anderson's character takes the blame. The sheriff arrests the bandit, and the last scene shows him in jail reading a Bible his sweetheart has given him.[49] With this ending Anderson signaled the bad man's conversion. Once the outlaw opens the good book and learns to pray, his religious conversion, the audience can assume, is complete, and he will not return to his renegade lifestyle. Such denouements made the bandit's previously depicted transgressions less offensive to reform-oriented moviegoers. Anderson used similar endings in westerns like *The Power of Good* (Essanay, 1911), *Broncho Billy's Christmas Dinner*

(Essanay, 1911), *Broncho Billy and the Girl* (Essanay, 1912), *Broncho Billy's Bible* (Essanay, 1912), *Broncho Billy's Sermon* (Essanay, 1914), and *Broncho Billy's Sentence* (Essanay, 1915).

Anderson's invocation of dominant bourgeois ideals of manhood and his introduction of evangelical sentiment helped make Broncho Billy more popular with middle-class women by mitigating the extent to which the character portrayed the characteristics of a stoic, isolated male. The series came to the screen at the end of a period of significant changes in the male role within families. The companionate marriage, suburbanization, and an economic system that provided white middle-class men with stable and reliable corporate employment were all forces behind a new paternal ideal historian Margaret Marsh has called "masculine domesticity." Men were now expected to take on more responsibility for their children's daily care and moral instruction and to spend their time away from work playing and traveling with their families.[50]

Although Broncho Billy never appeared as a biological parent, he often served as a surrogate and in that capacity reflected the new ideals of fatherhood (see Figure 5.3). In films like *Broncho Billy's Ward* (Essanay, 1913), *Broncho Billy and the Rustler's Child* (Essanay, 1913), and *Broncho Billy and the Baby* (Essanay, 1915), Anderson's western hero played with children, talked to them, looked after their welfare, and generally took on parenting responsibilities while their fathers were preoccupied with other matters. In such stories Broncho Billy took time out from his banditry to save a boy or girl in a desperate situation. Such incidents aroused the bandit's parental instincts and often put him on the road to reform. His actions endeared him to mothers who frequently interceded on his behalf with adult male community members trying to capture and arrest him for his misdeeds. After all, Broncho Billy had proven himself more conscientious of his obligations to children than had the men of the posse who were interested only in carrying out the letter of the law.

By showing Broncho Billy's paternal side, Essanay hoped to make families—particularly middle-class families—feel comfortable in nickelodeons. This was intended not simply to sell more tickets but also to prevent a "boys' culture," a working-class culture, or both from developing in theaters and intimidating other customers.[51] Accordingly, Anderson designed Broncho Billy westerns to have intergenerational appeal.[52] To attract adult women, he usually included a strong leading lady to play opposite him, one who could shoot a gun or ride a horse when called upon to do so. Moreover, unlike western filmmakers of the 1920s and later, Anderson was not reluctant to feature love stories prominently in his pictures.

Company publicity reinforced Essanay's attempts to make its product appealing to the entire family. The firm circulated a *Chicago Tribune* cartoon depicting a lone street urchin standing in front of a movie house and digging

Fig. 5.3 Scene from Broncho Billy's Heart *(1912). From the collections of the British Film Institute.*

into his pockets for change while well-dressed children, accompanied by their parents, stream in behind him to see the latest Broncho Billy film (see Figure 5.4). The image helped establish the idea that Essanay's product was universally appealing and that it attracted "respectable" families in particular. The lyrics to a publicity song, "Broncho Billy," reflect similar notions about the ideal audience for Essanay westerns. One chorus reads: "[L]et us hope that all the kiddies with their open mouths and eyes / will still be watching Billy when they've grown up to be wise. / While other little boys and girls with glee around will buzz / to see along with Pop and Ma what Broncho Billy does."[53]

In attempting to lure families to nickelodeons, Essanay took great pains to assure concerned parents that the western series and its other films were safe for children to view. The company routinely emphasized this point in its newsletter, *Essanay News.* One of the firm's publicists wrote:

> Just as many . . . children as adults are enthusiastic and regular patrons of
> photoplays. It is important to the welfare of the children that the right kind
> of pictures be shown in theaters. . . . [P]arents know they can take their
> children to see an Essanay drama or an Essanay comedy without fear of
> encountering viciousness. . . . Photoplays of beauty, of upright sentiment, of
> the highest morals—these only are being produced by Essanay.[54]

WHEN A FELLER NEEDS A FRIEND

Fig. 5.4 Broncho Billy cartoon from the Chicago Tribune. *From Slide,* Early American Cinema.

Essanay promised the moviegoing public that Anderson, even when he played an outlaw or a gambler, would never release a film that could have an "evil influence on the impressionable mind."[55] The company went as far as to position Broncho Billy as a celluloid baby-sitter. Parents could rest assured that if their children spent a Saturday afternoon in the movie theater with him, they would not pick up any bad habits and might even learn a valuable moral lesson.

The Essanay publicity department also played on the anxiety of parents concerned about their children's future prospects in a competitive labor market. Although Anderson's westerns were rarely explicit tales of social mobility, the firm's advertising materials promised parents that the lessons the cowboy hero taught—"moral courage," "endurance," and "patience in time of trial"—could lead to their children's economic success.[56] A poem published in the trade journal *Motography,* probably penned by Essanay insiders, told the story of a stranger who pays a newsboy's admission to a Broncho Billy film. Bolstered by the moral instruction he receives in the theater, the child climbs the social ladder and becomes a wealthy adult.[57] In an important indication of how much Anderson had disassociated his western hero from Jesse James and other western outlaws who fought against "the incorporation of America," Essanay billed Broncho Billy as a role model who could teach boys and girls lessons that would make them reliable and successful employees.

Although Essanay modified its western hero to appeal to the middle class, the company was careful not to alienate loyal working-class movie patrons. Anderson never depicted Broncho Billy as wealthy. Always a man of very modest circumstances, the character rarely appeared as a farmer, rancher, entrepreneur, or any kind of property owner; and he often surfaced as a vagabond, a miner, or a cowboy between jobs. At times he traveled on foot with only his saddle and bedroll (see Figure 5.5). Anderson, however, frustrated any attempt by moviegoers to read Broncho Billy as working-class. He moved the character around the social hierarchy from film to film. After appearing as a western tramp one week, it was not uncommon for him to crop up the following week as ranch foreman or deputy sheriff. Anderson also rarely allowed Broncho Billy to reflect a working-class ideology. The filmmaker mostly avoided labor issues in his pictures, and when he did take them up, he was not sympathetic toward unions. For example, in a film critics blasted for its potential to offend organized workers, *The Strike at "Little Jonny" Mine* (Essanay, 1911), Anderson played a miner who is an active member of his labor union.[58] When the workers call a strike, he is initially behind the cause. As the movement becomes violent, however, he abandons his fellow workers and rushes to protect the embattled mine owner. Together, Anderson's character and the boss hold off the striking mob until the sheriff and his deputies can restore order.[59]

As *The Strike at "Little Jonny" Mine* suggests, when Anderson depicted Broncho Billy as belonging to a low socioeconomic group, by the end of such films the character often adopted a moral position that gave him a kind of middle-class respectability. Whether it was a commitment to law and order, temperance, Christianity, or simply self-improvement, Anderson depicted his western hero—no matter where he positioned him within the social hierarchy—as aspiring to a bourgeois set of values. Broncho Billy's films worked like

Fig. 5.5 Scene from Broncho Billy's Love Affair (1912). From the collections of the British
Film Institute.

success manuals of the Gilded Age in that they pointed to "character" rather
than income as the marker of social identity.[60] They showed mixed-class movie
audiences that the distinction between rich and poor was less important than
the division between those striving to attain virtue and those who lived self-
ish, immoral lives. In this way, Essanay westerns participated in broadly defin-
ing the motion-picture audience as middle-class or aspiring to that social
status.

 Although the ideals of manhood, fatherhood, community, and religion
Broncho Billy projected emerged from the historical experience of the white
middle class during the Gilded Age and the Progressive era, Anderson was
successful in making these values compelling to those who did not share simi-
lar backgrounds. Writer Harry Golden recalled that immigrant boys like him-
self from New York's Lower East Side were attracted to Broncho Billy because
the western hero taught them about how men behaved in the "New World."
Golden recalled that his own father was a distant figure of authority in the
household who frowned upon physical affection. He found himself embar-
rassed by what he called his father's "Old World mannerisms" and way of

dressing. Broncho Billy provided a contrast to this traditional male role model because he embodied the new ideals of "masculine domesticity" practiced by the middle class. As Golden explained, "[I]mmigrant boys didn't troop to see Bronco Billy Anderson because . . . they couldn't stand their home life"; they embraced the character because he seemed more "American" than anything they experienced in their own neighborhoods. According to the writer, Broncho Billy taught him and his friends "New World" attitudes and instilled in them their "first ideals of American manhood."[61]

As such testimony suggests, over nine years of filmmaking Anderson had come up with the ingredients that would make the western good/bad man a truly mass-cultural phenomenon. He had created the foundation from which all other western movie heroes would grow. It would be left to other producers, however, to bring the character Anderson had invented to the new feature-length films of five or more reels and to the large, well-appointed, and elaborately designed motion-picture palaces built to attract middle-class audiences.

The popularity of Broncho Billy declined around 1915. Anderson eventually tired of the figure and began recycling many of his older stories.[62] Critics remarked that the series had lost some of its freshness. Also, unlike the leading independent manufacturers of westerns, New York Motion Picture and Famous Players Lasky, Essanay was unwilling to invest a lot of money in scenarios or into making feature-length western films.[63] Indeed, when it came to westerns, Anderson and Essanay were particularly committed to the short-film format. A trade journalist noted in late 1913 that Anderson was the only actor he could think of who had not taken part in at least one two-reel subject.[64] Although in 1915 Essanay joined with the Lubin, Selig, and Vitagraph Companies to form the VLSE (Vitagraph, Lubin, Selig, Essanay) features program to distribute longer films collectively, Anderson's partner, George Spoor, had no plans to lengthen Broncho Billy pictures.[65] The producer began to manufacture more features at Essanay's Chicago plant, but he saw no reason to do so at the West Coast studio. He told the press: "Our western dramas . . . are in a distinct class by themselves. . . . They contain the breezy style of the great out-of-doors with rapid and thrilling action. They have been found specially adapted to the present footage . . . and are so satisfactory that no change is contemplated."[66]

In January 1916, with both Anderson's and Spoor's commitment to westerns flagging, Essanay announced the end of the Broncho Billy series. Anderson would now devote his attention to making films in which he appeared as a "conventional society man."[67] This new series, however, never got off the ground because within a month the men had dissolved their partnership. According to the Los Angeles Examiner, Anderson sold his share of Essanay to Spoor for $2 million.[68] After buying out the filmmaker, Spoor immediately

closed the Niles Studio and a second Essanay plant located in Los Angeles to centralize all aspects of the business in Chicago.[69] In one of his many miscalculations, Spoor concluded that weather conditions were largely behind the industry's move to California and that with the improvement of lighting technologies, Chicago would resume its place as America's natural manufacturing and distribution center of motion pictures.

As Spoor downsized, he renewed his commitment to making quality shorter films of one, two, and three reels. Although independents were rapidly moving into feature production, he held on to the idea that most theaters would be more successful showing a varied program of short films.[70] He argued that for movie houses in small towns and outlying districts in large cities, features were impractical because it was too hard for customers to keep abreast of show times. Spoor celebrated the "come-and-go-as-you-please theater." He believed part of the charm of moviegoing lay in the fact that, in contrast to attending an opera or a stage production, there was no need to plan or get ready for the event.[71] As motion-picture palaces proliferated after 1914, features were increasingly in demand.[72] By the end of 1917, Spoor realized that he was badly mistaken about the direction the industry was taking in terms of film length. Essanay lost around $750,000 that year.[73] Consequently, the producer announced that his company would cease production of short films and only make special features of six or more reels.[74]

After leaving motion pictures, Anderson tried again to purchase his way into the theater business. At the beginning of 1917, he acquired the holdings of New York theater mogul H. H. Frazee.[75] Likely in need of money to finance his investments, Anderson returned to motion pictures, starting his own film production company. He made several new Broncho Billy features. Spoor, in financial straits himself, was not about to let Anderson milk the last profits from the western character, and he struck new prints of many old Broncho Billy films and re-released them through George Kleine System Distributors.[76]

Although Spoor's decision to flood the market no doubt hurt Anderson's efforts at a comeback, the general feeling among critics and audience members was that Broncho Billy was a phenomenon of the past. A journalist for the *Cleveland Dealer* wondered whether the new films would find success in an industry that had changed considerably since Anderson "delighted the small boy with his bad men of the West."[77] When the filmmaker's *Shootin' Mad* (Anderson Photoplay, 1918) played the Strand in New York, a reviewer for *Variety* noted "a slight ripple of applause" as Broncho Billy first appeared on-screen. Although several people in the audience recognized the character, others soon grew restless and began to mock the film. The critic concluded that "Anderson would have to build himself up all over again" if he were to appeal to "the grade of clientele" big Broadway theaters attracted.[78]

Unfortunately for Anderson, the western's future belonged to others—particularly William S. Hart, a popular western stage star the New York Motion Picture Company secured in 1914. As Essanay resisted making longer films, the screenwriters at New York Motion Picture developed feature-length vehicles for their new cowboy actor reminiscent of earlier Broncho Billy one-reelers. By 1916 Hart had captured the dominant position in westerns. Anderson blamed the failure of his Broncho Billy features on the western stage actor's growing popularity. "When I came back, they were all idolizing Bill Hart," he recalled. "[T]he westerns I made were good but they weren't good enough to compete . . . so I gave them up."[79] Although Anderson's attempt to revive his screen career was unsuccessful, Broncho Billy cast a long shadow, helping to define not only Hart's character but the western hero for years to come.

NOTES

1. Undated newspaper article from the G. M. Anderson biographical clipping file, Billy Rose Theater Collection, New York Public Library, Lincoln Center, New York City.

2. *Bioscope,* July 23, 1914, 401.

3. Henry Nash Smith, *Virgin Land: The American West as Symbol and Myth* (New York: Vintage, 1957), 135.

4. Jane Tompkins, *West of Everything: The Inner Life of Westerns* (New York: Oxford University Press, 1992), 31–33.

5. "The Indian and the Cowboy," *Motion Picture World* (MPW), December 17, 1910, 1399; "An Exhibitor's Complaint," *MPW,* November 18, 1911, 22; *MPW,* February 17, 1912, 558.

6. Quoted in "Bronco Billy: Fortune Went Thataway," *New York Post,* October 16, 1963, G. M. Anderson biographical clipping file, Billy Rose Theater Collection, New York Public Library, Lincoln Center, New York City.

7. For a description of *Broncho Billy's Redemption,* see *Film Index,* July 30, 1910, 20.

8. Everson interview with G. M. Anderson, 14 (author's collection).

9. *MPW,* December 2, 1911, 747.

10. *Bioscope,* February 9, 1911, 13.

11. Charles Chaplin, *My Autobiography* (New York: Simon and Schuster, 1964), 177.

12. *MPW,* July 11, 1914, 267; July 10, 1915, 237–238.

13. *MPW,* October 26, 1912, 328.

14. Everson interview with G. M. Anderson, 14.

15. "Anderson Breaks a Record," *New York Dramatic Mirror* (NYDM), March 11, 1914, 32.

16. Quoted in Michael Covino, "The Town That Would Be Hollywood," *East Bay's Free Weekly,* August 11, 1989, 15.

17. Everson interview with G. M. Anderson, 12.

18. Historian Kevin Starr discusses filmmaker Anita Loos's belief that the motion-picture industry lost an opportunity to connect with San Francisco's theatrical, literary,

and artistic communities when it chose Los Angeles over northern California. Kevin Starr, *Inventing the Dream: California Through the Progressive Era* (New York: Oxford University Press, 1985), 288.

19. "San Souci Theater Keeps Its Promise," *Show World*, May 29, 1909.

20. On Anderson's first attempts to try to break into the business of live theater, see ibid.; "Max Anderson Has Changed His Mind," *Show World*, June 5, 1909, 8; *Show World*, August 7, 1909, 7, 9; "Bush Temple Will Go Into Vaudeville Soon," *Show World*, November 13, 1909, 4; *Show World*, December 4, 1909, 13.

21. Chaplin, *My Autobiography*, 177.

22. On Anderson's theatrical activities involving the Gaiety and Anderson Players, see clippings from *Cleveland Plain Dealer*, June 26, 1913; *New York World*, October 6, 1914; *New York Review*, April 10, 1915, all from Anderson biographical clipping file, Billy Rose Theater Collection, New York Public Library, Lincoln Center, New York City.

23. William A. Settle Jr., *Jesse James Was His Name: or, Fact and Fiction Concerning the Careers of the Notorious James Brothers of Missouri* (Columbia: University of Missouri Press, 1966), 3.

24. Ibid., 174.

25. Daryl Jones, *The Dime Novel Western* (Bowling Green, Ohio: Bowling Green University Popular Press, 1978), 81.

26. Michael Denning, *Mechanic Accents: Dime Novels and Working-Class Culture in America* (London: Verso, 1987), 149–166. In developing his theories about how dime novelists adapted the traditional bandit tale to a capitalist context, Denning relies a great deal on the ideas Eric J. Hobsbawm developed in an appendix to his *Bandits* (New York: Pantheon, 1981).

27. *Block v. City of Chicago*, 87 N.E. 1011 (1909) at 1016.

28. *Motion Picture News (MPN)*, October 21, 1911, 24.

29. Chas. M. Stebbins to Selig, June 28, 1907, Selig Collection, Margaret Herrick Library, Los Angeles, California; *MPW*, March 20, 1909, 334.

30. "Conditions in Chicago," *MPN*, August 26, 1911, 6; "The James Boys in Missouri, From a Woman's Standpoint," *MPN*, September 2, 1911, 9; "The James Boys in Missouri," *MPN*, September 2, 1911, 8.

31. Lary May, *Screening Out the Past: The Birth of Mass Culture and the Motion Picture Industry* (New York: Oxford University Press, 1980), 53–55.

32. Henry F. May, *The End of American Innocence: A Study of the First Years of Our Own Time 1912–1917* (Chicago: Quadrangle, 1964), ix.

33. Louis Reeves Harrison, "Big Changes Taking Place," *MPW*, January 3, 1914, 24.

34. Eric J. Hobsbawm, *Social Bandits and Primitive Rebels: Studies in Archaic Forms of Social Movements in the 19th and 20th Century* (Glencoe, Ill.: Free Press, 1959).

35. Ibid., 18.

36. Quoted in Settle, *Jesse James Was His Name*, 6, 12.

37. "The James Boys in Missouri," *Views and Films Index*, April 4, 1908.

38. As Hobsbawm has noted, it is much more difficult for an individual with significant family responsibilities "to revolt against the apparatus of power." Hobsbawm, *Social Bandits*, 18.

39. For a description of *The Reformation*, see *Films and Views Index*, November 27, 1909, 9.

40. "Why Don't They Applaud," *Nickelodeon*, January 28, 1911, 97.

41. "The Indian and the Cowboy," *MPW*, December 17, 1910, 1399.

42. On the life and work of Peter B. Kyne, see the introduction to the Peter Bernard Kyne collection finding aid, August 1973, University of Oregon Library, Eugene.

43. This synopsis is based on Anderson's characterization of the story. I have been unable to locate Kyne's original piece.

44. Theodore P. Greene, *America's Heroes: The Changing Models of Success in American Magazines* (New York: Oxford University Press, 1970), 181.

45. Ibid., 280.

46. Paul E. Johnson, *A Shopkeeper's Millennium: Society and Revivals in Rochester, New York 1815–1837* (New York: Hill and Wang, 1978), 8.

47. Tompkins, *West of Everything*, 31–33.

48. "Essanay's Western Producer Complimented," *Film Index*, June 24, 1911, 8.

49. For a description of *The Bad Man's First Prayer*, see *NYDM*, April 19, 1911, 32; *Film Index*, April 15, 1911, 20.

50. Margaret Marsh, "Suburban Men and Masculine Domesticity, 1870–1915," in *Meanings for Manhood: Constructions of Masculinity in Victorian America*, Mark C. Carnes and Clyde Griffen, eds. (Chicago: University of Chicago Press, 1990), 111–127.

51. As Anthony Rotundo has pointed out, games of settler and Indian had long been a part of nineteenth-century boys' culture. Dime novelists drew upon this culture in designing their product, and so did the makers of the first western films. Anthony Rotundo, "Boy Culture: Middle-Class Boyhood in Nineteenth-Century America," in *Meanings for Manhood: Constructions of Masculinity in Victorian America*, Mark C. Carnes and Clyde Griffen, eds. (Chicago: University of Chicago Press, 1990), 18.

52. Everson interview with G. M. Anderson, 20.

53. "Broncho Billy," 1914, folder 3, box D, DeVincent Collection 309, National Museum of American History, Archives Center, Washington, D.C.

54. Quoted in *MPW*, November 7, 1914, 777.

55. "G. M. Anderson at All Times Has High Ideals in 'Broncho Billy' Films," *Essanay News*, August 28, 1915, box 1, "Motion Pictures," Warshaw Business Collection, National Museum of American History, Archives Center, Washington, D.C.

56. "Anderson's New Dramas Thrilling All," *Essanay News*, June 19, 1915, box 1, "Motion Pictures," Warshaw Business Collection, National Museum of American History, Archives Center, Washington, D.C.

57. *Motography*, March 1, 1913, 166.

58. *NYDM*, October 4, 1911, 31.

59. For a description of the film *The Strike at "Little Jonny" Mine*, see *MPW*, September 30, 1911, 978.

60. Judy Hilkey, *Character Is Capital: Success Manuals and Manhood in Gilded Age America* (Chapel Hill: University of North Carolina Press, 1997), 140.

61. Harry Golden, in *Five Boyhoods: Howard Lindsay, Harry Golden, Walt Kelly, William K. Zinsser, and John Updike*, Martin Levin, ed. (Garden City, N.Y.: Doubleday, 1962), 45, 50, 59, 67.

62. "G. M. Anderson," oral history transcript, 1958, Columbia University, New York City, 26.

63. Interview with Broncho Billy Anderson (sound recording), 1958, Turning Point Series, Archive of Recorded Poetry and Literature, Library of Congress, Washington, D.C.

64. *MPN,* October 4, 1913, 26.

65. *Motography,* April 17, 1915, 591.

66. *Motography,* July 31, 1915, 200.

67. "G. M. Anderson Creates Strong New Character," *Essanay News,* January 1, 1916, box 1, "Motion Pictures," Warshaw Collection, National Museum of American History, Archives Center, Washington, D.C.

68. *Los Angeles Examiner,* June 11, 1916, envelope 2131, Locke Collection, New York Public Library, Lincoln Center, New York City.

69. George K. Spoor, "The Course of Empire," *Motography,* February 2, 1916.

70. George K. Spoor, "Short Films to Stay," *NYDM,* July 8, 1916, 33.

71. George K. Spoor, "Smaller Theaters Must Have Variety," *MPW,* July 15, 1916, 437.

72. On the rise of the feature, see Eileen Bowser, *The Transformation of Cinema, 1907–1915* (Berkeley: University of California Press, 1990), 191–192; Richard Koszarski, *An Evening's Entertainment: The Age of the Silent Feature Picture, 1915–1928* (Berkeley: University of California Press, 1994), 163–164.

73. "Essanay Company May Retire From Picture Producing," *Variety,* March 1, 1918, 49.

74. "Essanay to Discontinue Program Releases," *MPW,* December 22, 1917, 1784.

75. *New York Mirror,* January 6, 1917, G. M. Anderson biographical clipping file, Billy Rose Theater Collection, New York Public Library, Lincoln Center, New York City.

76. On the re-release of old Broncho Billy one-reelers, see *MPW,* May 4, 1918, 727; May 25, 1918, 1160; July 20, 1918, 409.

77. "He Comes Back in Western Play in Short Time," *Cleveland Dealer,* January 1, 1918, G. M. Anderson biographical clipping file, Billy Rose Theater Collection, New York Public Library, Lincoln Center, New York City.

78. *Variety,* October 25, 1918. The Motion Picture Division of the Museum of Modern Art, New York City, houses a copy of Anderson's *Shootin' Mad.*

79. Everson interview with G. M. Anderson, 18.

"THE ARYAN"

William S. Hart and the Cowboy Hero in the Era of Features

Douglas Fairbanks seems to like the constant action, "bubbling-over" sort of activity, and there is no question as to his zealous regard for comedy and grins. To the contrary, William Hart never descends to the ridiculous or comedy to get a laugh, nor does he climb steeples or sides of barns to display his athletic prowess, but his work is ever mindful of dramatic values and colorings or the quiet, deep and telling characterization.[1]

—Photoplay Art, undated

When the history of the vanished frontier, so pregnant of perils and picturesque characters which confronted the pioneers in their march toward the sunset land in the days of gold, finally is written, it will be inevitable that the virile Western characterizations of William S. Hart shall exercise a powerful influence upon the historian. For keenness of conception, and fidelity to truth, these impersonations are unrivaled, and they are rapidly becoming a standard upon which the popular estimate of these characters may be truthfully based.[2]

—Paramount flyer, 1918

Actor William S. Hart, producer Thomas Ince, and screenwriters C. Gardner Sullivan and J. G. Hawks completed the project begun by "Broncho Billy" Anderson to create a western-film hero who would appeal to a large cross section of the moviegoing public, particularly middle-class patrons. Sullivan and Hawks took story ideas from successful western stage plays—like *Girl of the Golden West* and *The Virginian*—as well as older one-reel films and modified them to reflect the dominant notions of Anglo-Saxon manhood

and Progressive-era moral reform. Hart brought to his roles a reserved manner and a code of male honor belonging to an older Victorian era. Influenced also by his training in late-nineteenth-century classical acting, he created the laconic, controlled western hero who would become a defining element of the genre.

Hart dominated westerns during the period 1916–1919, and his pictures were among the most successful of the time. His popularity, however, began to decline in the 1920s. The actor made profitable westerns intermittently in the first half of that decade, but as the values he expressed became increasingly unfashionable—particularly with white, urban, middle-class audiences—his films were relatively less successful than they had been previously. Eventually, first-run movie palaces in downtown areas declined to run Hart's pictures or, for that matter, any westerns. The industry relegated the genre to smaller, less prestigious houses. Films could turn profits in these second-tier theaters but only if manufacturers kept production costs to a minimum. Such conditions led to the phenomenon of the low-budget "B" western.

Long before the invention of cinema, Hart had been interested in the two things that eventually brought him to the new medium: the frontier and dramatics. He was born in upstate New York in 1865, and his family moved west when he was eight. His father, Nicholas Hart, was an English, Oxford-educated immigrant, the son and grandson of prominent London criminal attorneys. Too restless and filled with wanderlust to settle into a sedate professional life, Nicholas built milling machines for a Milwaukee-based firm—a job that required that he and his family travel throughout Illinois, Iowa, Minnesota, Wisconsin, and the Plains states. His unrealized dream was to establish his own river mill in the West and to relocate his family there permanently.

When the health of William's Irish-born mother, Rosanna Hart, failed, she returned to the East. She took her younger children with her, but William was allowed to remain with his father and join him in his travels.[3] He had little opportunity for early formal education, spending his time working and playing outdoors. Indian playmates taught him to speak the Sioux language, and he thought of himself as "a white Indian boy."[4]

Out of consideration for Rosanna's health and the children's education, the entire family reunited and relocated to New York City while William was an adolescent. The boy worked as a messenger for the Everett House, a hotel frequented by the leading Shakespearean actors of the day. He had limited interactions with such theater notables as the renowned Italian tragedian Tommaso Salvini and France's foremost classical actress, Sarah Bernhardt. His tips often came in the form of theater tickets, so he saw a great number of plays.[5]

After watching Edwin Booth and Lawrence Barrett—America's "two greatest living actors"—perform in Shakespeare's *Julius Caesar*, William was in-

spired to pursue a career in theater.[6] His father was supportive, believing his son had inherited a gift for oration from his barrister ancestors. At Nicholas's insistence, however, William took fencing and dancing lessons and traveled to Europe to study the dramatic arts. This training, the senior Hart felt, would smooth out the "rough corners" the boy had acquired while living on the prairie.[7]

In search of refinement, William made two trips to England. The aspiring thespian did not find his European mentors there but rather in the United States, where many of the continent's finest classical actors either toured or lived. In his boyhood Hart had seen many of these foreign-born Shakespeareans perform in New York, and as a young actor he played alongside them in supporting roles. His first professional job was with the German actor Daniel Bandmann, whom Hart considered an excellent mentor. Later, Helena Modjeska, the acclaimed Polish actress, enlisted him as leading man for her first farewell tour of America.[8]

The foreign-born performers who dominated the classical stage in the United States during the last quarter of the nineteenth century helped usher in a new set of acting conventions that had a profound effect on Hart's performance style. As English was not their first language, these émigrés at times had difficulties capturing the subtleties of Shakespearean dialogue. They compensated by creating personal and idiosyncratic dramatic interpretations based on what they felt was the spirit of the material.[9] Their acting was marked by "believable underplaying," and they filled their "by-play" and their "business" with realistic details drawn from everyday life.[10] In contrast to the first three-quarters of the nineteenth century—when audiences judged a classical performance by an actor's ability to project an ideal type with clear diction, accurate oration, and precise, stylized, and graceful gestures—the new European émigrés such as Bandmann celebrated the "cosmopolitan quality" of Shakespeare, stressed the playwright's "thoughts and ideas" over his language, and emphasized interpretation.[11] Largely as a result of the impact of this generation of performers, the highly formalized classical acting tradition embodied by Booth and Barrett increasingly gave way to a style Americans referred to as the "new realism," or "naturalism."

Influenced by this dramaturgical turn, Hart developed a quiet, intense, and subdued acting style. As early as 1894 critics were lauding his use of facial expressions and gestures that "conveyed sentences of thought with but a movement or two."[12] A writer for the New York Journal called him a "masculine Julia Marlowe," a reference to a classical actress renowned for her understated style.[13] Others noted that he never ranted or called undue attention to his performances but revealed the meaning of the text through laconic bits of gesture. Above all, Hart absorbed his mentors' lessons regarding the dramatic

value of studied silence, insisting at one point early in his stage career that overly melodramatic dialogue be removed from the last scene of a play so he and his leading lady could perform it exclusively with gestures. Hart referred to this technique as bolstering "ten-twenty-and-thirty" material with an "Ibsen effect."[14]

Even though the critical response to Hart's work was favorable—the *New York Dramatic Mirror*, for example, predicted he would soon be a "mainstay of the . . . legitimate" stage—his career as a Shakespearean all but ended in 1896.[15] During that year the Theatrical Trust monopolized the booking system used by most American theaters and applied its influence to greatly reduce the number of Shakespeare's works performed around the country in favor of productions with wider popular appeal and greater moneymaking potential. Even the country's foremost classical actors could not get roles, and Hart—who had always found it difficult to maintain gainful employment in Shakespearean drama—had to abandon the Bard altogether. He soon found his niche playing in the popular and profitable costume dramas of the time and later in western stage plays.[16]

Early in his career Hart was drawn to villains, and his greatest stage successes came in "bad-man" roles. The scheming Iago of Shakespeare's *Othello* was his favorite part.[17] When cast as the "heavy," he gave some inspired performances, including his role as the nefarious Appius Claudius in the Roman costume drama *Virginius*. In this part Hart attempted, as he put it, to move "beyond consciousness." He stalked the ingenue with such zeal that he frightened his coactors, enraged the stage manager, and stunned the audience into silence. In 1899 he drew wide acclaim for his personification of yet another villain, Messala, in the premiere production of Lew Wallace's *Ben Hur*. The play was tremendously successful, and in an indication of Hart's broadening popularity, New York's Eden Musee made a wax figure of him dressed in full costume.[18]

In 1905 producer George Tyler cast Hart as Cash Hawkins in Milton Royle's *The Squaw Man*, a role that combined the actor's interest in the West with his penchant for villainous parts. The play was a runaway success and changed the course of the actor's career. Audiences thereafter associated him with cowboy characters. During the next nine years he rode the crest of the western stage drama's popularity, enjoying steady employment and increasing remuneration in such plays as Rex Beach's *The Barrier* and Owen Wister's *The Virginian*.[19]

Like most successful actors in legitimate theater, Hart paid little attention to moving pictures—until one day in January 1914. After arriving for a performance in Cleveland, Ohio, with his cast and crew, he noticed that the scenery trucks were still loaded and parked in front of the hotel even though the show was to begin in a few hours. Thinking the stagehands had gone off to a saloon and neglected their duties, Hart waited by the trucks to reprimand

them. A half hour passed before they came out of a movie house across the street, animatedly discussing the picture they had seen. Their enthusiasm so intrigued Hart that he went to see the show himself. A cowboy movie was among the films playing, and although impressed overall by the cinema, he was certain he could make a better western. He decided to study the medium. During the next several months he went to the motion pictures at every available opportunity.[20]

If Hart was genuinely enthusiastic about the possibilities the cinema offered for depicting the "real" West, he was also attracted by its potential financial rewards. Competition from the movies had reduced the number of touring theatrical companies in America by almost two-thirds between 1905 and 1915 and had created lengthy periods of unemployment for Hart. His initial salary in motion pictures was $125 per week, $50 less than what he had made in his most recent theater engagement. In the long run, however, motion-picture work was more consistent and therefore more lucrative.[21]

Hart had known New York Motion Picture Company's producer Thomas Ince since 1903 when they had acted together in the Revolutionary-era costume drama *Hearts Courageous*. While in Los Angeles on a theatrical tour, the actor talked to his old friend about producing westerns. Ince, concerned about the genre's flagging popularity, did not initially share the actor's enthusiasm. According to Hart, the producer told him that he was too late, that the market was "flooded," and that a cowboy film could not be sold "at any price."[22] Although the company still leased the large, scenic Santa Ynez Canyon property—which was perfect for filming westerns—and also housed a troupe of Indian performers, it had been producing relatively few cowboy pictures.

Cecil B. DeMille and the new Jesse Lasky Feature Play Company indirectly helped Hart's cause, facilitating his career in motion pictures with their inaugural effort, a five-reel adaptation of the stage play *The Squaw Man* (Lasky, 1914) starring famed legitimate actor Dustin Farnum. The film was a success and gave everyone in the industry reason to reconsider the genre's economic viability in the coming age of longer features of five or more reels. A few months after DeMille's release, Ince enlisted Hart to make two multireel westerns. After the producer screened one of them, *The Bargain* (NYMP, 1914), in a small theater in Los Angeles and found it to be tremendously popular, he hired Hart on a long-term basis.[23] Although Ince eventually planned to feature the cowboy actor in five-reel westerns, financial and organizational limitations prevented him from doing so. During the first year and a half of Hart's screen career, only three of the twenty-five films the actor made were longer than two reels.

In scripting Hart's first pictures, Ince's screenwriters borrowed selectively from many sources—including theatrical productions in which the actor had

performed, other western stage plays, and older one-reel cowboy and Indian films. Ince hired fast and competent writers, often with a background in journalism, whom he trained to function within the studio atmosphere. Rather than adapt the copyrighted material of playwrights, as other manufacturers of feature-length films had done, the New York Motion Picture producer preferred to rely on the imagination of his writers, who saved time and money by putting their original ideas directly into a form a production unit could use to shoot its pictures. Ince thus also avoided paying for screen rights to someone else's material. Under this system, the New York Motion Picture staff created a standardized western product that showcased a marketable and consistent screen persona for Hart.[24]

Not surprisingly, in many of his first films the cowboy actor played a figure reminiscent of Gilbert M. Anderson's "Broncho Billy," at the time the best-known western screen hero. Following this older model, Ince's writers created a bandit character for Hart who, in the end, was always willing to sacrifice himself for the better social good. In one of his earliest pictures, *Bad Buck of Santa Ynez* (NYMP, 1915), by scenarioist J. G. Hawks, the cowboy actor played Bad Buck, a man on the run from the law. The film opens as Buck has just broken out of jail. Although he is chased by a posse, his conscience compels him to stop and help a woman bury her recently deceased husband. Later a rattlesnake bites the widow's young daughter, and at the risk of being recaptured by the sheriff, he fetches the town doctor. Buck arrives with help in time to save the girl, but in the process lawmen shoot and kill him. As they realize the sacrifice he has made, members of the sheriff's posse take off their hats to honor the dead man.[25]

Although the Broncho Billy–type western hero was popular with cinema audiences, social reformers, and censorship boards, by around 1914 Anderson and other filmmakers had overused the figure. Critics, while praising the acting and settings of Hart's first films, complained about their hackneyed characters and plots. *Motion Picture World*'s Stephen Bush panned Hart's *The Bargain*, a film that also featured an Anderson-style western bandit, arguing that it was "nothing more than an old-fashioned 'western'" stretched out to five reels.[26] A critic for the *New York Dramatic Mirror* used the circus as a metaphor in explaining the difference between *The Bargain* and older cowboy films: "[I]nstead of one ring, there are three rings; the menagerie is larger, the clowns and acrobats more proficient; still, a circus is a circus, and likewise a western melodrama is just that."[27]

Hart's screenwriters at first had difficulty developing a cowboy hero distinct from Broncho Billy, but the New York Motion Picture staff eventually created a more original western bad-man role for the actor. During the second and third years of his moviemaking career, the industry began to build large,

well-appointed moving-picture palaces in urban centers to attract middle-class patrons. To appeal to that audience, filmmakers produced more elaborate films with higher production values. Motion-picture characters became more representative of the upper reaches of the social spectrum, and producers played on cross-class fantasies of conspicuous consumption.[28] To keep up with this trend, New York Motion Picture altered the image of the western hero, turning the character into a figure of authority, power, and prestige within a frontier settlement. Whereas Anderson played a cowboy vagabond who wore dusty work clothes and never owned property, Hart began to impersonate economically successful proprietors of gambling and dance halls who dressed like dandies in western finery. In making the western hero an entrepreneur, albeit in what some would consider immoral industries, New York Motion Picture spruced up the image of the frontier bad man for the audience of the moving-picture palace.

Jack Rance, the professional gambler character from David Belasco's successful 1905 play *Girl of the Golden West*, was the immediate inspiration behind the creation of Hart's new western hero. Scenarioist William Clifford indicated in the shooting script for *The Scourge of the Desert* (NYMP, 1915), one of the first films in which the cowboy actor played a dance-hall and saloon proprietor, that Hart should be "well dressed as per [the] costume of Jack Rance . . . [and] have [a] velvet coat on him, shirt cuffs shot a few inches below the sleeves."[29] In borrowing elements of the Belasco character, New York Motion Picture was again following the lead of DeMille, whose screen adaptation of *Girl of the Golden West* (Lasky, 1915) had appeared in theaters a month earlier. Hart, however, went on to make Rance-type roles his own, playing them in several subsequent two-reelers including *Keno Bates—Liar* (NYMP, 1915), *Mr. Silent Haskins* (NYMP, 1915), and *The Conversion of Frosty Blake* (NYMP, 1915), as well as in features throughout the rest of his career.

Although Ince's screenwriters borrowed from Belasco and DeMille in creating Hart's new character, they injected a social reformist ethos into his roles that was absent from both the original play and the Lasky film adaptation. In so doing, they hit upon a fundamental formula behind the cowboy actor's future work. New York Motion Picture's writers first transformed the Rance-like figure into a social reformer, albeit somewhat clumsily, in the early two-reeler *Mr. Silent Haskins*. Loosely based on Belasco's *Girl of the Golden West*, the play and film are both about the adventures of an unmarried woman who has inherited a saloon and dance hall on the frontier. Whereas "the girl" in the original play operates her western "business" with impunity, "the angel" of New York Motion Picture's version (Rhea Mitchell) is a leader of a local reform movement in the East and insists that her deceased uncle's surviving partner, Lon Haskins (Hart), shut down the den of iniquity that has come

under her ownership. He does so, dismissing the dance-hall girls and gamblers. Jim Black, the leader of the local gambling contingent, is angered by this turn of events. He plans to force "the angel" to marry him so he can reopen the gambling house. Determined to prevent this, Haskins agrees—in a scene directly borrowed from the stage drama—to play cards for the woman's hand. Haskins cheats in order to win, and the film ends with him taking "the angel" away to a better place.[30]

Whereas the cowboy actor and his team began to communicate messages of social improvement within the two-reel format, the ideologies of reform became more explicit and better articulated as they abandoned the shorter format and focused exclusively on westerns of five or more reels. Hart lacked the financial backing to produce such elaborate features routinely until Harry Aitken's Triangle Company absorbed New York Motion Picture at the end of 1915. Aitken helped change the face of western pictures by providing Hart and his filmmakers with Wall Street money, a nationwide magazine publicity campaign, and hundreds of the best movie houses in the country in which to screen their product. With this infrastructure behind him, the cowboy actor became a huge international star.

Harry Aitken and his brother Roy were midwestern Protestants who came to motion pictures from the insurance business. As part of a promotional scheme to sell some of their family's rural real-estate holdings, they rented an opera house and screened lantern slides and films. Increasingly interested in cinema as a business in its own right, they purchased several nickelodeons. To procure product for their theaters, the brothers began to import films. Later, raiding talent from Anderson and Spoor's Essanay Company, they opened their own studio, American Film Manufacturing of Chicago. The brothers gradually expanded both the production and exhibition ends of their business, calling their integrated holdings the Triangle Company.[31]

Although the firm was short-lived, going bankrupt soon after its founding, in many ways it heralded the future of the American motion-picture industry. Having personally invested $40,000 in D. W. Griffith's *Birth of a Nation* (Epoch, 1915), the Aitken brothers realized earlier than most that commercial cinema was moving in the direction of long, expensively produced feature films. Their company was also one of the first to be vertically integrated. The brothers produced pictures, distributed them, and exhibited them in their own theaters. Likewise, they were ahead of the competition in terms of bringing outside capital into the industry from prominent Wall Street investment banks.[32] The *New York Dramatic Mirror* called the Triangle Corporation "the most radical development" in motion pictures.[33]

The firm's program of films represented what was to that point the strongest effort made to woo patrons of legitimate theater to the movies. The Aitken

brothers heavily advertised their product in magazines targeted to the middle class, such as the *Saturday Evening Post*. At the debut of the Triangle program, the combination's flagship theater, the Knickerbocker, charged "regular Broadway" prices of fifty cents to two dollars a seat. By November 1915 Triangle had 200 theaters contracting for its service, many of which were formerly legitimate big-city houses.

To make the highest-quality films, Harry Aitken brought together three of the industry's finest producers/directors to serve as production heads for Triangle: Ince, Mack Sennett (the father of Keystone comedies), and D. W. Griffith. The three men focused on the regular production of features starring well-known stage personalities. To that end, the company hired dozens of Broadway actors, most of whom proved unsuccessful in cinema.[34] Hart said of this period at Santa Ynez Canyon: "[I]t rained stars like hailstones; and like hailstones, they melted under the California sun."[35] The cowboy actor, however, endured, making seventeen features for the company between 1915 and 1917.

The work of Ince's highly paid screenwriters was instrumental to Hart's success at Triangle. They modified the typical western, injecting it with contemporary bourgeois notions of social reform, Christianity, race, and manhood to attract the middle-class patronage the company sought. Hart recognized the importance of their efforts to his films, saying of their scenarios, "they are not merely western pictures, but in every instance there is some motive behind the story that has weight and depth and meaning that makes people think, and creates a profound impression."[36]

C. Gardner Sullivan was Hart's most important writer of Triangle and New York Motion Picture feature westerns. He was born in Stillwater, Minnesota, in 1886 and graduated from the state university. He began his writing career as a journalist and worked the city desks of newspapers throughout Minnesota as well as in New Orleans before ending up at William Randolph Hearst's *New York Evening Journal*.[37] There Sullivan developed an instinct for muckraking and social reform that he later carried into his movie scripts. Moreover, as Hearst was among the first newspaper editors to emphasize the visual aspects of journalism, the *Journal* provided ideal training for a future screenwriter. Particularly concerned about the writing of headlines, Hearst believed a reader should be able to glance at the paper "and get a reasonably clear and complete idea of the news of the day."[38] There was no place for dullness or complicated writing in his newsrooms. He insisted on simplicity and clarity to appeal to the widest possible readership.

While working for Hearst, Sullivan became increasingly interested in writing for cinema. He learned the craft by reading Epes Winthrop Sargent's "Photoplaywright" column in *Motion Picture World*, gradually developing and selling

scenarios to many leading U.S. film manufacturers.³⁹ In 1913 he left the news-
paper business to become a full-time freelance screenwriter. Ince bought many
of his stories and hired him as head of New York Motion Picture's scenario
department in May 1914.⁴⁰ Sullivan wrote the scripts for some of Ince's most
ambitious projects in the period 1914–1916, including *The Coward* (NYMP,
1915), *The Italian* (NYMP, 1915), and *Civilization* (NYMP, 1916). He also penned
many of Hart's most important films—among them the actor's first features,
The Bargain (NYMP, 1914) and *On the Night Stage* (NYMP, 1915). Ince consid-
ered him his best writer, and in 1918 *Variety* proclaimed him the most valu-
able scenarioist in the motion-picture industry—worth every penny of his
salary, which was rumored to be equal to a "railroad president's."⁴¹

Sullivan's most important contribution to New York Motion Picture, and
to Hart's films in particular, was his ability to integrate seamlessly into his
scenarios ideological themes that would attract middle-class patrons to movie
palaces. To make cowboy pictures more acceptable to this group of customers,
the screenwriter provided novel motivations for the western hero's violence,
which he based on dominant understandings of social reform, race, and Chris-
tianity. In a typical Sullivan-scripted Hart film, the story begins with saloon,
dance-hall, and gambling interests or criminal gangs dominating a corrupt
western settlement. Much of the action takes place in large, elaborate interior
sets filled with dance-hall girls, cowboys, Mexicans, and other western extras
(see Figure 6.1).⁴² Gambling, drunkenness, wild dancing, racial mixing, fist
fighting, and related forms of bacchanalia abound. Initially, the owners or
leaders of these malevolent institutions, unrestrained by law or moral authority,
pursue their fortunes in total disregard of traditional community mores and
values; and they oppose the founding of churches, newspapers, or other organiza-
tions that might create a climate of reform. After undergoing a conversion,
Hart's character proceeds to improve the frontier community by attacking one
or more of its corrupt institutions. His violent actions help establish order in the
western village, as well as bring about a renewed respect for Christian morality
and for social and racial hierarchies. In an indication of his success, the hero
ultimately makes frontier settlements inhabitable for virtuous white women.

Indeed, Sullivan sometimes invoked a white supremacist ideology to make
the genre more attractive to middle-class Americans. Racism was not new to
the western, but it had never been articulated in such a sophisticated fashion.
This theme was particularly evident in Sullivan's *The Aryan* (Triangle, 1916),
a film Hart considered among the greatest westerns ever made. In the picture
the cowboy actor played a miner, Steve Denton, who falls in love with a dance-
hall girl (Louise Glaum). Subsequently, she tricks him out of his gold, robbing
him not only of his fortune but also of his faith in white women's virtue. He
retreats to the desert and becomes the leader of a town known as Devil's Hole,

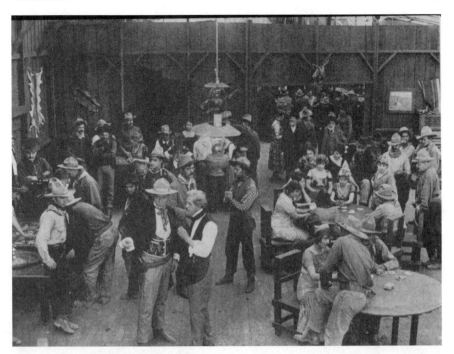

Fig. 6.1 Interior saloon set for one of Hart's pictures. Reproduced in George Fenin and William Everson, The Western From Silents to Cinerama *(New York: Orion, 1962).*

peopled by "fierce men, outlaws, murderers and thieves, most of them half breeds or Mexicans."[43] As Denton turns bad, he looks more and more like a mestizo. He dresses in a sombrero, a serape, and an "Indian belt," or what critics commonly referred to as Hart's "Mexican outfit."

As the story unfolds, a caravan of settlers loses its way in the desert, and Denton comes upon it. He refuses to help the imperiled migrants, especially since the party includes white women. A young girl (Bessie Love), disbelieving that an Aryan would turn his back on females of his own race, comes to Denton's hideout to beg for aid. The bad man still refuses and warns her that members of his gang have gone to the wagon train to "pay their respects." The girl accuses him of not being a "white man," for if he were he would never allow "half-breed greasers and Indian cut-throats" to rape women of European origin. Her entreaties are successful. She instills in him a sense of his respon-sibility to his race, and he mounts an attack against his own ruthless gang, rescuing the settlers (see Figure 6.2).[44]

The Aryan came on the heels of the Aitkens-backed Griffith spectacle *Birth of a Nation,* and in their treatment of racial issues the two films had much

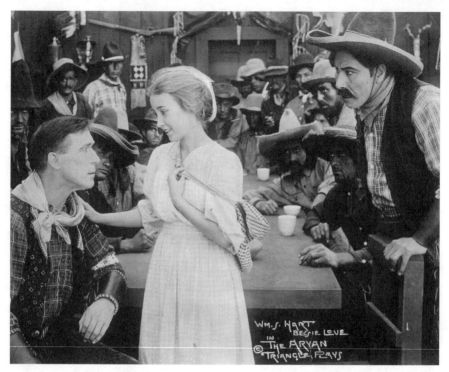

Fig. 6.2 Scene from The Aryan *(1916). From the Blum Collection, Wisconsin Center for Film and Television Research.*

in common. In his epic feature about the Civil War and Reconstruction, Griffith presented radical Republicans as traitors to white America for having given political power to former slaves in the South. According to the picture's logic, the Ku Klux Klan (KKK) rights this dangerous situation when it resorts to violence to reestablish white supremacy. Likewise, in Sullivan's *The Aryan,* Hart's character has betrayed his own people, having aided mestizo thugs who are making settlement in the West difficult for whites. Once called to his supposedly inherently racist instincts, however, he too—like the KKK—uses violence to effectively eliminate the threat posed by nonwhites. Although filmmakers had previously suggested it, they had never so clearly connected the hero's use of force in the western film with the maintenance of white supremacy.

Sullivan knew movie-palace audiences would accept a frontier hero who drew his six-guns to establish racial order, and he also guessed they would embrace a character who violently defended Christianity. Religious themes,

like racism, had been part of the cowboy and Indian picture for some time. Filmmakers, however, had never articulated them as explicitly as Sullivan would or connected them to issues of social reform and frontier community building. In this regard, he had the support and encouragement of the Aitken brothers, who felt motion pictures could become the "world's pulpit."[45]

The screenwriter imbued his films with particular ideas from the social gospel movement. This theology was among the most popular within American Protestantism from the 1890s to World War I. Believers regarded selfishness as the primary cause of evil in the world, and they advocated acts of goodwill to create social harmony and hasten the coming of the kingdom of God on earth. Sullivan's films betray a special interest in social gospel notions of masculine reform. According to historian Gail Bederman, Protestant ministers, in hopes of bringing men back into the fold, presented the closing of brothels and saloons as well as other moral improvement efforts as strenuous work that required the special efforts of "virile" men.[46] Such ideas were meant to encourage male Christians to get involved in church-related reform activities at a time when religiosity had acquired a "feminine taint."

In combining new notions of masculine virility with traditional Christianity, the social gospel movement provided the perfect ideology for Hart's westerns, appealing to middle-class men and women alike. Sullivan first introduced the theme of strenuous Christian action in *Hell's Hinges* (Triangle, 1916), a film that, like *The Aryan*, served as a prototype for many of Hart's subsequent efforts. In the picture the cowboy actor played Blaze Tracy, a leader of "the rough element" in an appropriately named frontier settlement, Hell's Hinges— "a gun-fighting, man-killing, devil's den of iniquity."[47] The town's few godly people, the so-called Petticoat Brigade, want to build a church, and they invite an eastern minister (Jack Standings) to their community. Silk Miller (Alfred Hollingsworth), Hell's Hinges' saloon and gambling-hall proprietor, conspires with Tracy to run the new minister out of the settlement. His plan is interrupted when Tracy falls in love with the pastor's godly sister, Faith (Clara Williams), who has accompanied her brother to the frontier. True to her name, the woman converts Tracy to Christianity, underscored in the film with a passage from the Bible, Matthew 21:22: "And all things, whatsoever ye shall ask in prayer, believing, ye shall receive."

Blaze Tracy abandons Miller's scheme, but the saloon owner, still intent on discrediting the minister, convinces a Mexican dance-hall girl (Louise Glaum) to get the reverend drunk and seduce him. Meanwhile, the town ruffians burn down the new church and force the Petticoat Brigade to the outskirts of the village. Pushed to the limits of his newfound Christian patience, Tracy takes matters into his own hands. He corners most of the town's prostitutes, gamblers, and dance-hall girls in the saloon and shoots out the

building's oil lamps, setting the structure on fire. Standing at the door with his guns drawn, he prevents the dance-hall denizens' escape so that for a short time they might have a "taste of hell." Eventually, the whole town is engulfed in flames. There is a montage of dark, smoky images with shadowy figures running chaotically to and fro. The preacher dies defending the church, but Blaze and Faith escape the tumult, presumably to continue missionary efforts elsewhere.[48]

Fans praised *Hell's Hinges* and similar Hart films for the Christian principles they projected. The cowboy actor, one moviegoer determined, was doing "missionary work as surely and as successfully as the clergy."[49] Another called Hart's *The Toll Gate* (Paramount, 1920) his "sermon on the mount."[50] After the latter film screened at the White House, President Woodrow Wilson held it up as proof that motion-picture producers could be leaders in "patriotic and religious educational life" rather than "unrepentant Israelitish worshipers of the golden calf."[51]

By using the western hero to promote Christianity, moral reform, and other Victorian values, Hart and the New York Motion Picture Company ultimately took the figure in a unique direction, one that only sometimes paralleled the characterizations of the most prominent twentieth-century frontier mythmakers: Frederic Remington, Theodore Roosevelt, and Owen Wister. These preeminent contemporaries of the cowboy actor popularized the notion that the western wilderness, free of the effeminizing forces of the city, challenged and therefore stimulated white men's masculinity.[52] Their ideas appealed to middle-class men who found their work increasingly deskilled under corporate capitalism and who were threatened by the movement of women into the public sphere. Such Americans abandoned Victorian ideals of self-denial and restraint and celebrated strength and virility as the basic qualities of manhood.[53]

As new notions of *masculinity*—a term that came to denote the changing ideals of maleness—surfaced in Hart's films, their full articulation would have alienated some of the women who dominated movie-palace audiences. Therefore the cowboy actor and his screenwriters modified the message: if the natural environment made men strong and virile, it also caused them to become dangerous and unpredictable. Only through the influence of white women and Christianity would the frontiersman renounce his life of instinct, take up Victorian ideals of manliness, and become a responsible and contributing member of a western community. In effect, the New York Motion Picture staff synthesized within Hart's westerns the two competing notions of middle-class manhood in America at the turn of the twentieth century: the traditional ideals of self-control, respectability, and honor and the new notions of masculine aggressiveness, strength, and strenuousness.

Screenwriter J. G. Hawks best articulated the tension in Hart's films between domestic Victorian values and the image of western masculinity propagated by Roosevelt, Wister, Remington, and others. After Sullivan, Hawks was Hart's most important screenwriter. Although less imaginative than his colleague, he was more immersed in western history. He filled his shooting scripts with lengthy descriptions of frontier settings and costuming, some of which he garnered from *Century Magazine*. He sometimes instructed the production staff to examine Frederic Remington's paintings so they could get a sense of the "real" West.[54]

In Hawks's *Blue Blazes Rawden* (Triangle, 1918), Hart played Rawden, a lumberjack and virile creature of instinct. The film opens in a redwood forest. Rawden and his crew, the "Hell Babies," have just been paid and are heading to a saloon to let off steam. In the establishment Babette Du Fresne (Maud George), a "half-breed" woman and the proprietor's sweetheart, catches Rawden's eye. She is attracted to him also. According to an intertitle, "a savage strain from an Indian mother makes the girl see a master in the forest wolf." The owner of the bar, "Ladyfinger" Hilgard (Robert McKim), is jealous of the attentions Rawden shows Babette, and the two men get into a vicious brawl. Ladyfinger ends up dead. Subsequently, Rawden takes possession of the saloon and indulges every bloodthirsty passion and impulse until the mother of the man he murdered arrives at the settlement. The woman's maternal love ignites a latent sense of Victorian values and decorum within Rawden, and he begins to ignore Babette's sexual advances. The picture ends as the reformed man sets out to make a new life for himself.[55]

In this film, as in many of the stories Hawks penned, the screenwriter connected Hart with the wilderness. The name "Rawden" alone suggests that he is "raw," untamed, and uncivilized. The outdoors has made him aggressive and masculine, as Wister or Roosevelt might have imagined, but it has also unleashed within him a brutality beyond his control. During fight sequences, Hart performs in a hysterical manner. Intercuts among him and a howling wolf and the mixed-blood Indian woman reinforce his savagery. Only through the influence of a white woman does Rawden renounce his life of instinct and take up the Victorian ideals of manhood. At the end of the film, Hart's character becomes a hero created in the image of white womanly virtue rather than one shaped by the rigors of the strenuous life.

Although Hart's films were similar to other contemporary imaginative depictions of western manhood, they were distinguished by their Victorian sentimentality. This was in part the result of his writers' efforts to appeal to the widest possible middle-class audience, especially women, but it also stemmed from Hart's personal proclivities and distinctive performance style. Hart, by age and disposition, was a Victorian.[56] Throughout his career he resisted the

physical, stunt-oriented performances popularized by such actors as Douglas Fairbanks and Tom Mix. Just as Hawks and Sullivan only partially engaged Roosevelt's, Remington's, and Wister's ideas about frontier masculinity for fear of putting off female moviegoers, Hart never fully embraced the visions of these dominant twentieth-century frontier mythmakers.[57] The actor owned many of the books they had written, but he responded mostly to the Victorian aspects of their ideas, particularly their patriotism and Anglo-Saxonism. In 1908, when acting in the stage play *The Virginian,* Hart challenged Wister on the truthfulness of his depiction of cowboy life, as it did not mesh with the frontier he had experienced as a boy. In typical Victorian fashion, he believed the basic honor of white men in the West would have prevented the kind of infighting among them the novelist had portrayed. The cowboy actor did appreciate the author's nationalism, and he wrote a gushing letter telling him so.[58] Similarly, he heralded Roosevelt for being "for America first, last and all the time," and in a self-conscious attempt to emulate the rough rider, in 1918 he wrote to the General Staff of the U.S. Army, volunteering to lead a troop of American cowboys to fight overseas.[59]

Hart's quiet and laconic performances also helped reinforce the association between his movies and the dominant ideals of Victorian-era manhood. As one film historian put it, even as the cowboy actor made his films, there was an "old-fashioned" element to his acting.[60] In developing his screen character, Hart used the basic gestural vocabulary learned from his European émigré mentors of the classical stage. He had spent the last ten years in the theater fine-tuning the techniques of "new realism," and, as is evident from the consistency of his acting throughout his stint in motion pictures, he made only minor changes to his style in adapting it to the screen. Those modifications were consistent with his stage mentors' aesthetic of underplaying. To keep within the camera's frame, Hart recalled, he had to simplify his movements further, eliminating what he referred to as "inessentials."[61]

Rather than demonstrate anger histrionically, Hart expressed contained rage by bending his knees, hunching over, and curling up his long frame in a way that drew comparisons to the coiling of a snake (see Figure 6.3). Similarly, he used his face to demonstrate self-control, responding to danger with an implacable expression. He claimed to have spent years manipulating "every line and expression" of his "physiognomy" so that when the time came he could express exactly the emotion he wanted without resorting to melodramatic excess[62] (see Figure 6.4). This style was markedly distinct from acting in earlier western films. Gilbert M. (Broncho Billy) Anderson, for example, allowed his character's emotions—pleasure, pain, anger, jealousy, and suspicion—to register immediately and clearly on his countenance following any provocation or stimulation. When excited, his movements approached slapstick abandon,

Fig. 6.3 Hart in famous "two-gun" pose. From the Blum Collection, Wisconsin Center for Film and Television Research.

and he tended to flail his arms wildly. Hart's acting was more psychological; his characters appeared to respond to thoughts and ideas rather than to physical stimuli.

Although some critics read Hart's studied quietness, slow and deliberate movements, intense gaze, and stone-faced expressions as indications of an "immobility of countenance," those with exposure to legitimate theater—especially middle-class filmgoers—recognized that the actor was drawing on the naturalistic conventions of the stage.[63] They also understood the relationship between his style and the ideals of Victorian manliness. His fans alternatively celebrated him as a "real man," "a man's man," and a "red-blooded he-man."[64] His appeal in this regard was international. The great Japanese filmmaker Akira Kurosawa recalled:

> An image remains emblazoned in my mind of William S. Hart's face. He holds up a pistol in each hand, his leather armbands decorated with gold, and he wears a broad-brimmed hat as he sits astride his horse. Or he rides through the snowy Alaskan woods wearing a fur hat and fur clothing. What

Fig. 6.4 Hart's "stone-faced" expression. From the Blum Collection, Wisconsin Center for Film and Television Research.

remains of these films in my heart is that reliable manly spirit and the smell of male sweat.[65]

Women especially responded to the image Hart projected. He was a hugely popular romantic lead, receiving many letters from female moviegoers who

wanted to "ride across the western hills" with him. Middle-class adult women seemed particularly receptive to the cowboy actor's embodiment of such Victorian virtues as godliness, self-control, willingness to postpone gratification, and honor. As one coed at Emory University confessed, "Valentino captivates for the moment, but Bill Hart is a being for worship."[66] Similarly, Margaret E. Duke of *Photoplayers Weekly* wrote, "[H]e is not a man merely destined to catch the eye of the gushing matinee maiden, but one that makes the person of mature intelligence 'sit up and take notice.'"[67]

Hart's Victorian attributes and acting style were appealing to women, but he risked having men view him as an effeminized matinee idol. The cowboy actor's physique and facial features helped shield him from such charges. He was tall—six foot two—and well built. The shooting scripts for his films made frequent reference to his size.[68] In a saloon full of dance-hall girls, Mexicans, and disreputable whites, he appeared dominant and powerful. Moreover, Hart was, as President Woodrow Wilson politely put it, "no pretender to screen beauty."[69] His face was elongated, and his eyes were piercing. Throughout his career fans and critics made disparaging comments about his looks. One journalist determined that Hart represented conclusive proof that "one does not have to be handsome to be a leading man in pictures."[70] Hart, too, considered himself unattractive, and he worried at first that people would throw things at his face when it appeared onscreen. Ultimately, Hart's "rugged features" proved an asset, drawing comparisons to Remington paintings and bronzes.

As his popularity grew among men and women alike, Hart soon reached a level of popularity only Mary Pickford, Douglas Fairbanks, and Charlie Chaplin consistently rivaled.[71] Like most major stars of the time, his performances became the defining element of his films. Charles Dullin, a major producer of new and avant-garde drama in Paris throughout the 1920s and 1930s, compared the cowboy actor's westerns to France's commedia dell'arte—an eighteenth-century dramatic form in which actors personified the same character over and over again and in which their performances were always the central feature of the theatrical event.[72] According to another critic, audiences did not go to Hart's westerns to see him hold up the dance hall but to see *how* he held it up because he did it a little differently each time. Studio publicity departments helped fuel this kind of reception of his films, suggesting such advertising slogans as "It's Hart. That's all. And that's enough. Don't miss it."[73]

The cowboy actor only realized the full extent of his popularity on a countrywide publicity tour in May 1917, when huge crowds greeted him at every stop. Outside a theater in the Bronx, a throng of fans mobbed him and tore the doors off his automobile.[74] In Chicago, 5,000 people overflowed into the street in front of the Triangle theater in which he was appearing, blocking

streetcar traffic in the area for half an hour.[75] As news of the tour spread, fans sent letters to the studio inviting the actor to dine at their homes when he was in town. They were eager to see Hart in person and experience an authentic part of the West. One typical letter read:

> I'm a city girl thru and thru but western life has always appealed to me. I've always wanted to go West and see the life that you depict but I've never had the chance[. I've] always wanted to see a real cowboy and now you've come to Chicago and I'd like to see you. . . . I work at Marshall Field and Co. on the fifth floor. I wish you'd come thru there.[76]

Publicly, Hart acted surprised by the outpouring of emotion from his fans, and he took the attention with great humility. He told one reporter that the frenzy was not the result of anything he had done but reflected Americans' enthusiasm to learn about and experience the Old West.[77] Privately, however, the crowds reaffirmed Hart's growing conviction that Ince and the Triangle Company were not paying him what he was worth. For all the money Triangle had spent bringing Broadway stars to the screen, it was he who had carried the burden for the company.[78] During his tour Hart had met with many Triangle exhibitors and learned that his pictures held local attendance records in theaters across the country. Yet he had not received a substantial raise since his first days in the film industry. Hart telegraphed Ince from New York, complaining about his "heartbreaking and nerve wrecking trip" and about the fact that the producer paid him less than he did many stars who had failed at the box office.[79] Their arrangement was indeed unfair, since the actor had helped make Ince a rich man. The cowboy actor had become, according to a Hart associate, Ince's "bread and butter"—a statement borne out by the producer's wildly fluctuating 1918 personal tax records, which indicate that somewhere between 63 and 93 percent of Ince's income came from Hart's films.[80]

Even as Hart drew tremendous crowds around the country, Triangle was in a shambles. For the most part, the company was making expensive pictures that were unpopular with audiences. Contract exhibitors defected from the company's program. Ince, whose obligation to Triangle had ended, was looking to get out, and he shopped around for a new corporate home for himself and Hart. The producer eventually signed with Paramount Artcraft and, together with the cowboy actor, formed the William S. Hart Production Company. In an attempt to keep Hart, Harry Aitken sued Paramount. The actor, however, was free of any obligation to Triangle because his contract stipulated that he was to work only under Ince's supervision. Aitken was more successful in keeping screenwriters Sullivan and Hawks at the collapsing Triangle, but they, too, eventually left—along with longtime Hart cameraman Joe August—and reunited with Ince and the cowboy actor at Paramount. To his reassembled

production team Hart added Lambert Hillyer, the director who would work on most of the actor's Paramount Artcraft features.

Hart's productions at the new company bore similarities to his Triangle pictures. Such westerns as *Tiger Man* (Paramount, 1918) and *Selfish Yates* (Paramount, 1918) featured the actor in the familiar role of a frontier bad man driven by instinct, passion, and worldly pleasures until he reforms and proves his basic commitment to Victorian values. Hart also stumped the country in his cowboy costume for the Liberty Loan campaign. He remained the champion of traditional morality—in this case delayed gratification—urging crowds "to give 'till it hurts like hell."[81] At Paramount Artcraft the actor tried to supplement his output of westerns with other kinds of films, but those releases earned considerably less than his cowboy pictures, suggesting that movie audiences were unwilling to separate Hart from his familiar persona.[82]

At the end of 1919 the cowboy actor broke with Ince because of lingering distrust over financial disputes. Hart took part in the initial meetings that led to the formation of United Artists—a company Pickford, Fairbanks, Griffith, and Chaplin founded to give them more creative control. Hart's initial interest in the new company waned as he learned of the actors' ambition to finance their own productions. Nevertheless, his involvement in early negotiations precipitated a bidding war between United Artists and Paramount for his services, and he ended up re-signing with the latter for $200,000 a picture—a $50,000 increase over his old contract.[83] Ince would no longer be his business partner, and in fact Hart's contract stipulated that the producer's name was not to appear anywhere in association with the actor's films. Separation from Ince also meant Hart no longer worked with Sullivan and Hawks. This diminished the quality of his output, as none of his subsequent screenwriters was as imaginative as those two.

Nonetheless, Hart's first release without Ince as producer, *The Toll Gate* (Paramount, 1920), proved a critical and financial success, grossing over half a million dollars.[84] It was perhaps Hart's most personal film. He claimed to have written the scenario himself along with his sister Mary Hart, but the script had Sullivan's distinctive hand behind it. It was, reviewers noted, very reminiscent of early Triangle westerns. The film reaffirmed the traditional ideals that had become associated with Hart, including Christianity, self-improvement, and loyalty to one's race.

After *The Toll Gate*, the profitability of Hart's films progressively declined. The status of the western genre as a whole suffered in the early 1920s. Studios increasingly associated such films with rural and small-town audiences. This demographic shift put Hart at a disadvantage in relation to other cowboy stars like Tom Mix because Paramount's marketing campaigns promoted cinema as a uniquely urban entertainment. The company upheld the well-appointed

downtown picture palace as the ideal site for moviegoing and denigrated the small-town theater experience.[85]

Although the urban, white middle class abandoned Hart's films as "preachy" and "old-fashioned," other kinds of moviegoers for whom Hart's images of western manhood still had resonance were as enthusiastic as ever. In 1921 the owners of the Princess Theater in Santa Ana, California, wrote to the actor describing their success screening his old Triangle pictures: "You are still very popular with our class of business—regular family trade—and if apparently your popularity is waning, we feel sure it is the program on which your pictures have been released as the Paramount caters to a class that are not picture fans."[86] Similarly, a man who ran a Paramount theater in southern Maryland that catered mostly to "river men engaged in oyster and fish business" sent a letter to the actor in which he complained that he could not afford to book Hart's first-run films. He was, however, able to rent his older product, and he found those films to be popular with the less "pretentious" people who, he believed, were the actor's biggest fans.[87] Another person witnessed the same phenomenon at a "cheap movie house" in New York. The theater had purchased all of Hart's old films and was running them over and over again for a packed and enthusiastic audience of "rough lower class" men.[88]

Hart and the western in general became so strongly associated with small-town and neighborhood audiences that United Artists, with which the cowboy actor signed a contract at the end of his career, found many of its big first-run theaters declining to screen his last film, *Tumbleweeds* (United Artist, 1925). Movie palaces, the firm explained, preferred "more up-to-date modern society dramas and spectacles."[89] Although an impressive number of theaters screened the film, they were second-tier venues that, according to United Artists, catered to the few patrons who still preferred western pictures.[90] Without access to first-run downtown movie houses, large-budget cowboy films like Hart was used to making could not turn an acceptable profit.

Just as Hart was still a hit in small-town and neighborhood theaters, his following among black filmgoers—who referred to him as "Two Gun Hicks" (a character he played in an early two-reeler)—also remained strong. Hart's moralism may have continued to resonate with many African Americans because, as historian Stanley Coben has pointed out, they held on to their own "Victorian ideas and social arrangements" throughout the 1920s.[91] According to J. C. Hammond, manager of some of the largest "black-belt" theaters in Chicago, Hart's popularity with his patrons was tremendous, second only to Chaplin's.[92] Similarly, Edward Henry, a projectionist for a black theater in Jackson, Mississippi, during the 1920s, recalled that "all you had to do was just put his name out there: . . . William S. Hart . . . [and] open the door and stand back."[93] In fact, the cowboy actor's popularity within the African American community

was so strong that in at least one major city—Washington, D.C.—United Artists screened *Tumbleweeds* in a black theater before releasing it in a white movie house.[94]

Outside of small-town and black America, Hart's career suffered not only from shifting tastes and mores but also from scandal. In 1922 his estranged wife, actress Winifred Westover, charged him with neglect and abuse; and another woman, Elizabeth MacCaulley, accused him of being the father of her illegitimate child. Both women later recanted, but the episodes received enormous press coverage, preventing Hart from making films for almost two years and tarnishing his image as a moralist.

The success of James Cruze's epic western *The Covered Wagon* (Paramount, 1923) eventually brought Hart back to the screen. Eager to capitalize on the market for the genre the film temporarily revived, Famous Players Lasky/Paramount hired the actor. Hart insisted, however, that he be allowed to produce westerns in the way he always had. He enlisted his old screenwriter, Hawks, and made *Wild Bill Hickok* (Paramount, 1923) and *Singer Jim McKee* (Paramount, 1923). Although both films were profitable, grossing over $300,000 apiece, they were not—much to the disappointment of the Paramount sales office—as successful as *The Covered Wagon*.[95]

For Hart's third comeback feature, the head of Paramount, Jesse Lasky, assigned an experienced writer and director with the expectation that they would create westerns more along the lines of *The Covered Wagon*, a film that avoided Victorian moralizing and celebrated American "progress" in settling the frontier. Lasky told Hart that although his comeback was popular, exhibitors' reports showed that audiences were dissatisfied with his screenplays. "Your fans," he wrote, "would like to see you in more vital stories, handled in a more modern manner. . . . [*Wild Bill Hickok*] seemed old fashioned, the story unconvincing and the working out of the ending unpopular."[96] But Hart refused to compromise his vision of what a western should be, and he dismissed the industry people Lasky assigned to him as "half baked." *The Covered Wagon* had no central hero figure, and Hart disapproved of making westerns that extolled Manifest Destiny without celebrating the self-sacrificing men who, he believed, had made settlement of the West possible. He felt the film was loaded with historical inaccuracies and dismissed it as a "sad affair."[97] To Hart's thinking, he was an expert on the West, and he balked at the idea of taking directions from anyone. He told his lawyers he would not work for Lasky unless he had complete creative control.[98] Such terms were unacceptable to the company, and the studio ended his contract.

By the mid-1920s Hart's career was over. Epic westerns like *The Covered Wagon* and John Ford's *Iron Horse* (Fox, 1924) proved of only fleeting interest, and the genre survived throughout the second half of the decade only in low-

budget "B" productions. Cowboy pictures virtually disappeared from the screens of first-run houses in large cities. At the October 1927 Federal Trade Commission conference on motion pictures, exhibitors complained that studios were forcing them to take western films under block-booking arrangements. They introduced a resolution calling for a moratorium on the production of cowboy pictures.[99]

The western's diminished position within the industry was in part a reflection of Hart's success at projecting his personal vision of the frontier onto the genre. The actor and his screenwriters had injected the cowboy film with notions of moral reform, ideas about masculinity in the West, and Victorian mores—thereby re-creating the genre for middle-class movie-palace audiences. Initially, fan magazines credited Hart with revitalizing the western and rescuing it from its "lurid" past, and critics celebrated his films for their ideas and "broadness of vision."[100] By the 1920s, however, white, urban middle-class audiences viewed Hart's values and acting style as passé and began to reject the genre altogether. Yet Hart refused to compromise his vision, believing he was reflecting the real West. If his films were "old-fashioned," it was, he said, because the West itself was old-fashioned. Rather than attempt to retool his formula to reflect the new values of the urban middle classes, he increasingly made films only for segments of the moviegoing public: small-town, black, and lower-middle-class white audiences who still ascribed in some measure to the Victorian ideals of manhood Hart believed were fundamentally "western."

NOTES

1. Undated clipping from *Photoplay Art*, scrapbook 1915–1918, box 4 oversize, William S. Hart Collection, Seaver Center, Los Angeles County Natural History Museum, Los Angeles, California [hereafter W.S.H. Collection, Seaver Center].

2. Paramount flyer for *The Tiger Man* (1918), general newspaper clippings, box 9, W.S.H. Collection, Seaver Center.

3. William S. Hart, *My Life East and West* (New York: Houghton Mifflin, 1929), 27.

4. Merle Crowell, "The Famous 'Two-Gun Star' of the Movies," *American Magazine* (July 1921): 19.

5. Hart, *My Life East and West*, 73–82.

6. Unattributed clipping, scrapbook 1915–1918, box 4 oversize, W.S.H. Collection, Seaver Center. On Booth and Barrett, see Charles H. Shattuck, *Shakespeare on the American Stage: From Booth and Barrett to Sothern and Marlowe* (Washington, D.C.: Folger Shakespeare Library, 1987), 46.

7. Hart, *My Life East and West*, 87.

8. Ibid., 103–130.

9. Shattuck, *Shakespeare on the American Stage*, 143.

10. Edwin Duerr, *The Length and Depth of Acting* (New York: Holt, Rinehart and Winston, 1962), 388.

11. Daniel E. Bandmann, *An Actor's Tour, or Seventy Thousand Miles With Shakespeare* (Boston: Cupples, Upham, 1885), 37.

12. "Rhea at the Opera House," *Daily Sun,* September 18, 1894, box 4 oversize, W.S.H. Collection, Seaver Center.

13. Article excerpted in Hart, *My Life East and West,* 135.

14. Ibid., 164.

15. *New York Dramatic Mirror (NYDM),* 1895, box 3 oversize, W.S.H. Collection, Seaver Center.

16. Shattuck, *Shakespeare on the American Stage.*

17. *Post Express,* October 4, 1894, box 3 oversize, W.S.H. Collection, Seaver Center.

18. Hart, *My Life East and West,* 149.

19. Ibid., 166–197.

20. "Why I Went to the Movies and How I Got In," *St. Louis Daily Globe-Democrat,* June 28, 1919, 10, box 6 oversize, W.S.H. Collection, Seaver Center.

21. On Hart's salary, see Hart, *My Life East and West,* 199, 209.

22. Ibid., 210.

23. Ibid., 210–211.

24. *NYDM,* June 17, 1916, 20; February 12, 1916, 35.

25. *Bad Buck of Santa Ynez,* Motion Picture Division, Library of Congress, Washington, D.C.

26. *Motion Picture World (MPW),* December 5, 1914, 1340.

27. *NYDM,* November 18, 1914, 33.

28. On the moving-picture palace, see Richard Koszarski, *An Evening's Entertainment: The Age of the Silent Feature Picture, 1915–1928* (Berkeley: University of California Press, 1990), 9–61; Maggie Valentine, *The Show Starts on the Sidewalk: An Architectural History of the Movie Theater* (New Haven: Yale University Press, 1994), 31–89; Steven J. Ross, *Working-Class Hollywood: Silent Film and the Shaping of Class in America* (Princeton, N.J.: Princeton University Press, 1998), 173–211.

29. "Scourge of the Desert" folder, box 1, Gatewood W. Dunston Collection, Manuscript Division, Library of Congress, Washington, D.C. [hereafter Dunston Collection, Library of Congress].

30. *Mr. Silent Haskins,* Motion Picture Division, Library of Congress, Washington, D.C.

31. "News Articles Concerning Aitken Brothers" and "Printed Materials," box 45, Aitken Brothers Papers, Wisconsin State Historical Society, Madison.

32. Ibid.

33. *NYDM,* September 29, 1915, 30.

34. *NYDM,* November 6, 1915, 33.

35. Hart, *My Life East and West,* 213.

36. Undated, unattributed clipping, folder 3, "Scrapbook 'Artcraft Pictures' ca. 1917–ca. 1918," box 117, W.S.H. Collection, Seaver Center.

37. On Sullivan's life and career, see unidentified clipping, William S. Hart clipping file, folder 1, Blum Collection, Wisconsin State Archives, Madison; "Successful Scenario Writers Receive High Remuneration," *Variety,* October 25, 1918, 33; William J. Reilly, "We Have With Us To-day," *MPW,* April 10, 1920, 235.

38. Quoted in Roy Everett Littlefield III, *William Randolph Hearst: His Role in American Progressivism* (Lanham, Md.: University Press of America, 1980), 13.

39. *MPW,* April 10, 1920, 235.

40. *NYDM,* May 27, 1916, 26.

41. *NYDM,* February 12, 1916, 35; *Variety,* October 25, 1918, 33.

42. New York Motion Picture's "combination saloon, dance hall and gambling house," one trade journalist remarked, "quite does away with the notion that the western underworld drinks and gambles and fights in cramped quarters." *NYDM,* November 18, 1914, 37.

43. *The Aryan* scenario, folder "The Aryan," box 1, Dunston Collection, Library of Congress.

44. Ibid.

45. Quoted in Lary May, *Screening Out the Past: The Birth of Mass Culture and the Motion Picture Industry* (New York: Oxford University Press, 1980), 65.

46. Gail Bederman, "'The Women Have Had Charge of the Church Work Long Enough': The Men and Religion Forward Movement of 1911–1912 and the Masculinization of Middle-Class Protestantism," *American Quarterly* (September 1989): 432–465.

47. *Hell's Hinges,* Netherlands Film Museum, Amsterdam.

48. Ibid.

49. [Signature illegible] to Hart, March 8, 1920, folder T, box 69, W.S.H. Collection, Seaver Center.

50. Norma Croley to Hart, April 21, 1920, folder 3, "Fan Mail 1920, 1921," box 70, W.S.H. Collection, Seaver Center.

51. Smith D. Fry, Historian of the Capitol, to Hart, June 13, 1925, folder 5, "General Correspondence," box 11, W.S.H. Collection, Seaver Center.

52. On Remington's, Roosevelt's, and Wister's views of the West, see Edward G. White, *The Eastern Establishment and the Western Experience: The West of Frederic Remington, Theodore Roosevelt, and Owen Wister* (New Haven: Yale University Press, 1968).

53. Gail Bederman, *Manliness and Civilization: A Cultural History of Gender and Race in the United States, 1880–1917* (Chicago: University of Chicago Press, 1995), 10–20.

54. *The Cold Deck* shooting script (1917), folder "The Cold Deck," box 1, Dunston Collection, Library of Congress; *The Tiger Man* shooting script (1918), folder "Hawks, 'The Tiger Man,'" box 12, Thomas Ince Collection, Library of Congress, Washington, D.C.

55. *Blue Blazes Rawden,* Motion Picture Division, Library of Congress, Washington, D.C.

56. Diane Koszarski, *The Complete Films of William S. Hart: A Pictorial Record* (New York: Dover, 1980).

57. Hart was more philosophically connected to his friend, cowboy painter Charles Russell, than he was to Remington, Roosevelt, or Wister. As historian Richard Etulain has noted in his *Re-imagining the Modern American West,* Hart and Russell—who had been friends since 1902—were both deeply nostalgic for what they felt to be the "authentic" West and were suspicious of those who lacked firsthand experience of that West. Hart used a portrait of himself that Russell had painted in 1908 as the frontispiece

of his autobiography, and he drew considerably from the cowboy artist in developing his western persona. Like Russell, Hart rode a pinto horse. Moreover, the actor wore the long woven sash of the Métis, a mixed French and Cree Indian people, that Russell had adopted after living and working among them in Montana. On the connections between Hart and Russell, see Richard W. Etulain, *Re-imagining the Modern American West: A Century of Fiction, History, and Art* (Tucson: University of Arizona Press, 1996), 30, 68; John Taliaferro, *Charles M. Russell: The Life and Legend of America's Cowboy Artist* (Boston: Little, Brown, 1996), 136, 140.

58. Letter from William S. Hart to Owen Wister, November 11, [1918], folder "Correspondence F–H," box 76, Owen Wister Collection, Manuscripts Division, Library of Congress, Washington, D.C.

59. On Hart's admiration of Roosevelt, see "Pay Tribute to Roosevelt," *Paterson New Jersey Call,* October 18, 1919, box 8 oversize, W.S.H. Collection, Seaver Center; Hart to the Officers of the General Staff, October 11, 1918, folder 3, "General Correspondence," box 11, W.S.H. Collection, Seaver Center.

60. Edward Wagenknecht, *The Movies in the Age of Innocence* (Norman: University of Oklahoma Press, 1962).

61. Undated clipping, folder 3, "Scrapbook 'Artcraft Pictures' ca. 1917–ca. 1918," box 117, W.S.H. Collection, Seaver Center.

62. Charles Kenmore Ulrich, ed., "Exhibitor's Press Book" for *Square Deal Sanderson,* undated, box 6 oversize, W.S.H. Collection, Seaver Center.

63. One editorial cartoonist produced four sketches of the actor, labeling each with a different emotion even though Hart wore the identical blank expression in every picture. Louis Reeves Harrison, "Review of *The Disciple,*" *MPW,* October 30, 1915, 810; "Review of *Blue Blazes Rawden,*" *Photoplay* 13, no. 6 (May 1918): 67.

64. "Wm. S. Hart Is Co-Ed's Hero," *Buffalo New York Times,* July 7, 1923, box 9 oversize, W.S.H. Collection, Seaver Center; Shelly W. Denton to Hart, November 30, 1923, folder "RE: Hart's Attempted Comeback in Wild Bill," box 1, W.S.H. Collection, Seaver Center; a fan to Hart, March 8, 1820, folder T, box 69, W.S.H. Collection, Seaver Center; folder "Chicago Tribune," box 1, W.S.H. Collection, Seaver Center.

65. Akira Kurosawa, *Something Like an Autobiography* (New York: Vintage, 1983), 36.

66. "Wm. S. Hart Is Co-Ed's Hero," W.S.H. Collection, Seaver Center.

67. Margaret E. Duke, "My Impressions of William S. Hart," *Photoplayers Weekly,* undated, scrapbook 1915–1918, box 4 oversize, W.S.H. Collection, Seaver Center.

68. Shooting script for *Sheriff's Streak of Yellow* (1915), *Jim Cameron's Wife* (1914), and *A Knight of the Trials* (1915), boxes 1 and 2, Dunston Collection, Library of Congress.

69. Smith D. Fry, Historian of the Capitol, to Hart, June 13, 1925, W.S.H. Collection, Seaver Center.

70. "Review of *The Darkening Trail,*" *Motography,* June 12, 1915, 967.

71. At the end of 1918, when sales figures indicated that Hart's popularity was waning somewhat, he still placed fifth in a *Motion Picture Magazine* popularity contest behind Pickford, Fairbanks, Harold Lockwood, and Marguerite Clark. "The Motion Picture Hall of Fame," *Motion Picture Magazine* (December 1918): 12.

72. Charles Dullin, "Art of William S. Hart," *Manila P.T. Daily Bulletin,* December 4, 1920, box 8 oversize, W.S.H. Collection, Seaver Center.

73. *MPW*, April 6, 1918, 135.

74. Unattributed clipping, scrapbook 1915–1918, box 4 oversize, W.S.H. Collection, Seaver Center.

75. Folder 29, "Souvenir of the Trans-continental Trip of May 8 to June 8, 1917," box 116, W.S.H. Collection, Seaver Center.

76. Unsigned letter to Hart, May 29, 1917, folder "Fan Mail 1917–1918," box 70, W.S.H. Collection, Seaver Center.

77. George Blaisdell, "Bill Hart Hits the Great White Trail," *MPW*, June 2, 1917, 1422.

78. Kalton C. Lahue, *Dreams for Sale: The Rise and Fall of the Triangle Film Corporation* (New York: A. S. Barnes, 1971), 135.

79. Reprinted in *Parker Read Jr. v. William S. Hart*, "Cross Examination of Ince," box 14, W.S.H. Collection, Seaver Center.

80. Folder "Ince Personal Income Tax," box 54, Ince Collection, Library of Congress, Washington, D.C.

81. *MPW*, May 11, 1918, 832.

82. From the time of Hart's first production for Artcraft in 1917 to the point at which Paramount mounted a new and expanded advertising campaign at the end of 1919, four of Hart's five smallest-grossing films were nonwesterns.

83. Hart, *My Life East and West*, 274–285.

84. William S. Hart Deposition, 169–170, *William S. Hart and Mary Hart v. United Artists Corp.*, Supreme Court of the State of New York, box 15, Aitken Brothers Papers, Wisconsin State Historical Society, Madison.

85. Katherine Fuller, *At the Picture Show: Small-Town Audiences and the Creation of Movie Fan Culture* (Washington, D.C.: Smithsonian Institution Press, 1996), 109–110.

86. Mr. and Mrs. Walker to Hart, February 12, 1921, folder W, box 69, W.S.H. Collection, Seaver Center.

87. Rock Point, Maryland, theater owner to Hart, January 1, 1921, folder "3 Fan Mail 1920, 1921," box 70, W.S.H. Collection, Seaver Center.

88. [Signature illegible] to Hart, March 8, 1920, folder T, box 69, W.S.H. Collection, Seaver Center.

89. "*Hart v. United Artists Company* Correspondence 1927–34," box 184, United Artists Collection, Wisconsin State Historical Society, Madison.

90. Arthur Weinberger to Paul O'Brian, September 28, 1938, "*Hart v. United Artists Company* Correspondence 1938," box 184, United Artists Collection, Wisconsin State Historical Society, Madison.

91. Stanley Coben, *Rebellion Against Victorianism: The Impetus for Cultural Change in 1920s America* (New York: Oxford University Press, 1991), 69–90.

92. Quoted in *MPW*, September 13, 1919, 1633.

93. Quoted in Pearl Bowser and Louise Spence, "Micheaux's 'Biographical Legend,'" in *The Birth of Whiteness: Race and the Emergence of U.S. Cinema*, Daniel Bernardi, ed. (New Brunswick, N.J.: Rutgers University Press, 1996), 62.

94. In Washington, D.C., much to the chagrin of some of Hart's friends in the U.S. Senate, his *Tumbleweeds* opened in the black Howard theater instead of the white Mutual theater.

95. Hart, *My Life East and West,* 274–285.

96. Jesse Lasky to Hart, November 11, 1923, folder 4, "Correspondence—Lasky, Jesse (and others) re: Hart's Split With the Famous Players Lasky Corp., 1922–24," box 112, W.S.H. Collection, Seaver Center.

97. William S. Hart to Mr. Sautter, folder 6, "General Correspondence," box 11, W.S.H. Collection, Seaver Center.

98. "Correspondence—Lasky, Jesse (and others)," W.S.H. Collection, Seaver Center.

99. William Grossman to Hart, October 24, 1927, folder "Correspondence—House Grossman and Vorhaus 1b," box 20, W.S.H. Collection, Seaver Center.

100. *Motion Picture Classic,* March 1916, scrapbook 1915–1918, box 4 oversize, W.S.H. Collection, Seaver Center.

"NO MORE LACES AND PLUMES"

Neighborhood Theaters, Boy Culture, and the Shaping of "Shoot-'em-up" Stars

Many a manager's "out" is Tom Mix. "All I have to do is put Mix's name out front and they come back like prodigal sons," he [the manager] says. "There's affection and trust in their eyes again when they lay down their dough. They take for granted that Mix will never go up against less than twenty guys. There's a man for 'em."[1]

—*Variety*, 1928

Not a bad picture [*Yankee Señor* (Fox, 1926)]. It pleased. But oh my, where is Tom's crowd? Hardly had enough to pay rental. He better take his gloves off and put his leather pants on if he expects to get his friends to come and see him.[2]

—Arch Catalano, exhibitor from
Rochester, Pennsylvania, 1926

During the mid- to late 1920s, motion-picture–palace exhibitors virtually abandoned westerns because the genre was unpopular with audiences. Studios, however, continued to produce such films largely for one- or two-day showings in the more modest theaters located in neighborhoods and small towns. Lacking the rental revenue from downtown movie palaces, producers had to keep down the costs of these so-called shoot-'em-ups to make them profitable. Reduced budgets led to increasing rigidity of the genre's

conventions, a trend further exacerbated by the fact that boys and other fans of cowboy pictures tended to reject any deviations from basic formulas. Not needing to pay for originality or innovation, studios further lowered expenditures on westerns, free from fear that in doing so they would lose their core audience.

Those who frequented the second-tier theaters where the shoot-'em-ups were shown had considerable influence in determining the genre's content. They were especially possessive of cowboy stars and were dubious of any efforts by studios to "dress them up" to expand their appeal to movie-palace patrons. For a film to play in a large first-run theater, women—an important segment of the audience in those houses—needed to find its central male characters appealing. Producers of high-budget "special features" shaped their films accordingly. William S. Hart's cowboy persona in part had grown out of his studio's efforts to appeal to female spectators. Even more important, the 1920s saw the rise of such sensual matinee idols as John Barrymore and Rudolph Valentino, whom studios promoted largely to attract women.

The male-dominated audiences in neighborhood and small-town houses perceived many movie-palace actors as "sissies." To their way of thinking, these leading men exhibited too few of the qualities associated with vigorous masculinity. Shoot-'em-up fans distrusted Hollywood-manufactured stars and demanded tough, authentic heroes. Studios responded by developing the stoic, isolated cowboy hero, a figure scholar Jane Tompkins has identified as the central protagonist of sound-era westerns.[3] The character's emergence, however, was not so much a reaction against Victorian moralism, as she suggests, as a response to female viewers' influence over the cinematic depiction of men in high-budget motion-picture–palace releases.

The cowboy heroes of the 1920s departed in significant ways from the patterns William S. Hart and Gilbert M. Anderson had established in the teens. Moviegoers admired these older stars' screen characters for the courage they displayed in overcoming their sinfulness and selfish natures. Now, physical prowess and dexterity were the keys to a western actor's success. Moreover, the "real-life" exploits of screen figures were as important as their filmic performances. In fact, aficionados of the shoot-'em-ups viewed professional acting with skepticism. Dramatic talent was always less important to them than a cowboy star's ability to ride a horse, fight his own fights, and endure physical punishment. Although western actors were as much creations of the Hollywood publicity machine as was the typical matinee idol, studios tried to convince male moviegoers that cowboy stars had proven their strength, athleticism, and courage in the world outside the movies.

As filmmakers began to emphasize western stars' athleticism, moral and psychological battles became less prevalent in the genre. The relationship be-

tween a cowboy and his leading lady also diminished in importance. Whereas the heroines in Anderson and Hart films served as virtuous exemplars who often had a transforming effect on the heroes, female characters in the shoot-'em-ups carried little moral authority. They typically related to the star only in a flirtatious manner and often took secondary roles to male sidekicks or horses.

This new kind of cinema cowboy hero ascended to prominence as the industry consigned westerns to second-tier houses. William Hart refused to suffer the indignity of being relegated to these modest theaters, and he ended his career in 1925 after United Artists (UA) failed to get his last picture, *Tumbleweeds* (1925), widely released in movie palaces. The cowboy star had spent $300,000 to make the film, and it realized only about $80,000 above its cost. The actor sued the company over what he interpreted as its bad-faith effort to distribute the picture. UA could do little, however, as Hart was a victim of the genre's shifting popularity. The studio tried to rent *Tumbleweeds* to the best downtown theaters at premium prices, but the proprietors of those venues rejected it, as they had most westerns. To keep the film within the budget of neighborhood and small-town exhibitors, who wanted to screen it to smaller audiences and for shorter runs, UA discounted the film's rental fee. At the reduced rate, the company managed to get the picture into 10,701 theaters across the country—more than half of the movie houses in the United States. It was, in fact, the studio's second-most widely released film that year and likely would have been more profitable if Hart had kept production costs down. Without the higher revenues from movie palaces, however, the extravagantly produced *Tumbleweeds* barely returned its investment.[4]

Although Hart was unwilling to make low-budget westerns, plenty of cowboy actors were eager to do so. When marketed and produced to appeal to the patrons who fancied them, such films could be quite profitable. In fact, in 1928, even as operators of urban movie palaces complained that the genre was not attracting customers, three of the country's top ten box office draws were cowboy actors: Tom Mix, Ken Maynard, and Hoot Gibson. In contrast to the "special-feature" stars who made two or three films annually for the first-run theaters, these men appeared in a dozen or more so-called program westerns a year.[5] Any one of their pictures performed modestly compared with the most successful special features, but the combined profits from cowboy films were substantial. The shoot-'em-ups were a dependable and important source of revenue for studios, and the most popular western actors were among the highest-paid talent in the industry.

The success of program westerns depended on their wide distribution to small-town and neighborhood houses. According to poet and film critic Carl Sandburg, Tom Mix's Fox pictures, for example, opened in more theaters—7,000—than those of any other actor.[6] Especially popular in municipalities

with populations under 5,000, Mix and the other shoot-'em-up stars drew crowds to houses like the Amuse-U Theatre in Melville, Louisiana; the Lyrus Theater in Lyrus, Colorado; the Temple Theater in Aberdeen, Mississippi; the Strand Theater in Gallup, New Mexico; and the Lyric Theater in Versailles, Kentucky. Proprietors of these businesses made more than "a little money," they reported, playing program westerns to "the rank and file" moviegoer.[7]

Although all the so-called big five cowboy stars—Tom Mix, Buck Jones, Hoot Gibson, Tim McCoy, and Ken Maynard—were popular in these modest venues, Mix's Fox films proved the most consistent draws, and small-town and neighborhood exhibitors clamored for his pictures. According to the owner of a theater in a working-class hamlet in Pennsylvania, no other star could bring in "crowds like Mix"[8] (see Figure 7.1). Similarly, Roy E. Cline, operator of the Osage Theatre in Oklahoma, testified: I "have always heard of box-office breakers but had never seen any of them till I ran these two . . . [Mix films]; we advertised these to the limit—did they come?—I say they did! In fact, we smashed all house records."[9] Although movie palaces largely ignored Mix, he maintained a box office draw on the strength of his success in the smaller houses that surpassed that of most other stars, even those whom studios promoted more aggressively.[10] Such smaller rental contracts eventually added up, and Mix's five-reelers for Fox grossed an average of $600,000 to $800,000 apiece.[11]

As mentioned previously, even though cowboy stars were drawing impressive crowds in smaller theaters, without the revenue from the movie palaces, studios had to keep production costs of program westerns down. During the mid- to late 1920s, the budgets for such films came nowhere near the mark Hart had set with Tumbleweeds. Even Tom Mix, the most successful cowboy actor of his day, made films that came in around $175,000 apiece—a generous sum for the shoot-'em-ups but modest compared with the budgets for special features.[12] A critic for Variety surmised that Mix productions "cost less than any other drawing picture possibly could." The actor's fancy western costume and hat, he determined, were his films' only real extravagances.[13]

Other studios handled the manufacture and distribution of low-budget and routinely produced cowboy films, or program westerns, similarly to Fox. First National spent $75,000 to $80,000 on the films of its cowboy star, Ken Maynard.[14] Metro Goldwyn Mayer (MGM), which favored higher-class productions and had initially resisted entrance into the program western field, hired Tim McCoy to make cowboy pictures budgeted at $90,000 to $125,000 each. After producer David O. Selznick came up with the idea of shooting some of these films two at a time, "side by side," using double camera setups, Metro Goldwyn Mayer produced them even more cheaply.[15]

Although most Maynard, Mix, and McCoy films cost half to less than a third as much as Hart's Tumbleweeds, they had lavish production budgets compared

Fig. 7.1 Tom Mix. From the Blum Collection, Wisconsin Center for Film and Television Research.

Fig. 7.2 Buck Jones. From the Blum Collection, Wisconsin Center for Film and Television Research.

with some of the more run-of-the-mill program westerns. The films of Buck Jones, Fox's most important cowboy star after Mix, more accurately reflected the norm (see Figure 7.2). He made westerns that cost between $50,000 and

$75,000, and they went out with few or no promotional materials. Studios produced the shoot-'em-ups—even the best ones—very quickly and cheaply, and exhibitors often complained of technical problems.

Into the 1930s, the general trend of the program western was toward increasingly diminishing budgets. Studios could cut manufacturing costs to the bone without losing the films' core fan base because western-film aficionados had unique aesthetic criteria that had little to do with production values or quality acting. In fact, this audience often reacted negatively when studios put their western heroes in expensive special features. They wanted few additions or departures from the basic structure of the shoot-'em-ups—which usually included several chases on horseback, extended fight scenes, sensational and realistic stunt work, rugged scenery, and a familiar star dressed in his fancy cowboy costume.

Although fans of program westerns were a large and diverse group, brought together only by their love of the genre, young men were a particularly important segment of the audience. According to the Fox studio, for example, Mix's films played particularly well with boys under sixteen.[16] Children flocked to neighborhood and smaller houses on Saturday afternoons to see their favorite cowboy hero's latest release. Even into the 1950s, film critic and western movie fan Brian Garfield recalled, this weekend ritual was "a standard rite of male adolescence."[17] Exhibitors' reports from the mid-1920s confirmed that children often enjoyed western films adults found boring or distasteful. One theater operator observed of Buck Jones's *Not a Drum Was Heard* (Fox, 1924), "[C]hildren liked it, but older folks walked out."[18]

American boys, of course, were not the only audience for these pictures. There was also a demand for them abroad. Unlike the situation with more expensive special features, studios did not need foreign sales to offset the cost of program westerns, but the shoot-'em-ups were popular around the world anyway. Even in non-Western countries, where knowledge of the English language and American culture was limited, spectators could still appreciate cowboy pictures for their action and sensationalism.[19] According to the Disney Corporation, as late as 1941 exhibitors in interior Brazil continued to screen the silent pictures of Tom Mix, William S. Hart, and other western stars. Showmen put together a dozen or more of such films and advertised the program simply as "Twelve Cowboys."[20]

American adults, especially those in rural areas and small towns who found the antiurban subtext of many shoot-'em-ups appealing, also followed cowboy stars. Most of Buck Jones's fan mail, for example, came from mature moviegoers. Similarly, according to the Fox studio, "older people who have tired of romance," along with boys, showed up to Mix films.[21] Small-town exhibitors confirmed these impressions of various cowboy films: "Farmers eat it [cowboy

194 "NO MORE LACES AND PLUMES"

films] up." "They all like it old and young." "They all . . . turn out for Mix."²²
Western stars were also admired by such American notables as President Warren
G. Harding, poet Carl Sandburg, and labor activist Eugene V. Debs. In 1921,
when Debs was in prison for his opposition to World War I, a friend wrote to
him, trying to lift his spirits with the thought that one day they together
would "see Tom [Mix] do his stunts and . . . laugh."²³

African Americans continued to be an important segment of the domes-
tic audience for the western. They enthusiastically supported the cowboy stars
of the 1920s as they earlier had William S. Hart. According to a projectionist
at a black theater in Jackson, Mississippi, large crowds always showed up for
Mix films.²⁴ Similarly, in his study of the recreation and amusement patterns
of African Americans in Washington, D.C., Howard University sociologist
William H. Jones reported that westerns in the 1920s were popular in the
cheapest movie houses. The city's African American community supported at
least three venues specializing in westerns—the Jewel, the Blue Mouse, and
Happyland—with a combined seating capacity of more than a thousand people.
Jones described them as "situated among a rather rough class of people," cater-
ing largely to boys, and screening pictures "of the mediocre type, featuring
such actors as 'Buck Jones,' 'Tom Mix,' etc."²⁵

Whatever the actual audience demographics for program westerns, studios
made and promoted these films largely with children in mind. This marketing
strategy was not altogether new. In 1911 the Essanay Company had created its
Broncho Billy character at least in part to appeal to boys and girls. Yet whereas
this older cowboy figure—at least at the beginning of a typical film—behaved
in unvirtuous ways, makers of program westerns, seeking to keep their films
suitable for younger moviegoers, rarely depicted their heroes as morally flawed.
Gibson, McCoy, Mix, Jones, and Maynard never smoked or drank in their
films. Moreover, they dressed impeccably. According to McCoy, his clothes
were "always so clean and neat" because he hoped to set a "decent example"
for young people, to provide "a mark" for them "to shoot at."²⁶ Mix explained,
"The kids, the little fellows, who go to see my pictures, try to follow my ex-
ample. That's why I never have smoking, drinking or swearing in them. There's
enough of that elsewhere. I hope that I give the fertile brain of Young America
good thoughts and clean ideals."²⁷

Knowing boys were put off by kissing scenes, producers of program west-
erns kept romantic material to a minimum. Dick Foran, a cowboy actor of the
1930s, explained, "You can be respectful, devoted, even pally with the heroine,
but you can't do any tender love scenes, because if you do, you're apt to get
hoots and cat-calls."²⁸ In general, filmmakers limited the role of the leading
lady and emphasized the cowboy hero's relationship with his horse, younger
brother or friend, or an effete older sidekick. This is not to say the shoot-'em-

ups had no romance, but these other, nonsexual relationships muted such sentiment. Producers sometimes included horses in love scenes, moving them between the star and the heroine to prevent the two from kissing or using them to obstruct the camera's view of the kiss. The hero's sidekick often ridiculed the cowboy star if he expressed too much affection for a woman.

To further appeal to young men, cowboy stars of the 1920s played particularly boyish characters. Producers infrequently featured children in shoot-'em-ups because western actors themselves were supposed to represent the epitome of youthfulness. Studios presented them as fun-loving vagabonds who, aside from bringing the villain to justice, were free of pressing adult obligations. This was in contrast to the characters of Gilbert M. Anderson and William S. Hart, who by the end of their films often proved themselves paternal figures of conscience.

The program western stars were not the only ones in the motion-picture industry marketing juvenility to attract audiences. In general, during the 1910s and 1920s Americans increasingly valorized youth and began to develop a special sensitivity toward childhood issues. According to historian Gilman M. Ostrander, the twentieth century saw the abandonment of "a patriarchal faith" in the wisdom that developed with age and experience and a growing celebration of the promise of youth, innovation, and technology.[29] Motion pictures reflected this trend. Buster Keaton and Harold Lloyd often played exuberant childish men in their comedies. The same was true for Douglas Fairbanks, a highly physical actor who brought to the screen what historian Gaylyn Studlar has called "an idealized, boyish masculinity."[30]

Yet as stars of the special features, Keaton, Lloyd, and Fairbanks had to appeal to the movie palaces' female spectators and had to concern themselves with their product's international reception. The makers of program westerns, who targeted neighborhoods and small-town houses, could pitch their performance more directly to American boys. Consequently, young fans could exert their collective will to determine the content of cowboy films, an influence they did not have over movie-palace–oriented material. According to journalist Kyle Crichton, when it came to westerns, children did not need "a national organization" to make their tastes known. If they saw something they did not like, they merely "set up such a clamor of loud, insulting, vulgar noises" that exhibitors and producers had no choice but to respond.[31]

In addition to accommodating boys by manipulating the content of shoot-'em-ups, studios directed publicity material toward them, hoping to extend the movie-house culture further into their lives. In the early 1930s Buck Jones started a fan club called the "Buck Jones Rangers." Millions of young people joined the Boy Scouts–like organization, which encouraged its members to go hiking and camping and gave them opportunities to earn medals of merit.[32]

Even Hart, realizing he was losing ground in the 1920s to Mix and other cowboy stars who catered more overtly to children, began to publish a syndicated western adventure and outdoor activities column geared toward young men called "Bill Hart's Campfire Stories."[33]

As studios constructed and promoted program westerns to attract and hold the attention of young boys, the boys showed their loyalty, following the cowboy stars' careers with almost a religious devotion. Western fan and critic Buck Rainey recalled:

> When I was a kid growing up in . . . the 20s and 30s my best and closest friends were "reel" cowboys. I knew and loved them all—Buck Jones, Ken Maynard, Hoot Gibson, George O'Brien, Rex Lease, Billy Cody, and Tim McCoy were intimate acquaintances. . . . It mattered not that the B-Westerns . . . were devoid of substance, we . . . loved them then and remember them now as the greatest movies ever made and the finest aggregation of stars ever to inhabit Hollywood.[34]

Through frequent attendance at shoot-'em-ups, youthful fans acquired intimate knowledge of the western productions of their favorite stars. According to fan Brian Garfield, any "'B' moviegoer worth his salt could sketch you a map showing the location of every phony rock and bush on Monogram's back lot; he knew every turning of the Republic cave set and every chip of weathered paint on Eagle-Lion's Western town set."[35] Ken Maynard's fans instantly recognized whenever filmmakers used a double for his horse Tarzan because they were so familiar with the animal's markings.[36]

Young enthusiasts dressed like their favorite cowboy stars and played out Wild-West fantasies with their friends. As an adult, a fan of Tim McCoy confessed to his childhood hero, "[W]e kids used to get right up there in the front row. . . . And I had a slingshot and a pocketful of iron staples and any time the outlaws got anywhere near you, I shot the hell out of them."[37] This emulation did not end once boys left the movie theater. In games of cowboys and Indians, they assumed the persona of their favorite western star. Movie fan Richard F. Seiverling recalled one year when he and his friend received cowboy suits for Christmas. Seiverling fancied himself as Tom Mix and his friend as Buck Jones. They dressed in their costumes and had contests to see which western star was superior. Seiverling wrote about it for his high-school paper:

> I challenged him [my friend] to a roping contest. . . . I beat him. . . . We competed against each other in drawing guns. Another victory for Tom Mix. To end the argument, I raced him for a whole block on my horse Tony. Evidently I left him in the dust because he didn't finish the race. As a result I decided that I was the fastest and bravest cowboy on the plains.[38]

As stories such as these suggest, the industry successfully encouraged the development of an entire subculture around the program western. Boys and adults who frequented small-town and neighborhood houses embraced the phenomenon, in part as a conscious rejection of the movie-palace experience. Loyal shoot-'em-up fans dismissed the costume spectacle and other films that dominated the screens of downtown houses as entertainment for female matineegoers.[39] The western audience's antipathy to movie-palace–oriented pictures was perhaps stronger than the studios wanted. Any attempt by manufacturers to modify shoot-'em-ups to appeal to patrons of first-run theaters met resistance in the second-tier houses (see Figure 7.3). Whenever studios cast their western stars in something other than a straightforward cowboy role, they were reportedly "swamped under an indignant sea of disapproving fan mail".[40]

Western aficionados were particularly weary of studios putting cowboy stars in costume dramas, a genre they associated with female spectators. As Studlar has pointed out, producers commonly sexually objectified men in such films in order to please women. The costume dramas of John Barrymore and Rudolph Valentino were the most prominent examples of the industry's creation of a sensualized leading man to appeal to the so-called matinee girls of the first-run theaters.[41]

In an attempt to please this same demographic, the Fox studio cast Mix in the costume drama *Dick Turpin* (1925). Critics heralded the picture as "the logical vehicle" for the cowboy star to "bow into the first-run houses."[42] Mix's core fans in the small-town and neighborhood theaters, however, rejected the film. They correctly sensed that Fox was trying to boost Mix's sex appeal to attract more female fans. This diminished his credibility in the second-run houses as a "man's man." Exhibitors worried that fans did not like Mix dressed in a fancy costume, and they urged him to "get back into . . . western chaps."[43] According to one theater operator, *Dick Turpin* had "too much sex and not enough action." In a reference to Valentino he begged, "Won't they please quit trying to make a sheik out of Mix and give him a real western picture."[44] An exhibitor from Melville, Louisiana, summed up the feeling of many: "Tom Mix is not the drawing card he used to be since Billy Fox has dolled him up" and put him in special features (see Figure 7.4).[45]

If the cowboy actor had proven a more successful draw in movie palaces, he likely would have abandoned the western altogether for the costume picture, as Douglas Fairbanks had done when his popularity increased. Tom Mix, however, never made a successful transition to the larger downtown theaters and therefore had to remain receptive to the demands of the small-town and neighborhood audiences who always turned out to see him. After *Dick Turpin*, Fox avoided putting the cowboy star into historical dramas. In a promotional

Reelism

"What's the matter, Martha?"
"Never could — *kerchoo* — stand that alkali dust!"

Fig. 7.3 Cartoon playing on women's distaste for westerns. From Photoplay, July 1920.

article the company promised "no more laces and plumes for Tom Mix! His followers have decided that a Wild West he-man has no business playing around in costume."[46]

Fox was not the only studio to discover that western fans did not want their cowboy stars in movie-palace–oriented special features. In 1926 Universal put its most important buckskin actor of the 1920s, Hoot Gibson, in an expensive western called *Flaming Frontier*. The film opened on Broadway at the Colony Theater; admission prices were a costly $1.00 to $1.50. The studio heavily promoted the picture, hiring an Indian wars veteran, General Edward S. Godfrey, to introduce it on opening night.[47] In spite of the company's deci-

Fig. 7.4 Tom Mix in costume drama Dick Turpin *(1925). From Robert S. Birchard,* King Cowboy: Tom Mix and the Movies *(Burbank, California: Riverwood Press, 1993).*

sion to increase expenditures on producing and marketing *Flaming Frontier,* audiences at the cheaper houses rejected it as an inappropriate vehicle for the cowboy actor. The owner of the Opera House in Barnes City, Iowa, said of the film, "[T]he fact that Hoot Gibson played the lead kept many of my best customers away as they could not imagine him in anything but a shoot-'em-up western."[48] Another exhibitor wrote from Montpelier, Idaho, "Carl [Laemmle] wanted to do Hoot a good turn and spent a lot of money on this . . . but Hoot is badly miscast. Not the kind of a picture for Hoot."[49] H. L. Bendon of the Grand Theatre in Port Allegany, Pennsylvania, agreed: "We think the funniest sight is when Hoot tried to look sad and broken hearted; people laughed [and] thought he was acting funny. He's all right if you keep him in honest-to-gosh westerns."[50]

The First National studio also had ambitions to expand the appeal of program westerns beyond small-town and neighborhood houses. The firm hired circus stunt rider Ken Maynard to star in cowboy films, and it spent money

buying stories and shooting on location. Its efforts resulted in what film critic
Jon Tuska called "one of the best series of programmer Westerns ever manu-
factured."[51] According to the company's promotional material, Maynard would
appeal to more than just the fans of shoot-'em-ups. The studio claimed:

> Ken's pictures . . . aren't merely Westerns. You can't dismiss them with that
> word—and neither can your patrons. They are Westerns only in that they
> deal with the West. In every other sense they are epics, classics, super-
> productions that contain every bit as much love interest, story, character
> development, and photography as the best feature pictures ever turned out
> by a major producing company.[52]

Yet the extra money spent on Maynard's First National films likely did
not translate into greater profits because the pictures, like Mix's and Gibson's,
fell short of success in first-run theaters. In 1927 a reviewer for *Variety* rhetori-
cally asked why the studio had gone to "the trouble and expense of buying the
screen rights" for a novel to produce the screenplay for Maynard's *Somewhere
in Sonora* (First National, 1927) when it was, after all, merely a program west-
ern. He concluded that "if the picture was intended to hit the first runs it has
shot wide of the mark."[53] Not only did the increased production values of
Maynard's westerns fail to lead to movie-palace success, they also annoyed the
core fans of shoot-'em-ups who wanted "straight westerns" without fancy em-
bellishments. These spectators even found the Native American extras in
Maynard's films an unnecessary distraction. One small-town exhibitor advised
First National to keep Indians out of westerns because although they had
enjoyed their moment in cinema, they were no longer popular.[54]

Even the most prestigious studios, such as Metro Goldwyn Mayer, were
unable to produce westerns that circulated to any significant extent outside
neighborhood and small-town theaters. The studio hired McCoy in 1927 to
make historical costume dramas, some with frontier themes. The budgets for
these pictures were generous by shoot-'em-up standards, and the firm had
every intention of turning McCoy into a major star. Of his heady days at
MGM, the actor recalled that he was a privileged person on the lot, attending
black-tie parties and socializing with the studio's best-known talent. To his
way of thinking, he occupied a "social strata" [sic] above that of the average
cowboy actor.[55] His films, however, were no more successful in the movie pal-
aces than those of any other western star. His first picture, *War Paint* (MGM,
1926), opened in a second-run house in New York. A reviewer who liked the
film encouraged moviegoers to "make a pilgrimage" to their local neighbor-
hood theater to see it.[56] Other critics warned MGM, however, that it was "too
expensive to make mere westerns on this scale considering the depleted mar-
ket awaiting products of this type."[57]

Fig. 7.5 Luther Standing Bear, left, and Tim McCoy, right, on location for MGM. From the Blum Collection, Wisconsin Center for Film and Television Research.

Whereas movie palaces largely ignored McCoy, small-town exhibitors complained that MGM was trying too hard to depart from the typical shoot-'em-up formulas. One advised, "[L]ay off this Indian stuff and put him in good action pictures."[58] Another wrote in his exhibitor's report, "[G]ood historical picture, but [I] think that McCoy would be better in a . . . western."[59] In the long run, the traditional program western audience won out in determining the direction of McCoy's career. According to Tuska, when MGM discovered its cowboy actor was most successful in straightforward cowboy pictures geared to the Saturday matinee crowd, the studio abandoned its efforts to turn him into a major star.[60] In fact, the company used McCoy's failure in the first-run market to help sell him to small-town and neighborhood audiences. A fan magazine quoted the cowboy actor as saying, "Well, I may not be a star on Broadway . . . but I'm a wow in Wyoming" (see Figure 7.5).[61]

Since elevating the budgets of program westerns rarely led to a corresponding increase in their popularity, filmmakers avoided more innovative productions, leading to increased redundancy in plots. Western writers with

new ideas found studios reluctant to spend extra money to adapt their work to the screen. The head of the scenario department at Paramount explained his company's position to author Stuart N. Lake: "[D]one at a reasonable cost . . . [your story] would look like little more than a Western. And we can't afford to do it expensively so that it could fall into the . . . *Covered Wagon* class."[62]

Manufacturers standardized the plots of these films not just to save money but also to meet the expectations of shoot-'em-up fans who wanted mostly to see their western heroes engaged in impressive riding and stunt work. The genre's loyalists found original stories more distracting than entertaining. Ultimately, they considered plots successful if they connected action sequences in a logical and coherent fashion. Consequently, studios rejected the work of any scenario writer who tried to move away from standard formulas. Harold B. Lipsitz, scenario editor at Fox, explained to western-fiction writer Eugene Cunningham why his stories would be unacceptable for Tom Mix and Buck Jones films:

> What we are using here are old ideas, situations and characterizations presented in new clothing. . . . [W]e want to get away from . . . "plot." We like well-defined, straight, one-line stories leading to a definite climax, and not cluttered up by too much in the way of plot development. When we get this type of story and, in addition, have a good character lead with fast action and chances for comedy, we usually have material for a successful western picture.[63]

The shoot-'em-ups indeed suffered from unoriginal and largely indistinguishable plots, but studios compensated for this shortcoming by creating magnificent, larger-than-life cowboy heroes. They cultivated exaggerated star personas for their western actors and placed them in films in which their presence dominated all other elements of the narrative. The cowboy films of the 1920s were highly romantic in the sense that filmmakers kept backgrounds and scenarios constant while emphasizing the heroic qualities of their leading men. If spectators could always predict the denouement, the variety and vividness of a given program western stemmed from the particular ways in which the star used his physical strength, ingenuity, and dexterity to overcome obstacles.

In marketing their shoot-'em-ups, studios tried to get fans invested in the small differences among the various cowboy stars. Universal claimed Hoot Gibson was unique for incorporating humor into his cowboy roles.[64] Fox and First National, respectively, argued for the superiority of Tom Mix's and Ken Maynard's stunts and horse-riding ability. To the most loyal spectators, these distinctions were crucial. Writer and western fan Buck Rainey admired Buck Jones in particular because he felt the actor was a "Mr. nice guy, a star without blemish, a man worthy of a child's admiration and trust."[65] Others appreciated Tim McCoy for the icy-cold stare he used to intimidate villains.

Yet for all the minor differences among the big five cowboys, the studios, in attempting to portray an ideal of western heroism acceptable to American boys and small-town audiences, had created very similar characters. Mix, Jones, Gibson, Maynard, and McCoy were all white men more or less the same age. All except Mix, who was a decade older than the others, were born between 1891 and 1895. Each maintained either to be a native of the West or to have lived there since childhood. They had all served in the military, and studios often exaggerated the extent of their soldierly accomplishments. None was a professional actor, and with the exception of McCoy, they had entered the movie business largely on the strength of their horsemanship. At the height of their careers, the cowboy stars were all excellent athletes. Each claimed to do his own stunts and boasted of being able to endure great physical punishment.

In developing and promoting a cowboy star, it was crucial for studios to affirm the connection between the actor and the West. In the words of one industry writer, if the screen hero had been born and raised in the region, it helped give him credibility as a "narrator and spokesman for the American pioneer."[66] During an earlier period of American cinema, the industry made much of the authenticity of its western landscapes. By the end of the 1920s, however, manufacturers considered it imperative that cowboy stars appear as bona fide regional figures. The studios marketed these men as indigenous heroes whom they had not created but had merely discovered. Male audiences in second-run theaters could rest assured that the cowboy actors were worthy of adulation because the environment of the American West had tempered and shaped their character and masculinity. Western stars were not, in contrast to matinee idols, Hollywood-made men. Their claim to authenticity lay not in their filmic performances but "in something further back, more fundamental, nearer to the soil."[67]

According to his studio biographer, Mix was "a native-born son of the great southwest."[68] First National billed Maynard as "a Texan with a drawl, a real cowboy."[69] In press books for Gibson's films, Universal included material on his childhood in Tekamah, Nebraska, claiming the actor had "lived all his life in the West, where he spent his time learning the arts of the outdoors, cattle roping, cow-punching, herd-riding and the sundry other necessary accomplishments of a cattle man."[70] Similarly, MGM's publicity department wrote articles about McCoy's activities on his working ranch in Wyoming.[71]

In addition to being authentic regional figures, cowboy stars had to affirm publicly their loyalty to the nation as a whole before they could play in neighborhood and small-town houses. This was fairly easy for them to accomplish, as each had served in the U.S. Armed Forces during foreign wars. When the actors' actual military records were not sufficiently impressive, studios embellished them. Mix, for example, was in the army at the time of the Spanish-

American War but had never seen action. Fox speciously claimed that he was in the Battle of Guaymas in Cuba, had participated in the Boxer Rebellion, and had fought in the Philippines and in the South African Boer War.[72] Similarly, Buck Jones, according to the studio, patrolled the U.S.-Mexican border as part of the U.S. Cavalry and later, when stationed in the Philippines, had been shot by Moro bandits.[73]

Among the other cowboy stars, Hoot Gibson and Ken Maynard were veterans of World War I. Maynard's studio made the additional but bogus claim that he had fought in the Mexican Revolution.[74] Tim McCoy was the most active soldier of the group and the only one who did not need to exaggerate his military record. He was in a cavalry unit in World War I and achieved the rank of lieutenant colonel. Later, Governor Robert Carey of Wyoming appointed him that state's adjutant general. During his time as an actor, he was in the army reserves and fought in World War II.[75] Cowboy stars, McCoy believed, should give war priority over moviemaking. He recalled of his enlistment in the army at age fifty to fight in World War II: "I used to say at the time that any guy who was physically fit to do the things we had to do in Western pictures ought to be in there doing his stuff . . . and not playing Indians."[76]

Studios publicized and exaggerated the military careers of cowboy stars for the same reason they claimed the actors had western roots: it helped establish the men as more than mere creatures of Hollywood. The actors had honed their shooting and riding skills and had proven their bravery not only on studio back lots but also in arenas where the stakes were much higher. The army, at the time an exclusively male institution, and not the motion-picture industry had shaped their manhood and character. Fans who insisted on "authentic" physical masculinity respected stars for putting their bodies in harm's way. Moreover, the cowboys' war records were instrumental in affirming their American identity at a time when exotic undertones of matinee idols like Rudolph Valentino made small-town audiences uneasy. In 1929 writer Herbert Cruikshank, worried about the influence of the "Von's, and ski's, and de la's" in Hollywood, thanked the cowboy actors for keeping "the movies safe for America against the encroaching invasion of foreign stars and foreign stories."[77] The studios made the most of such sentiment in promoting their western heroes. Fox had Mix muse in his company-produced autobiography, "I don't think God made anything finer than a first-class American citizen. And I hope I'm making some of the boys who come to see Tony and me better Americans."[78]

Just as the western stars' military careers helped authenticate them in the eyes of fans who might otherwise have dismissed them as "drugstore cowboys," it was also important that the actors prove themselves in the field of rodeo

and Wild-West performance. Riding was the sine qua non of the shoot-'em-up star's claim to legitimacy. Any public display of deficiency in horsemanship might damage his reputation. A fan of William S. Hart remembered gleefully an incident at a rodeo where the audience heckled Tom Mix for failing to mount a "pinwheeling" horse. Someone yelled from the stands, "Hey Tom! Do they tie the horse for you, in the pictures? Or how do you get on?"[79]

In fact, the big five were all excellent horsemen and participated to varying degrees in rodeos and Wild-West shows before, after, and during their time in the movies.[80] In 1906 Tom Mix began work for the Miller Brothers' 101 Ranch Wild West Show and eventually became one of its leading cowboy performers. There he mastered bulldogging, a new rodeo event originated by African American cowboy Bill Pickett, in which a contestant on horseback captures a steer and holds it down by biting the animal's top lip.[81] In 1909 Mix left the 101 Ranch to form his own Wild-West show, and he intermittently toured with several other outdoor troupes, including Will A. Dickey's Circle D Wild West Show and Indian Congress. When he retired from the movies, Mix returned to the outdoor show circuit, touring in the Tom Mix Circus.

To promote Mix's pictures, Fox frequently published articles that referred to his days as a trouping cowboy performer.[82] Moreover, the western star centered many of his films around riding feats. The first reel of Mix's *The Great K and A Train Robbery* (Fox, 1926) contains five major stunts of horsemanship. Mix slides down a rope attached to the top of a steep cliff and onto his mount, Tony. He then rides up to a runaway carriage and rescues a girl from it. Subsequently, Tony and Mix gallop toward a moving train, and the cowboy places the girl gently onto the caboose. Afterward, the Fox star jumps under the locomotive and lassos a man riding beneath it.[83]

Mix set the standard for other cowboy stars. Quality horsemanship became a basic prerequisite for success in the shoot-'em-ups. Hoot Gibson was also a well-respected rider. In 1910 he performed with the Dick Stanley–Bud Atkinson Wild West Show. During the summer months he worked in Los Angeles for the Selig and Biograph Companies, looking after their horses and acting as a stunt double. In 1912 he won the award as best all-around cowboy at the Pendleton, Oregon, rodeo. A few years later Universal hired Gibson to double for the western star Harry Carey. The studio eventually featured him in leading roles, which gave him an opportunity to demonstrate his riding ability. As their titles indicate, horsemanship was a central element in many Gibson pictures, including *The Galloping Kid* (Universal, 1922), *Ridin' Wild* (Universal, 1922), *Ride for Your Life* (Universal, 1924), *The Saddle Hawk* (Universal, 1925), *The Buckaroo Kid* (Universal, 1926), *Hero on Horseback* (Universal, 1927), *Galloping Fury* (Universal, 1927), and *Riding for Fame* (Universal, 1928).

In 1926 First National took stunt riding to a new level, hiring circus rider Ken Maynard. An exhibitor wrote of one of the cowboy's first films that he "is making a lot of old-timers look like children on a merry-go-round."[84] Like Gibson, Maynard had won best all-around cowboy at the Pendleton, Oregon, rodeo. Prior to working in motion pictures, he was a trick rider for the best organizations in outdoor amusement: Buffalo Bill's Wild West show and the Ringling Brothers' Barnum and Bailey Circus. Over the course of his career he had honed his horsemanship skills and could perform such spectacular feats as riding four horses abreast. He also learned roping tricks from the renowned Mexican vaquero Vicente Oropeza. Critic and western-film fan Ted Reinhart called Maynard's riding "poetry in motion." "His able sense of balance, athletic skills, and touch, coupled with complete absence of concern for self," he wrote, "made Ken Maynard on horseback a sight to behold" (see Figure 7.6).[85]

As riding became more central to westerns, so did horses.[86] During the 1920s, makers of shoot-'em-ups increasingly anthropomorphized these animals. It was essential, according to actor Dick Foran, that the cowboy's horse save him at least once in every picture.[87] When a western hero was hurt, his trusty mount was often first on the scene and usually galloped away quickly for help. A horse could also use its mouth to untie ropes in the event a villain had bound up its master. By bending down and encouraging him to mount, the western hero's hoofed friend occasionally reminded the cowboy that it was time to get on with an important task. A horse could also help the hero flirt with a leading lady by prancing around or performing some other stunt in her presence.[88]

In many ways these animals became extensions of the actors who rode them. Most cowboy stars used the same mounts over and over. Mix rode Tony, Jones shared the spotlight with Silver, and Maynard worked with a horse named Tarzan. Horses and their riders even dressed alike.[89] Maynard and Tarzan worked especially well together. They performed many tricks, including a frequent routine in which the actor whispered into the horse's ear and the animal answered back by shaking or nodding its head. One fan characterized the team's rapport as "almost mystical."[90]

The animals received prominent billing and considerable publicity and soon became stars in their own right. Studios listed their names in the credits of films in which they appeared and sometimes in titles as well. First National press books often contained articles detailing the exploits and history of Maynard's Tarzan. Fox put out similar promotional material for Tony, arranging for publication of the horse's "autobiography" in 1923. Moreover, promotional material about the animals appeared in fan magazines and theater publications.[91] Some in the industry, Gibson and McCoy among them, felt that elevating horses to star status broke faith with the real West. Fans, however,

Fig. 7.6 Ken Maynard on horseback. From Jon Tuska, The Filming of the West *(Garden City, New York: Doubleday, 1976).*

responded well to this promotional strategy. William S. Hart received hundreds of condolence letters when his horse Fritz died in 1938, even though Fritz had been retired from films for nearly two decades.[92]

As the promotional material on horses and riding suggests, a cowboy actor's dramatic talents were secondary to his equestrian abilities. To a core audience that viewed with suspicion any Hollywood figure who seemed manufactured

for consumption in movie palaces, a star's successful manipulation of his horse was proof of authentic western manhood. Riding became one of the essential litmus tests distinguishing mere thespian from true cowboy. The horse, according to one western fan, was the only prop a western star could not dispense with if he were to "project the quality of believability."[93]

In addition to riding, shoot-'em-up fans required cowboy stars to perform other athletic feats that further proved their strength, courage, and manliness. Although spectacular stunts had been a part of westerns almost since filmmakers adapted the genre for cinema, Tom Mix and the Fox studio increased their frequency and complexity, and the other companies followed suit. In *Sky High* (Fox, 1922), for example, Mix's character uses an airplane to stop the immigration of Chinese into the United States through Mexico. He pulls a house filled with men down a canyon in *The Texan* (Fox, 1924) and dons a pair of skis to pursue a bad guy in *The Trouble Shooter* (Fox, 1924).[94]

For all the public knew, Mix, Jones, Gibson, Maynard, and McCoy performed their own stunts. "He really does the things the pictures say he does," Carl Sandburg wrote of Mix. "Trick photography isn't brought onto his lot. Years of this honesty have convinced the millions that Mix is to be trusted."[95] In reality, the cowboy actors sometimes used doubles, but studios swore to secrecy anyone standing in for a western star.[96] Even when western-film director Lambert Hillyer broke the code of silence surrounding this issue and admitted that Tom Mix and William S. Hart did not always perform their own stunts, fans were disinclined to believe him, as such information damaged the sense of "authentic" heroic manhood on which the actors had built their careers.[97]

In an effort to confirm that cowboy stars took real risks with their bodies, publicity writers sometimes cataloged the physical injuries the actors had incurred while making films. Mix's studio-produced autobiography listed some of the accidents in which he had supposedly been involved:

> He had three ribs broken when he was kicked . . . in a scuffle in a snow scene; nine stitches were taken in a gash in his head when someone hit him with the wrong chair; a spur made a cut three-quarters of an inch deep on the side of his head when he threw a man and the man's legs flew up; in taking one picture a tooth was broken—and repaired between scenes; a toe was crushed when a horse fell on it.[98]

Using Mix's image to promote its breakfast cereals to children, Ralston Purina produced an outline of the cowboy's body and enumerated twenty-six locations where he had been injured during his career.[99]

Such publicity was standard for other cowboy stars as well. According to MGM, McCoy "had some sort of nasty fall" in every picture. Moreover, the

studio added, the actor never took an anesthetic because he did not want to miss experiencing the pain.[100] Likewise, *Photoplay* quoted Buck Jones as saying, "I been mighty lucky this year—only got hurt 7 times, and then just little things like busted ribs and a broken foot and leg."[101]

Studios used such promotional material to encourage male-dominated audiences to appreciate cowboy actors' ability to withstand physical punishment. Publicity like this helped frame movie acting and viewing as distinctly manly pursuits. If in the costume drama filmmakers enhanced leading men's erotic appeal to attract female spectators, in the shoot-'em-ups producers presented cowboy heroes as abused yet stoic figures for men and boys to admire. According to film critic Steven Neale, the studios subjected stars' bodies to mutilation, both real and imagined, to prevent them from becoming objects of sexual desire.[102] In minimizing the erotic element in the creation of cowboy heroes, studios encouraged the growth of the largely male subculture that surrounded the production and consumption of the genre.

Strength, endurance, athleticism, and a lack of focus on sensuality became the hallmarks of the western star in the 1920s. These ideals reflected then-new notions of masculinity popular in the United States. Men, suffering a loss of autonomy in the corporate workplace and threatened by women's entrance into the public sphere, rejected Victorian notions of decorum and celebrated the physical aspects of manliness. Boxing, camping, weight lifting, and similar activities grew in popularity. The shoot-'em-ups, confined as they were to neighborhood and small-town houses, were among the purest examples of Hollywood's engagement with the new notions of manhood. Relatively free from concern about how women would respond to the stoic, isolated male hero, studios were able to feature such a character in the genre. Unlike early western-film figures, the new cowboy star did not look to women or to the church to teach him how to act in a virtuous manner. He had an internal code of morality based on manly instinct. His victories in all physical contests— whether barroom fights, gun battles, bronco busting, or horseback riding— were proof enough that he stood for what was right (see Figure 7.7).

The model of western heroism Hollywood established in the 1920s was powerful and enduring, although a few attempts were made to subvert it. Early in the decade, an actress named Texas Guinan had some success as a shoot-'em-up star. Billed as the female William S. Hart, Guinan came to the movies after working as a chorus girl in vaudeville. She began her film career with the Triangle Film Company, starring in such films as *The Gun Woman* (Triangle, 1918) and *The Love Brokers* (Triangle, 1919). In 1920 she made twenty-five two-reel westerns for the Frohman Amusement Corporation and Reelcraft Films. A year later she produced four more films, two of which her own company, Texas Guinan Productions, manufactured.[103]

7.7 Jones still suggests a new emphasis on the cowboy hero's physical strength

By playing a traditionally male role, Guinan challenged the shoot-'em-ups' conventions and created a unique product. Her character shared many characteristics with the big five cowboy stars. She was a gritty and tough cowgirl

who rode and fought as hard as any man. In one critic's opinion, she was "a better imitation of Bill Hart than a dozen male actors one can name."[104] Like all male western stars, she claimed never to let anyone double for her; to prove it she listed the injuries she had suffered on the set, telling a journalist "outside of a couple of stitches in my right eye, a cracked nose, a game leg and a blister where I hit the saddle, I'm getting along nicely."[105]

Although she made many films, Guinan was ultimately a marginal figure in the industry because she threatened the male subculture that surrounded the shoot-'em-ups. Whereas for the most part Americans saw the big five movie cowboys as role models who could help turn boys into manly adults, the federal government believed Guinan had a corrupting influence on young men. In marketing to children, she attracted a lot of boys to her publicity tours. After she temporarily took one troubled runaway into her home, the youth's parents reported the incident to the Federal Bureau of Investigation (FBI). To the government's way of thinking, Guinan, an entertainer and a divorcée, was automatically suspect. Although Guinan was never formally charged with any wrongdoing, the FBI identified her as a "moral pervert" whose activities centered "primarily on young boys."[106] Partly for this reason, she left movies to become a hostess in the decidedly more adult nightclub world.

The black-owned Norman Film Company also attempted to develop a different kind of western, but with little success. The studio hired Bill Pickett, the famous African American showman and star of the Miller Brothers' 101 Ranch Wild West Show, to play in all-black cowboy pictures. Pickett made two films for the company, *The Bull-Dogger* (Norman, 1921) and *The Crimson Skull* (Norman, 1921). Norman planned other pictures but never shot them. Unfortunately, the producers did not attempt to turn Pickett into a star. Other actors played the leading roles in these films, and the cowboy's stunts only provided the background. Although Pickett's rodeo performances were impressive, the Norman pictures did not, in the estimation of film historian Thomas Cripps, rise above the mainstream Hollywood western.[107]

The films of Guinan and Pickett aside, western producers in the 1920s continued what was a more than decade-old industry practice of taking the somewhat more diverse group of characters in Wild-West shows and older cowboy and Indian films and creating a single western hero. In shaping the central figure of the shoot-'em-ups, major studios ignored such important stars of Wild-West shows as Lucille Mulhall, Annie Oakley, Bill Pickett, Iron Tail, Antonio Esquivel, and Vicente Oropeza because they did not fit the typical racial or gender profile of the western hero. Compared with these other figures, Mix, Gibson, and Jones were relatively obscure participants in outdoor amusement. It was not until they entered the film industry that they became famous.

In the long run, even the big five fell victim to the narrowing definition of western-film hero. As strength and dexterity were such fundamental aspects of the role, when these cowboy stars' fortunes began to rise, they always had to guard against the impression that they had grown "soft." Maynard's and Gibson's careers suffered seriously as they began to gain weight. They were so heavy in their last films that they could not perform the stunts that had made them famous. McCoy, on the other hand, fought hard to keep fit. He recalled, "We'd work out all the time. I mean you had to keep in shape, in physical shape. I'd have my horse brought over . . . and I'd ride him for an hour or so and then go over to the lot and work out in the gymnasium every day."[108] Mix's increasingly extravagant Hollywood social life proved a problem for Fox. As the actor had built his reputation on being a hard worker, the studio had a difficult time justifying his decadence to his fans. Publicity writers blamed his wives for forcing him to climb the social ladder while at heart he remained a simple cowboy. In a studio-produced article the star reportedly claimed, "I'm still a cow-puncher and I want to believe that if I go into the home of one of the cow-punchers that work[s] for me I'll be welcome not because I've had a certain amount of success . . . but because I'm still one of the boys."[109]

Despite falling victim to the excesses of success, all of the big five had careers into the sound era. Each, however, had to move to a less prestigious studio and make even lower-budget films. As these men grew older, other actors took their places. Although the faces were new, the so-called B westerns of the 1930s, 1940s, and 1950s did not depart significantly from the patterns set by the original producers of the shoot-'em-ups. Studios continued to make such films largely for boys and other male spectators who, looking for an alternative to the movie palace, patronized small-town and neighborhood houses. The Saturday western matinee continued to be a defining entertainment experience for another generation of young men.

NOTES

1. "Review of 'Daredevil's Reward,'" *Variety*, January 25, 1928. Reprinted in Robert S. Birchard, *King Cowboy: Tom Mix and the Movies* (Burbank, Calif.: Riverwood Press, 1993), 212.

2. Exhibitor report, *Moving Picture World* (*MPW*), July 10, 1926, 107.

3. Jane Tompkins, *West of Everything: The Inner Life of Westerns* (New York: Oxford University Press, 1992), 31–33.

4. "*Hart v. United Artists Company* Correspondence 1927–1934," box 184, United Artists Collection, Wisconsin State Historical Society, Madison.

5. Brian Garfield, *Western Films: A Complete Guide* (New York: Rawson Associates, 1982), 35.

6. Dale Fetherling and Doug Fetherling, eds., *Carl Sandburg at the Movies: A Poet in the Silent Era, 1920–1927* (Metuchen, N.J.: Scarecrow, 1985), 128.

7. "Straight From the Shoulder Reports," *MPW*, October 30, 1926, 569.

8. *MPW*, July 4, 1925, 39.

9. *MPW*, September 26, 1925, 317.

10. "Review of *Dick Turpin*," *Variety*, January 28, 1925.

11. Aubrey Solomon, *Twentieth Century–Fox: A Corporate and Financial History* (Metuchen, N.J.: Scarecrow, 1988), 4.

12. Robert S. Birchard, *King Cowboy: Tom Mix and the Movies* (Burbank: Riverwood, 1993), 124.

13. "Review of *Riders of the Purple Stage*," *Variety*, April 25, 1925.

14. Raymond E. White, "Ken Maynard: Daredevil on Horseback," in *Shooting Stars: Heroes and Heroines of Western Film*, Archie P. McDonald, ed. (Indianapolis: Indiana University Press, 1987), 24.

15. Kalton Lahue, *Winners of the West: The Sagebrush Heroes of the Silent Screen* (New York: A. S. Barnes, 1970), 238.

16. Tom Mix, "How I Was Roped for the Pictures," *Ladies Home Journal* (March 1927): 15.

17. Garfield, *Western Films*.

18. Quoted in *MPW*, May 24, 1924, 386.

19. Ruth Vasey, *The World According to Hollywood 1918–1939* (Madison: University of Wisconsin Press, 1997), 161.

20. "Handbook for Disney Survey of South America," September 1941, 3, Walt Disney Archives, Burbank, California.

21. Kyle Crichton, "Horse-Opera Star," *Colliers*, May 9, 1936, 55, 58; Mix, "How I Was Roped for the Pictures," 15.

22. *MPW*, April 4, 1925; August 29, 1925; August 27, 1927.

23. Quoted in Roy Rosenzweig, *Eight Hours for What We Will: Workers and Leisure in an Industrial City, 1870–1920* (Cambridge: Cambridge University Press, 1983), 214.

24. Pearl Bowser and Louise Spence, "Micheaux's 'Biographical Legend,'" in *The Birth of Whiteness: Race and the Emergence of U.S. Cinema*, Daniel Bernardi, ed. (New Brunswick, N.J.: Rutgers University Press, 1996), 62.

25. William H. Jones, *Recreation and Amusement Among Negroes in Washington, D.C.: A Sociological Analysis of the Negro in an Urban Environment* (Westport, Conn.: Negro Universities Press, 1970), 116–118.

26. Quoted in James Horowitz, *They Went Thataway* (New York: E. P. Dutton, 1976), 275.

27. Unidentified clipping, "We Interview Tom Mix," Tom Mix clipping file 2, Blum Collection, Wisconsin Center for Film and Television Research, Madison.

28. Quoted in Margaret Farrand Thorp, *America at the Movies* (New Haven: Yale University Press, 1939), 128–129.

29. Gilman M. Ostrander, *American Civilization in the First Machine Age: 1890–1940* (New York: Harper and Row, 1970), 9–10.

30. Gaylyn Studlar, *This Mad Masquerade: Stardom and Masculinity in the Jazz Age* (New York: Columbia University Press, 1996), 13.

31. Kyle Crichton, "Horse-Opera Star," *Colliers*, May 9, 1936, 55, 58.

32. Ibid.

33. On Mix's cultivation of youthful moviegoers at the expense of Hart, see Richard Kazarski, *An Evening's Entertainment: The Age of the Silent Feature Picture, 1915–1928* (Berkeley: University of California Press, 1990), 291.

34. Buck Rainey, "The 'Reel' Cowboy," in *The Cowboy: Six-Shooters, Song, and Sex*, Charles W. Harris and Buck Rainey, eds. (Norman: University of Oklahoma Press, 1976), 19.

35. Garfield, *Western Films*, 42.

36. Jon Tuska, *The Vanishing Legion: A History of Mascot Pictures 1927–1935* (Jefferson, N.C.: McFarland, 1982), 124.

37. Quoted in Horowitz, *They Went Thataway*, 275.

38. Richard F. Seiverling, "Tom Mix and Tony: A Partnership Remembered: A Pictorial and Documentary Presentation," 1980, 10, box 1, Tom Mix Collection, American Heritage Center, Laramie, Wyoming.

39. On the feature films of the movie palaces in the 1920s, see Sumiko Hagashi, *Cecil B. DeMille and American Culture, the Silent Years* (Berkeley: University of California Press, 1994); Steven J. Ross, *Working-Class Hollywood: Silent Film and the Shaping of Class in America* (Princeton: Princeton University Press, 1998), 173–211.

40. Unidentified clipping, Beth O'Shea, "They Prefer Him Hart-Boiled," Tom Mix clipping file 2, Blum Collection, Wisconsin Center for Film and Television Research, Madison.

41. Studlar, *This Mad Masquerade*, 90–198.

42. "Review of *Dick Turpin*," *Variety*, January 28, 1925.

43. Quotation in *MPW*, November 13, 1926, 107; May 22, 1926, 343; January 2, 1926, 63.

44. *MPW*, April 24, 1926, 612.

45. *MPW*, August 7, 1926, 360.

46. Unidentified clipping, Beth O'Shea, "They Prefer Him Hart-Boiled."

47. "The Custer Massacre," in *The New York Times Film Reviews 1913–1968*, vol. I (New York: New York Times and Arno Press, 1970), 606; "Review of *The Flaming Frontier*," *Variety*, April 7, 1926.

48. *MPW*, December 18, 1926, 529.

49. *MPW*, March 19, 1927, 221.

50. *MPW*, November 27, 1926, 236.

51. Jon Tuska, *The Filming of the West* (Garden City, N.Y.: Doubleday, 1976), 162.

52. First National press book for *Somewhere in Sonora*, reel 10a, microfilm collection 448, Warner Pressbooks, United Artists Collection, Wisconsin State Archives, Madison.

53. "Review of *Somewhere in Sonora*," *Variety*, March 30, 1927.

54. *MPW*, December 24, 1927, 33.

55. Horowitz, *They Went Thataway*, 272.

56. "A Departure in 'Westerns,'" *Christian Science Monitor*, undated clipping, newspaper clippings 1917–1978 file, box 5, McCoy Collection, American Heritage Center, Laramie, Wyoming.

57. "Review of *Law of the Range*," *Variety*, November 7, 1928.

58. *MPW*, December 18, 1926, 528.

59. *MPW*, December 10, 1927, 56.

60. Jon Tuska, "In Retrospect: Tim McCoy, Part I," unidentified article from the Tim McCoy biography file, American Heritage Center, Laramie, Wyoming.

61. Carol Johnston, "A Wow in Wyoming," *Motion Picture Classic* (May 1928): 51, 85.

62. Merritt Hulburd, Head of Scenario Department, to Stuart N. Lake, December 21, 1933, folder 86, "Paramount Productions, Inc. to Stuart N. Lake," box 9, Stuart N. Lake Collection, Huntington Library, Pasadena, California.

63. Harold B. Lipsitz to Eugene Cunningham, August 12, 1927, "William Fox Studio" file, box 10, Eugene Lafayette Cunningham Collection, Huntington Library, Pasadena, California.

64. Jon Tuska, "The History of the Western: Notes on the Creation of 'They Went Thataway,'" *Classic Film Collector* (Spring 1971): 61.

65. Buck Rainey, *The Life and Films of Buck Jones: The Silent Era* (Waynesville, N.C.: World of Yesterday, 1988), 10.

66. J.B.M. Clark, ed., *The West of Yesterday* (Los Angeles: Times-Mirror, 1923), 28–29.

67. Ibid.

68. Ibid.

69. Dorothy Spensley, "Young Lochinvar Maynard," *Photoplay* (October 1926): 110.

70. Clipping from *Taming the West* (Universal, 1925) press book, Hoot Gibson biography file, Motion Picture Academy Library, Los Angeles, California.

71. Betty Standish, "Colonel Tim McCoy Camps Out for Breakfast," *Motion Picture Magazine* (February 1928): 66.

72. Mix's fictitious military record is detailed in his studio autobiography. Clark, ed., *The West of Yesterday*, 28–29.

73. Rainey, *Life and Films of Buck Jones*, 17–18.

74. On Maynard's military career, real and imagined, see White, "Ken Maynard," 23.

75. On McCoy's military career, see Tim McCoy, *Tim McCoy Remembers the West: An Autobiography* (Garden City, N.Y.: Doubleday, 1977), 120–140, 251–254.

76. Quoted in Horowitz, *They Went Thataway*, 274.

77. Herbert Cruikshank, "Ken Carries On," *Motion Picture Classic* (June 1929): 60, 90.

78. Quoted in Clark, ed., *The West of Yesterday*, 28–29.

79. Eugene Cunningham to Hart, June 4, 1931, folder "William S. Hart," box 5, Eugene Cunningham Collection, Huntington Library, Pasadena, California.

80. I cannot go into the rodeo and Wild-West show careers of all the cowboy stars here. For a general overview of this subject, see Buck Rainey, "Cinema Cowboys on the Sawdust Trail," *Classic Images* (November 1983): 12–14, 75.

81. On Mix's rodeo exploits, see Paul E. Mix, *Tom Mix: A Heavily Illustrated Biography of the Western Star* (Jefferson, N.C.: McFarland, 1995), 52.

82. See, for example, *Loew's Weekly*, October 24, 1921.

83. *The Great K and A Train Robbery*, Motion Picture Division, Library of Congress, Washington, D.C.

84. *MPW*, October 22, 1927, 516.

85. Ted Reinhart, "King of the Saddle Ken," *Screen Thrills 2*, 1976, Ken Maynard biography file, Motion Picture Academy Library, Los Angeles, California.

86. Horses had, of course, been a part of western films since the invention of the genre, and fans had responded to the use of particular animals at least as far back as 1910 when the New York Motion Picture Company used a large white mare named Snow-ball. William S. Hart, who was involved in animal rights and on the national board of directors for the Society for the Prevention of Cruelty to Animals, also had done much to elevate the status of horses in the genre. He regularly featured a pinto named Fritz in his films, turning the animal into a star over the objections of producer Thomas Ince.

87. Quoted in Thorp, *America at the Movies*, 128–129.

88. Some of the best examples of horse tricks can be seen in *The Red Raiders* (First National, 1927) Motion Picture Division, Library of Congress, Washington, D.C.; and *Somewhere in Sonora* (First National, 1927), Wisconsin Center for Film and Television Research, Madison.

89. According to Foran, a western actor's mount had to be "as dolled up as the hero." Quoted in Thorp, *America at the Movies*, 128–129.

90. Reinhart, "King of the Saddle Ken."

91. *Loew's Weekly*, June 18, 1923.

92. Folder "Letters on the Death of Fritz," box 10, William S. Hart Collection, Seaver Center, Los Angeles, California.

93. Reinhart, "King of the Saddle Ken."

94. The UCLA film archive houses copies of *Sky High* and *The Texan*. For a description of Mix on skis in *The Trouble Shooter*, see Fetherling and Fetherling, eds., *Carl Sandburg at the Movies*, 98.

95. Ibid., 129.

96. Lambert Hillyer quoted in Robert S. Birchard, "Silent Guns: The Early Western Stars," in *The Hollywood Corral: A Comprehensive B Western Roundup*, Don Miller, ed. (Burbank: Riverwood, 1993), 299.

97. See correspondence between Gatewood Dunston and Lambert Hillyer in Gatewood Dunston Collection, Manuscript Division, Library of Congress, Washington, D.C.

98. Clark, ed., *The West of Yesterday*, 42.

99. See the Ralston Straight Shooters material reproduced in Seiverling, "Tom Mix and Tony," 24.

100. Johnston, "A Wow in Wyoming," 51.

101. Joan Jordan, "A Rodeo Romeo," *Photoplay* (October 1921): 42.

102. Steven Neale, "Masculinity as Spectacle," *Screen* 24, no. 6 (November–December 1983): 14–15.

103. See Guinan filmography in Louise Berliner, *Texas Guinan: Queen of the Night Clubs* (Austin: University of Texas Press, 1993), 215–216.

104. Quoted in ibid., 81.

105. Ibid., 82.

106. From Guinan's FBI file, quoted in ibid., 88.

107. Thomas Cripps, *The Negro in American Film, 1900–1942* (New York: Oxford University Press, 1977), 182.

108. Quoted in Horowitz, *They Went Thataway*, 271.

109. Mix, "How I Was Roped for the Pictures," 15.

EPILOGUE: GALLOPING OUT OF THE SILENTS

The question now arises, how long shall the West remain the sole empire of romance which pictures have made distinctively their own? Where do we ride from here? All other forms of human expression have their cycles. All arts have their waves. If the flow of Western photoplay ever ebbs, what will its successor be?[1]

—Journalist Randolph Bartlett, 1919

The success of the silent western was instrumental in Hollywood's birth and development. In creating and then refining the genre, undercapitalized domestic manufacturers—Selig Polyscope, New York Motion Picture, and Essanay—pioneered location shooting in the Far West, exploited the area's natural environment and its peoples, and drew on popular images of the region circulated in dime novels, Wild-West shows, and stage melodrama. These firms financed the growth of their operations by supplying the

tremendously popular and cheaply produced cowboy and Indian picture to exhibitors in the United States and around the globe. In the process, the genre's producers helped establish the U.S. industry as the world's dominant cinema, made Los Angeles the center for American filmmaking, and created an enduring screen image of heroic white men.

Initially, manufacturers worked in the West without establishing permanent studios there. They traveled light, bringing only a motion-picture camera and a few actors so they could readily relocate when they wanted a change of scenery or when the weather turned inclement. The troupes shot their films and sent the negatives to manufacturing plants in Chicago and New York, where workers developed, processed, duplicated, and delivered them to exchanges. Nomadic filmmakers did not have to expend much labor creating scenarios, as many of the conventions of the first westerns came from dime novels and so-called cheap theater. Producers only needed to mix the ingredients—landscape, light, melodramatic forms, histrionics, popular conceptions of American history, Wild-West props, and "authentic" cowboys and Indians—into preexisting molds. It was like bottling water from a mountain spring and, although less environmentally damaging, was reminiscent of the extraction industries traditionally associated with the West. As in mining, agricultural production, logging, and fishing, the first filmmakers in the region were providing a vital material for corporations based elsewhere that in turn created a finished product and supplied it to an expanding global market.

The first narrative filmmakers went west in response to the popularity of the British crime films and Edison's *The Great Train Robbery* (1903). They planned to make similar stories against Wild-West backgrounds. The frontier's popular association with conflict and violence made it a logical setting for such pictures. As one contemporary reviewer put it, the West became the "peg" upon which filmmakers could "hang the cloak of melodrama." This dramatic form—with its tendencies toward strong emotionalism, moral polarization, histrionic expression, conspiratorial plots, and breathtaking suspense—was particularly suited to a region already sensationalized in dime novels, Wild-West shows, and popularly priced theater.[2]

In the first westerns, producers created a carnivalesque world in which characters collided with violent and chaotic force. Manufacturers filled these films with guns and knives, abductions and robberies, chases, and bloody altercations. Cowboys were as likely to be villains as heroes, producers often depicted American Indians as morally superior to whites, and male protagonists did not predominate. In fact, motion-picture producer Gilbert M. Anderson used female leads in the first films marketed as westerns. Moreover, before he developed his famous Broncho Billy character, Anderson often played Mexican and Indian heroes. He relied on crude racial stereotypes but nonetheless

created sympathetic nonwhite screen characters. Filmmaker and studio head James Young Deer and his wife, Lillian Red Wing, presented some of the most complicated and controversial Native American heroes of the silent era. Before the motion-picture business fully adopted systems of modern industrial production and while film censorship was in its infancy, these Indian performers produced many films that dealt with issues of racism and assimilation.

Like so many bonanzas in the West, the cowboy and Indian film boom eventually came to an end, or so it seemed to many in the industry. By 1912 seven major studios were operating year-round in California: Selig, New York Motion Picture, Kalem, Nestor, American, Pathé West Coast, and Essanay. They all specialized in Wild-West subjects. With increased competition and a declining domestic demand for the genre, the leading companies had to make their westerns bigger and better to maintain their market shares. Manufacturers could no longer merely rely on scenic landscape and chase scenes to make a film popular. Westerns needed larger-than-life heroes or casts of hundreds.

As the domestic demand for westerns sagged, the industry increasingly courted more affluent patrons. Exhibitors who built bigger and better-appointed theaters to attract middle-class customers were especially annoyed by the heavy production of cowboy and Indian pictures. They associated the genre with dime novels, ten-twenty-thirty melodrama, and other "cheap amusements" from which they sought to distinguish cinema. Westerns, they worried, with their crime and violence, were keeping "the better class" of patron—particularly women—out of movie theaters.

In response to these conditions, New York Motion Picture's Bison Company, under the direction of famed producer Thomas H. Ince, began to manufacture some of the longest, most elaborate, and most expensive westerns ever made. The firm hoped its "Bison-101" features would legitimate the genre in the eyes of its opponents. The company invested heavily in plant and equipment, leasing 18,000 scenic acres along the ocean in Los Angeles and temporarily acquiring many of the Indians from the Miller Brothers' 101 Ranch Wild West Show. These motion pictures were among the first multireel subjects released as part of a regular program of films, and their success helped encourage a general trend toward lengthier and more expensive westerns.

Specializing in epic films with casts of hundreds, Ince provided employment for many Native American performers. Under his industrial methods of film production, however, in which he broke up motion-picture making into discrete parts, the actors had very little creative input. The producer thought of Indians mostly as scenic elements, and he effectively pushed them into the background of westerns. As filmmakers increasingly used nonwhite characters as extras rather than in central roles, they cleared the way for the emergence of the white cowboy as the genre's leading figure.

By 1912, recognizable western heroes had emerged in cinema. At first they were God-fearing, Victorian men oriented toward home and family; but by the mid-1920s the stoic, isolated cowboy figure predominated. Anderson created the first readily identifiable western-film hero, Broncho Billy, for the same reasons Ince produced elaborate Bison-101 features: to combat flagging domestic demand for the genre and to attract patrons of higher social status. In creating his character, Anderson drew on evangelical Christian themes—especially the idea of redemption—as well as on new notions about men's domestic and paternal roles. Unlike cowboy heroes of a later period, Broncho Billy did not turn his back on religion or home life. If at the beginning of a typical film he appeared briefly as an isolated bandit figure, the bulk of the story concerned his symbolic adoption into a family and subsequent conversion to Christianity. Essanay marketed Broncho Billy westerns as "uplifting" entertainment for the entire family and presented the cowboy hero as an ethical role model who could teach children moral lessons that would lead to their personal success.

Actor William S. Hart and the New York Motion Picture Company took up where Anderson left off. They drew on even a more specific set of middle-class ideals—including the social gospel—to make heroes of feature westerns appeal to wealthier audiences and to women, whom, beginning in the mid-1910s, the industry was trying to lure into the new movie palaces. Influenced by his training in classical drama, Hart developed many of what became the clichéd characteristics of sound-era cowboy film heroes. The actor played silent men who controlled or repressed their emotions. Like Broncho Billy, however, over the course of a film Hart's western figures proved themselves innately domestic and religious. In a typical Hart western, a cultured and refined white woman encourages the hero to convert to Christianity and to dedicate his life to social reform. She tempers the rough, aggressive qualities he has developed living on the frontier while providing direction for his independence, manly strength, and other positive western attributes. Ultimately, Hart's figures only partly conformed to Frederic Remington's, Theodore Roosevelt's, and Owen Wister's ideals of the white man of the frontier as the paragon of American masculinity shaped and rejuvenated by the region's demanding natural environment. Instead, the cowboy actor's characters modeled themselves after virtuous white women from whom they learned to be responsible citizens in a frontier community.

Female spectators, who made up a disproportionate share of the audience in downtown urban movie palaces where Hart's westerns were screened, were instrumental in determining the qualities of his cowboy hero. Yet in the early 1920s, when the western's popularity among audiences in first-run theaters faded, the industry relegated the genre to neighborhood and small-town the-

aters, and pleasing women became less important to producers of cowboy films. Studios began to manufacture westerns to serve a niche market made up primarily of men and boys who patronized second-run theaters as alternatives to the movie palaces. This resulted in filmmakers developing the stoic, isolated cowboy, whom Jane Tompkins, in her *West of Everything,* has identified as the sound-era western's central protagonist.[3] Led by the Selig and subsequently Fox star Tom Mix, cowboy actors of the 1920s lost the preachy Victorian qualities associated with Hart and Broncho Billy. Themes of moral and social reform as well as leading ladies and romance became less important in the genre. Instead, manufacturers highlighted the hero's relationship with his male sidekick or horse and placed a greater emphasis on rodeo riding and other physical risks cowboy stars took during production.

Without the revenues from movie palaces, studios had to cut the westerns' budgets to keep them profitable. Their quality suffered, but the fans did not mind. The men and boys who patronized the shoot-'em-ups tended to reject higher-budgeted westerns as attempts by studios to take their stars out of the neighborhood houses and make them appeal to the disproportionately female audiences of movie palaces.

Although these so-called program westerns did not meet with critical acclaim, they were important to Hollywood's economic well-being. By the 1920s, most major studios had a cowboy star whose films were reliable and consistent moneymakers. The "B" western phenomenon continued into the 1930s, 1940s, and 1950s; and Saturday matinee shoot-'em-ups introduced yet another generation of children to cinema. Although few artistically significant films came out of the studios' B lots, the pictures helped to create and sustain a moviegoing culture and to propagate—in the United States and abroad—particularly powerful images of race, manhood, and the natural environment of the American West. Moreover, some participants in production of the shoot-'em-ups made the leap to bigger arenas. John Ford, Gene Autry, John Wayne, and Ronald Reagan all sprang from Hollywood's B corrals and took something of that culture with them. In the process, they profoundly impacted the movies, popular music, and American society and politics.

NOTES

1. Randolph Bartlett, "Where Do We Ride From Here?" *Photoplay* (February 1919): 36–37.

2. Peter Brooks, *The Melodramatic Imagination: Balzac, Henry James, Melodrama and the Mode of Excess* (New Haven: Yale University Press, 1976), 11–12.

3. Jane Tompkins, *West of Everything: The Inner Life of Westerns* (New York: Oxford University Press, 1992).

INDEX

Page numbers in italics indicate illustrations.

Accord, Art, 78
Across the Plains (Selig, 1910), 62
Acting style, 46, 101(n46), 160–161, 172–173
Actualities, 9–10, 12
African Americans, 178–179, 184(n94), 194
Aitken, Harry, 164, 165, 176
Aitken, Roy, 164
American Film Company, 48, 164, 219
Amet, Edward Hill, 40
Anderson, Gilbert M., 10, 20, 25–26, 27, 35(n72), 38, 41–42, 49–51, 56–59, 133–153, 157, 172, 188, 195, 218. *See also* Broncho Billy character
Anderson, Nathaniel, 24–26, 136
Arapaho Indians, 86
Armour, Philip D., 25
Aryan, The (Triangle, 1916), 166–168, *168*
August, Joe, 176
Autry, Gene, 221

Bad Buck of Santa Ynez (NYMP, 1915), 162
Bad Man's First Prayer, The (Essanay, 1911), 145
Balshofer, Fred, 72–73, 77, 81, 99(n5), 114, 115, 118
Bandit King, The (Selig, 1907), 27, 137
Bandmann, Daniel, 159
Bargain, The (NYMP, 1914), 161, 162
Barrett, Lawrence, 158, 159
Barrier, The, 160
Barrymore, John, 188, 197
Battle of Guayman, 204
Battle of Little Big Horn, 125
Battle of the Redman (NYMP, 1911), *124*, 132(n78)
Battle of Tien-Tsin, 63
Battle of Wounded Knee, 63
Baumann, Charles, 72, 73–74, 113, 115
Beach, Rex, 160
Belasco, David, 163
Bell, E.J., 40
Ben Hur, 160

224 INDEX

Bernhardt, Sarah, 158
Berst, J.A., 82
Big Bear Valley, California, 79, 100(n23)
Biograph Company, 4, 41, 45–46, 48, 54,
 130(n40), 205
Birth of a Nation (Epoch, 1915), 164, 167–168
Bison Company, 51, 76–80, 81, 84, 100(n23),
 100(n34), 115, 219. See also New York
 Motion Picture Company
Bison-101 features, 107, 113, 114, 117, 121–128,
 219, 220
Blazes Rawden (Triangle, 1918), 171
Blazing the Trail (NYMP, 1912), 121, 122, 123
Boggs, Francis, 42–43, 46, 59, 63, 65(n19), 77
Boosterism, 18–19, 20
Booth, Edwin, 158, 159
Boots and Saddles (Selig, 1909), 60
Bosworth, Hobart, 46, 47, 66(n29), 85–86
Boxer Rebellion, 204
Broncho Billy and the Baby (Essanay, 1915), 146
Broncho Billy and the Girl (Essanay, 1912), 145
Broncho Billy and the Rustler's Child (Essanay,
 1913), 146
Broncho Billy character, 53, 57, 58, 63, 133–
 153, 162, 194, 218, 220, 221. See also
 Anderson, Gilbert M.
Broncho Billy's Bible (Essanay, 1912), 146
Broncho Billy's Christmas Dinner (Essanay,
 1911), 145
Broncho Billy's Heart (Essanay, 1912), 147
Broncho Billy's Love Affair (Essanay, 1912), 150
Broncho Billy's Narrow Escape (Essanay, 1912),
 143
Broncho Billy's Redemption (Essanay, 1910), 135
Broncho Billy's Sentence (Essanay, 1915), 146
Broncho Billy's Sermon (Essanay, 1914), 146
Broncho Billy's Ward (Essanay, 1913), 146
Brooks, W. A., 116, 127
Brotherhood of Railway Trainmen, 108
Brownlow, Kevin, 6
Brulatour, Jules, 74
Buck Jones Rangers, 195
Buckaroo Kid, The (Universal, 1926), 205
Bucking Broncho Contest (Selig, 1903), 15
Buckwalter, Harry H., 10, 12–13, 14, 18–19,
 22–23, 27, 30, 34(n58), 42–43
Buffalo Bill Wild West show, 61, 62, 206
Buffalo Bill, 42, 61, 144
Bull-Dogger, The (Norman, 1921), 211
Bush, Stephen, 84, 110, 162

California: and early filmmaking, 41–42, 43–
 48, 56, 219. See also Los Angeles, California;
 Niles, California
Carey, Robert, 204
Carlisle Indian School, 71, 75, 88, 92–93, 96–
 97
Catalina Island, 50
Catskill Mountains, 77
Cattle Rustlers, The (Selig, 1908), 42–43
Celebrations on the Ranch (Pathé, circ. 1913), 77
Censorship, 72, 80, 86, 89, 94–95, 138–139, 140
Champion Film Company, 94
Chaplin, Charlie, 57, 135, 136, 137, 175, 177
Chemehuevis Indians, 83, 101(n51)
Cheyenne Brave, The (Pathé, 1911), 82
Cheyenne Indians, 86, 116
Chicago, 11, 12, 30–31, 39, 41, 50, 51, 54–55,
 60, 61, 64, 218
Children, 109–110, 111, 146–149, 155(n51),
 193, 194–197
Christianity, 134, 142–143, 145–146, 166, 168–
 170, 220
Cinématographe. See Lumière cinématographe
Civilization (NYMP, 1916), 166
Clark, Marguerite, 183(n71)
Clifford, William, 163
Cody, Bill, 196
Cole Younger and Frank James Wild West
 show, 42
Colorado, 56; and image in film, 9, 14–19, 21–
 24, 27, 42, 43. See also Denver
Comstock, Anthony, 108, 129(n8)
Conversion of Frosty Blake, The (NYMP, 1915),
 163
Conway, Jack, 78
Cooper, James Fenimore, 112
Covered Wagon, The (Lasky, 1923), 6, 179, 202
Coward, The (NMP, 1915), 166
Cowboy and the Squaw, The (Essanay, 1910),
 58
Cowboy Justice (Selig, 1909), 60
Cowboy Millionaire, The (Selig, 1909), 51
Cowboy's Baby, The (Selig, 1908), 42
Cowboys, 51; and image in film 15–16, 16, 64,
 133, 135
Crescent Film Company, 73, 74
Crime films, 10, 20, 42, 49, 60, 89, 137–141, 142
Cripple Creek, Colorado, 21–24
Crosby, James, 43
Cruze, James, 6, 179

Cunningham, Eugene, 202
Curse of the Redman (Selig, 1911), 48, 85–87, 86, 87
Custer's Last Fight (NYMP, 1912), 125–126

Damion and Pythias, 48
Daring Daylight Burglary (Sheffield Photo, 1903), 20
Darkfeather, Mona. *See* Josephine Workman
Davy Crockett in Hearts United (NYMP, 1909), 74
Deadwood Dick series, 138
Debs, Eugene V., 194
DeMille, Cecil B., 6, 83, 97–98, 161, 163
Denver, 10, 13, 27, 50
Deserter, The (NYMP, 1912), 121, 132(n78)
Desperate Poaching Affray, A (Haggar, 1903), 20
Dick Stanley-Bud Atkinson Wild West Show, 205
Dick Turpin (Fox, 1925), 197, *199*
Dickson, William K., 61
Dime novels, 42, 52, 89, 107–109, 112, 125, 128(n5), 129(n8), 138, 154(n26), 155(n51), 219
Disney Corporation, 193
Dix, Otto, 53
Domino, 128
Dumb Half Breed's Defense, The (Essanay, 1910), 58

Eagle-Lion Studios, 196
Eagleshirt, William, 119
Eastman Company, 74
Edison Manufacturing, 4, 10, 54, 61
Edwards, Bill, 77
El Paso, Texas, 50
Empire Film Exchange, 73
Esquivel, Antonio, 211
Esquivel, Pedro, 61
Essanay Film Manufacturing, 3, 30, 38, 39, 41, 48–51, 54–56, 63, 94, 111, 134, 135, 137, 149, 164, 194, 217, 219
Everson, William, 6
Exhibition venues for motion pictures: and churches and YMCAs 20; and Parks, 19; and vaudeville, 12, 40–41; and Wild West shows, 20. *See also* Hale's Tours

Fabian, Ann, 5
Fairbanks, Douglas, 157, 172, 175, 177, 195, 197

Falling Arrow, The (Lubin, 1909), 92, 102(n69)
Famous Players Lasky, 151, 179
Farnum, Dustin, 49, *98*, 161
Female Highwayman, The (Selig, 1906), 27
Fenin, George, 6
Film audiences, 5, 64(n3). *See also* African Americans; Children; Women: as film audiences; Western films: and popularity with audiences
First National Film Company, 190, 199–200, 202, 206
Flaming Frontier (Universal, 1926), 198–199
Flight of Red Wing, The (NYMP, 1909), 81
For the Love of Red Wing (NYMP, 1909), 81
For the Papoose (Pathé, 1912), 95
For the Sake of the Tribe (Pathé, 1911), 93
For the Squaw (Pathé, 1911), 95–96
Foran, Dick, 194, 206
Ford, John, 2, 6, 179, 221
Fort Lee, New Jersey, 74, 75
Fox Film Company, 63, 190, 192, 193, 197, 202, 204, 208, 211
Frawley, Jack, 73
French auteur theory, 2
French, Charles K., 74, 77
Friedman, Moses, 88
Frohman Amusement Corporation, 209
Frohman, Charles, 59

Galloping Fury (Universal, 1927), 205
Galloping Kid, The (Universal, 1922), 205
George, Maud, 171
German Americans, 11
Gibson, Hoot, 189, 190, 194, 196, 198–199, 202, 203, 204, 205, 206, 208, 211, 212
Girl From Montana, The (Selig, 1907), 27–28, 29, *30*
Girl of the Golden West (Lasky, 1915), 163
Girl of the Golden West (opera), 28
Girl of the Golden West (play), 52, 157, 163
Glaum, Louise, 166, 169
Golden, Harry, 150–151
Graham, Evelyn, 74, 77
Grandon, Ethel, 114
Granger Movement, 138
Great K and A Train Robbery, The (Fox, 1926), 205
Great Train Robbery, The (Edison 1903), 10, 20–21, 26, 73, 218
Griffith Park, 79

Griffith, D.W., 6, 76, 164, 165, 177
Guinan, Texas, 209–211
Gun Woman, The (Triangle, 1918), 209
Gunfighter Nation, 3

Hale, George C., 19
Hale's Tours, 19–20
Harding, Warren G., 194
Harrison, Louis Reeves, 98, 125, 141
Hart, Mary, 177
Hart, Nicholas, 158
Hart, Rosanna, 158
Hart, William S., 46, 63, 72, 83, 90, 128, 153,
 157–180, 182(n57), 188, 189, 193, 195, 205,
 207, 208, 209, 211, 216(n86), 220
Hawks, J.G., 157, 162, 171, 172
Hayakawa, Sussue, 119
Hearst, William Randolph, 165
Hearts Courageous, 160
Hell's Hinges (Triangle, 1916), 169–170
Hero. *See* Western film hero
Hero on Horseback (Universal, 1927), 205
Hillyer, Lambert, 177
History of Cripple Creek (Selig, 1904), 24
Hobsbawm, Eric J., 141, 142, 154(n26),
 154(n38)
Hold-Up of the Leadville Stage, The (Selig 1904),
 21, 21–22, 137
Hollingsworth, Alfred, 169
Horsely, David, 108–109
Horsemanship, 29, 205
Horses, 206–207, 216(n86), 216(n88)
Hoxie, Jack, 83
Hydraulic Giants at Work (Selig, 1902), 16

Imperialism, 62–63
In the Bad Lands (Selig, 1909), 60
In the Days of the Thundering Herd (Selig, 1914),
 83
Ince, Thomas H., 72, 106, 114–115, 118–119,
 131(n68), 131(n69), 157, 161–162, 165, 176,
 216(n86), 219
Inceville, 115–116, 119–120, 131(n54)
Independent motion picture companies, 71
Independent Moving Picture Company (Imp),
 80, 114
Indian and the Child, The (Essanay, 1912),
 69(n99)
Indian Fire Dance (Selig, 1902), 18
Indian Girl's Sacrifice, An (Essanay, 1910), 58

Indian Hideous Dance (Selig, 1902), 20
Indian Land Grab, The (Champion, 1910),
 102(n76)
Indian Massacre (NYMP, 1912), 121, 132(n78)
Indian Parade Picture (Selig, 1902), 20
Indian Vestal (Selig, 1911), 48
Indian's Bride, An (NYMP, 1909), 92
Indian's Gratitude, An (Selig, 1908), 42, 43
Indian's Sacrifice, An (Essanay, 1910), 58,
 102(n76)
Indians. *See* Native Americans
Inslee, Charles, 74, 77
Iron Horse, The (Fox, 1924), 6, 179
Iron Tail, 211
Italian, The (NYMP, 1915), 166

James Boys in Missouri, The (Essanay, 1908), 42,
 137, 138, 139, 142
James Boys Weekly, The, 42
James, Jesse, 42, 49, 138, 141, 142, 144
Jesse Lasky Feature Play Company, 161
Jones, Buck, 190, *192*, 192–193, 194, 195, 196,
 202, 203, 206, 208–209, *210*, 211

Kalem Company, 41, 48, 51, 54, 57, 76, 219
Kay Bee, 128
Keaton, Buster, 195
Keno Bates-Liar (NYMP, 1915), 163
Kershaw, Elinor, 114
Kessel, Adam, 72, 73–74, 116, 126
Keystone Company, 165
Kinetoscope, 11
Kinodrome, 40–41, 65(n8)
Kitses, Jim, 2
Kleine, George, 13, 26, 67(n71), 152
Kolle, Herman, 73–74
Ku Klux Klan, 23, 34(n58), 168
Kurosawa, Akira, 173
Kyne, Peter B., 144

Labor unions, 149
Laemmle, Carl, 80, 127, 198
Lake, Stuart N., 202
Lease, Rex, 196
Lee, Lawrence, 41, 141
Lenihan, John H., 2, 3
Leupp, Francis, 85
Liberty Loan campaign, 177
Lieutenant's Last Fight, The (NYMP, 1912),
 132(n78)

Lipsitz, Harold B., 202
Little Daughter of the West, A (NYMP, 1912), 121
Lloyd, Harold, 195
Location shooting, 38, 45, 46, 49–50, 56, 217
Lockwood, Harold, 183(n71)
Los Angeles, 46; and the development of the motion picture industry, 4, 38, 43, 45, 49, 54, 56, 64, 77–79, 82–83, 115, 218
Love Brokers, The (Triangle, 1919), 209
Love of an Indian (Pathé, 1913), 100(n41)
Love, Bessie, 167
Lubin Company, 41, 54, 76, 100(n34), 151
Lubin, Siegmund, 73
Lumière cinématographe, 11–12
Lumière Company, 74
Lynching at Cripple Creek, The (Selig, 1904), 21, 22–24, 34(n56)

MacCaulley, Elizabeth, 179
Manifest Destiny, 62–63
Marlowe, Julia, 159
Masculinity, 146, 151, 170, 172, 203
May, Karl, 53
Maynard, Ken, 189, 190, 194, 196, 199–200, 202, 203, 204, 206, *207*, 208, 212
McCellan, George B. Jr., 139
McCoy, Tim, 190, 194, 196, 200–201, *201*, 202, 203, 204, 206, 208, 211
McGee, James L., 43, 45
McKim, Robert, 171
Méliès Company, 41, 54, 73
Memories of a Pioneer (NYMP, 1912), 121
Mended Lute, The (Biograph, 1909), 76
Metro Goldwyn Mayer, 190, 200, 208
Mexican Revolution, 204
Mexican's Faith, The (Essanay, 1910), 58, *59*
Mexican's Gratitude, A (Essanay, 1909), 58
Mexicans, 118; and image in film, 57–59, 135, 166
Middle class, culture, 64(n3), 94, 113, 134, 137, 138, 139, 145, 146, 163, 169, 171
Military, 60, 62, 125, 172, 204
Miller Brothers' 101 Ranch Wild West Show, 61, 75, 106, 113, 115–116, 118, 121, 123, 132(n73), 134, 205, 211, 219
Mining, 16
Minnematsu, Frank, 63
Miscegenation, 90–91, 92–96, 102(n85)
Mitchell, Rhea, 163

Mix, Tom, 53, 63, 83, 172, 177, 187, 189–190, *191*, 193–194, 197, *199*, 202, 203–204, 205, 206, 208, 211, 212, 221
Modjeska, Helena, 159
Monogram Studios, 196
Montana School Marm, A (Selig, 1908), 42
Montgomery, Frank, 127
Mosher and Harrington motion picture exchange, 73
Motion picture companies. *See individual companies by name*
Motion Picture Distributing and Sales Company, 80, 126–127
Motion picture exhibition, 11–12, 40
Motion Picture Patents Company, 41, 53
Motive Motion Picture Company, 108
Mount Shasta, 48
Mountain Meadows Massacre, 121
Movie palaces, 188
Mr. Silent Haskins (NYMP, 1915), 163–164
Mulhall, Lucille, 28, 211

Nash, Thomas S., 13, 30
National Board of Censorship, 89, 94, 139
National Film Renting Company, 39
Nationalism, 38, 62–63, 106, 125
Native Americans: and assimilation, 87–88, 90, 91, 94–96, 98–99, 101(n66); as film actors, 60, 61, 84, 116, 118, 119, 120–121, 219; as film makers, 5, 57, 72, 80–83; and image in film, 16–18, *17*, 57–59, 71, 72, 74–75, 80, 83–99, *88*, 200; and image in legitimate theater, 83–84, 90–91. *See also individual tribes by name*
Nativism, 11
Nestor Motion Picture Company, 48, 108–109, 121, 219
New Orleans, 43
New York Motion Picture Company, 3, 45, 48, 57, 72–75, 82, 94, 106–107, 111, 113–115, *117*, *120*, 126, 131(n54), 134, 153, 161–162, 163, 164, 166, 216(n86), 217, 219, 220. *See also* Bison Company
New York's Child Welfare Committee, 111
Nickelodeon theaters, 37–39, *39, 40,* 106, 110, 111, *111,* 129(n7), 138, 139; and middle class patronage of, 64(n3), 146
Night Riders, 138
Niles, California, 51, 135, 136, 137
Norman Film Company, 211

Norris, Frank, 112, 130(n41)
Not a Drum Was Heard (Fox, 1924), 193

O'Brien, George, 196
O'Brien, Jack, 49
Oakley, Annie, 28, 61, 211
Office of Indian Affairs, 87, 121, 132(n73)
Oklahoma, 61, 116, 121
On the Night Stage (NYMP, 1915), 166
On the Warpath (Selig, 1909), 60
Oropeza, Vicente, 61, 206, 211
Outbreak, The (Selig, 1911), 44

Panorama of Ute Pass (Selig, 1902), 15
Paramount Artcraft, 176, 177
Pat Henry Massacre, 121
Pathé Company, 41, 45, 48, 51, 54, 58, 67(n66),
 73, 82, 89, 97, 100(n34), 219
Perry, Pansy, 29, 30
Persons, Thomas, 21, 30, 42
Pet of the Big Horn Ranch (Selig, 1909), 61
Pickett, Bill, 205, 211
Pickford, Mary, 175, 177, 183(n71)
Pocahontas, 101(n66)
Ponca Indians, 116
Populist Movement, 138
Porter, Edwin S., 20, 73
Post Telegrapher, The (NYMP, 1912), 121,
 132(n78)
Power of Good, The (Essanay, 1911), 145
Pratt, Richard H., 96–97
Prospector and the Indian, The (Pathé, 1912), 95–
 96
Prospectors, The (Vitagraph, 1906), 27, 35(n80)

Racism, 72, 91, 94, 118–119, 166–169
Railroads: and early cinema, 12, 32(n15)
Ranch King's Daughter, The (Selig, 1910), 62
Ranch Life in the Great Southwest (Selig, 1910),
 62, 63
Ranchman's Love, The (Selig, 1908), 42
Ranchman's Rival (Essanay, 1909), 57
Range Pals (Selig, 1911), 48
Reagan, Ronald, 221
Realism, 112–113
Red Eagle, the Lawyer (Pathé, 1912), 93
Red Girl and the Child, The (Pathé, 1911), 82
Red Raiders (First National, 1927), 216(n88)
Red Wing, Lillian, 72, 75–76, 77, 77, 78, 80–83,
 81, 96–98, 98, 118, 219

Red Wing's Gratitude (Vitagraph, 1909), 76
Red Wing's Recovery (NYMP, 1909), 81
Redskin's Bravery, The (NYMP, 1911), 80
Reelcraft Films, 209
Reformation, The (Essanay, 1909), 143
Remington, Frederic, 170–172, 182(n57), 220
Republic Studios, 196
Revolutionary War, 75
Ride for Your Life (Universal, 1924), 205
Ridin' Wild (Universal, 1922), 205
Riding for Fame (Universal, 1928), 205
Ringling Brothers' Barnum and Bailey Circus,
 75, 206
Road Agents, The (Essanay, 1909), 137
Robbins, Jesse, 41, 49
Roosevelt, Theodore, 13, 85, 170–172,
 182(n57), 220
Royal Gorge (Selig, 1902), 15
Royle, Edwin Milton, 89, 91
Runaway Stage Coach (Selig, 1902), 14
Russell, Charles, 182(n57)
Russell, W.K., 49

Saddle Hawk, The (Universal, 1925), 205
Salvini, Tommaso, 158
Samuels, Zerelda, 142
San Antonio, Texas, 54
San Bernardino, California, 79
San Diego, California, 50
San Francisco, 136, 137, 153(n18)
Sandburg, Carl, 189, 194, 208
Santa Barbara, California, 50
Santchi, Tom, 43
Sargent, Epes Winthrop, 165
Saturday Evening Post, 144, 165
Savage, Henry, 59
Schlichter, Rudolf, 53
Scourge of the Desert, The (NYMP, 1915), 163
Screen writing, 124–125, 157, 161–164, 165–
 166, 171, 201–202
Selfish Yates (Paramount, 1918), 177
Selig Polyscope Company, 3, 12, 24–25, 38, 41,
 42–48, 45, 54–56, 55, 62, 63, 84, 85–87, 111,
 137, 151, 205, 217, 219, 221
Selig, William N., 10–12, 60
Selznick, David O., 190
Sennett, Mack, 165
Sherman Indian School, 85
Sherry, J. Barney, 77
Shields Lantern Slide, 73

Shootin' Mad (Anderson Photoplay, 1918)
Shoshone Indians in Scalp Dance (Selig, 1902), 18
Singer Jim McKee (Paramount, 1913), 179
Sioux Indians, 60
Six Guns and Society, 2
Sky High (Fox, 1922), 208
Slotkin, Richard, 3, 62. *See also Gunfighter Nation*
Smallwood, Ray, 114
Smith, Arthur, 49
Smith, Henry Nash, 2, 134
Smith, Maxwell, 77
Social gospel movement, 169
Social reform, 163–164, 166. *See also* Middle class
Society for the Prevention of Cruelty to Animals, 216(n86)
Soldier's Honor, A (NYMP, 1912), 121
Somewhere in Sonora (First National, 1927), 200, 216(n88)
South African Boer War, 204
Southwest Museum, 46
Spanish-American War, 63, 203–204
Spencer, Richard V., 124
Spoor, George K., 30, 39–41, 64(n4), 65(n8), 151–152
Spoor, Harry A., 52
Squaw Man, The (Lasky, 1914), 83, 97, 98, 161
Squaw Man, The (play), 52, 89–90, 91, 92, 93, 95, 160
Squaw Man's Revenge, The (Pathé, 1912), 102(n85)
Squaw's Revenge, The (NYMP, 1909), 74
Stage acting, 159
Standing Bear, Luther, *201*
Standings, Jack, 169
Streychmans, H. J., 126
Strike at "Little Jonny" Mine (Essanay, 1911), 149
Stunts, 63, 205, 208
Sullivan, C. Gardner, 157, 165–166, 172, 181(n37)

Taft, William Howard, 86, 135
Texan, The (Fox, 1924), 208
Texas Guinan Productions, 209
Texas Rangers, 63
Thanhouser, 84
Theatrical Trust, 160
Tiger Man (Paramount, 1918), 177
Todd, Harry, 43
Toll Gate, The (Paramount, 1920), 170, 177

Tompkins, Jane, 3, 4, 134, 145, 188, 221. *See also West of Everything*
Totheroh, Roland, 51
Tournament of Roses Parade, 98
Tousey, Frank, 42, 108–109
Trailed by Bloodhounds (Paul, 1903), 20
Triangle Film Company, 51, 164–165, 176
Trouble Shooter, The (Fox, 1924), 208
True Heart of an Indian, The (NYMP, 1909), 74
Tumbleweeds (United Artist, 1925), 178–179, 184(n94), 189
Turner, Otis, 59, 61, 62, 63, 124
Turpin, Ben, 41–42
Tuska, Jon, 6
Tyler, George, 160

U.S. Cavalry, 60, 125, 204
U.S. West, and image in film 5–6, 15–17, 27, 31, 38, 113
Under Mexican Skies (Essanay, 1912), 69(n99)
Underwood and Underwood Company, 73
United Artists, 177, 178, 189
Universal Film Manufacturing Company, 63, 109, 127, 198, 202, 205
Ute Indian Snake Dance (Selig, 1902), *17, 18*

Valentine, Robert, 87
Valentino, Rudolph, 188, 197, 204
Vaudeville. *See* exhibition venues for motion pictures: and vaudeville
Venice, California, 115
Victorianism, 29, 141, 142, 170, 171, 172, 175, 188, 209, 220, 221
Violence in westerns, 22–24, 106, 107, 166
Virginian, The (play), 49, 52, 157, 160, 172
Virginius, 160
Vitagraph Company, 4, 41, 54, 84, 151
VLSE, 151

Wallace, Lew, 160
War of 1812, 75
War on the Plains (NYMP, 1912), 121, 122–123, 132(n78)
War Paint (MGM, 1926), 200
Ward, Jean, 43
Washington, DC, 86
Wayne, John, 221
West of Everything, 3
Western Chivalry (Essanay, 1909), 57
Western comedies, 56, 57

Western Federation of Miners, 23
Western film hero, 5, 38, 56–59, 63, 64, 106, 133–153, 162–163, 188, 189, 194–195, 203–212
Western films: and definition of, 6; and the establishment of the U.S. film industry, 53–54, 67(n66); as exports 52–53, 111–112, 113, 193; and industry sentiment against, 109–110; and popularity with audiences, 37, 51–53, 11
Western Hearts (Selig, 1911), 31
Western Hero, The (Pathé, 1909), 54, 67(n71)
Western Justice (Selig, 1907), 27–28, 29
Western stage melodramas, 52, 89, 107
Westover, Winifred, 179
Whaylen's Wild West on Canvas, 20
Wheeler, Edward, 138
When the Heart Calls (Selig, 1912), 102(n76)
White Oak (Paramount, 1921), 83
Why the Sheriff's a Bachelor (Selig, 1911), 31
Wild Bill Hickok (Paramount, 1923), 179
Wild West shows, 15, 20, 211, 215(n80): in motion pictures, 60, 61, 62, 64, 78, 83, 106–107, 114, 118, 121–122. *See also* specific show names
Wild West Weekly, 108
Will A. Dickey's Circle D Ranch and Wild West Show and Indian Congress, 61, 62, 63, 205

Willat, Irvin, 131(n69)
William S. Hart Production Company, 176
Williams, Bert, 11
Williams, Clara, 50, 169
Wilson, Woodrow, 170–172, 175
Winnebago Indians, 75, 81, 100(n32)
Wister, Owen, 49, 160, 170, 182(n182), 220
Woman's Christian Temperance Union, 139
Women: as film audiences, 5, 106, *198*, 220; and image in film, 5, 28–29, 142–143, 146, 171, 189; in westerns 28–29, 50–51, 72, 75–76, 77, 80–83, 96–98, 118, 209–211
Working class, culture, 107, 138, 149
Workman, Josephine, 82
World War I, 204
World War II, 204
Wright, George B., 109
Wright, Will, 2, 3, 4. *See also Six Guns and Society*

Yosemite Valley, 48
Young Deer, James, 58, 72, 75–76, 77, *78*, 80–83, *81*, 89, 91–99, 100(n34), 100(n41), 118, 119, 219
Young Deer's Bravery (NYMP, 1909), 81
Young Deer's Return (NYMP, 1909), 81, 92
Younger Brothers, The (Essanay, 1908), 42, 137
Younger, Cole, 138, 141